Behold yon sea of isles, boy,

Behold yon sea of isles,

Where every shore

Is sparkling o'er

With Beauty's richest smiles.

For us hath Freedom claimed, boy,

For us hath Freedom claimed

Those ocean-nests

Where Valor rests

His eagle wing untamed.

from "Ino" in The Summer Fete
by Thomas Moore

WHERE VALOR RESTS
Arlington National Cemetery

NATIONAL GEOGRAPHIC
Washington, D.C.

Essay RICK ATKINSON

Afterword BRIG. GEN. CREIGHTON ABRAMS, JR. (U.S.A. RET.)

ESSAYISTS

JAMES BALOG
DAVE BLACK
DAVID BURNETT
BRUCE DALE
DAVID ALAN HARVEY
BRIAN LANKER

PHOTOGRAPHERS

SUSAN BIDDLE
CHIEF PHOTOGRAPHER'S MATE JOHNNY BIVERA, NAVY
MICHEL DU CILLE
LIEUTENANT COLONEL MICHAEL EDRINGTON, ARMY
WENDY GALIETTA
SERGEANT HARAZ GHANBARI, ARMY
TECHNICAL SERGEANT STACI MCKEE, AIR FORCE
SERGEANT FERDINAND THOMAS II, ARMY
MASTER SERGEANT JIM VARHEGYI, AIR FORCE

Page 1: A wreath at the Tomb of the Unknown Soldier honors the 150th anniversary of Arlington National Cemetery's founding. Pages 2 and 3: Headstones from Section 54. Page 4: The Eternal Flame at the President John F. Kennedy Memorial. Page 5: On guard at the Tomb of the Unknown Soldier.

CONTENTS

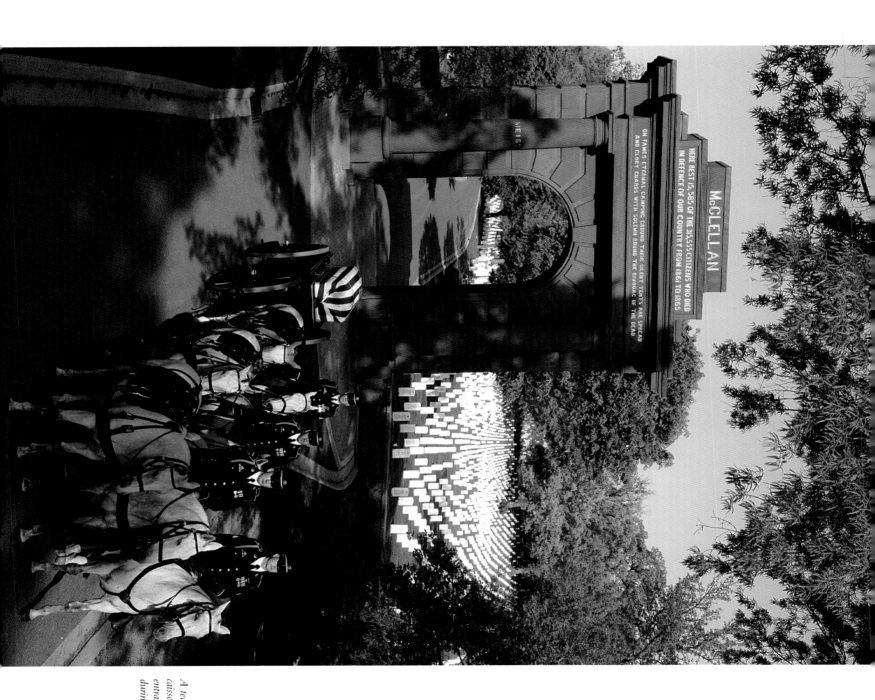

A team of horses ridden postilion style draws a caisson through McClellan Gate, the original entrance to Arlington National Cemetery, during a full honors Army funeral.

Preface

A TRIBUTE TO THE PAST, PRESENT, AND FUTURE

LIKE ARLINGTON NATIONAL CEMETERY itself, this book arose from a desire to memorialize the valiant heroes who died in service to the nation. In addition to presenting the next of kin with a folded flag after interment or inurnment, the Army wanted family members to have available something from Arlington that reminded them of their loved one and the hallowed place where he or she will rest eternally. Thus came the challenge of creating a book that was every bit as elegant, tasteful, and relevant as a military honors funeral and worthy of the most sacred square mile in America.

Meeting this challenge required heavy artillery: writers and photographers with more than ten Pulitzer Prizes among them as well as a phalanx of accomplished military photojournalists. Their orders: bring their own vision to what they discovered at Arlington. The result: their different personalities, perspectives, and techniques created some of the most singular and moving impressions of the cemetery ever published. And to a person, even the most hard-boiled war photographers, everyone became emotionally involved.

How could they not? From every point of view—aesthetic, patriotic, historic—Arlington brims with emotion. The grounds are simultaneously sad and beautiful, "undulating, handsomely adorned, and in every respect admirably fitted for the sacred purpose to which they have been dedicated," according to an 1864 newspaper report, the year the cemetery officially opened. A century and a half later, these elysian fields continue

to inspire—whether it's the workers who dote over every grave and blade of grass, the 300-plus service members who every day give honors to the fallen, the sentinels who guard the Tomb of the Unknown Soldier, the tourist who marvels at the seemingly infinite rows of marble tributes to eternity, or the Arlington Lady who represents the military in offering solace to family members at funerals.

Even though Arlington belongs to the nation, it belongs above all to the valorous men and women—and to their families—who have sacrificed everything for their country. They are the ones who inspired this book and in whose debt the nation will forever remain.

Some have asked, "Why Arlington? Why now?" To which our response is, "Why not Arlington? Why not now?" Whatever our opinions about war, there is never a time when the values consecrated at Arlington are irrelevant, when the lives of those who died in defense of this country are not "marketable."

This is not a political book but a patriotic one. As you leaf through the pages, we think you'll agree in our digital age, nothing expresses itself quite like a finely crafted photography book. Everyone who worked on this book went into the same kind of loving detail that goes into everything at Arlington. Our express goal was to do justice to this hallowed, timeless monument and to let those who visit carry the memory forever with them.

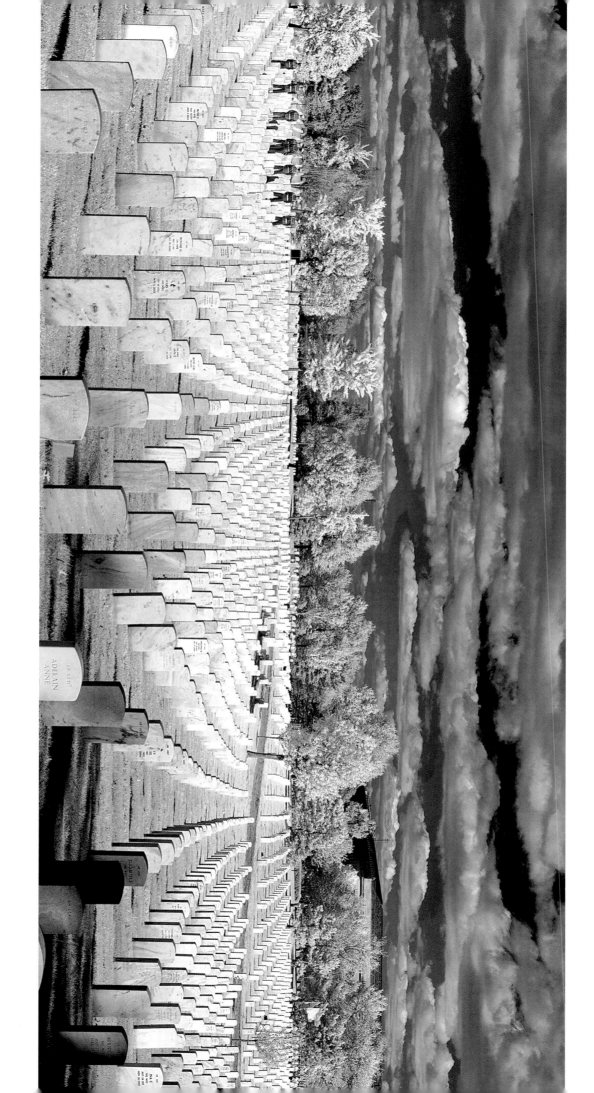

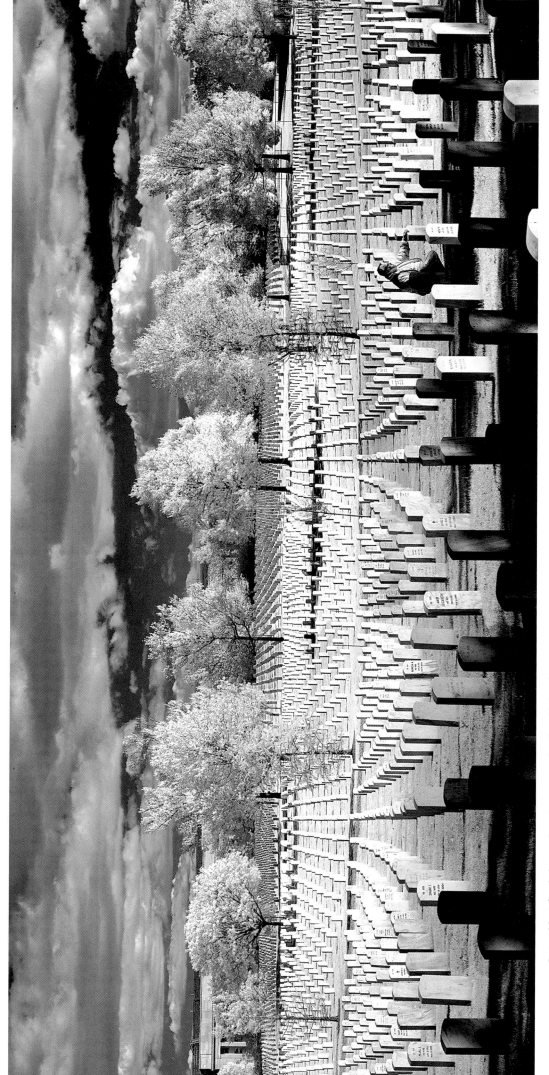

Captured by infrared photography, a lone mourner kneels amid the columns of grave markers that stretch infinitely across Arlington's spectral landscape.

A ten-star intersection of Second World War generals. No form of weather halts the eternal guarding (right) of the Tomb of the Unknown Soldier, where, every Christmas, wreaths adorn the marble slabs commemorating unidentified remains from World War I, World War II, and Korea. A fourth wreath adorns the crypt that previously held the remains of a Vietnam veteran. Though the remains were later identified and removed, the wreath remains to honor all Vietnam veterans.

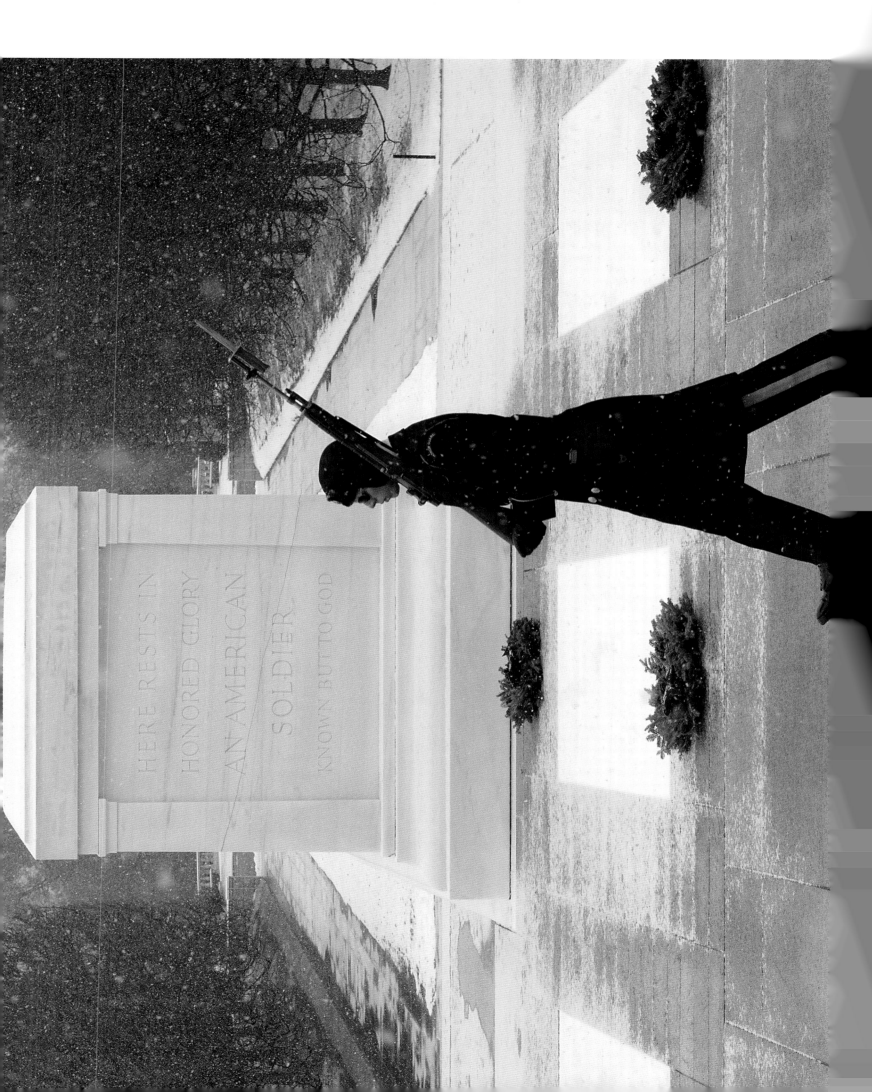

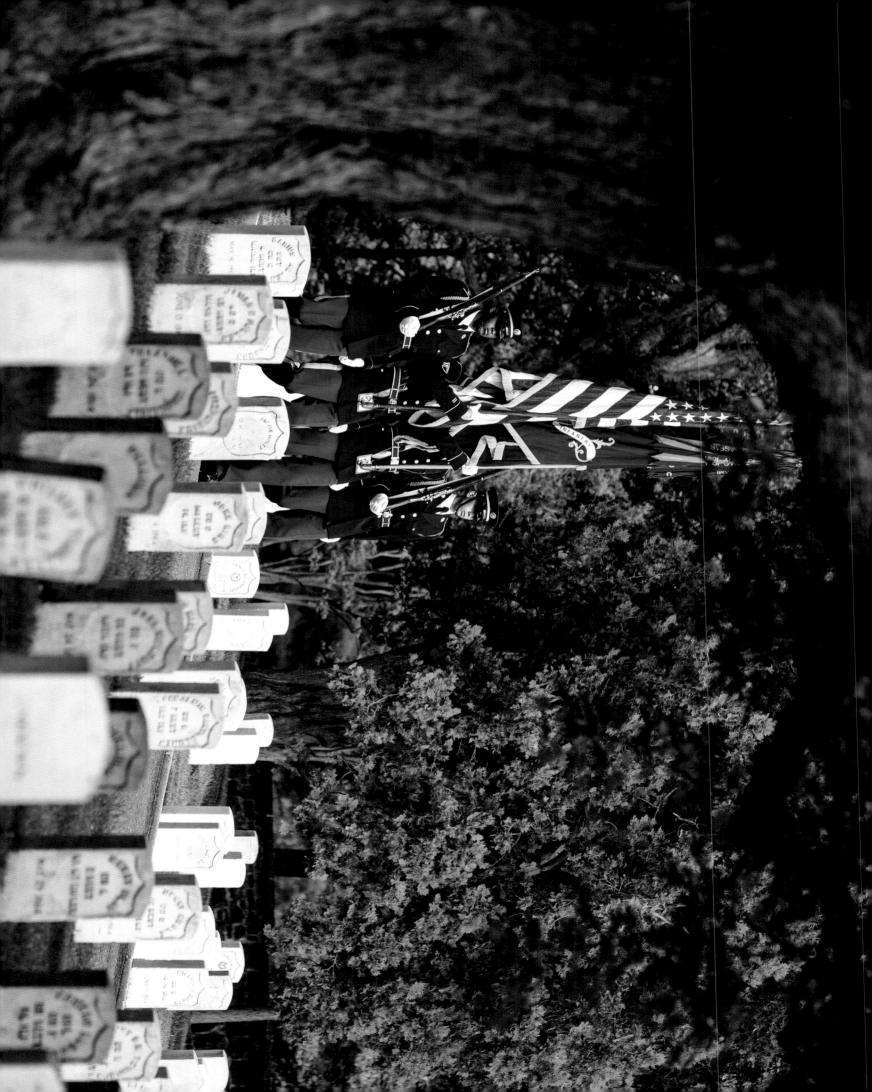

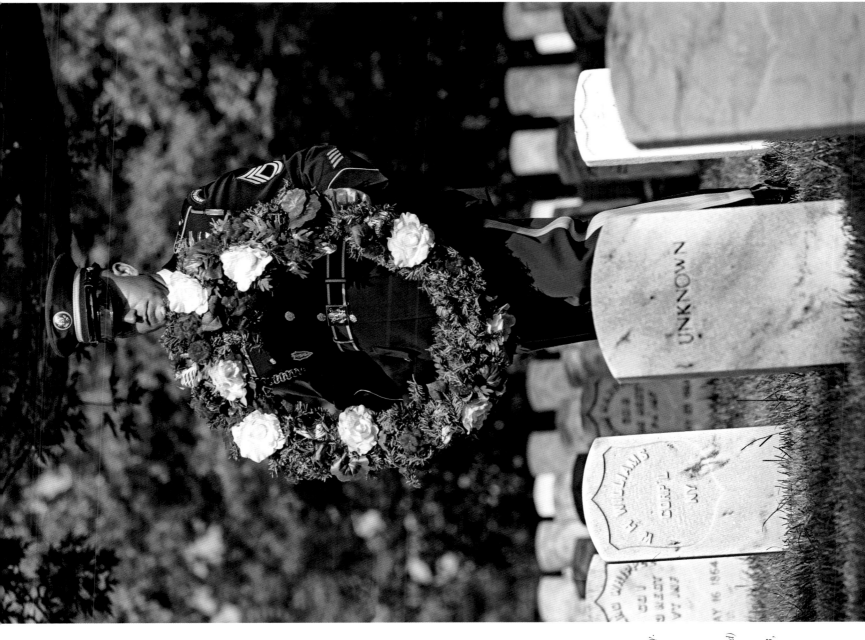

A color guard from the 3rd Infantry (Old Guard) processes toward the grave site of Union Army Pvt. William Christman (left), the first military burial at the cemetery. This ceremony marked the beginning of commemorations of the 150th anniversary of Arlington National Cemetery in Arlington, Virginia, May 13, 2014.

A member of the 3rd Infantry (Old Guard) Honor Guard carries a commemorative wreath to the grave of Private Christman for a ceremonial wreath-laying on May 13, 2014, exactly 150 years since his burial on May 13, 1864.

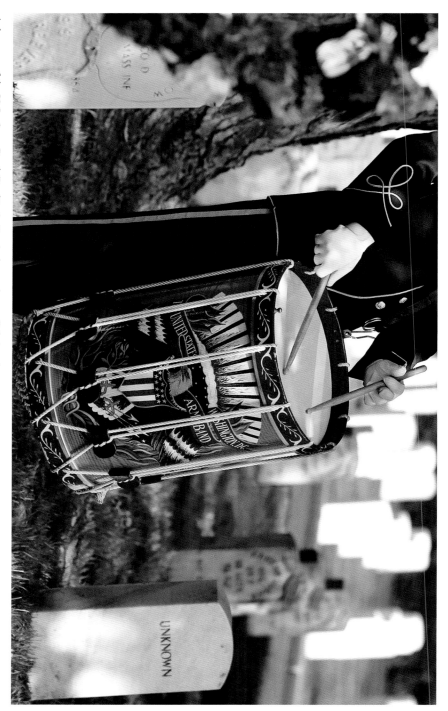

A drummer of the U.S. Army Band (Pershing's Own) plays a drum roll during the performance of "Taps" at the grave site of Union Army Private Christman. Christman, 20, enlisted in the 67th Pennsylvania Infantry and was hospitalized for measles five weeks later, dying on May 11, 1864.

Jack Lechner (right), then Deputy Superintendent of Arlington National Cemetery, places his hand over his heart at the grave site of Private Christman on the 150th anniversary of his burial.

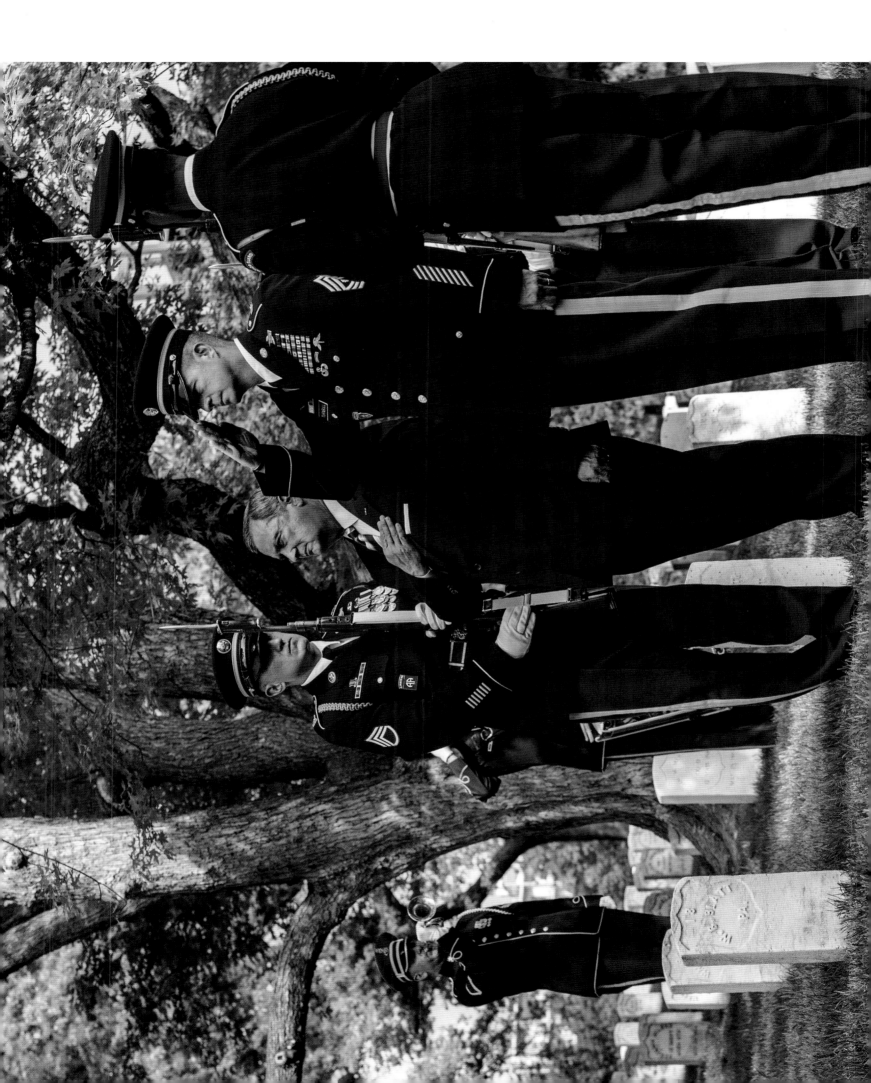

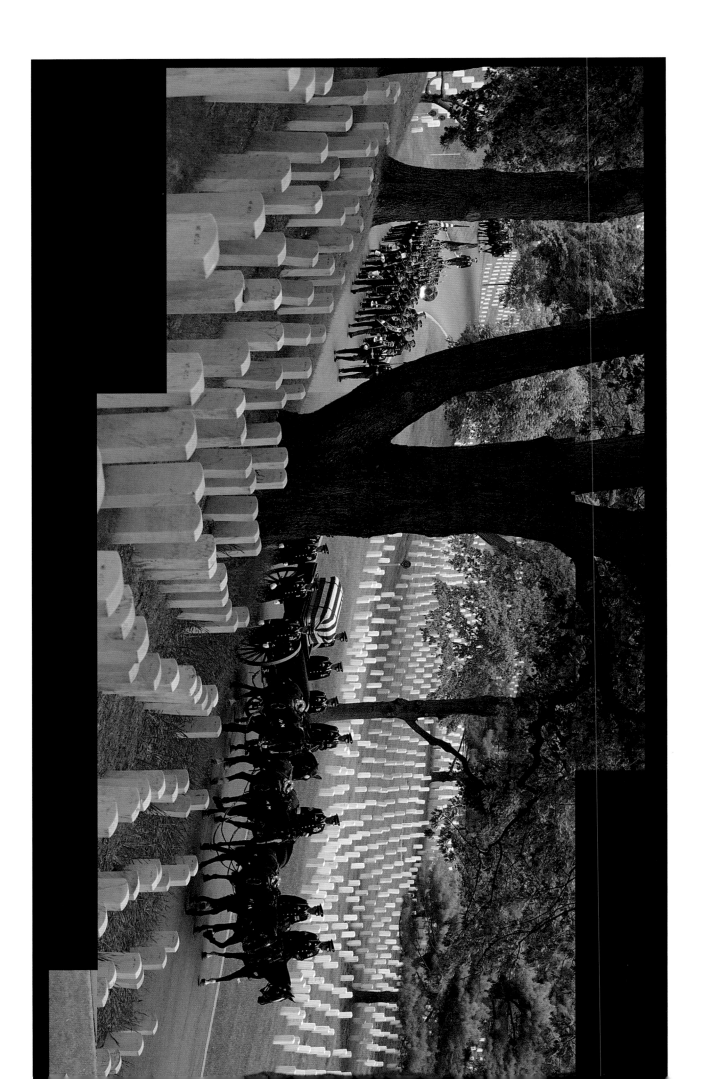

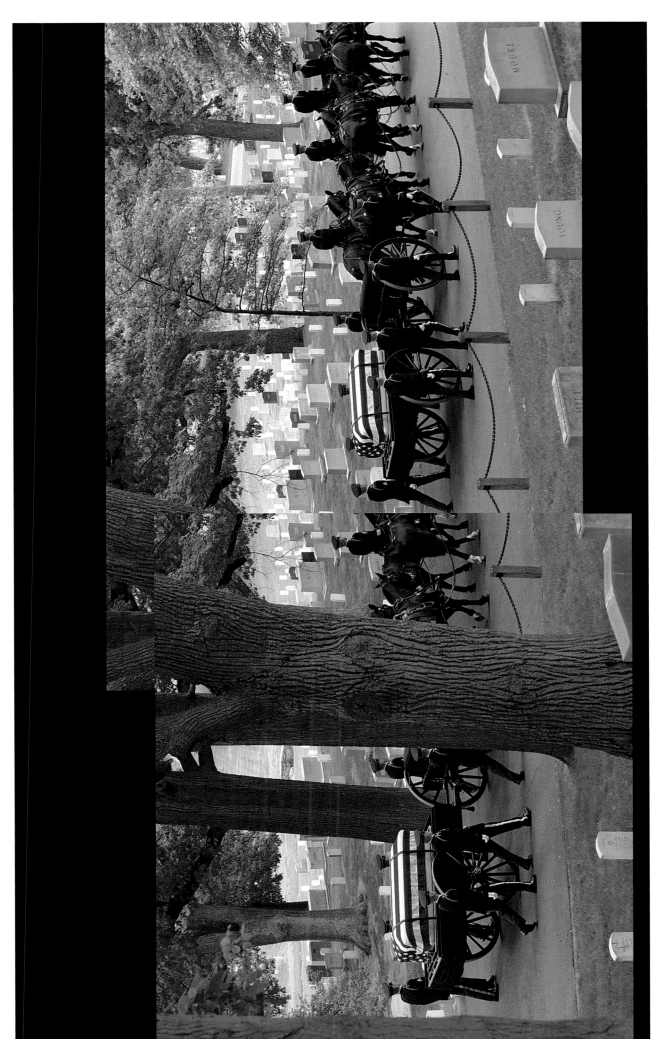

At one of two dozen funerals that take place each day, a caisson bearing the flag-draped casket of retired Army 1st Lt. Walter P. Kuzmuk rolls through Arlington's winding roads.

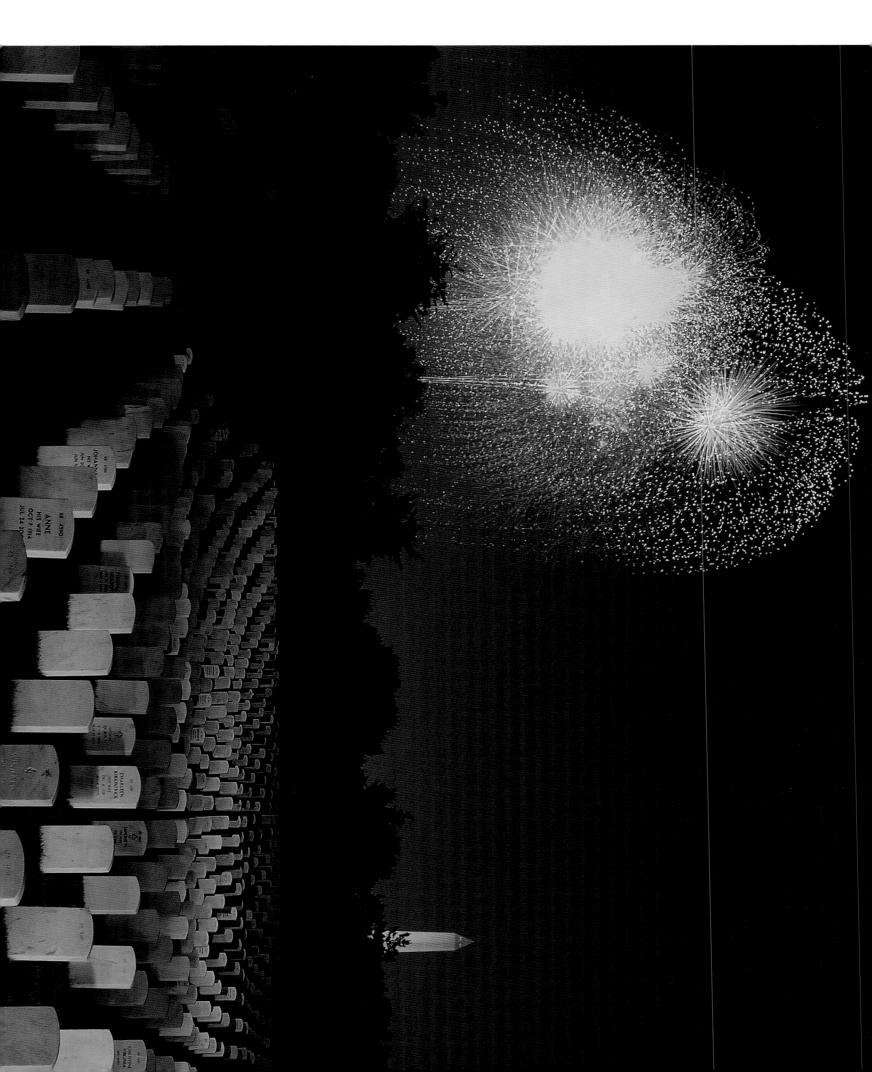

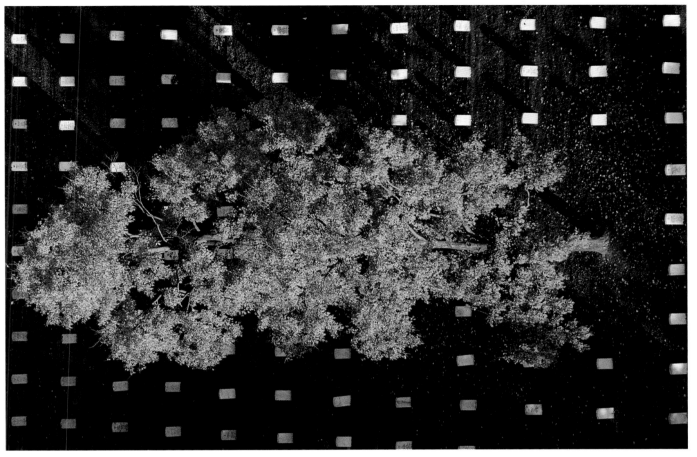

Colorful explosions of July 4th fireworks (left) and fall foliage fill the skies above Arlington.

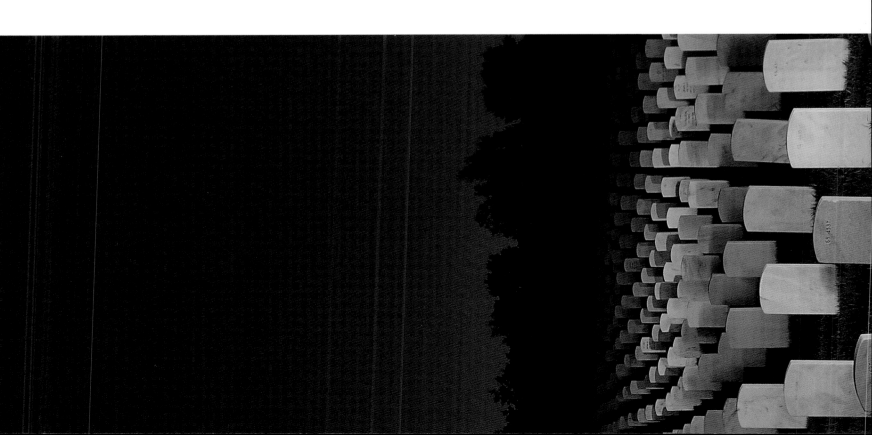

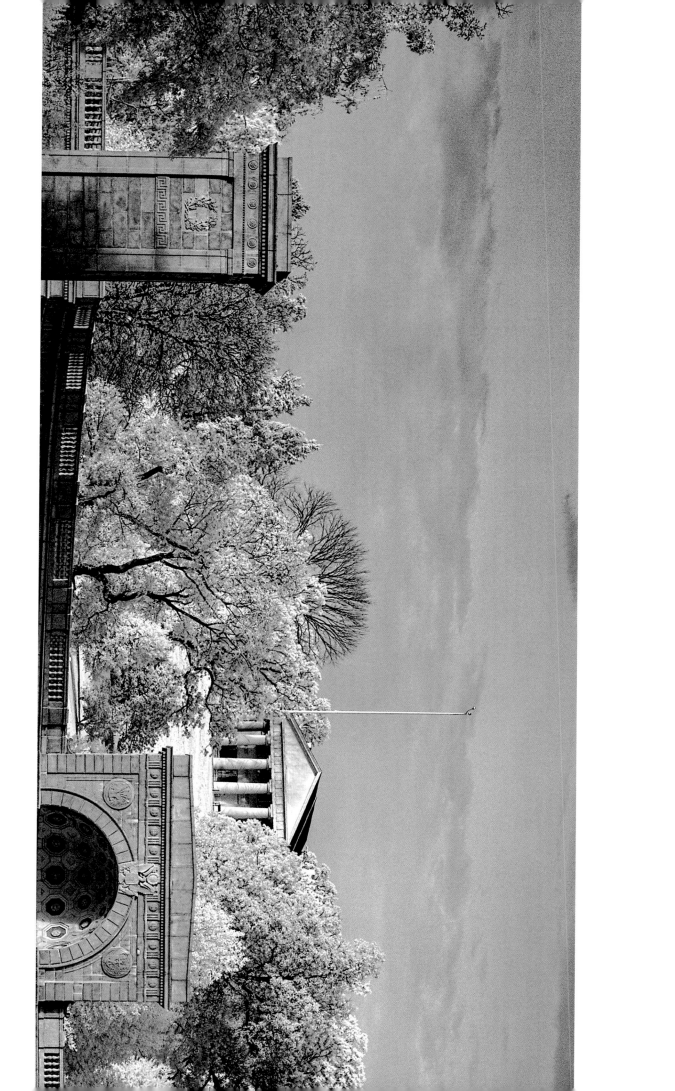

Framed by the colonnades of trees and Arlington House, the Women in Military Service for America (WIMSA) Memorial creates a glorious panorama.

The first page of the Arlington grave register, dated 1864, lists William Christman (spelled incorrectly) as the cemetery's first burial.

Essay RICK ATKINSON

A PLACE OF REVERENCE AND REMEMBRANCE

NOTHING IN WILLIAM HENRY CHRISTMAN'S brief life suggested that in death he would become a singular figure in American history. A laborer from Lehigh County, Pennsylvania, Christman enlisted in the Union Army on March 25, 1864, for a $60 cash bounty and a $300 promissory note from his government. The muster rolls of the 67th Pennsylvania Infantry Regiment recorded that he was 5' 7½" tall, with sandy hair, gray eyes, and a florid complexion. Twenty-one years old and unmarried, he bore a scar on the left side of his neck and three prominent moles on his back. "I em well at the preasant time ant hope that my few lines will find you the same," he wrote his parents from Philadelphia on April 3, 1864. Military life suited him, he added. "I like it very good. We have enuph to eat and drink."

Three weeks later young Christman was hospitalized for measles. He grew sicker, and on May 1 was admitted to Lincoln General Hospital, a mile east of the Capitol in Washington, D.C. There, in Ward 19 on Wednesday, May 11, he died of peritonitis, a toxic inflammation of the membrane lining the abdominal cavity. An inventory of Christman's effects listed his modest legacy, including a hat, two flannel shirts, a pair of trousers, a blanket, a haversack, a canteen.

With the Civil War now in its fourth sanguinary year, Christman's body was among all too many bodies overwhelming the nation's capital. Every steamer up the Potomac River carried dead soldiers from Virginia battlefields, sheeted forms laid across the bows. Hospitals—often converted churches, public halls, or private mansions—ran out of burial space; more than 5,000 graves filled the Soldiers' Home cemetery alone. In desperate need of an expedient solution, Army quartermasters on May 13, 1864, trundled William Christman's mortal remains to a new burial ground that had been identified above the south bank of the Potomac on the confiscated family estate of the Confederate commander, Robert E. Lee. The place was called Arlington.

Another Union soldier would be buried on the gentle slope near Christman later that Friday, with six more the next day, and an additional seven on May 15. By the time the war ended 11 months later, some 16,000 graves stippled the rolling greensward at Arlington as part of a deliberate plan to ensure that the Lee family could never reoccupy the estate, and to purify land ostensibly dishonored by General Lee's actions. With 600,000 dead in the Civil War, passions ran high.

In the more than 150 years since William Christman's burial those passions have cooled, but the veneration of Arlington as a place of reverence and remembrance has only increased. From the muddy potter's field of 1864, Arlington has grown to a vast necropolis of more than 400,000 dead in a leafy tract that has more than tripled in size from the original 200 acres. Of the 3.7 million square miles composing the United States of America, none is more sacred than the roughly square mile of Arlington National Cemetery.

Here are buried presidents and privates, five-star generals and anonymous souls known only to God. Here too are buried more than 400 recipients of the Medal of Honor, and ten times that many Civil War "contrabands"— fugitive or liberated slaves—whose headstones are chiseled with the simple epitaph "citizen" or "civilian." Arlington today holds dead veterans from every American war since the Revolution, including several hundred from the conflicts in Iraq and Afghanistan who are buried in Section 60, perhaps the saddest acre in America today.

Four and a half million visitors a year stroll beneath the white oaks and red maples, deciphering the nation's martial contours in the endless ranks of headstones that sweep from the ridgeline to the river flats below. Two dozen

or more funeral corteges also roll through the cemetery each weekday, and the sounds of another service member going to his or her grave—the clop of caisson horses, the crack of rifles, the drear blare of "Taps"—carry on the soughing wind from early morning until late afternoon.

This has long been a liminal place, a threshold where the living meet the dead, and where national history is intertwined with personal loss. Yet Arlington also is a shrine to valor and sacrifice, to service and fidelity. Those interred here tell a story not just of the Republic in war and in peace, but also of a transcendent ideal, conceived in liberty and reconsecrated in every new grave dug, every benediction murmured, every commitment into the hallowed ground. In this city of the dead, it is an ideal that lives on.

THE ARLINGTON SAGA begins with death.

Hazel-eyed Martha Dandridge was 19 years old in 1750 when she married a wealthy Virginia landowner named Daniel Parke Custis, who abruptly died seven years later. In 1759, she remarried a tall, ambitious soldier-planter named George Washington. Martha's son from her first marriage, John Parke Custis, grew up at Mount Vernon and in 1781 joined General Washington as an aide at Yorktown in time to see Lord Cornwallis surrender his trapped British army, effectively ending the American Revolution. Unhappily, the young man also contracted "camp fever," probably typhoid. Washington arrived at his sickbed, as he later wrote, "in time to see poor Custis breathe his last." He was 26.

The commander in chief adopted John Custis's infant son, George Washington Parke Custis, known as Wash, who remained at Mount Vernon for more than 20 years, until after the deaths of the former president, in 1799, and Martha, in 1802. Within months of his grandmother's passing, Wash Custis began to build a memorial to his celebrated kinsmen. He chose a 1,100-acre tract he had inherited after his natural father's death at Yorktown, a bucolic blend of wooded slopes and river bottoms with a commanding view of the new federal city rising across the river. He initially planned to call the place Mount Washington, but instead chose Arlington to honor an earlier family estate on Virginia's eastern shore.

The Greek Revival mansion he built with slave labor—with Doric pillars five feet in diameter—took 16 years to complete. Constructed of brick, with stucco finishes of faux marble and sandstone, Arlington housed not only the Custis family but an enormous trove of Washington memorabilia and heirlooms: British and Hessian battle flags; corn drills; china; Martha's money chest; the commander in chief's pocket telescope and the red-trimmed tent he used at Yorktown; and the bed in which he died at Mount Vernon. Custis found himself perpetually in debt, not least for his extravagant purchases of mementos to enlarge the so-called Washington Treasury.

Though he considered himself a modern planter using the latest scientific methods, Custis was a poor manager whose true passions ran to painting—usually of huge historical canvases depicting Washington in heroic poses—playwriting, oratory, and party-giving. To those who voiced proper esteem for the Father of Our Country, Custis might snip a swatch from Washington's tent or a signature from an original document to give as a souvenir, according to a National Park Service ranger. Some came simply to admire the gorgeous vista: The Marquis de Lafayette described the panorama from Arlington's center hall as "the finest view in the world."

One visitor came with different intentions. Lt. R. E. Lee, a West Point–trained engineer and scion of another prominent if impoverished Virginia family, had known the Custis clan since boyhood. Wash Custis's only surviving child, the diminutive and vivacious Mary Anna Randolph Custis, had attracted numerous suitors, including a young congressman from Tennessee named Sam Houston. But it was the gallant Lieutenant Lee who won her hand. On June 30, 1831, they were married beneath an archway in the Arlington parlor. Although Lee was often away on Army assignments, he later wrote that in Arlington "my affections and attachments are more strongly placed than at any other place in the world."

"Wash" Custis was a painter and built Arlington as a memorial to his stepgrandfather, George Washington. His depiction of the general at the Battle of Monmouth stands in the Morning Room at Arlington House.

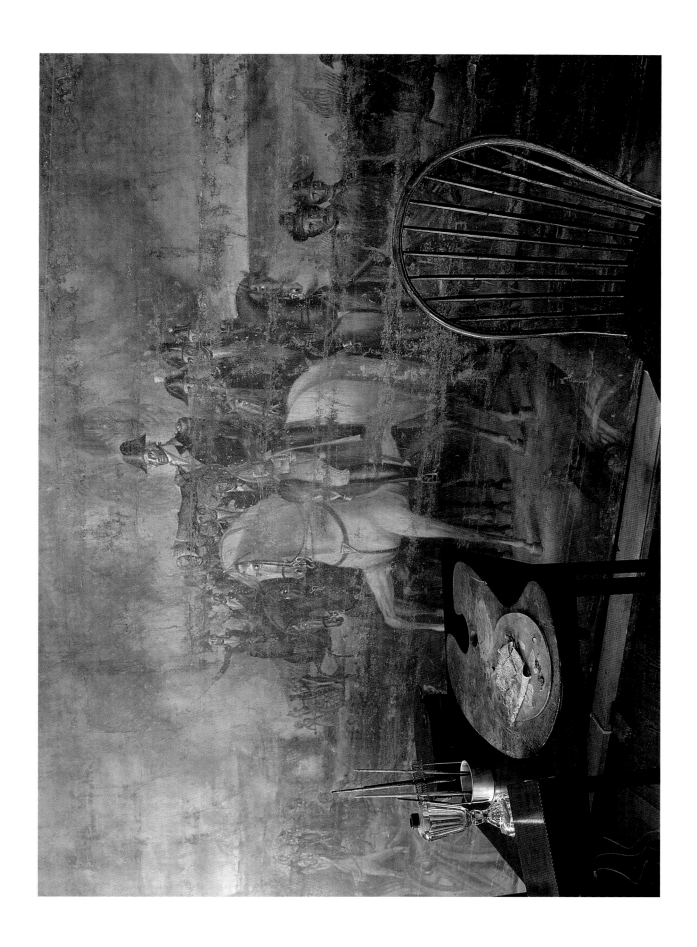

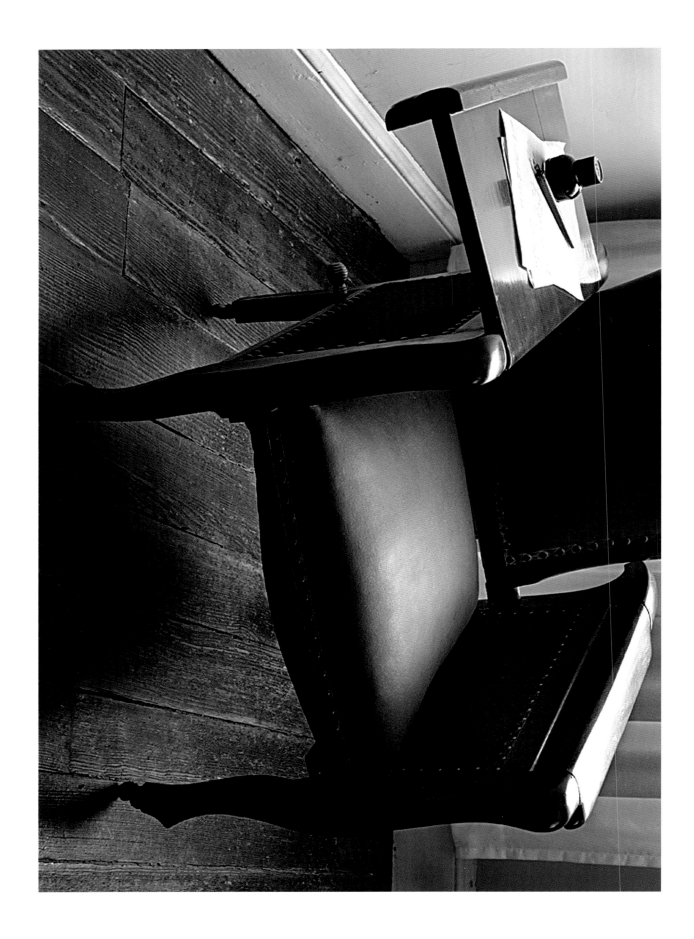

Gen. Robert E. Lee's writing chair at Arlington House.
Lincoln offered Lee command of the Federal field army but
Lee refused, writing his resignation from the Army.

Mary Lee chose her childhood room on the second floor as the couple's master bedroom. Six of the Lees' seven children were born in an adjacent closet converted to a birthing room; their survival of infancy was ascribed to scrubbing the walls with antiseptic borax. Mary ran the house, which she would inherit upon her father's death in 1857, despite rheumatoid arthritis that eventually confined her to a wheelchair. A landscape painter and an avid gardener who grew 11 variants of rose, she tutored the children and led the family prayers each morning and evening in the parlor.

To Robert fell the task of reviving an estate on the verge of ruin. Custis had owned some 200 slaves to work his three plantations, many of them inherited from Martha Washington. (One light-skinned slave who was said to be Custis's illegitimate daughter, Maria Carter Syphax, had been emancipated in the 1820s and given a 17-acre tract.) More than 60 slaves toiled at Arlington, harvesting corn and wheat for sale in District of Columbia markets. Yet only 300 acres were cultivated, mostly along the river. Taking extended leaves from the Army, Lee adopted severe measures to turn a profit, including renting slaves to neighboring planters and consigning others to field work near Richmond.

It was while on furlough at Arlington that Lee first stepped to the center of the national stage. On the morning of October 17, 1859, a young cavalry lieutenant named J. E. B. Stuart galloped up to the mansion with a sealed message ordering Lee to report to the War Department immediately. There he was dispatched with a detachment of Marines to the river town of Harpers Ferry, where an abolitionist firebrand named John Brown had seized hostages. Lee routed the insurgents, freed the prisoners, and arrested Brown, who was hanged in December.

Sixteen months later the American cataclysm foreshadowed at Harpers Ferry broke in full fury. On April 18, 1861, with the approval of Abraham Lincoln, Lee, now a Colonel, was offered command of the Federal field army to confront the southern insurrection that had exploded at Fort Sumter several days earlier. For hours Lee paced in his second-floor bedroom, the creaking floorboards audible to Mary and the children in the morning room below. After midnight on Saturday, April 20, he trudged downstairs with his letter of resignation from the Army. "Well, Mary, the question is settled," he told his wife. Soon he was on a train for Richmond and eventual command of the Confederate armies. "War is inevitable," Lee wrote Mary, "and there is no telling when it will burst around you."

She vowed not to "stir from this house, even if the whole northern army were to surround it." But warnings of an impending Union attack across the river caused her to pack up the family silver and George Washington's papers. On May 15, Mary handed the house keys to a trusted slave, Selena Gray, and decamped with 12 wagons of household goods, eventually settling in Richmond, where she and her daughters knitted wool socks for Confederate soldiers.

On May 23, Virginians voted overwhelmingly in a referendum to affirm the state's secession. Within hours, in one of the first major actions of the Civil War, 14,000 Union soldiers crossed the Potomac to capture Alexandria and to occupy the high ground above the river. Within a week three New York regiments were camped on the Arlington estate, felling trees and dismantling rail fences for firewood. The house soon served as a headquarters for Brig. Gen. Irvin McDowell. "The fences are gone and the country around here is all stumped over and trod down," a Union soldier wrote. "Ain't it pleasant?"

Selena Gray, after advising soldiers "not to touch any of Mrs. Lee's things," warned General McDowell that his troops were pillaging the Washington Treasury. Heirlooms that escaped plunder were subsequently crated, labeled "captured at Arlington," and hauled to the Patent Office in downtown Washington for storage. Federal soldiers scribbled graffiti on the attic rafters. "Your old home has been so desecrated that I cannot bear to think of it," Lee wrote his daughters. "I should have preferred it to have been wiped from this earth."

Under a federal "Act for the Collection of Taxes in the Insurrectionary Districts," an assessment of $92.07 was levied against the Arlington

plantation. Mary Lee dispatched a cousin to pay the sum only to learn that tax commissioners insisted on property owners appearing personally to settle their debts. On January 11, 1864, the 1,100 acres of the Arlington estate was publicly auctioned and sold to the only bidder, the U.S. government, for precisely the assessed value of $26,810. As Lee had told his family, "They cannot take away the remembrances."

BRIG. GEN. MONTGOMERY C. MEIGS was a Georgian who not only remained loyal to the Union but also loathed both the Confederacy and those serving it. As quartermaster general of the U.S. Army, Meigs found himself grappling with the urgent issue of dead soldiers in Washington, where mortuaries had sprung up next to houses, markets, and restaurants. The *Washington Chronicle* complained that "it insults the meanest animals to have their dead and food in juxtaposition." With the arrival of early summer 1864, "the weather grew hot. Filled with shipments of corpses, Washington stank like a charnel house," historian Margaret Leech wrote in her Pulitzer Prize–winning *Reveille in Washington*. "The people, who could not accuse the dead, vented their horror on the embalmers."

Meigs petitioned Secretary of War Edwin M. Stanton for permission to convert the Custis-Lee estate into a military cemetery. Without waiting for Stanton's formal authorization, which would be issued on June 15, Meigs ordered the interments to begin. Poor Christman was buried near the northern perimeter of the estate, his name neatly inked in a government ledger with the wrong middle initial: William L. Christman. Soon as many as 40 burials took place each day, perfunctory inhumations that rarely featured even a chaplain in attendance. Still, the conversion of Arlington to a graveyard pleased most Yankees. "The grounds are undulating, handsomely adorned, and in every respect admirably fitted for the sacred purpose to which they have been dedicated," the *National Republican* observed on June 17.

In an August visit to Arlington, Meigs was furious to find that soldiers living in and around the mansion—reluctant to bury the dead too close to their bivouac—had located the cemetery a half mile away, near the old field slave quarters. "It was my intention to have begun the interments nearer the mansion," Meigs later noted. Ordering 26 bodies brought immediately from Washington, he personally supervised their burial along the perimeter of Mary Lee's rose garden "to more firmly secure the grounds known as the National Cemetery to the Government by rendering it undesirable as a future residence or homestead."

Soon the acreage around the house sprouted thousands of wooden grave markers. Lincoln himself occasionally visited ailing soldiers in nearby field hospitals; no doubt the melancholy tranquillity of Arlington suited him. Among those interred was Meigs's son, Lt. John Rodgers Meigs, who as chief engineer of the Army of the Shenandoah was gunned down at the age of 22 by Confederate cavalrymen in October 1864. His antipathy to the Confederacy now informed by personal grief, General Meigs made Arlington even less appealing as a homestead by positioning a mass grave in the rose garden with the bones of 2,111 anonymous soldiers, most of them killed at the two Bull Run battles. "A literal Golgotha," the *National Intelligencer* reported. "Skulls in one division, legs in another, arms in another, and ribs in another." An inscription on the sealed vault lauded the "noble army of martyrs."

Defeated and disenfranchised, Robert E. Lee never saw Arlington again and made no effort to reassert his family's ownership of the estate before his death in 1870. But Mary was reluctant to surrender her birthplace without at least a last look. "Life is waning away," she wrote. "I do not think I can die in peace until I have seen it once more." A few months before her death in 1873, she drove to the rear of the house. "They have done everything to debase and desecrate it," she lamented, and refused to step from her carriage.

It fell to her oldest son, George Washington Custis Lee, to challenge the government's confiscation. An 1854 graduate of West Point who had served as an aide-de-camp to Jefferson Davis, the Confederate president, young Lee filed a lawsuit asserting ownership. In December 1882,

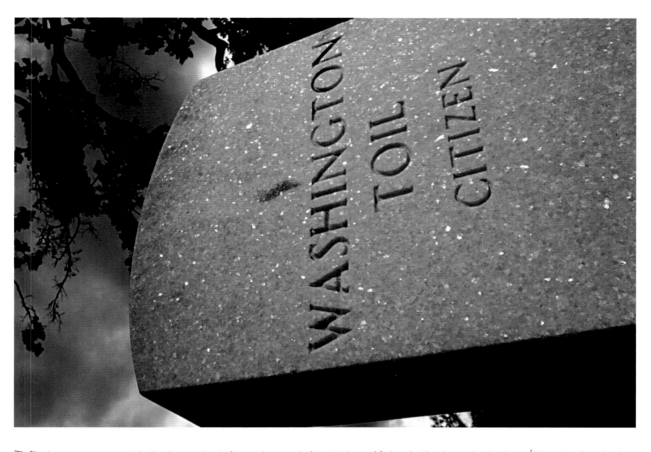

In Section 27, the headstones of fugitive and liberated slaves, known also as "contrabands," bear only the sparest of epitaphs. More than 3,000 slaves are buried there.

the U.S. Supreme Court ruled five to four that Arlington had indeed been seized without due process. The U.S. government was therefore trespassing and would be forced to vacate the property and to exhume more than 17,000 graves.

For several months the government and the Lee family haggled. In March 1883, Congress appropriated $150,000 to buy the property outright, and on May 14 the deed was recorded in a local courthouse to forever transfer Arlington to the possession of the people of the United States.

More than 400,000 burials later, Arlington National Cemetery today is a complex, vibrant organism within the nation's best known necropolis. Grave digging remains central to cemetery operations, although the task has been mechanized since 1955 when the purchase of a Trenchmaster excavator allowed a grave to be dug in 12 minutes for less than $10; previously, digging by hand with a long-handled shovel took all day and cost $29.

These days crews roam the cemetery with powerful backhoes, searching for the wooden stakes left by a surveyor who measures and marks each new plot to be opened. On a late summer morning in Section 2 on Arlington's upper slopes, a backhoe operator named Charles Montgomery eases his among headstones covered with plastic trash cans to prevent accidental chipping. Forty feet away a stone obelisk marks the grave of Maj. Gen. Joseph "Fightin' Joe" Wheeler, the Confederate cavalry commander who died in 1906 after also serving as a U.S. Army general in the Spanish-American War. "Soldier, Statesman, Gentlest, Tenderest and Most Lovable of Men," his epitaph reads. A few paces uphill is the grave of Maj. Gen. George Crook, which features a bronze tableau depicting the "Surrender of Apaches Under Geronimo to General Crook" in 1883.

"My job's just to dig the holes, then cover 'em back up," Montgomery says. "I start my way in the back of the grave and work my way to the front, trying to keep it straight." Centering the backhoe boom on the headstone in an adjacent row, Montgomery gnaws at the earth with the steel teeth of his 32-inch bucket. This particular grave is an "open-up":

A recently deceased 98-year-old rear admiral will be reunited with his wife, who was laid to rest on this spot, nine feet down, in 1991. The admiral's casket will go atop hers, at seven feet. In five minutes a yawning hole has been dug, with the corners square, the sides true, and the spoil in a neat pile. "When I've got the bucket like this with the boom all the way down, that's seven feet," Montgomery says. "I been doin' this a long time, and I just know it."

After each interment a hydraulic tamper beats the earth to crush out air pockets. Still, subsidence requires refilling up to 10,000 graves each year. The dead in fact need perpetual care. Each day maintenance crews mow more than a hundred acres, reset several dozen leaning headstones, and power-wash a thousand stones. (Water pressure must be carefully modulated to avoid chewing into soft marble, particularly the older stones such as those in Sections 1 and 13.) Because the white painted headboards used during the Civil War required replacement every five years—at $1.23 each—Arlington briefly experimented with "Meigs Markers" made of a metal alloy from melted-down munitions. In 1879, the government adopted white marble for all national cemeteries; the familiar slab used today was designed by a board of officers after World War I. Twenty-four inches aboveground, thirteen inches wide, and four inches thick, it accommodates only the sparest biographical details and brief "terms of endearment," all within a maximum of 12 lines and 15 characters per line. Each stone can also carry a spiritual symbol, of which 57 have been authorized, from Episcopal and Muslim to atheist and Hindu.

Burials at Arlington for many years following William Christman's were listed on a five-by-eight-inch index card stored on an enormous Kardex revolving file. A large blueprint for each of the cemetery's 70 sections pinpointed every plot, along with trees, old sprinkler heads, gas lines, and other landscape idiosyncrasies. A map key indicated whether a particular plot was "available," "occupied," "obstructed," or "reserved." (Arlington no longer accepts reservations, but some remain valid from before the practice was halted in February 1962.) Today cemetery officials validate grave locations with a modern global positioning system to digitize all site information and to confirm precisely how many people are buried here and their identity.

More than 7,000 funerals a year take place in Arlington. A daily spread sheet lists them hour by hour, giving not only the location and depth of new graves but also a few hints of each life now ended: rank, next of kin, military service, whether the deceased was a decorated veteran. To prevent the corteges from colliding and to keep maintenance work at a respectful distance from graveside ceremonies, a sheaf of maps shows hourly funeral routes on the cemetery's 45 roads and walkways.

"The challenge is to ensure that we beautify the grounds without in any way compromising the grave sites," said a former chief of grounds and burial operations who worked here for a quarter century. He oversaw not only burial operations, but also Arlington's 25,000 square feet of shrubs, 15,000 square feet of flower beds, and 9,000 trees—black cherry, red oak, eastern red cedar—including 600 or so we believed were growing when the Lees lived here. Every morning brings new issues to finesse without roiling Arlington's dignity: A possible pesticide drift has killed a hemlock in Section 33; a water leak in Section 7A threatens to drown a boxwood; a small grass fire in Section 31 has left a charred patch 60 feet in diameter; workers told to "rock hound" a new swatch in Section 56 have not cleared away enough stones and debris.

Regulations now permit mourners to embellish graves temporarily with artifacts or love tokens other than flowers. (Each week workers collect 90 cubic yards of decaying "floral matter" as well as dozens of other items.) In Section 64 a grieving mother has placed several stuffed bears in a weeping willow near the grave of her young son—

In Section 60 many of the graves of the dead from Iraq and Afghanistan are temporarily appointed by the grieving with little amulets for the next world: a ceramic fortune cookie; a bottle of beer; a spent 9-mm brass cartridge; a sliver of agate from the fallen soldier's native Kentucky; laminated photos of wives, sweethearts, children. On a smooth stone, a

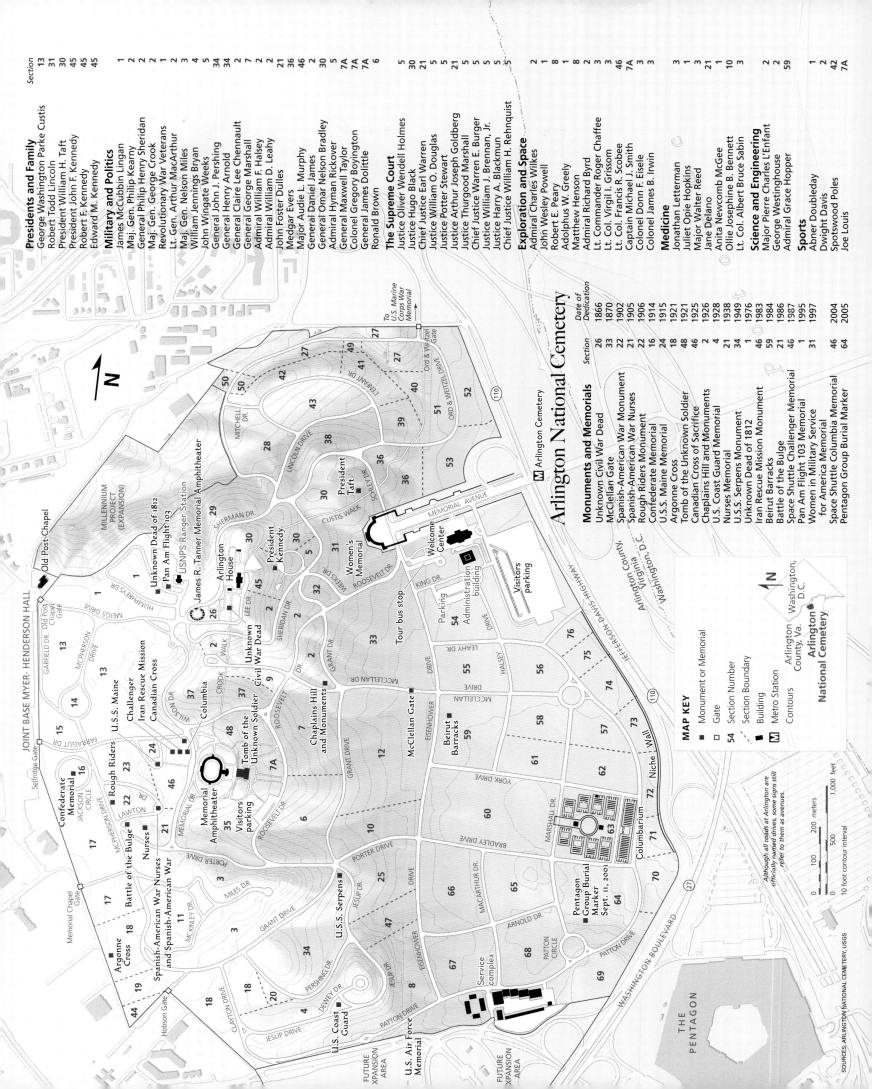

Arlington National Cemetery

Presidents and Family

	Section
George Washington Parke Custis	13
Robert Todd Lincoln	31
President William H. Taft	30
President John F. Kennedy	45
Robert F. Kennedy	45
Edward M. Kennedy	45

Military and Politics

	Section
James McCubbin Lingan	1
Maj. Gen. Philip Kearny	2
General Philip Henry Sheridan	2
Maj. Gen. George Crook	2
Revolutionary War Veterans	1
Lt. Gen. Arthur MacArthur	2
Maj. Gen. Nelson Miles	3
William Jennings Bryan	4
John Wingate Weeks	5
Medgar Evers	36
General John J. Pershing	34
General Henry Arnold	34
General Claire Lee Chennault	2
General George Marshall	7
Admiral William F. Halsey	2
Admiral William D. Leahy	2
John Foster Dulles	21
Medgar Evers	36
Major Audie L. Murphy	46
General Daniel James	2
General Omar Nelson Bradley	30
Admiral Hyman Rickover	5
General Maxwell Taylor	7A
Colonel Gregory Boyington	7A
General James Dolittle	7A
Ronald Brown	6

The Supreme Court

	Section
Justice Oliver Wendell Holmes	5
Justice Hugo Black	30
Chief Justice Earl Warren	21
Justice William O. Douglas	5
Justice Potter Stewart	5
Justice Arthur Joseph Goldberg	21
Justice Thurgood Marshall	5
Chief Justice Warren E. Burger	5
Justice William J. Brennan, Jr.	5
Justice Harry A. Blackmun	5
Chief Justice William H. Rehnquist	5

Exploration and Space

	Section
Admiral Charles Wilkes	2
John Wesley Powell	1
Robert E. Peary	8
Adolphus W. Greely	1
Matthew Henson	8
Admiral Richard Byrd	2
Lt. Commander Roger Chaffee	3
Lt. Col. Virgil I. Grissom	3
Lt. Col. Francis R. Scobee	46
Captain Michael J. Smith	7A
Colonel Donn F. Eisele	3
Colonel James B. Irwin	3

Medicine

	Section
Jonathan Letterman	3
Juliet Opie Hopkins	1
Major Walter Reed	3
Jane Delano	21
Anita Newcomb McGee	1
Ollie Josephine B. Bennett	10
Lt. Col. Albert Bruce Sabin	3

Science and Engineering

	Section
Major Pierre Charles L'Enfant	2
George Westinghouse	2
Admiral Grace Hopper	59

Sports

	Section
Abner Doubleday	1
Dwight Davis	2
Spotswood Poles	42
Joe Louis	7A

Monuments and Memorials

	Section	Date of Dedication
Unknown Civil War Dead	26	1866
McClellan Gate	33	1870
Spanish-American War Monument	22	1902
Spanish-American War Nurses	21	1905
Rough Riders Monument	22	1906
Confederate Memorial	16	1914
U.S.S. Maine Memorial	24	1915
Argonne Cross	18	1921
Tomb of the Unknown Soldier	48	1921
Canadian Cross of Sacrifice	46	1925
Chaplains Hill and Monuments	2	1926
U.S. Coast Guard Memorial	4	1928
Nurses Memorial	21	1938
U.S.S. Serpens Monument	34	1949
Unknown Dead of 1812	1	1976
Iran Rescue Mission Monument	46	1983
Beirut Barracks	59	1984
Battle of the Bulge	21	1986
Space Shuttle Challenger Memorial	46	1987
Pan Am Flight 103 Memorial	1	1995
Women in Military Service for America Memorial	31	1997
Space Shuttle Columbia Memorial	46	2004
Pentagon Group Burial Marker	64	2005

MAP KEY

- ■ Monument or Memorial
- □ Gate
- **54** Section Number
- Section Boundary
- ■ Building
- Ⓜ Metro Station
- Contours

Although all roads at Arlington are officially named drives, some signs still refer to them as avenues.

Arlington County, Va.

Arlington National Cemetery

10 foot contour interval

JOINT BASE MYER- HENDERSON HALL

THE PENTAGON

SOURCES: ARLINGTON NATIONAL CEMETERY, USGS

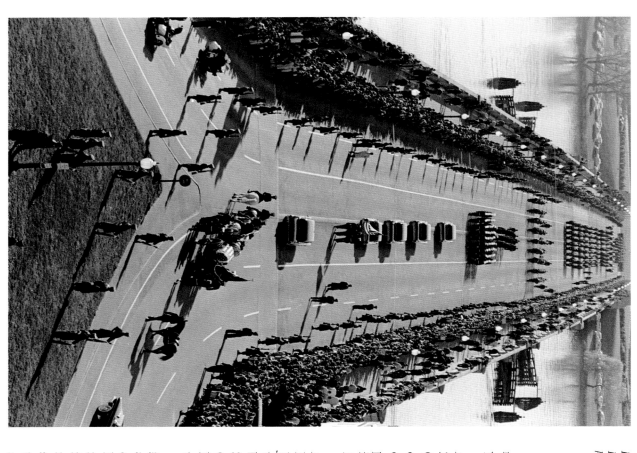

In 1963, mourners paying tribute to President John F. Kennedy filled the walkways along Memorial Bridge as his funeral procession approached the cemetery.

message neatly printed in indelible ink could crack the hardest heart: "I love you, Daddy. Happy birthday."

A SINGLE SHEET of paper listed the 24 funerals scheduled for November 25, 1963, beginning with an Air Force Reserve colonel named Edward C. Forsythe at 9 a.m. in Section 35. Yet it was the last of those two dozen ceremonies on the list, scheduled for 3 p.m. in Section 45, that would forever change Arlington. With the name of the deceased's next of kin misspelled—perhaps reflecting the bewildered anxiety that afflicted cemetery officials as it did all Americans—the entry read: *"John Fitzgerald Kennedy, Cdr. in Chief NOK: Jaqueline Kennedy, widow."*

In the decades after the Civil War, Arlington had grown at a modest rate. Among the most poignant events in the cemetery was the first Decoration Day—now called Memorial Day—on May 30, 1868. President Andrew Johnson gave all federal workers the day off "for the purpose of strewing with flowers or otherwise decorating the graves of comrades." Wearing black satin sashes and singing "Father Come Home," children from the Soldiers' and Sailors' Orphan Asylum tossed blossoms on graves near the Custis-Lee mansion; Maj. Gen. James A. Garfield, who as president 13 years later would be sent to his own grave by an assassin's bullet, lauded those "for whom death was a poem the music of which can never be sung."

By the end of the 19th century, Arlington harbored almost 19,000 graves, with an average of one interment a day. Visitors often picnicked among the headstones, while vendors peddled ice cream, peanuts, and cigars. On holidays politicians spouted florid oratory of the "sleep on, great host" variety. War dead from the Revolution and the War of 1812 were reinterred here to extend Arlington's historical arc. The mass burial of sailors from the U.S.S. *Maine*, which blew up in Havana harbor in February 1898, raised national awareness of Arlington; in the first repatriation of American servicemen killed abroad, scores of flag-draped coffins were lowered into their graves simultaneously. Eventually the battleship's salvaged mast rose above 229 crewmen in Section 24. The burial of prominent, long-lived

Civil War heroes, including Gen. Philip H. Sheridan in 1888, also elevated Arlington's status. Yet a facile routine obtained for a century: An Army quartermaster pamphlet in 1933 advised those sending a deceased loved one for interment, "The shipping case should be marked 'Officer in Charge, Arlington National Cemetery, Fort Myer, Va.'"

That all changed with Kennedy's death. The president, during a visit to Arlington earlier that year, had unwittingly selected his own grave site. Surveying the serene vista below the mansion he reportedly murmured, "I could stay here forever." Mrs. Kennedy approved the location, and a grave was opened through the hard clay and oak roots. Since the solid mahogany casket weighed 1,200 pounds, military pallbearers in the small hours of November 25 practiced carrying a duplicate coffin filled with sandbags and further deadweighted with two soldiers sitting on top.

The president's burial, a somber pageant of grace and dignity, was watched by a worldwide television audience. Within three years, 16 million visitors paid homage to the site in Section 45, which was soon expanded to a three-acre sanctuary paved with Cape Cod granite and softened with sedum plants. The Institute of Gas Technology in Chicago installed an Eternal Flame as a beacon of remembrance. "It's as eternal as anything man-made can be," a cemetery official later observed.

Requests for burial in Arlington dramatically increased, a demand soon aggravated by more than 58,000 American deaths during the Vietnam War, when as many as 47 funerals in one day crisscrossed the cemetery. From the late 1950s until 2000, the number of graves would nearly triple, from 93,000 to 250,000. As cemetery officials searched for more contiguous land to augment Arlington's acreage, new eligibility rules sharply restricted burials to a small percentage of veterans, including those who die on active duty, those honorably retired after a career in the military, those highly decorated for valor, and their spouses.

EVEN A SHORT STROLL through Arlington is a perambulation through the American narrative. The graves of prominent military figures abound, of course, including World War II commanders like Generals of the Army George C. Marshall and Omar N. Bradley, and Fleet Admiral William F. "Bull" Halsey, Jr. Gen. John J. Pershing, who led the American Expeditionary Forces in World War I, lies beneath a simple government-issue stone in Section 34, near his grandson, who was killed in Vietnam. Other veterans achieved fame in arenas beyond the battlefield, including boxer Joe Louis, author Dashiell Hammett, civil rights leader Medgar Evers, Supreme Court Justice Oliver Wendell Holmes, Jr., and Army physician Maj. Walter Reed, whose headstone in Section 3 notes that "He Gave to Men Control Over That Dreadful Scourge Yellow Fever."

Section 27 is particularly poignant, with stones devoid of dates, terms of endearment, or the leanest biographical detail, such as "Mrs. Bannister, Citizen," or "Jackson, Citizen," or simply, "Power Boy." Here nearly 4,000 African Americans are buried, many of them denizens of Freedman's Village, established in 1863 on the confiscated Arlington plantation as a so-called model community for emancipated slaves, runaways, and those liberated by Union troops. The village was gone by 1900, but the dead remain. Other stones, inscribed "U.S.C.T.," commemorate U.S. Colored Troops who served the federal cause during and after the Civil War. If "in the democracy of the dead all men at last are equal," as poet and politician John James Ingalls wrote, some were more equal than others: Segregation by race and by rank held sway for decades before the ascent of contemporary egalitarianism.

Time has dulled the serrated edges of many tragedies and misadventures memorialized here, such as the Confederate dead who were interred at Jackson Circle beneath headstones that came to a slight point, ostensibly "to keep the Yankees from sitting on them"; or the cenotaph of an Army major who went down with the *Titanic* in 1912; or even the mass graves for the 250 dead from the Coast Guard ammunition ship U.S.S. *Serpens*, which exploded and sank off Guadalcanal in January 1945.

Yet other, fresher calamities still sear, like the graves of 21 servicemen killed in the Beirut barracks bombing of 1983, or the memorial cairn to

270 people murdered by a terrorist bomb on Pan Am Flight 103 over Lockerbie, Scotland, in 1988. Of the 184 victims killed when American Airlines Flight 77 smashed into the Pentagon at 9:37 a.m. on September 11, 2001, 64 are buried at Arlington. In the final moments of its flight, the hijacked Boeing 757 screamed over the southern edge of the cemetery at 530 miles an hour. The horrific impact flung debris several hundred yards into Sections 69 and 70, which for more than a week remained an FBI crime scene.

Perhaps nowhere do tragedies past and present mingle more vividly than in a former chapel in Section 13, once known as the Field of the Dead. The inconspicuous whitewashed building is now routinely used as a receiving vault. Stout wooden trestles on wheels cradle the caskets of soldiers killed overseas and whose interments are scheduled for the following morning. Occasionally a grieving widow keeps a moment's vigil here.

On a storage shelf above the vault's concrete floor, beneath a gray canvas cover, is a wooden platform, seven feet long and upholstered with a black velvet pall and black cotton tassels. It is a catafalque, an exact duplicate of the platform upon which the body of Abraham Lincoln lay in state in the Capitol Rotunda in 1865. The original bier remains in the Capitol crypt, but this second catafalque was built in 1958 when it was decided to inter unknown soldiers from both World War II and the Korean War simultaneously. Five years later, John Kennedy's mahogany casket would lie on this bier in the East Room of the White House. Now it awaits another national cataclysm.

A FOUL AUTUMN RAIN lashes Arlington at dawn. Inside the memorial amphitheater facing the Tomb of the Unknown Soldier, a soldier in dress blues stands at attention while reciting the Sentinel's Creed for his assembled family and comrades from the Old Guard, the 3rd Infantry Regiment, which provides many of Arlington's ceremonial troops. "My dedication to this sacred duty is total and wholehearted," vows Specialist Jason R. Magnuson. Then his commander, Col. Robert P. Pricone, pins a Tomb Honor Guard Badge on Magnuson's right breast pocket. Since 1957 only 623 badges have

been awarded. Pricone tells him, "We expect soldiers in our honor guard to embody warrior values. Your challenge now is to live up to that every day."

The Tomb Honor Guard badge is one of the most difficult badges to earn in the U.S. Army: of 15 soldiers in one trainee class, none was deemed worthy. It is also easy to forfeit. Twenty badges have been revoked over the past half century for actions deemed dishonorable, from drug use to dozing on duty. If a nation's character can be gauged by how its war dead are treated, then the Tomb of the Unknown Soldier and those who guard it are intended as a perpetual American affirmation of duty and honor. "My standard," the Sentinel's Creed asserts, "will remain perfection."

In the "Catacombs," a subterranean warren beneath the tomb, perfection requires compulsive attention to detail. Tomb Honor Guards spend hours each day preparing their uniforms, with a press machine, fabric steamers, elbow grease, and endless "mirror time." A ruler calibrated to one sixty-fourth of an inch is used to be certain that buttons and decorations are properly aligned. White cotton gloves are molded to the hand with Velcro straps and soaked in water to allow a better grip on the slick M14 rifle stock. A rubber "fat man belt" helps even those with husky torsos achieve the hourglass ideal, preferably with a 29-inch waist. Heavy wool tunics fit so snugly that each sentinel requires help wriggling into it. Masking tape rollers lift lint from the fabric, while stray threads are singed off with a cigarette lighter; when the tunic grows nappy, soldiers carefully "burn the blouse" with hair spray and flame.

"The shoes get weathered—humidity, sun, rain," says Sgt. Christopher J. Moore, a Las Vegas native and badge holder number 544. "We sand the pores from the leather, starting with 800 grit and working to 2000 grit, then add Kiwi polish and water to build it back up to a mirror finish. It might take six hours to get a good finish where there are no smudges. The soles are rubber and leather, and they're built up to force us to lean back so that the yellow stripe down the side of the pant leg is vertical. Humans naturally lean forward on the balls of their feet, but that would make the stripe less than perpendicular to the ground."

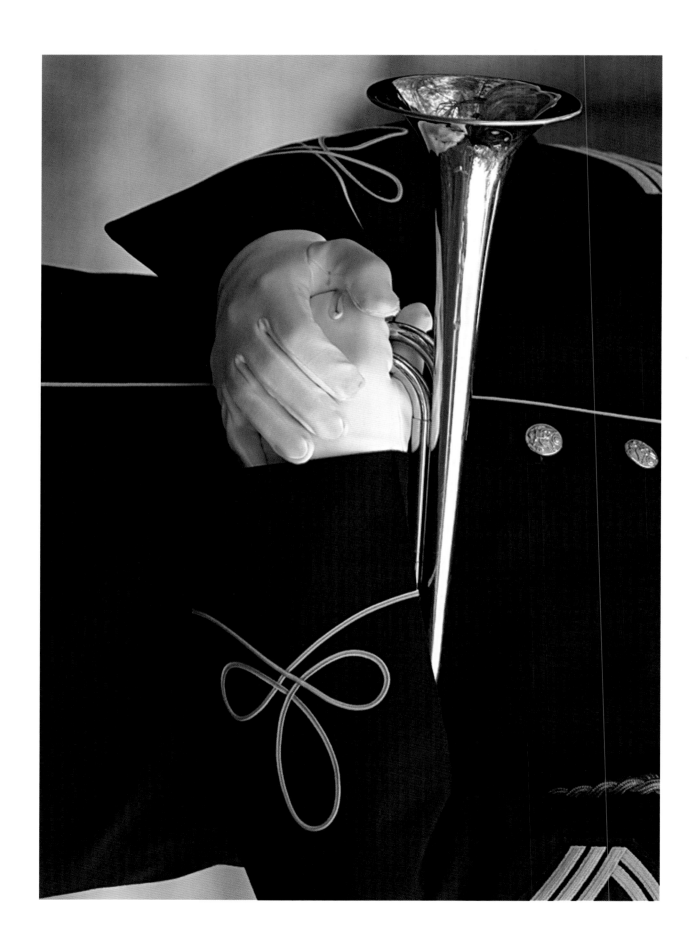

No ritual carries more emotional impact than the playing of "Taps" at the end of each ceremony. Each of the services provides buglers for funerals at Arlington.

Precision and ritual also hold sway before the Tomb, where Honor Guards in mirrored sunglasses walk half-hour shifts "on the mat" in summer, hour-long shifts in winter. With an idiosyncratic stride intended to keep the upper body from bobbing, the soldier glides for 21 steps across the memorial plaza, then turns to face the Tomb for 21 seconds before retracing his steps. (In finding a personal rhythm, Sergeant Moore has learned that 15 respirations equal 21 seconds.) During the Changing of the Guard Ceremony, Tomb Honor Guards signal each other with discreet scrapes of their steel shoe taps on the granite plaza. In the evening, when Arlington is closed to the public, the vigil shifts to a less formal "roving guard" in everyday uniforms, while Honor Guards work to correct their defects, from imprecise heel clicks to "monster walking"—striding, for example, with the left leg and left arm in unison rather than in counterpoint.

"After being here for a while people start to have orthopedic problems from their feet up," says Staff Sgt. Anthony Oliva, badge holder number 526. "Heel clicks are tough on the knees, and the rigid posture can hurt the lower back." He shrugs and smiles, then returns to his relentless pursuit of perfection.

"It's not just a duty, not just a job. It's an honor," Sergeant Moore adds. "The more you know about the Tomb, the more reverence you have for it. It's a way of keeping tradition."

That tradition began with the random selection of a single soldier in France among more than 1,200 unidentifiable remains from the Great War. Brought home aboard the U.S.S. *Olympia*, the casket was interred on November 11, 1921, and eventually surmounted by a roughly 80-ton sarcophagus of Yule marble quarried in Colorado, similar to that used for the Lincoln Memorial. Cabinet secretaries and Supreme Court justices, veterans and foreign dignitaries poured into Arlington for the ceremony, many of them forced to walk across the Potomac bridges by what was described as "the greatest traffic jam in Washington's history." Mourners sang "Nearer My God to Thee," and in his eulogy President Warren G.

Harding voiced hope that the day would mark "the beginning of a new and lasting era of peace on earth, good will among men."

It was not to be. World War II and Korea produced more unknowns, who were interred on Memorial Day 1958 in a ceremony meticulously planned with a 73-page script but marred by torrid weather that prostrated some 400 spectators with heat exhaustion. They may have been the last unknowns, not because President Harding's "lasting era of peace" arrived, but because modern DNA analysis and identification procedures now give a name to even the most insulted remains. A Vietnam unknown, entombed in 1984, was exhumed in 1998 and reinterred in St. Louis after tests proved that the serviceman was 1st Lt. Michael J. Blassie, an Air Force pilot shot down in May 1972. Today the empty vault carries the inscription "Honoring and Keeping Faith With America's Missing Servicemen, 1958–1975."

Among other challenges, cemetery officials today face possibly replacing the massive Tomb. Two hairline cracks, with a combined length exceeding 44 feet, nearly encircle the monument. First discovered in 1963, the fissures have grown worse despite grouting repairs in 1975, 1989, and most recently in 2009 and 2012. A block of the same type of marble was donated to the cemetery in 2009 should it become necessary to replace the monument.

HOUR BY HOUR, year by year, ritual and ceremony at Arlington link yesterday to today, while providing a rhythm that dignifies death and consoles the living. The morning begins at 4 a.m. in the stables of the 3rd Infantry Regiment caisson platoon on adjacent Joint Base Myer-Henderson Hall. Soldiers assigned to the Old Guard shine their brass, clean the equestrian tack, and wash the horses to be used in the day's funerals—deep dents in the sheet metal lining the shower room walls show that some steeds resent the predawn ablutions more than others. The platoon has its own coal-fired forge and master farrier, who shoes the horses every six weeks and adds borium studs for extra traction on Arlington's hilly roads. A platoon leatherworker, using the 1916 "Field Artillery Harness Quartermaster

"Drawings" as a blueprint, also fashions the reins, girths, and other tack from thick rolls of cured rawhide.

"Horse teams are in matched colors, all blacks or all grays," says Sgt. Jared Bolton. Six horses pull a 1918 artillery caisson that bears either a coffin or an urn with cremated remains placed on a tray that slides out of a Batesville mock casket. (Any officer buried in Arlington is entitled to ride to his or her grave on a caisson.) Soldiers in dress blues ride postilion style on the left mounts. Deceased Army or Marine Corps colonels and generals may also be honored with a caparisoned horse—a riderless mount tacked with a saber and cavalry boots fitted backward in the stirrups to signify a fallen warrior looking back at his troops a final time. An ancient ritual, the "cap horse" was used in Lincoln's funeral but most famously in Kennedy's cortege, where the handsome, spirited Black Jack, a gelding Morgan and quarter horse cross, seemed representative of the slain president's vigor.

By midmorning, honors are under way across the cemetery. Many traditions seen in today's military funerals date back to the Civil War. For example, caissons were used because of a shortage of ambulances; shortages of caskets meant that flags were used to cover bodies. Now each ritual has its own intricacies. The flag used in a military officer's funeral is boxed—folded 13 times into a trim triangle, stars out—in one minute and fifty-four seconds, which is precisely the duration of the hymn played by the band. The seven soldiers in a firing party pull their triggers three times successively so that each volley of blanks sounds like a single shot, a particular challenge given that acoustics vary from section to section. "Every movement that these guys do with their weapons has to have a cadence that's burned into their brains," says Staff Sgt. Robert F. McLauchlin, who waited with the honor guard in Section 54 to bury a retired colonel, a World War II veteran. "The goal is to make the movements look mirrored, like you cloned one guy."

No ritual is repeated more often, or carries more enduring emotional power, than the playing of "Taps" at the end of a ceremony. It too has Civil War origins, having been composed in July 1862 during the Peninsular campaign on Virginia's James River by Brig. Gen. Daniel Butterfield, who supposedly whistled a new tune for his brigade bugler to replace the bland "lights out" call previously used in Union bivouacs. Again, the most memorable rendition came during Kennedy's funeral when an Army bugler, numb from standing outdoors for nearly three hours, cracked the sixth note. "It was like a catch in your voice, or a swiftly stifled sob," wrote author William Manchester.

More than 50 military buglers have played at Arlington, including Army bugler Master Sgt. Allyn Van Patten, who once estimated he had blown "Taps" at least 8,000 times during a quarter century of service at the cemetery. "It's a nice piece of music. It's like a song," Van Patten said. "Unlike a lot of bugle calls, you can infect it, you can play music with it." He added, "I don't want to be detached when I play during a funeral. I want to do something for that family. They'll never know who I am, but they'll never forget."

At 24 notes, "Taps" has the virtue of brevity. At Arlington, where every day more than 25 services must be coordinated with military precision, time can become the enemy.

SPACE, OR RATHER, the lack of it, is also an enemy. For more than a half century, Arlington's guardians have cautioned that the cemetery is running out of room. As author Philip Bigler noted in his comprehensive history, *In Honored Glory*, a surge in interments during World War II led to a warning in 1944 that grave space "will be exhausted in five to seven years . . . Only 14,000 more persons can be buried in Arlington." Grave dimensions were reduced, from 6 by 12 feet to 5 by 10; tiered burials—with caskets stacked like bunk beds in the same hole—were adopted in the early 1960s, followed by the controversial new regulations that sharply curtailed eligibility. Parcels of land were appended over the years, notably 190 acres from former Fort Myer South Post. Still, at the current rate of interment, Arlington may be at capacity around 2060.

A master plan, drafted in 1998, identified 14 parcels of land abutting the existing cemetery. Collectively those tracts, formerly owned by other federal agencies, will provide another 125 acres. Topography is always an

The surface roots of an old oak encase a grave marker. Space is the challenge to Arlington's future. At the current rate of interment, the cemetery may reach capacity around 2060.

issue because steep slopes are the grave digger's bane—800 graves per acre is the optimum.

Arlington has benefited from the increasing American preference for cremation, which requires much less space for both in-ground burial or inurnment in the cemetery's columbarium. About 60 percent of the funerals today are cremations. With the additional land procured, Arlington's census by the end of this century could reach a half million, comparable to the living population of the District of Columbia. Eligibility is a sensitive political issue and may be tightened again in the distant future.

Each opened grave yields roughly one and a half cubic yards of excess dirt, and that spoil is now used to build up the final few acres in a new swatch formerly part of South Fort Myer. Some 20,000 graves will occupy the sector, with a sweeping view of the Potomac, and 5,000 niches for cremated remains have been built into the cemetery's perimeter wall. A long, grassy stretch also remains unturned in Section 60, sacred ground awaiting those whose fates will lead them here. Roughly one in every ten soldiers killed in Iraq is buried at Arlington, a higher percentage than from any previous American war.

THE SEASONS RISE, the seasons fall away. Arlington bustles year-round, but with a stately, measured grace. Wash Custis's mansion recently completed a six-year, three-million-dollar overhaul by the National Park Service that included installing fire suppression and climate-control systems. Extensive damage from an earthquake in August 2011 was also repaired.

A squall line blows through, tossing the great trees. Rain pelts the graves and laves the headstones, each emblematic of who we were, where we've been, and what we have become. Then the afternoon skies fair and the final funeral processions of the day snake through the great yard, bearing another old soldier to his rest, or perhaps a soldier no older than William Christman was.

Across the river, the federal city gleams in the dying sun. A tranquil silence descends, broken only by the distant rap of a drum.

No landmark more solemnly embodies the historical arc of the United States than this shrine to the fallen, where every hallowed acre narrates the growth of our republic and the affirmation of its ideals through sacrifice. Arlington is the **HISTORY**

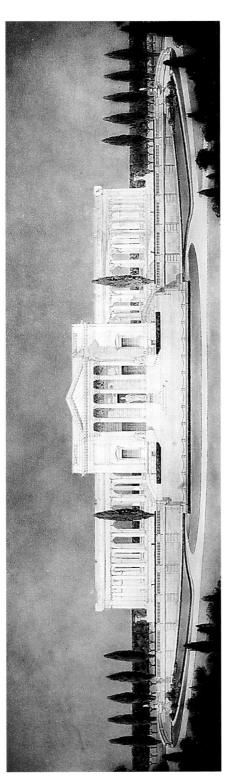

Arlington Memorial Amphitheater dedication rendering, circa 1920

ESTABLISHED IN 1864 on the acreage once owned by the families of two of this country's greatest generals—George Washington and Robert E. Lee—Arlington inters the remains of soldiers from battles dating from the Revolutionary War to the present. The land, which for a time functioned as farmland for freed slaves, currently serves as the final resting place for more than 400,000 valiant men and women, including 2 presidents, 11 Supreme Court justices, 26 astronauts, and a myriad of prominent Americans and foreign nationals. In addition to the endless rows of white grave markers and the expanding columbarium, more than two dozen structures punctuate the landscape, including the Confederate Monument, John F. Kennedy Memorial, Pentagon Group Burial Marker, and the Tomb of the Unknown Soldier, dedicated to American soldiers "known but to God." The most prominent edifice, the Memorial Amphitheater, annually hosts services on Easter, Memorial Day, and Veterans Day. In addition, some 142 of Arlington's lovingly maintained trees pay homage to the fallen. Planted in memoriam by numerous organizations, they provide living cenotaphs in this sacred bivouac of the dead, immortalizing courage and enshrining sacrifice in the same way every marble grave marker does. The result is a tableau that chronicles the forging of a nation.

Photographs from the ARLINGTON ARCHIVE

A rare view, circa 1838, of Washington, D.C., from Arlington House

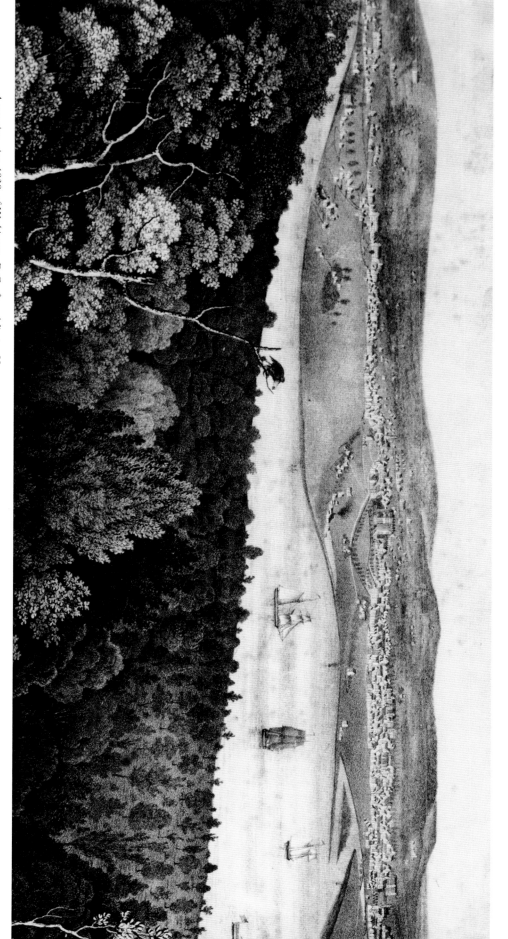

1861
Civil War begins. Gen. Robert
E. Lee resigns from the Union
Army, joins the Confederacy,
and abandons his 1,100-acre
Arlington estate. Union troops
occupy the house. ▼

1864
Federal government confiscates
Arlington when Mrs. Lee fails
to pay property taxes in person.
More than 1,100 freed slaves
are given Arlington land.

1864
U.S. government purchases
Arlington and establishes a nat-
ional cemetery. Pvt. William H.
Christman is Arlington National
Cemetery's first interment.

1865
Civil War ends. More than 15,000
are now buried at Arlington.

1868
First Decoration Day (renamed
Memorial Day) is held.

1883
After a Supreme Court decision
returns title of Arlington to Lee's
son, he sells it to the U.S. govern-
ment for $150,000.

1892
The first of the Revolutionary War
casualties are reinterred.

1898
U.S.S. *Maine* explodes in Havana,
killing 260. The Spanish-American
War galvanizes the nation.

1900
Congress approves construction
of Confederate Memorial.

1911
Pierre L'Enfant, planner of Wash-
ington, D.C., is reinterred with a
monument overlooking the city.

1913
President Woodrow Wilson
dedicates *Maine Memorial.*

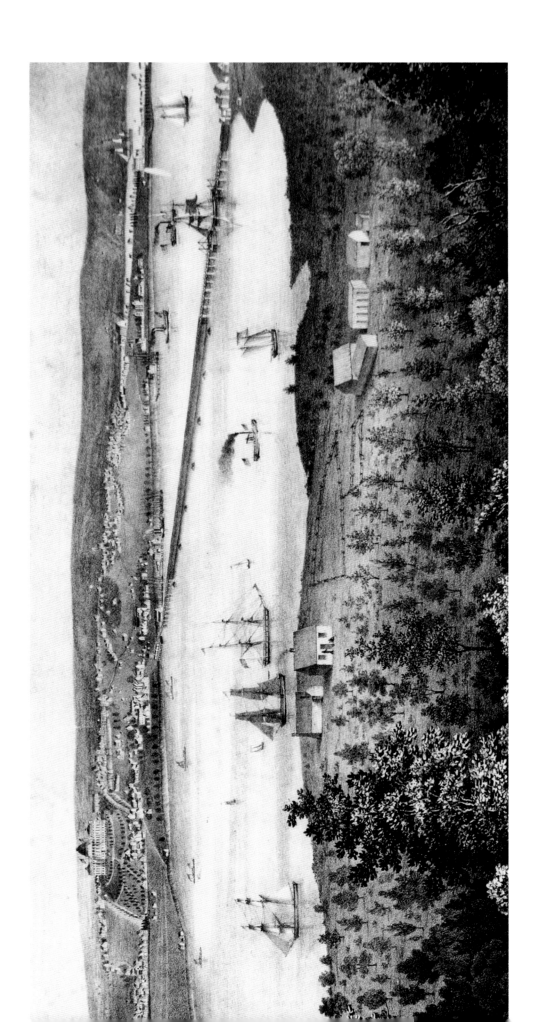

1915
Construction on the Memorial Amphitheater begins. ▲

1917
United States enters World War I.

1920
The Memorial Amphitheater opens. A beaux arts structure designed by Frederick D. Owens of Carrere & Hastings and dedicated to the Army, Navy, and Marine Corps, it serves as a place of assembly.

1921
President Warren G. Harding presides at the dedication of the Tomb of the Unknown Soldier of World War I.

1925
Arlington House becomes Memorial to George Washington Parke Custis and Robert E. Lee.

1930
William H. Taft becomes first President buried at Arlington.

1937
The Tomb of the Unknown Soldier is put on 24-hour guard. Elite 3rd Infantry Regiment sentinels take over 11 years later.

1941
The U.S. enters World War II.

1948
Air Force Arlington Ladies are founded by Mrs. Gladys Vandenburg, wife of the USAF chief of staff.

1949
Mass memorial service for 250 casualties of the *U.S.S. Serpens* explosion.

1950
Korean conflict begins.

1958
Burial of World War II and Korean conflict unknowns.

1963
President John F. Kennedy is interred at Arlington National Cemetery. His grave site overlooks the nation's capital and is marked by the eternal flame. ▶

An Army survey team relaxes at the Custis family plot in an 1864 photo.

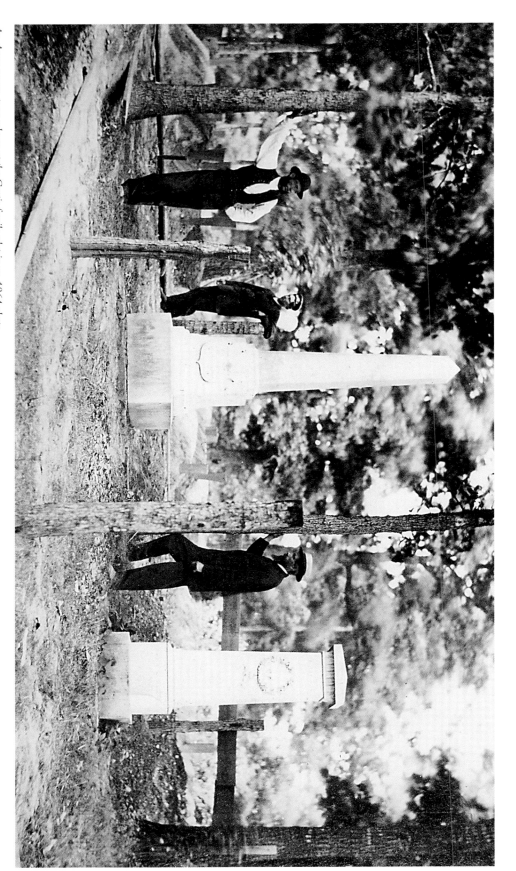

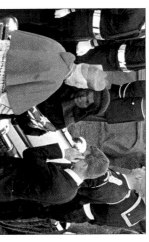

1967
Eligibility criteria changes limit burials to members of the active armed forces, retired members, Medal of Honor recipients, elected officials, and persons holding high-level government positions.

1968
Senator Robert F. Kennedy is interred in a grave adjacent to his brother, John F. Kennedy.

1971
Audie Murphy, the most decorated World War II soldier, is buried in Arlington. ▶

1973
Mrs. Julia Abrams, wife of the Army Chief of staff establishes the Army Arlington Ladies.

1980
The first of Arlington's nine Columbarium Courts, for cremated remains, opens.

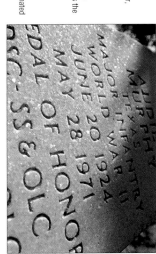

1984
President Ronald Reagan presides over the interment of the Vietnam Unknown soldier. ▶

1985
Navy's Arlington Ladies are established.

1987
Space Shuttle *Challenger* Memorial is dedicated.

1996
Sgt. Heather Lynn Johnsen becomes first female Tomb Guard.

1998
Vietnam Unknown is exhumed and identified as Air Force 1st Lt. Michael Joseph Blassie.

2001
World Trade Center and Pentagon are attacked.

2002
Group burial for the unidentifiable remains of Pentagon attack victims. The Pentagon Group Burial Marker is dedicated.

2004
Memorial to the space shuttle *Columbia* victims is dedicated.

2006
Land Development 90 completed, the last 40 acres of the old South Fort Myer lands.

2010
GPS and digital registration for remains are introduced.

2013
Cemetery expands onto land of former Navy Annex.

2014
Arlington National Cemetery celebrates its 150th anniversary.

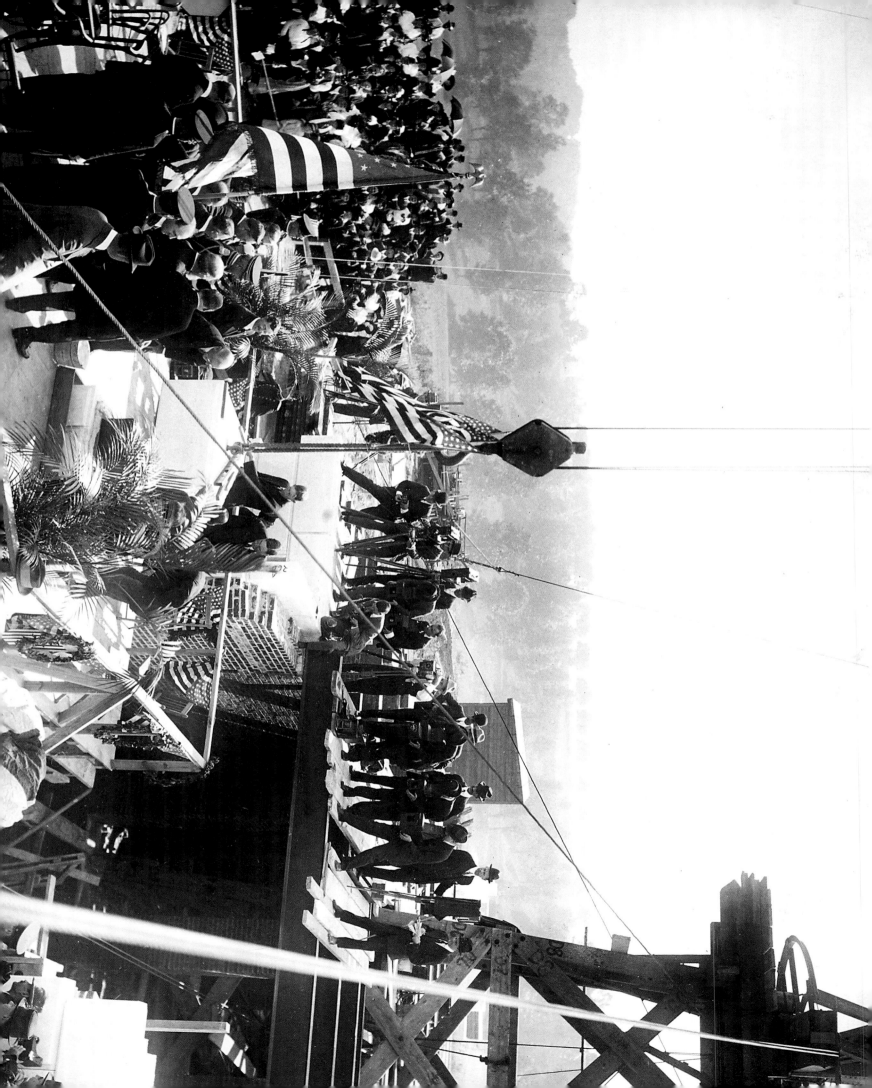

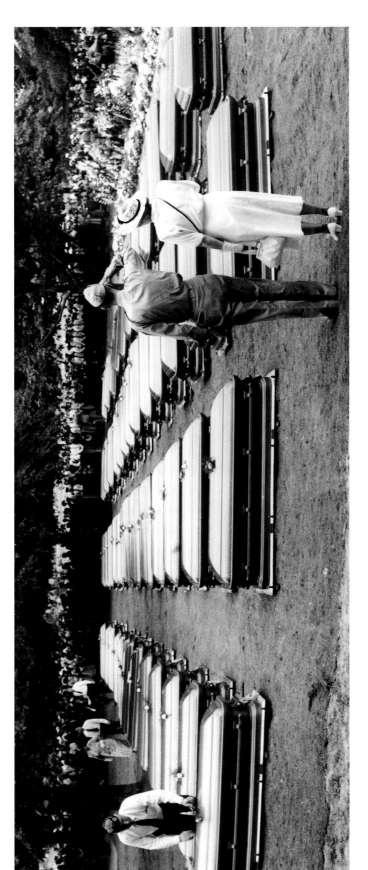

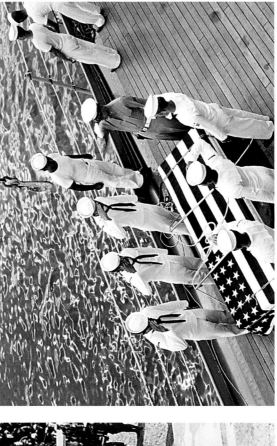

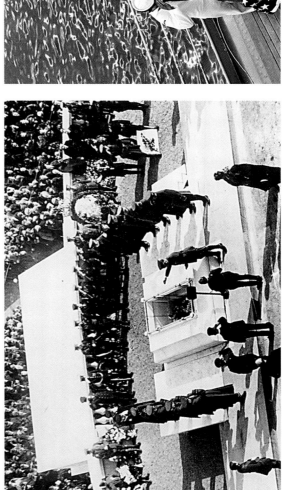

President Woodrow Wilson (opposite) lays the cornerstone at the Memorial Amphitheater on October 13, 1915. Clockwise from top: In Arlington's largest group burial ever, 52 caskets honor the 250 victims in the U.S.S. Serpens explosion; naval pallbearers in Guantánamo Bay render appropriate honors before moving the casket of the Unknown Soldier in 1958; President Warren G. Harding presides over the emplacement the Tomb of the Unknown Soldier in 1921.

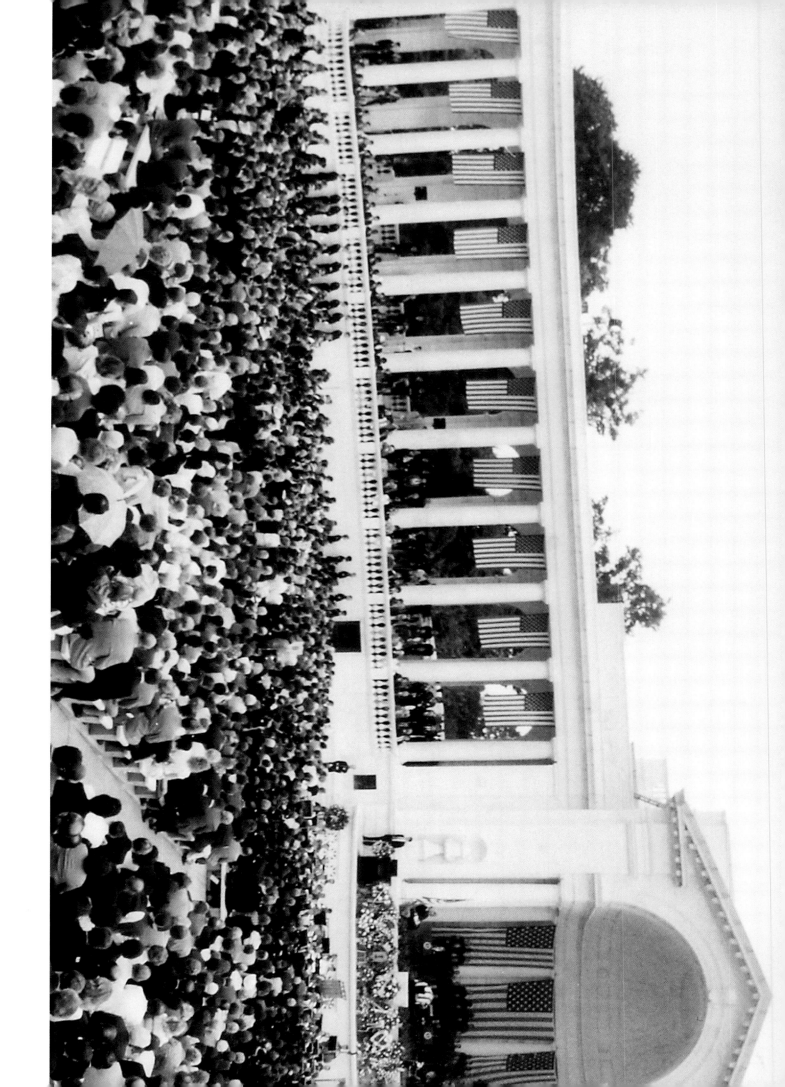

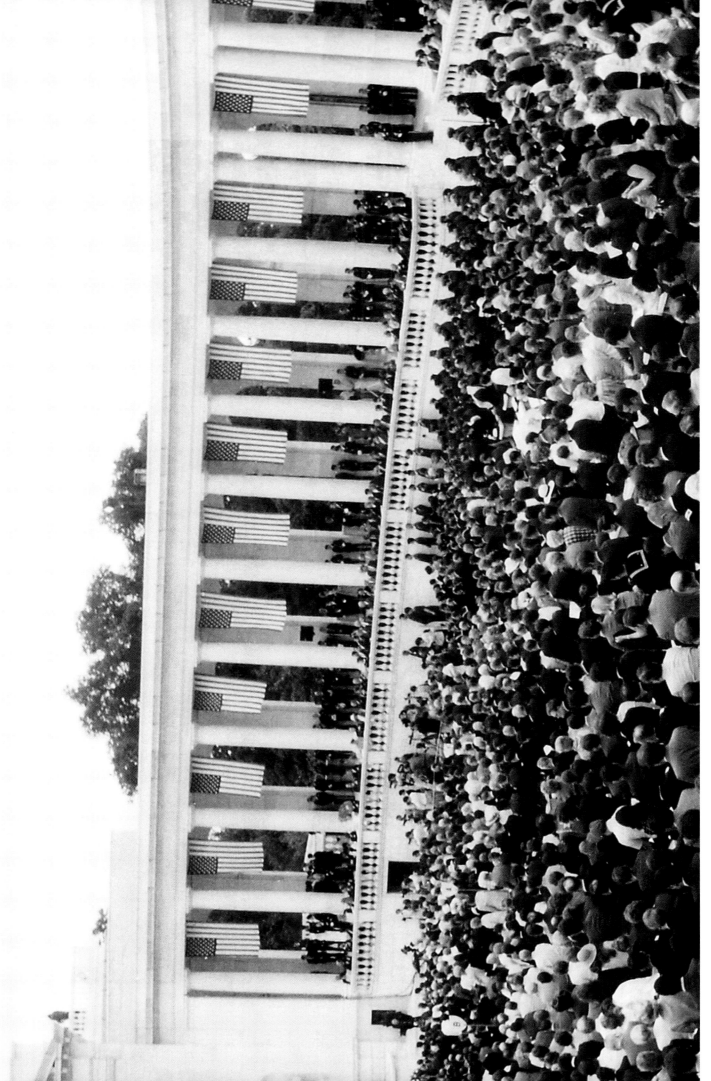

On Memorial Day 1984, final rites are held in the Memorial Amphitheater for the Vietnam Unknown Soldier. The remains were later identified as those of Air Force 1st Lt. Michael Joseph Blassie and reburied in Jefferson Barracks National Cemetery.

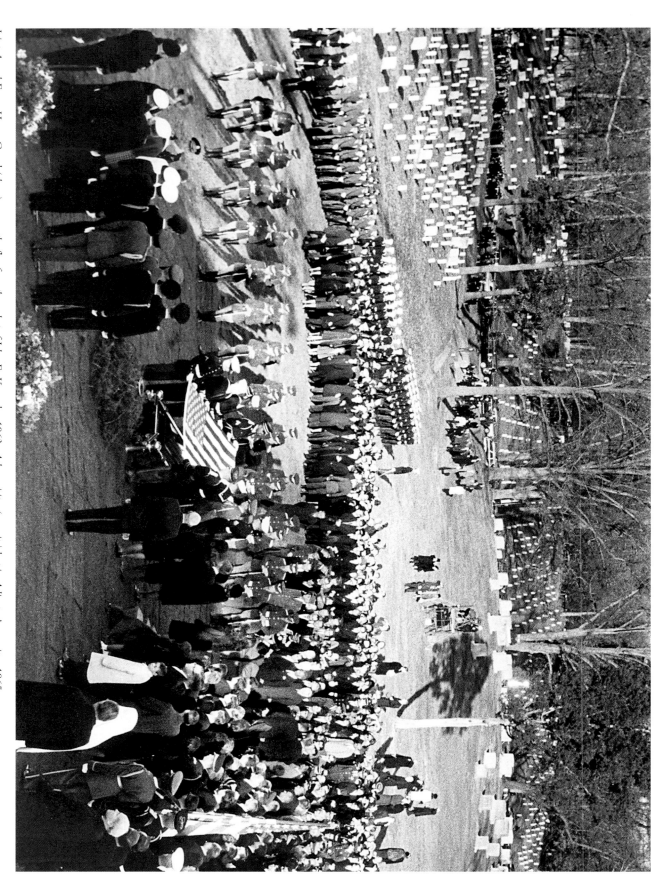

Joint Armed Forces Honor Guard (above) remove the flag from the casket of John F. Kennedy, 1963. A lone visitor (opposite) lost in Arlington's serenity, 1965.

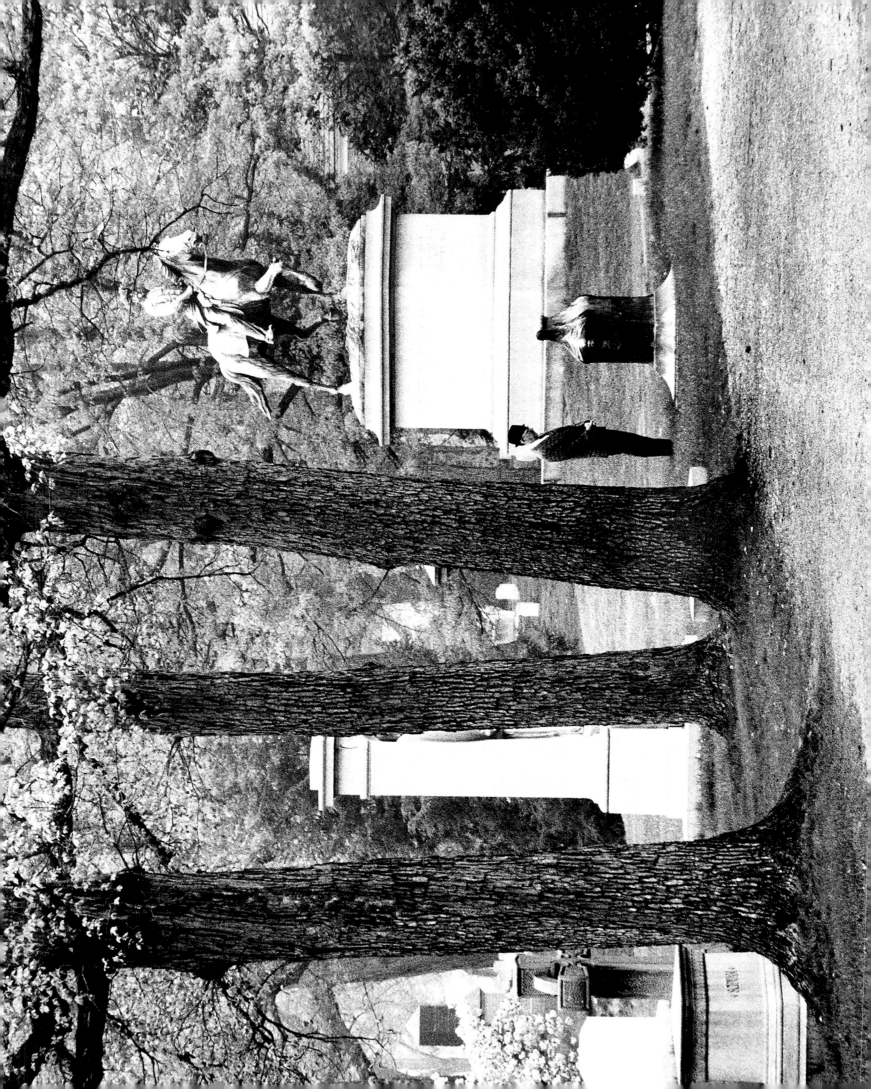

Burial at Arlington eternally and ceremonially unites the soldier with hundreds of thousands of his or her compatriots. As it rolls along the tree-lined hills studded with endless rows of headstones, the funeral cortege represents the **FINAL MARCH**

A full honors funeral includes a marching band, firing party, caisson, and bugler for the playing of "Taps."

IN ADDITION TO "standard" military honors, which include a chaplain, a three-round volley by a firing party, and the playing of "Taps," Arlington offers officers, warrant officers and any active-duty soldier a "full" military honors funeral consisting of a procession to the grave site with a horse-drawn caisson carrying the flag-covered casket, marching band, escort of troops, and a four-man color guard. The funeral cortege presents a ritualized pageant that dates to the Civil War and resonates with the hypnotic rhythm of Arlington's undulant terrain. The procession repeats itself up to eight times a day, employing the services of both 300 soldiers and numerous volunteers from the different service branches—all of whom ensure that no soldier ever goes to his grave alone. Every funereal step in these elaborately choreographed marches inspires reflection on mortality and the continuum of history. Captured in evolving panoramas, the images on these pages express that continuum. Their composition and construction suggest both the passage of time and the timelessness of ritual, both the finality of death and the nobility of life lived in service to the nation. Each frame seamlessly flows into the next, like so many monuments to time spaced evenly across the landscape, echoing the solemn cadence of the soldier's ultimate retreat.

Photographic Essay by JAMES BALOG

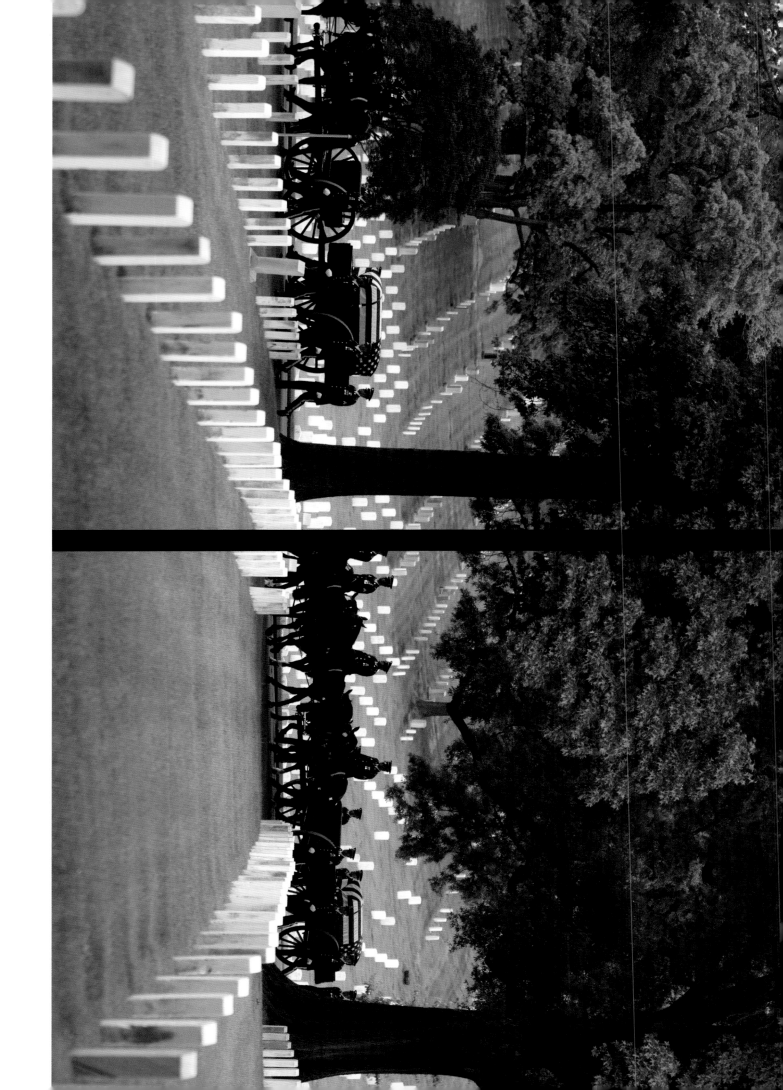

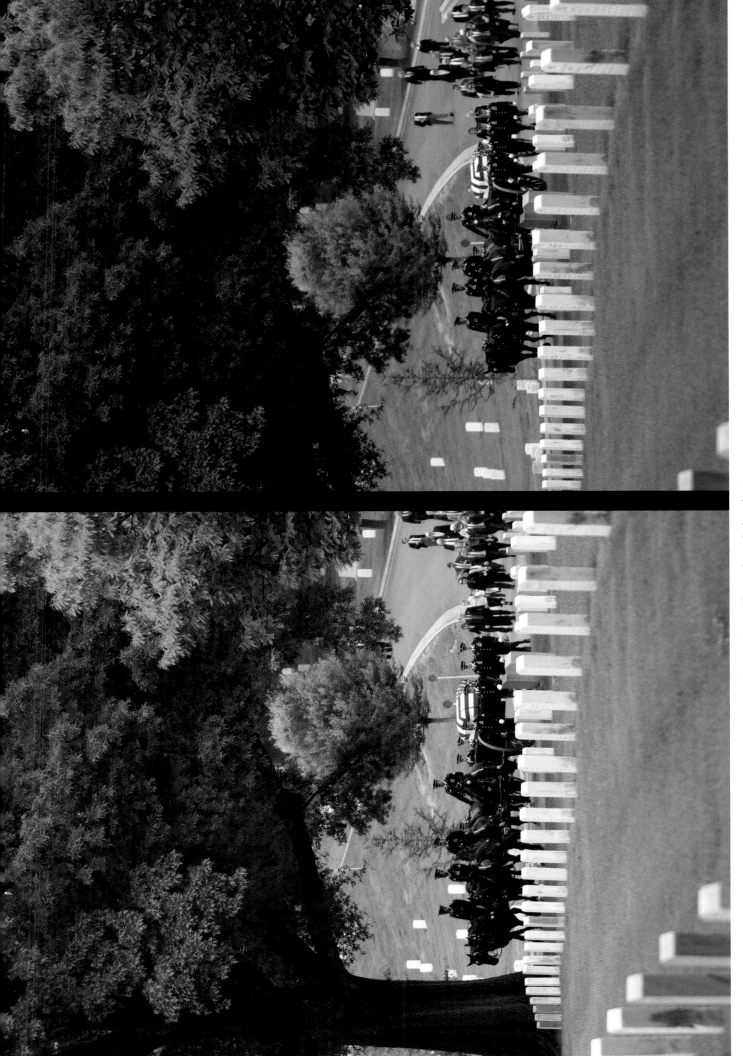

In a full honors funeral, a ritual with origins in the Civil War, a half dozen horses ridden postilion style draw the caisson bearing the flag-draped casket of an Army officer. Here, Capt. Walter Hynes makes his last march.

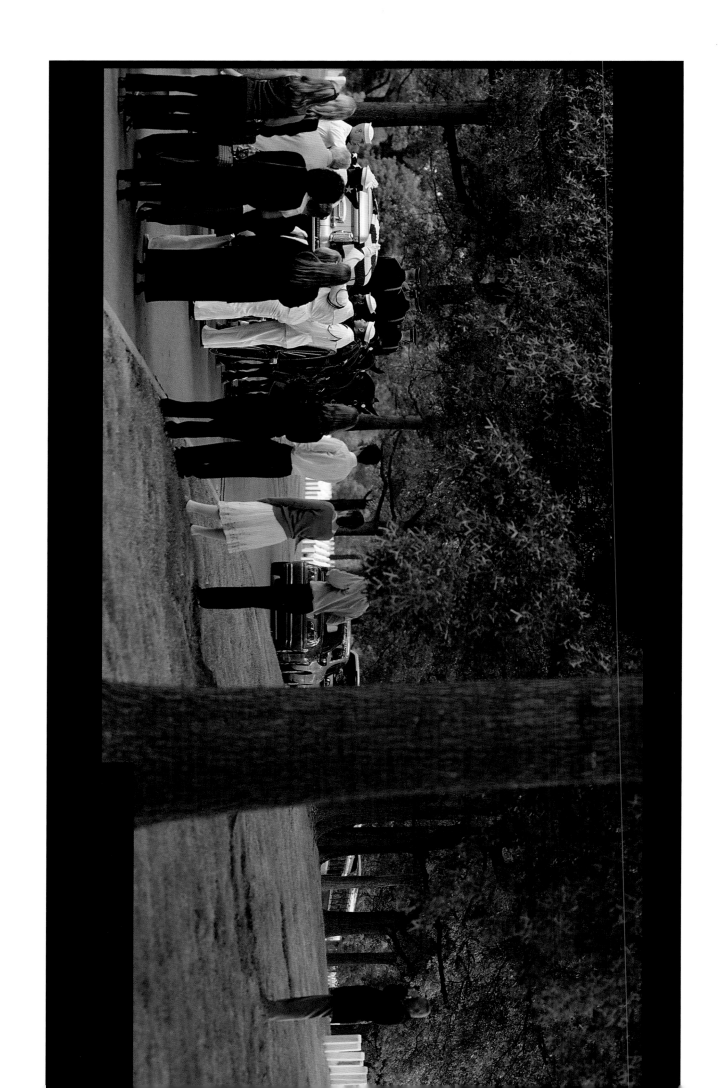

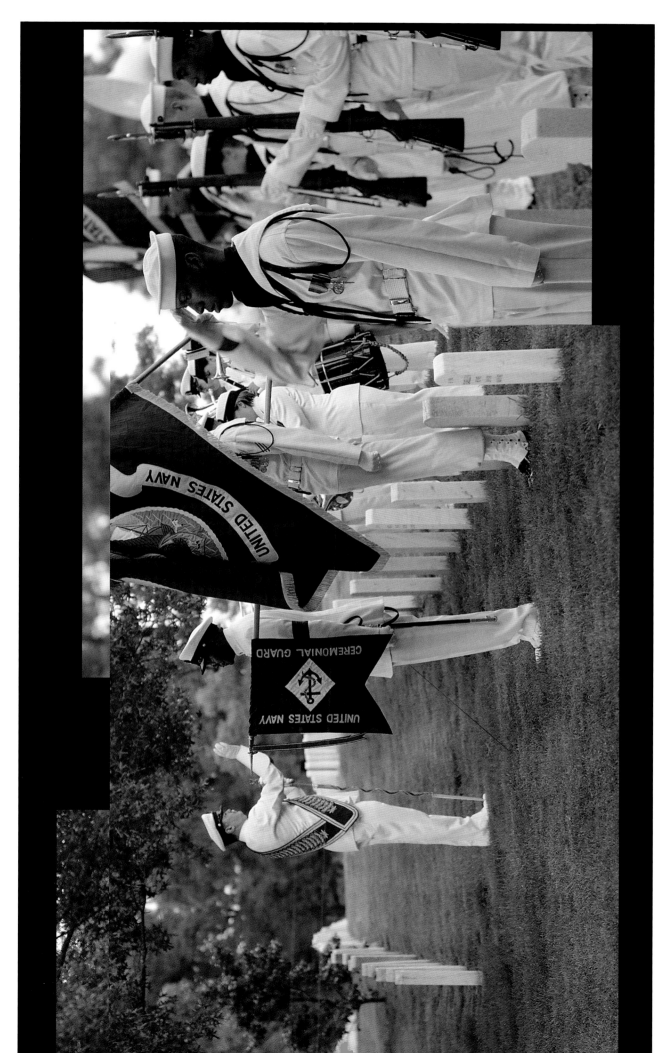

*Mourners witness the unveiling of the casket during the full honors ceremony of Navy Lt. Cdr. E. Joseph Kalakowski.
Since 1931 the U.S. Navy Ceremonial Guard has rendered final honors at every Navy funeral at Arlington.*

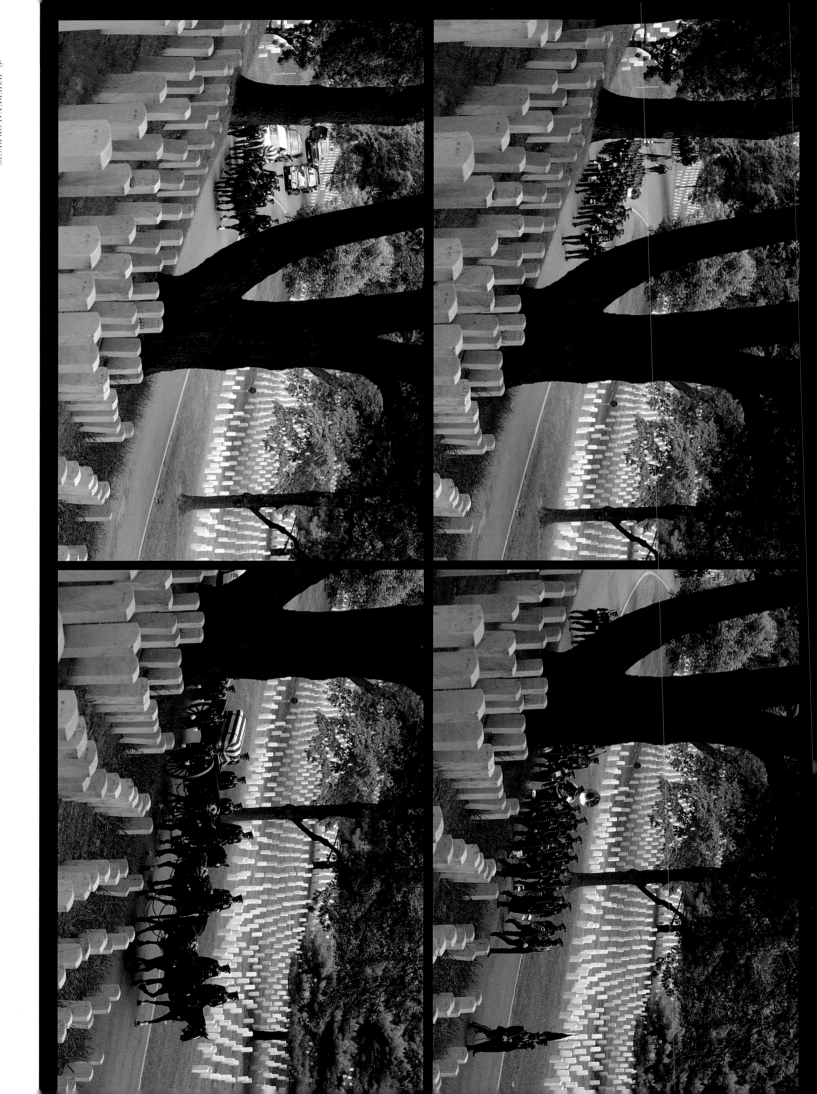

The Old Guard escorts many funeral cortèges through the endless ranks of headstones each day. The sounds of another soldier going to his grave provide a rhythm that dignifies death and consoles the living.

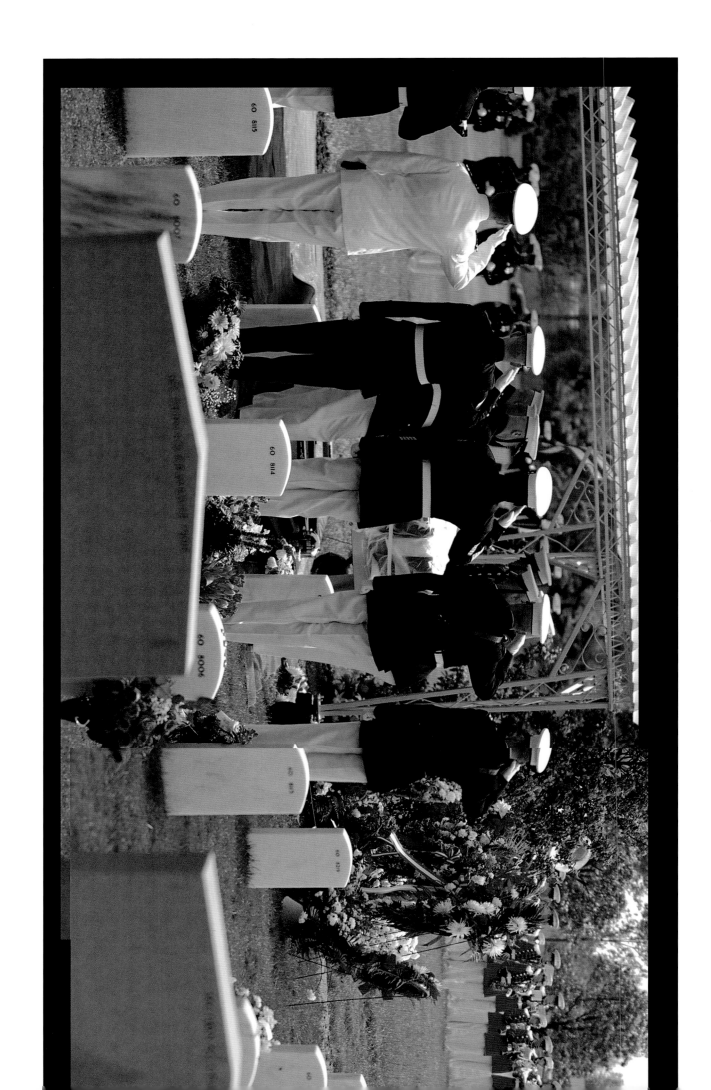

All soldiers killed in active duty receive a full honors funeral, regardless of rank. On May 15, 2006, U.S. Marine Corps Capt. Brian S. Letendre, a 27-year-old killed in Iraq, was buried in Section 60 at Arlington. As the body bearers perform the final transfer of the casket to the resting site, the Marine Band plays the "Marines' Hymn."

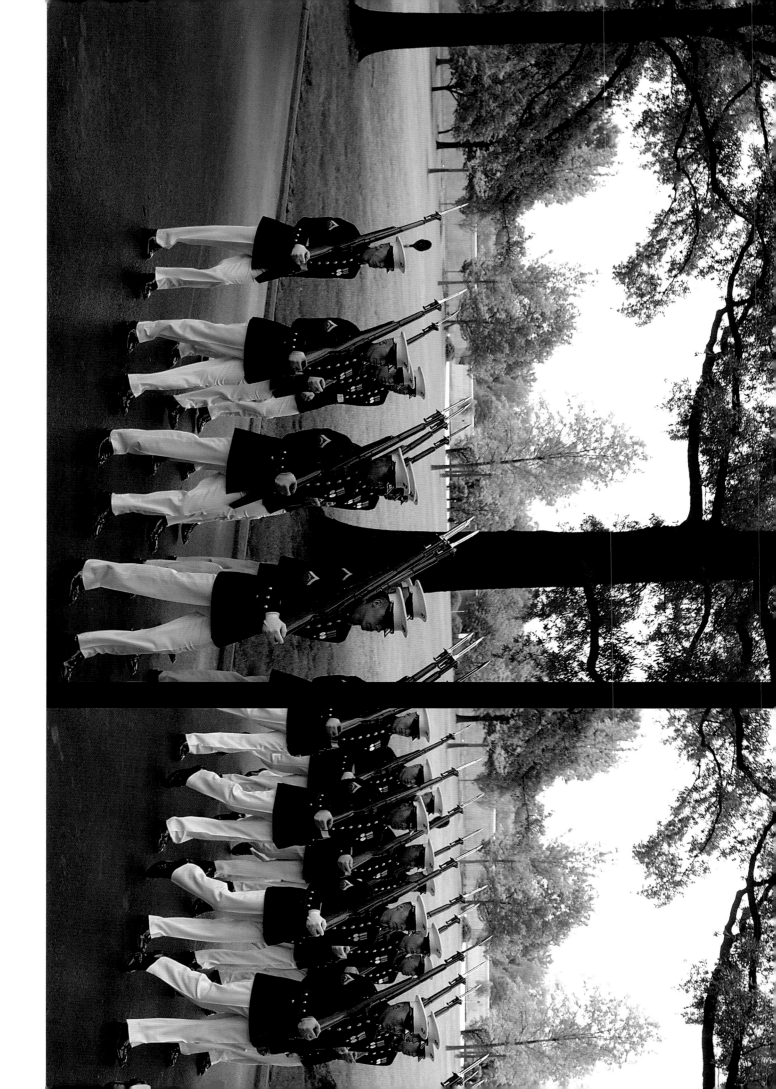

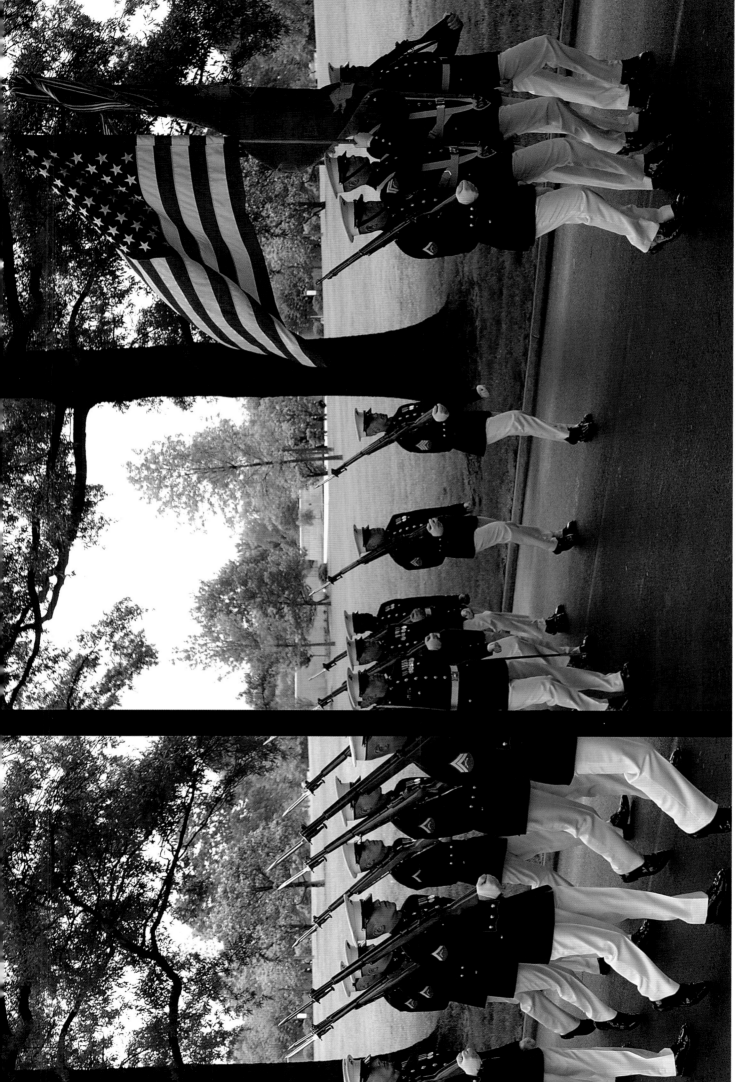

From the angle of their bayonets to the shine on their boots, members of the U.S. Marine Corps Honor Guard mirror each other with donelike precision as they march from the grave site of fellow corps member Capt. Brian S. Letendre.

If fall is, as Albert Camus wrote, "a second spring, when every leaf is a flower," then it is also the season when Arlington National Cemetery blossoms, proudly displaying its colors in an annual celebration of AUTUMN

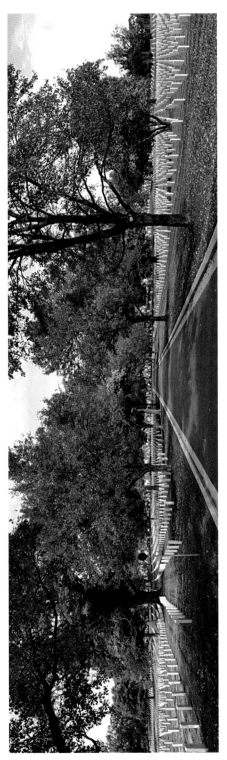

A blaze of maples lines McPherson Drive, near Section 18.

ARLINGTON CARRIES THE season in vibrant bouquets. Maples, birches, oaks, and other tree species from around the world take root in this fertile earth, their flourishes of red, gold, purple, and orange foliage soughing and waving, like so many flags, above the serried rows of still, white stones. As the days grow shorter, the air crisper and more invigorating, the land aches with the remembrance of erstwhile harvests. All the world seems alive with color, a spinning, kaleidoscopic canvas of life. Yet the leaves are brightly dying. They will drop to the ground, as many a soldier did, in blazing glory. Some will be raked, some will rot, and some will become almost ethereal as their pigment drains. They will then drift, featherlike, among the headstones, dancing and mingling with the spirits that inhabit these hallowed grounds. Their communion is organic, an inexorable, natural element of the season's spectral cycle. Its dramatic arc, as recorded on the following pages with traditional and infrared photography techniques, celebrates both the fiery beauty of autumn and the pallor of its inherent melancholy, the splendor of fall amid the splendid ranks of the fallen. To every thing, Ecclesiastes instructs us, there is a season—and autumn irrefutably and beautifully belongs to Arlington National Cemetery.

Photographic Essay by BRUCE DALE

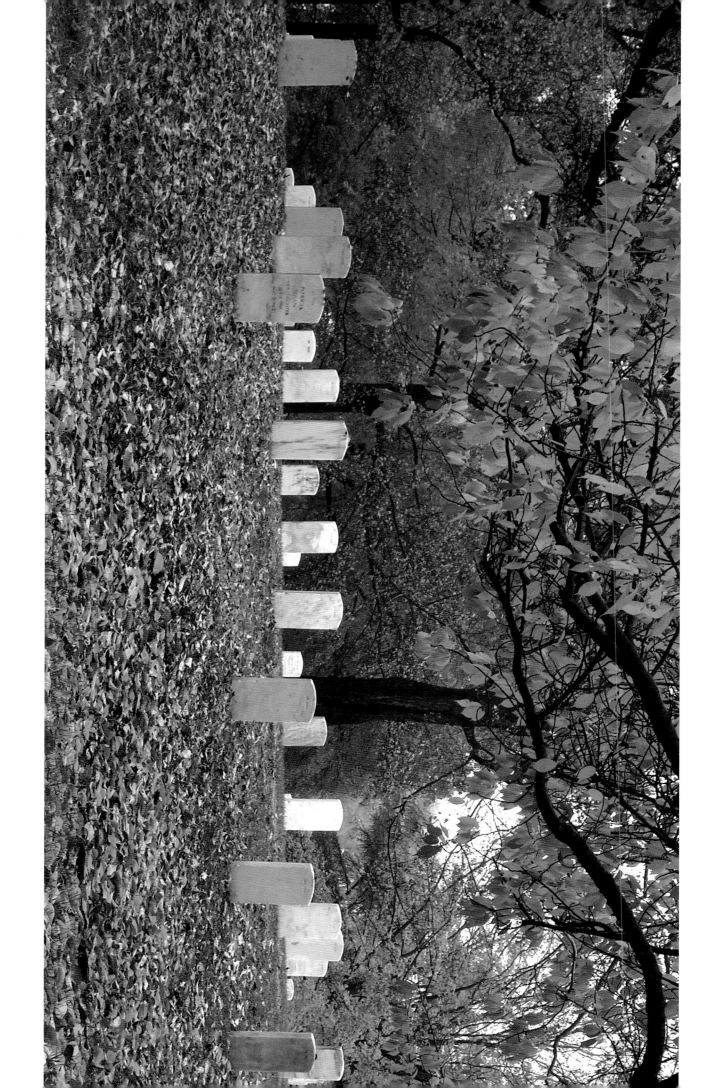

Autumn leaves blanket the ground under a Japanese cherry tree.

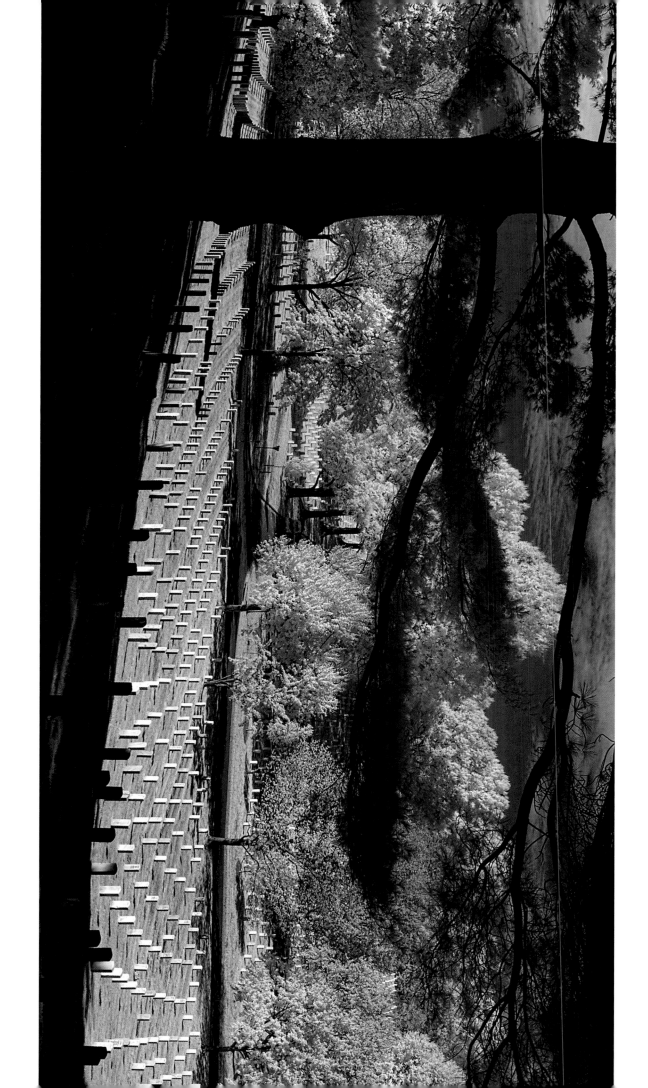

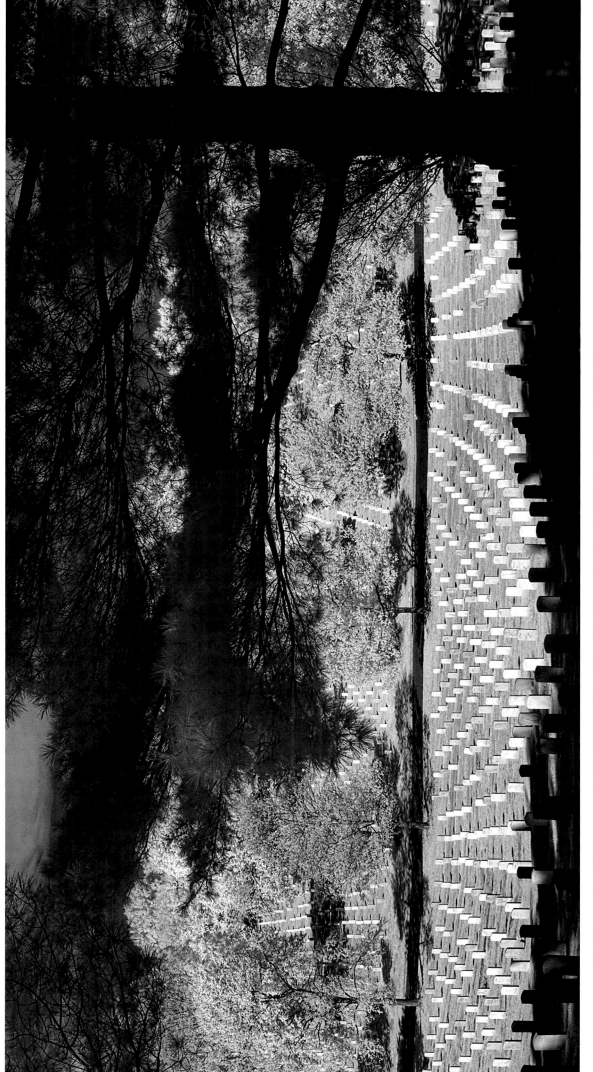

Although autumn leaves fill the cemetery with color, their lack of life-sustaining chlorophyll casts them in a ghostly light through the use of an infrared camera.

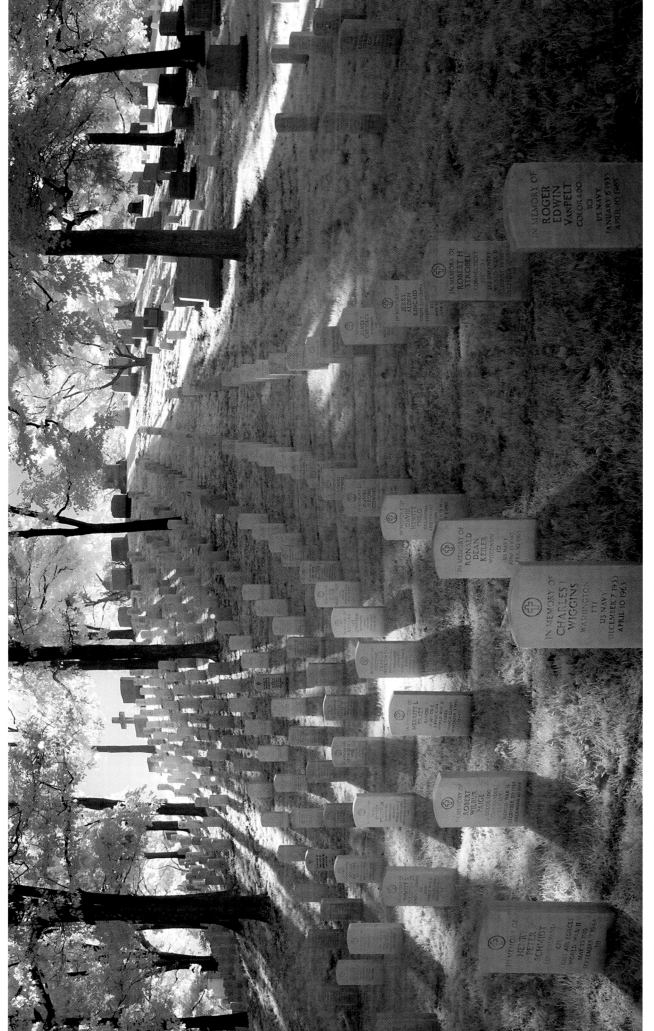

The same autumn sun can bathe a cemetery section with a glowing warmth or frost it in shadows.

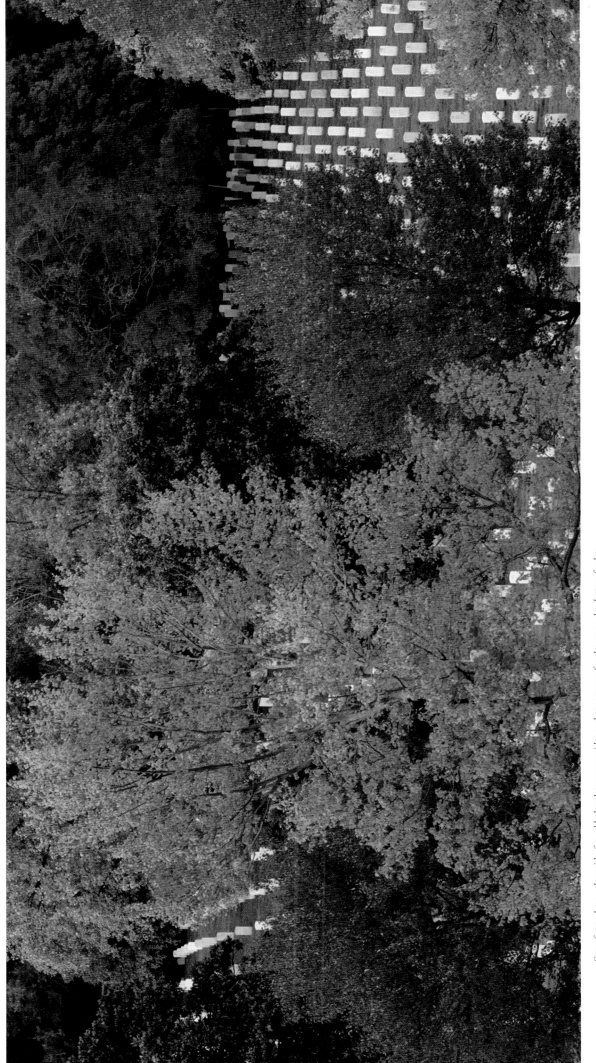

Seen from above, the grid of marble headstones provides a clean canvas for the annual splatter of colors.

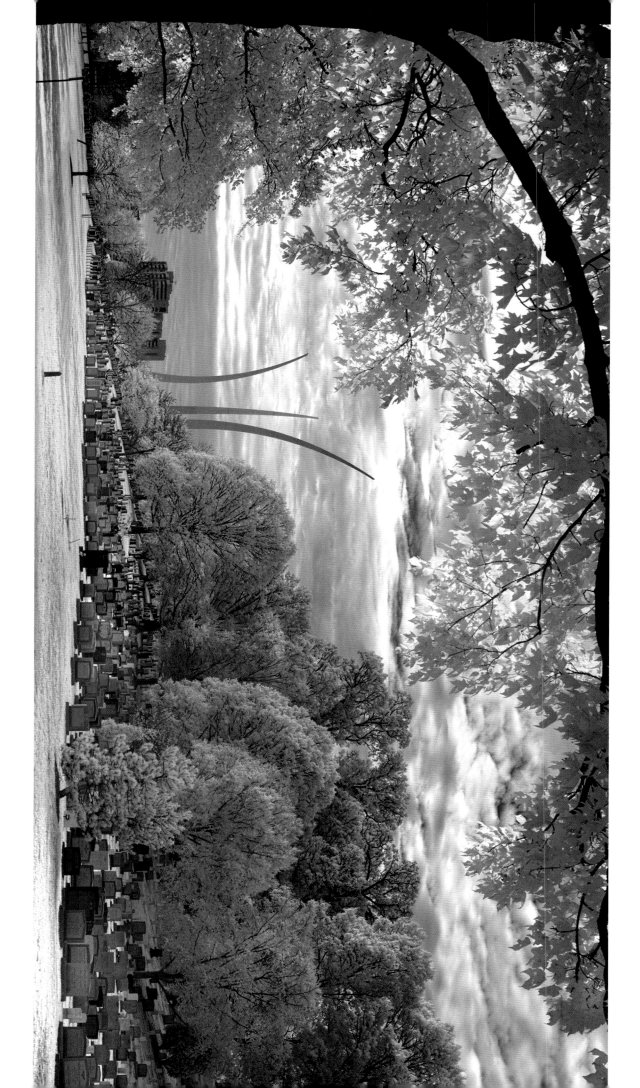

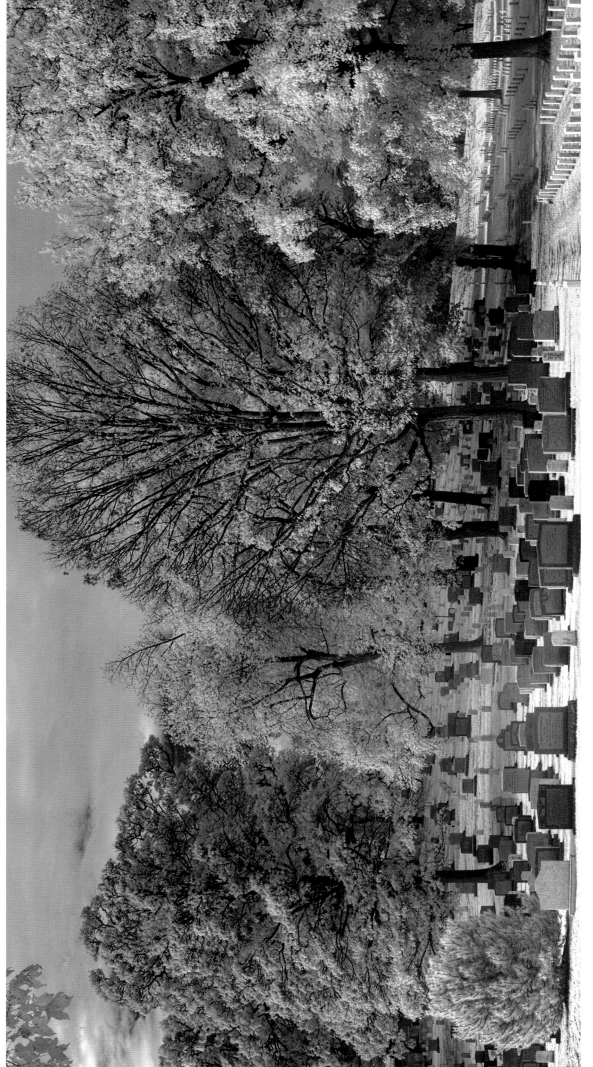

The Air Force Memorial looms as one of the many architectural forms of our nation's capital that echo the natural shapes of Arlington's wooded necropolis.

Like the valiant men and women laid to rest at Arlington National Cemetery, the individuals whose paths cross on these hallowed grounds represent the diversity from which our nation springs and draws its strength.

These are the PEOPLE

THEY ARE THE visitors, soldiers, workers, and volunteers from all walks of life who make Arlington National Cemetery the sacred place it has become. They respect and appreciate the beauty of the flowing land and the sacrifice of those who lie beneath it. They are the men and women in whom Arlington inspires a common reverence for our nation, its history, and its ideals. They represent a cross section of America, a people whose very presence amid the tombstones and memorials bears out Lincoln's resolution that the dead shall not have died in vain, that those who served—and died—did so for a purpose greater than themselves. For Arlington

is more than a military burial ground; it is an organic chronicle of the nation, fertilized not only by the blood of the fallen and the tears of their loved ones, but also by the sweat of workers, the honor of soldiers, the commitment of volunteers and the heartfelt appreciation of the four million men, women, and children who make the pilgrimage every year. In their own words, the individuals pictured on the following pages express their communion with this living monument. Woven together, their impressions epitomize in very different, personal, and profound ways the necessary ingredients to forge a national identity and to ensure an enduring heritage.

CAPT. CHARLES HAMLIN
Army Chaplain

Photographic Essay by BRIAN LANKER

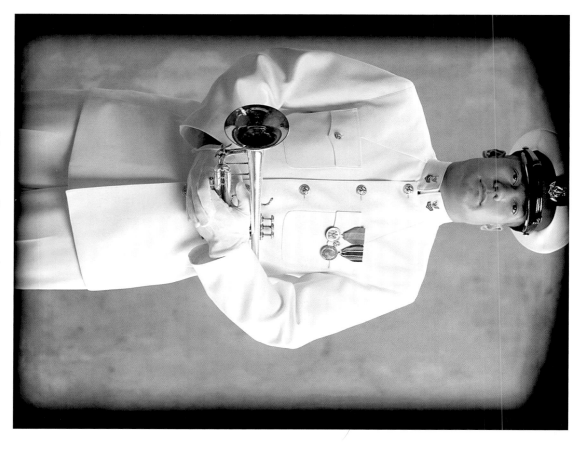

MUSICIAN 1 BRANDON ALMAGRO
Navy Trumpeter

"Whether it's a full honors service or standard honors service, it's always a very heavy feeling playing taps at Arlington, even when no family is present. All I can do is give my most heartfelt honors and respect to the particular person who is being buried, no matter what his or her rank. The only way I can describe it is that whole aura comes about you and you want to make it as perfect as you possibly can."

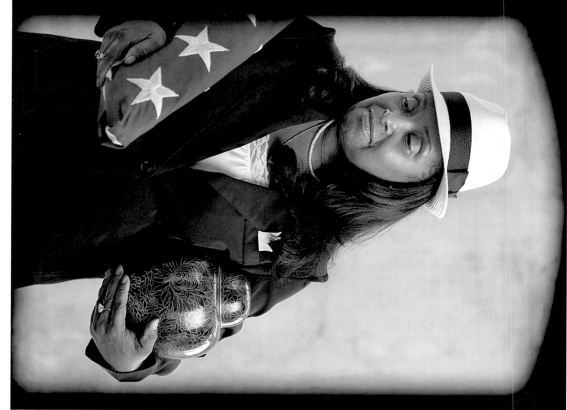

SHARRON CAMPBELL
Cemetery Representative

"When families come for the committal services or funerals, I meet with them and get them to the service. My mother, a funeral home manager, taught me to respect grieving people. So I treat them gentle, just let them talk. I explain exactly how the service will be. Surprisingly, they like the order of things. When they all leave smiling, I feel like 'mission accomplished.' It's like the final stage of grief."

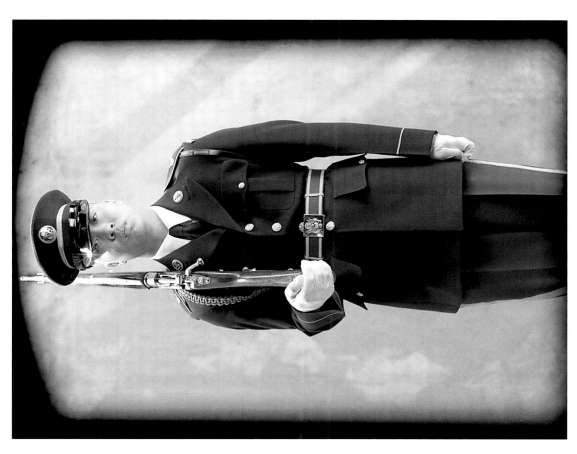

PVT. 1ST CLASS ANTHONY MONROE-WARREN
Army Color Guard, 3rd U.S. Infantry

"Our battalion performs colors at services for officers and active-duty personnel. We try to be as precise as possible, giving the best honors we can give. Seeing so many people crying every week can be extremely emotional, but the role we perform is not about us or for us. It's about our fallen brothers and sisters and for their families. Our job is to put service above self."

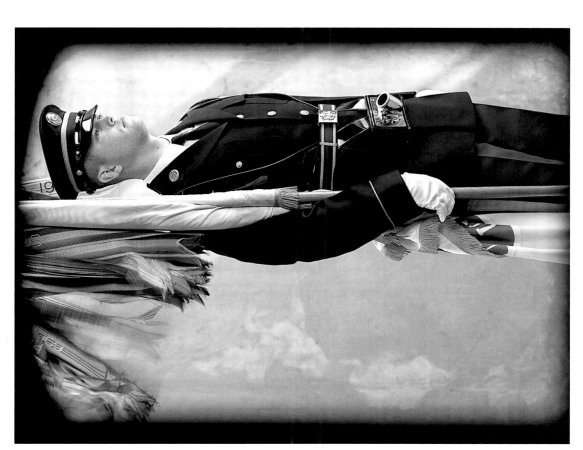

SPECIALIST BYRON SMITH
Army Color Guard, 3rd U.S. Infantry

"Even with all the training that goes into becoming a color guard, I did find my first full honors funeral pretty depressing. I suppose that's normal, but I always remember it's my duty to be there for the family and the other soldiers. I perform as many as four funerals a day, and I usually prefer the flag-bearer positions. Family members and visitors are in awe of what we do. It's a good feeling."

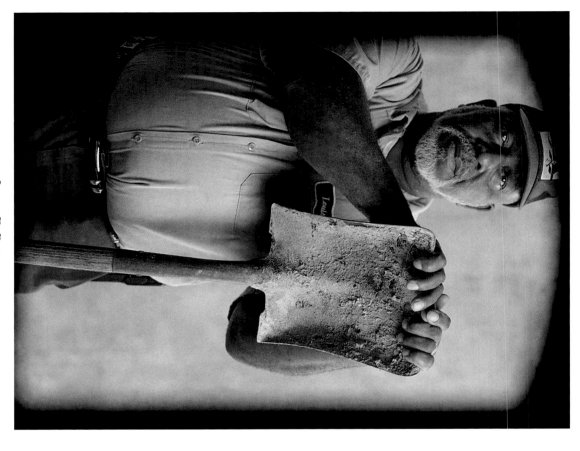

LOUIS D. PACK

Gravedigger/Backhoe Operator

"I never knew a cemetery could be so beautiful and be so sad. When you work here, you take such pride in what you do. We straighten headstones, replace headstones, clean them, and keep the place looking beautiful. I like to think that what I'm digging aren't just holes in the ground. They are the eternal resting places and the final honors for those who honored our country."

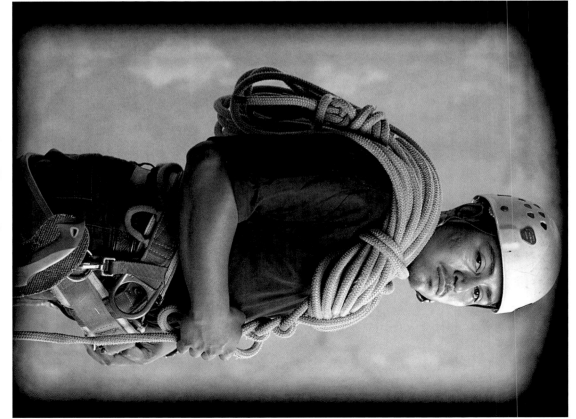

JESUS VASQUEZ GONZALEZ

Arborist

"This was my first job after coming from Mexico, and everything I've learned about this country comes from Arlington National Cemetery. It gives me pleasure to help make things so beautiful. The trick is to be as unobtrusive as possible when trimming the hedges and trees because there are funerals and ceremonies happening all the time. We have to cut, clean, and clear out quickly and quietly."

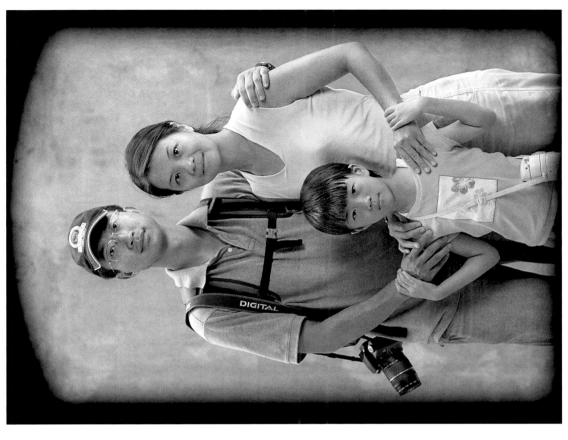

PEIYONG ZHOU, LILY QIN, AND REBECCA ZHOU
Chinese Tourists

"We lived in Chicago briefly, and before we returned to Beijing we visited Washington to see the famous monuments and buildings. But a cemetery? We had heard a great deal about Arlington National Cemetery, about how beautiful and moving it was, but nothing prepared us for the emotions we felt. You don't have to be an American to appreciate the strong sense of history and sacrifice."

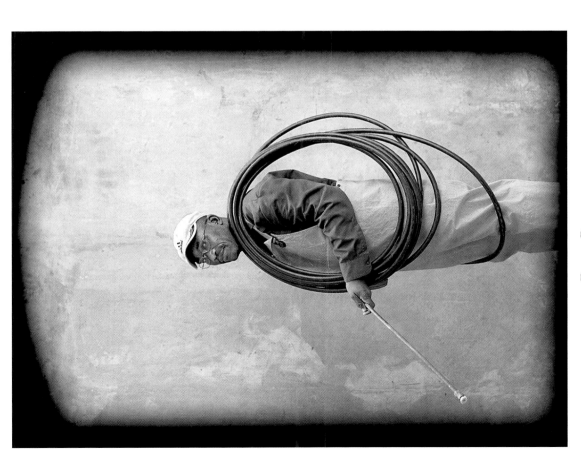

FIRMIN BENOIT
Pressure Washer

"I personally clean about 700 to 800 headstones a day, plus monuments, and every Thursday I wash John F. Kennedy's grave. When I first read his quote, 'Ask not what your country can do for you; ask what you can do for your country,' I swore I would wash this place special. I also make sure to help visitors when they ask for directions. I help so many people. I never take their money, only their gratitude."

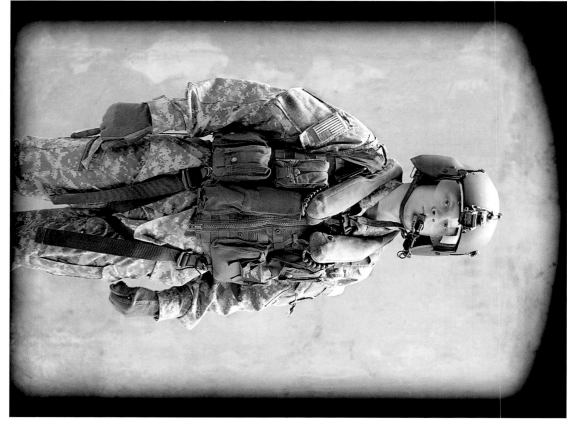

CHIEF WARRANT OFFICER 2 DANIEL HANSEN

Army Helicopter Pilot

"Any time you're part of a flyover at Arlington it chokes you up, knowing what these people gave and actually looking down on the cemetery and the families. It's one of the proudest missions we do. It takes timing and coordination, so we'll practice days in advance. Creating one of the last memories in honor of someone who gave everything for their country is about as far from routine as it gets."

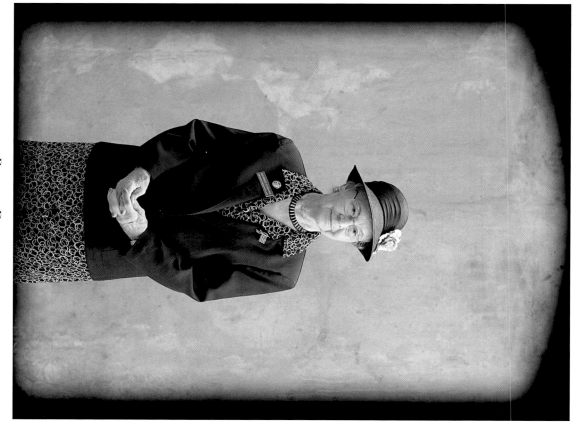

BERNICE DUNHAM

Navy Arlington Lady

"I feel truly honored to serve as a naval representative at Arlington. The thing that attracted me from the beginning was that I was giving of myself, with the purpose of comforting the family. We always have a military escort. They're fine young men, but sometimes they have problems, too, and just need a person to talk to. It means a lot in life to have compassion; and not everyone is able to give in this way."

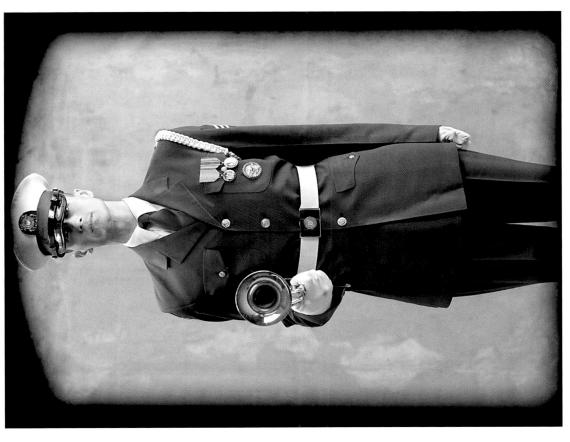

SEAMAN KENNETH MCABEE
U.S. Coast Guard Bugler

"We're a small service, small honor guard. But when it comes to the passing of our fellow soldiers, it's important to have someone play the bugle instead of turning on some electronic device. I always play 'Taps' no matter the rank of the soldier. I'll also play 'America the Beautiful' during the flag folding.

One time a family asked me to play 'Amazing Grace' and I naturally honored the request."

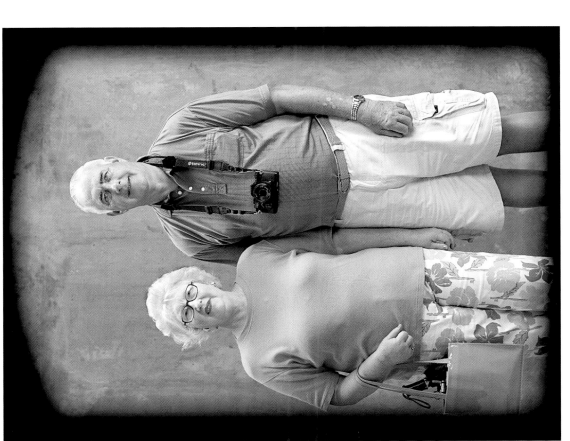

JUDITH AND PAUL W. SCOWDEN
Ohio Tourists

"We've been to Washington, D.C., eight times since 1958, and every time we visit Arlington. It's just a beautiful experience to see all those tombstones and the names of those who gave their lives for our country's freedom. It's a patriotic thing, but it's also living history, something that, if it weren't around, our kids wouldn't know about it. History is disappearing from our textbooks; this provides a lesson in itself."

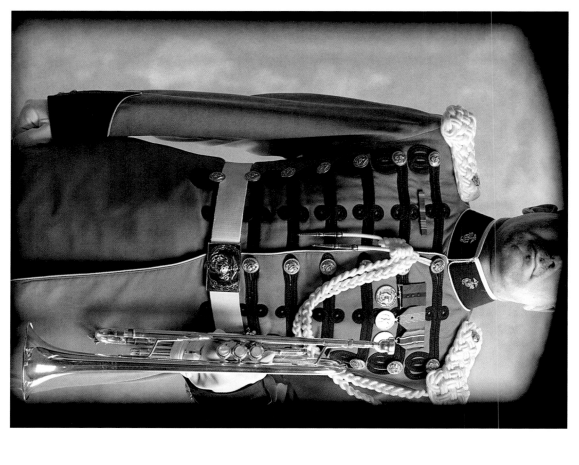

MASTER SGT. JOHN L. ABBRACCIAMENTO
Marine Trumpeter

"I've played for the president at the Kennedy Center, but I can't think of anything more significant than anonymously playing 'Taps' at Arlington. I've done it for 14 years and it never gets old. You don't want to say a funeral is beautiful, but that's what a military funeral is. When people hear the haunting notes of 'Taps,' they *know*. They cry. And I feel their grief. It's not about me; it's about the families."

CORPORAL THOMAS SCATES
Marine Body Bearer

"It takes seven months to complete Body Bearer Ceremonial Drill School. The whole time you're lifting weights and learning drills. Six of us carry the casket, which can weigh 700 pounds. I'm a 'tugger,' one of the two gentlemen in the middle who are the weight carriers. There are 16 body bearers, and we take great pride in seeing our fellow Marines to their final resting place. There are no do-overs."

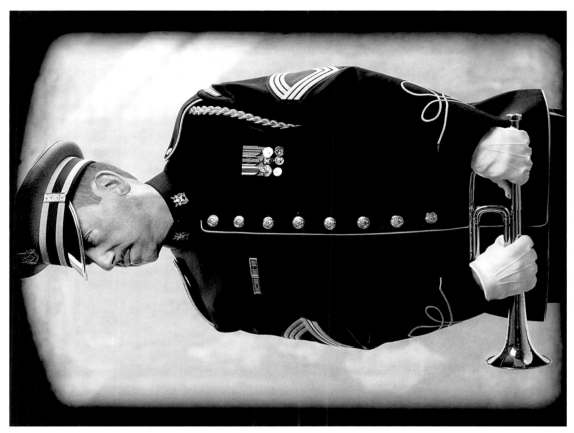

MASTER SGT. ALLYN VAN PATTEN
Army Bugler

"I figure I've played 'Taps' about 10,000 times during the two dozen years I've been a bugler. The work-load at Arlington has certainly increased with the passing of many World War II veterans. I've had people ask how I can isolate myself from all the sorrow, and I tell them I can't do that. I wouldn't want to do that. I appreciate the role I play in the grieving process and hope that it's the beginning of some closure."

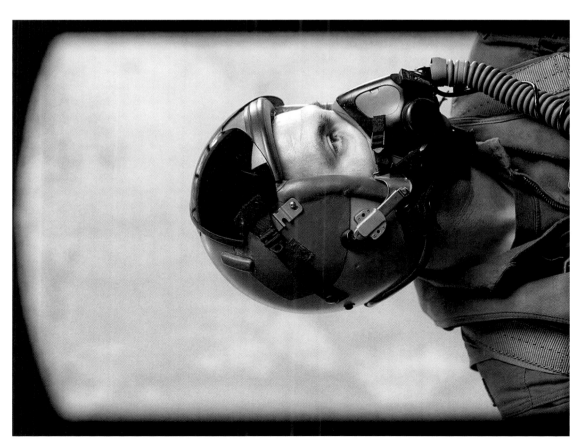

MAJ. ROBERT BALZANO
Pilot, D.C. National Guard

"My squadron, the Capital Guardians, defends the National Capital Region and supports memorial services at Arlington. When we fly over in the missing man formation—wherein the number three plane abruptly pulls straight up—we do so not for ourselves, but for our fallen comrades. It is one of the greatest honors for a fighter pilot to be part of such an event. It brings everything into perspective."

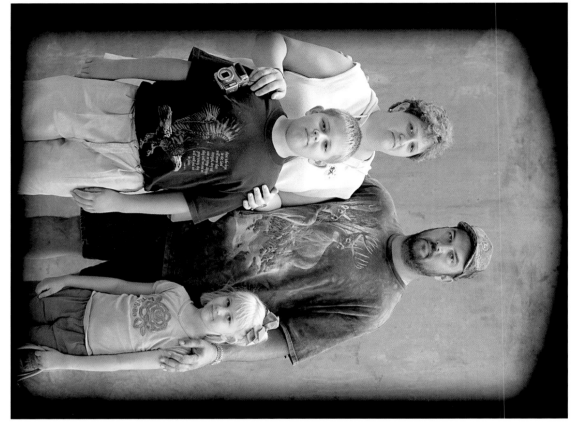

WYONNA, TONY, ALEX, AND CORAL JEANE
Louisiana Tourists

"We had come to D.C. for our son's leadership conference and wanted to experience Arlington. It's so beautiful, so solemn. Those rows and rows of headstones, each one a fallen soldier, are just incomprehensible in number. We saw the changing of the guard and a horse-drawn funeral procession that stopped not far from us. We did not intrude, but felt, as Americans, extremely connected to it."

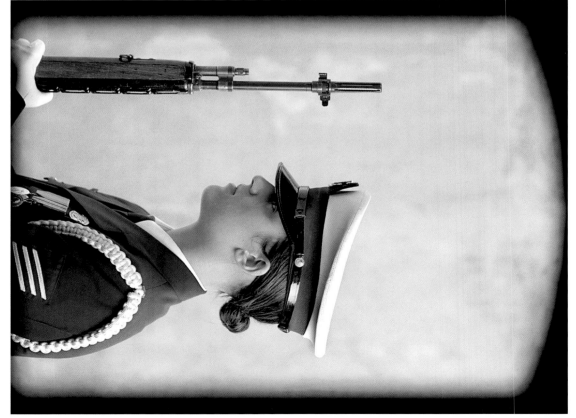

SEAMAN CARA WARNER
U.S. Coast Guard Firing Party

"Every funeral at Arlington gets a firing party. We're well prepared, although I'm always nervous something could go wrong with the weapon. We march a certain number of yards behind the casket and stand at a distance from the service before firing our salute. We're far enough away not to hear a lot of the service, but the body bearers have to look the widow in the eye. I don't think I could do that."

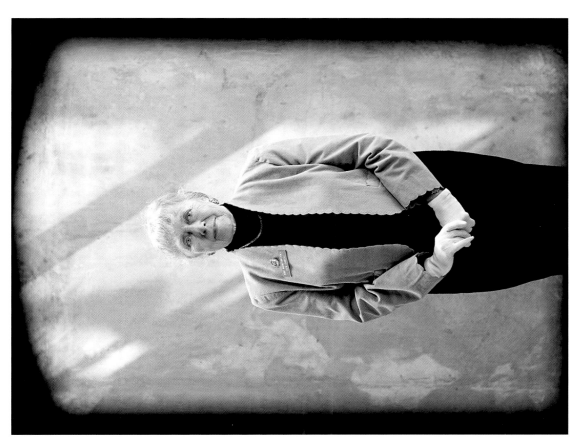

CISSIE CHRISCO
Army Arlington Lady

"I've served as an Arlington Lady for 30 years. I believe no soldier should go to his last retreat alone. The families feel as though they have a human connection. I've made many friends among them. Over the years, I've placed wreaths for them, or accompany them to the grave or columbarium when they visit. They thank us, but it's who should thank them. Arlington's a place where everyone's a hero."

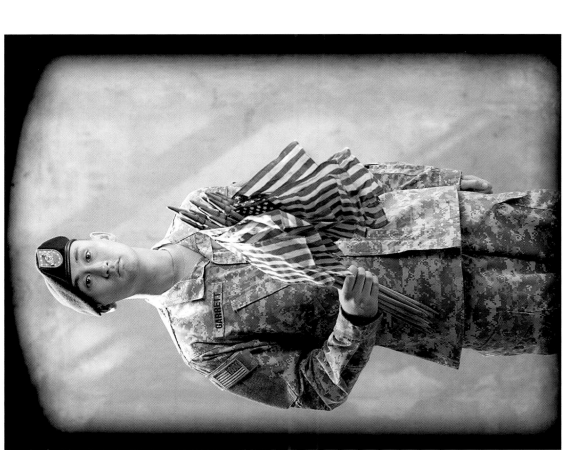

PVT. 1ST CLASS JUSTIN GARRETT
Soldier, 3rd U.S. Infantry

"My regiment, known as 'The Old Guard,' gets to perform the flags-in ceremony every Memorial Day. We center a flag exactly one foot in front of more than 250,000 gravestones. It takes about three hours; then we patrol the cemetery all weekend to ensure no grave loses its flag. Getting to sow the cemetery with symbols memorializing those who died for our country is an honor I can't describe."

Every aspect of this sacred square mile reflects the standard of perfection to which platoons of workers and soldiers aspire on a daily basis. In the execution of their duties, they exhibit an extraordinary sense of CARING

Kelvin Dixon, one of seven cemetery representatives, counsels the next of kin.

THE SAME PRIDE, orderliness, and precision that defined the lives of the soldiers buried at Arlington also distinguish them in death. The cemetery's dedicated service members and workers see to that. From the bugler blowing "Taps" to the groundskeeper blowing leaves, these ministrations ensure that every monument sparkles, every tree majestically branches, every section stays green and groomed, and every burial proceeds with reverence and dignity. For Arlington is a tableau that intrinsically commands the full respect not only of those who visit it, but also of those who nurture and maintain it, as well as of those who duly perform the ceremonies that take place throughout the day. Whether you consider the farrier who shoes the caisson horses or the leatherworker who fashions their reins, the quarrier who grinds the marble headstones or the pressure washer who blasts them clean, the members of the cemetery's supporting cast acquit themselves with profound pride. They never intrude, never waver in their commitment. They imbue the place with nobility, holding as their ideal the fallen men and women who so valorously executed their duties—and who were so regally marched to their graves. There, for eternity, they will rest in honored glory beneath an impeccably and lovingly maintained landscape.

Photographs by SELECT PHOTOGRAPHERS

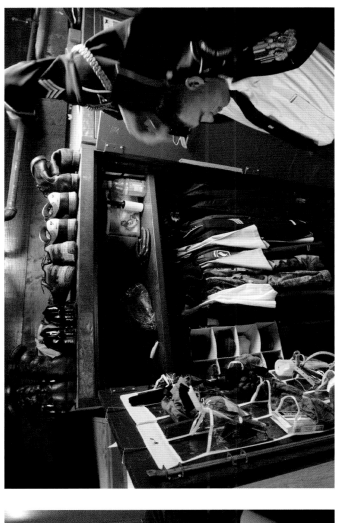

Responsible for all ceremonial displays in the cemetery, soldiers in the Old Guard maintain an impeccably perfect appearance. Brass gets polished, uniforms stay starched and pressed, and boots often take six hours to polish.

Every six weeks, the 3rd Infantry's master farrier (left) reshoes the caisson horses, often adding borium studs for traction. Always matching in color, the horses are led to the procession by a handler (opposite).

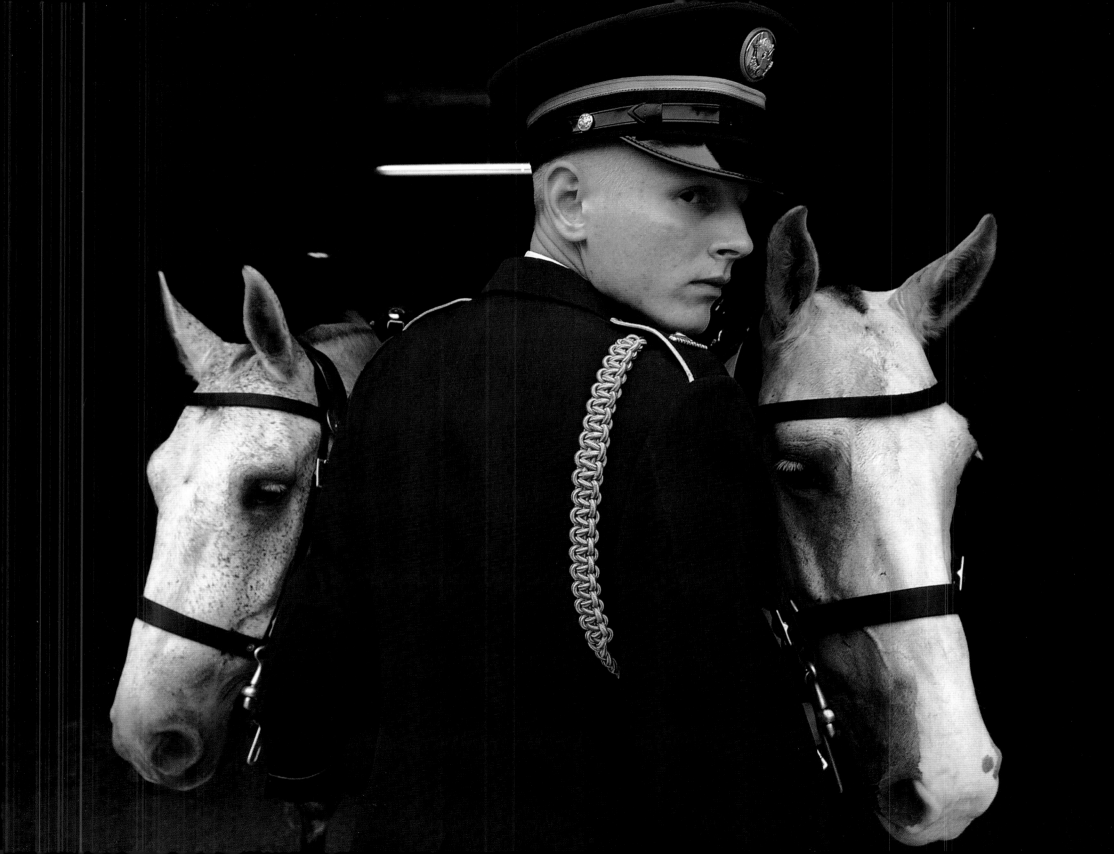

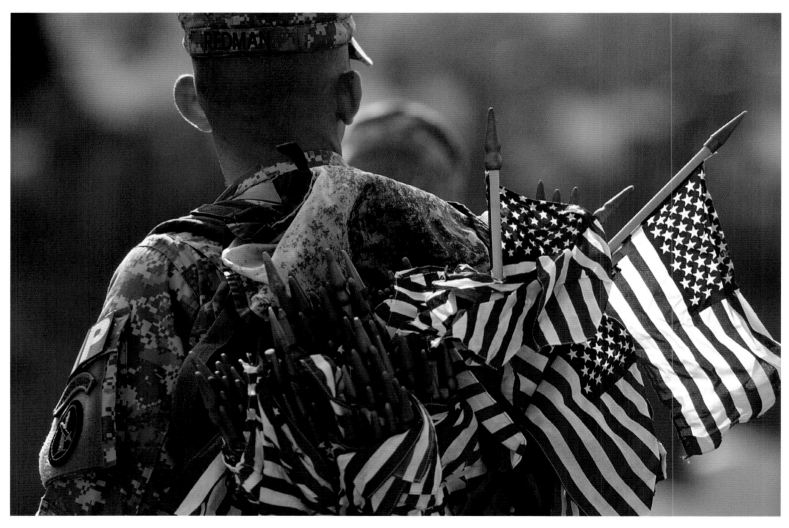

Pvt. 1st Class Kevin Redman (above) of the Army's 289th Military Police Company distributes
miniature flags during the annual flags-in ceremony on the Thursday before Memorial Day.
Until 2010, all services, including the Marines (opposite), participated in the flags-in ceremony.
Now, only the U.S. Army conducts the flags-in and flags-out ceremonies.

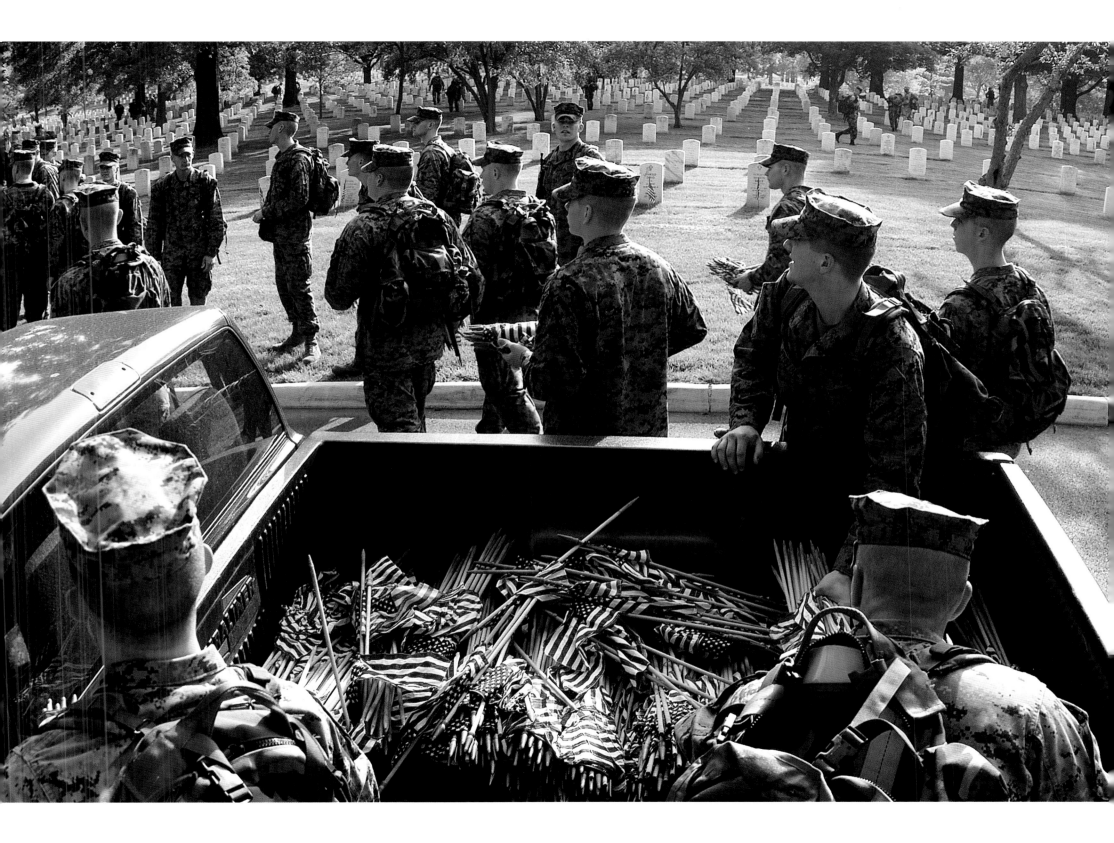

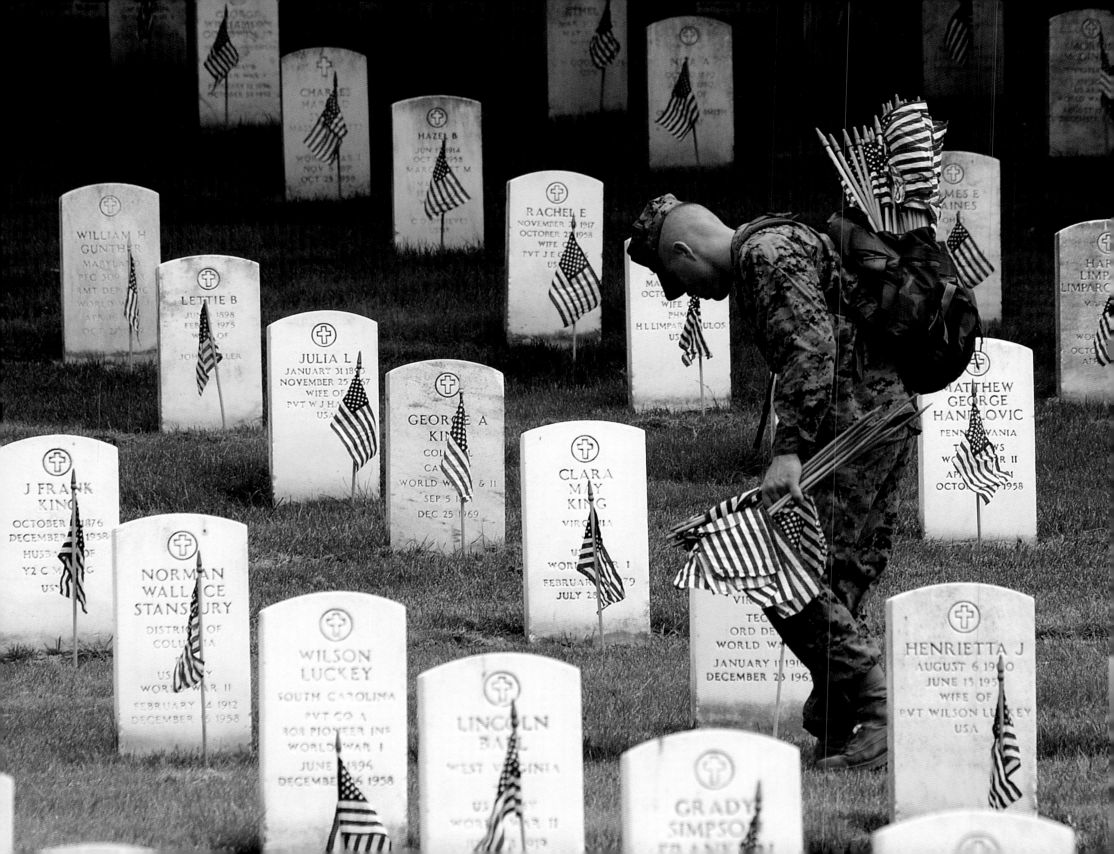

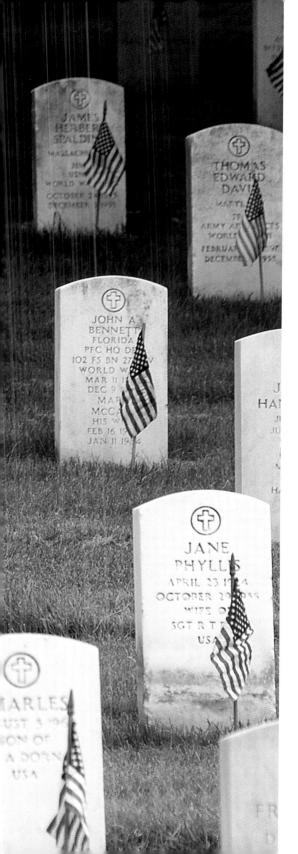

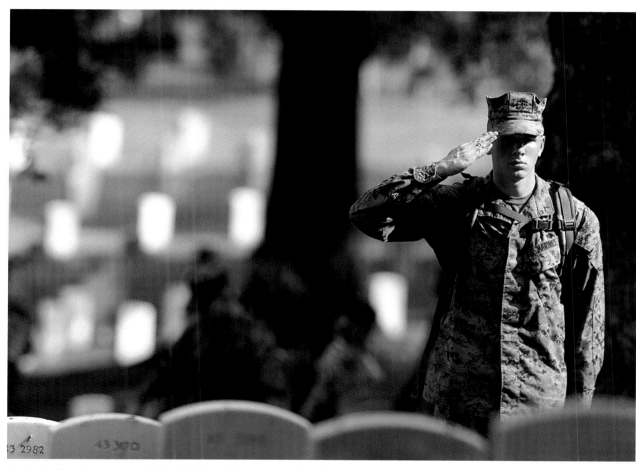

During the flags-in ceremony, a Marine (left) plants flags exactly one foot from the center of each grave marker. Here a Marine (above) finishes the task with a salute.

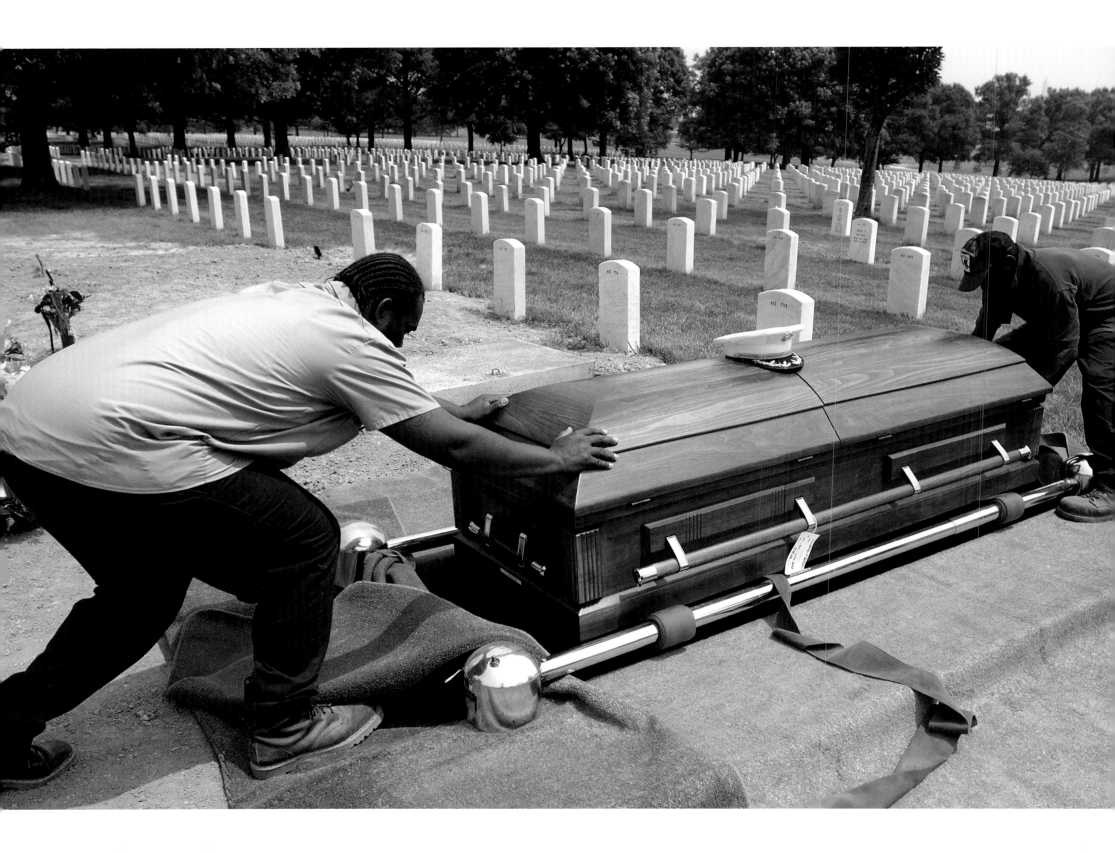

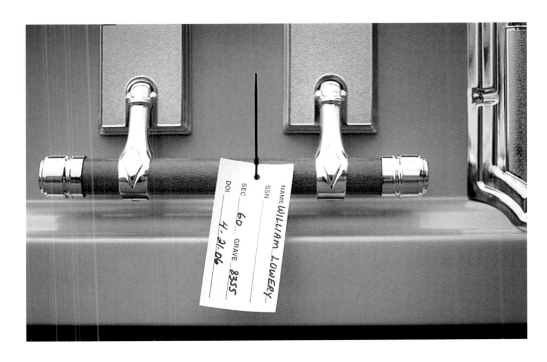

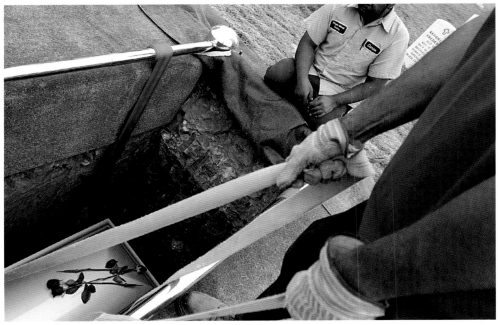

With precision and physical strength, workers position and lower caskets dozens of times every day. The remains of Staff Sgt. William Lowery, middle, identified after being missing in action for almost six decades, await interment.

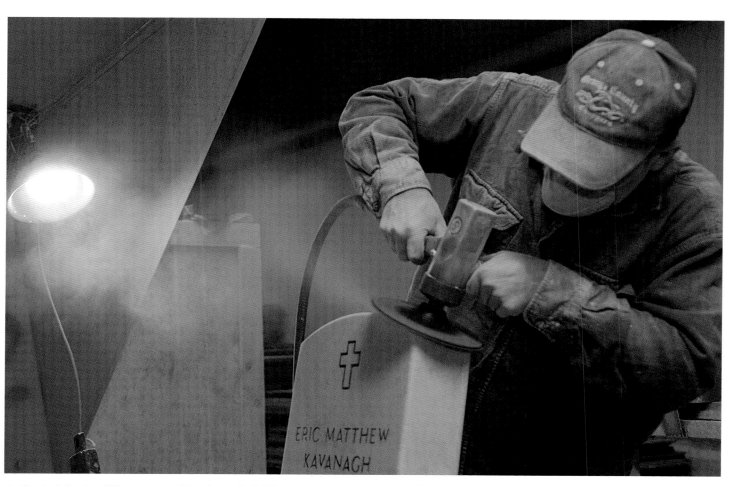

At Granite Industries of Vermont, some 550 miles north of Arlington, workers Gary Williams and Mark Beaudet (left) move a massive slab of Danby marble, from which grave markers will emerge. Robert McCallum, a combat engineer with the Vermont National Guard who just recently returned from a tour in Iraq, grinds down the grave marker of Pvt. 2 Eric Kavanagh, who was killed in action there September 20, 2006.

Using a level, a string, and the sharp eye of his brother Israel, Alejandro Simaj DeLaCruz repositions a tilting headstone.

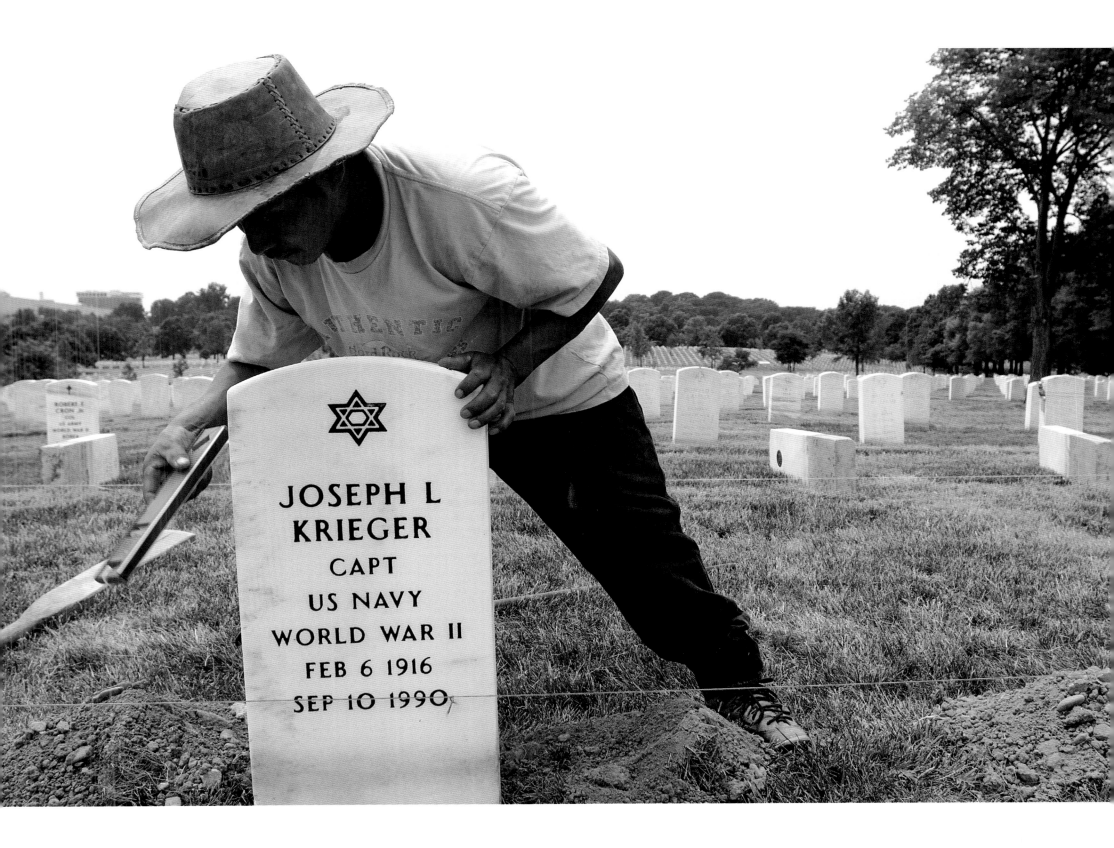

JOSEPH L
KRIEGER
CAPT
US NAVY
WORLD WAR II
FEB 6 1916
SEP 10 1990

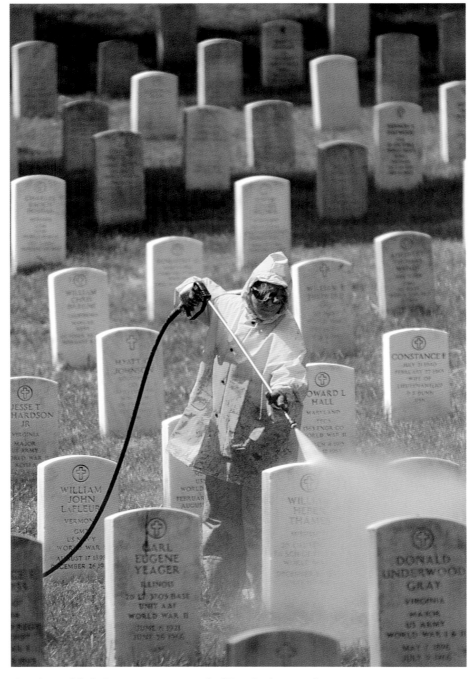

A worker carefully bathes every monument to the fallen. On dawn patrol,
Kevin Thomas (right) cleans the tops of headstones in preparation for a funeral.

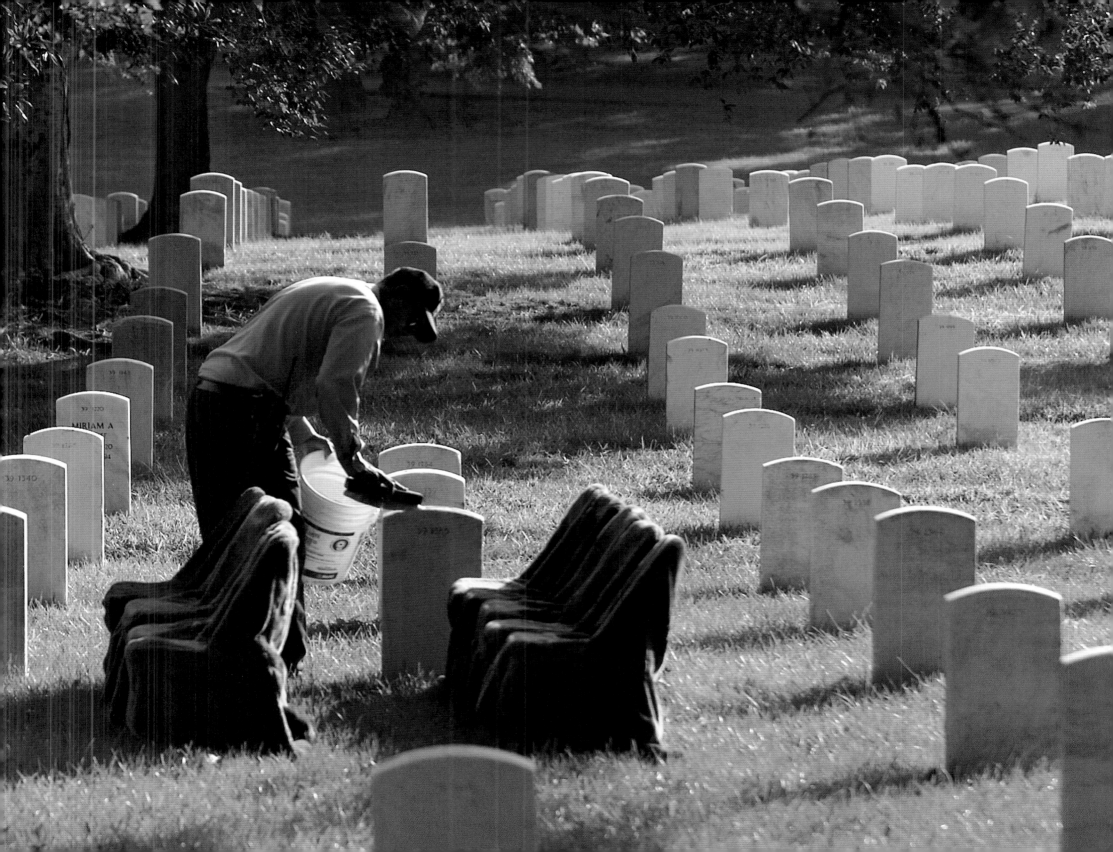

In their martial pomp and lockstep precision, Arlington's memorial observances inspire pride, reverence, and unity; they bond the living and the dead, the soldier and the civilian. Taking place in the air and on the ground, they are **SALUTES**

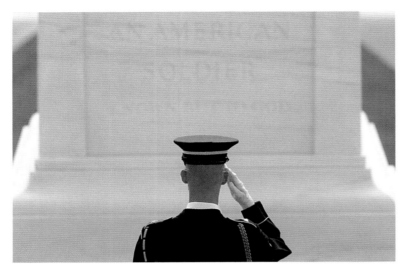

The Sergeant of the Guard salutes the Tomb of the Unknown Soldier.

EVER SINCE MAY 30, 1868, when the dedication of the original cemetery took place on what would become known as Memorial Day, Arlington National Cemetery has served as the most visible and appropriate setting for the nation to honor those who died in its defense. By the eve of World War I, the popularity of military ceremonies helped occasion the construction of the much larger Memorial Amphitheater—a commanding marble structure, modeled on ancient Greek and Roman edifices, that opened in 1920, five years after President Woodrow Wilson laid the cornerstone and shortly before the establishment of Armistice Day (Veterans Day). Today, numerous military societies assemble amid the columns for annual memorial events. More than 5,000 patriots arrive every Easter, Memorial Day, and Veterans Day. They come to pay tribute to heroes, both known and unknown, and to bear witness to the spectacle that accompanies official observance: the presentation of colors, the presidential laying of the wreath, the planting of flags, the firing of guns, the roar of cannons, the ruffle of drums and flourish of trumpets. Jet fighters streak directly above, while soldiers, sailors, airmen, and Marines all stand at attention. As the following photographs suggest, these salutes transcend pomp. They kindle something within us that is bigger than we are—the pride in being part of a nation.

Photographs by SELECT PHOTOGRAPHERS

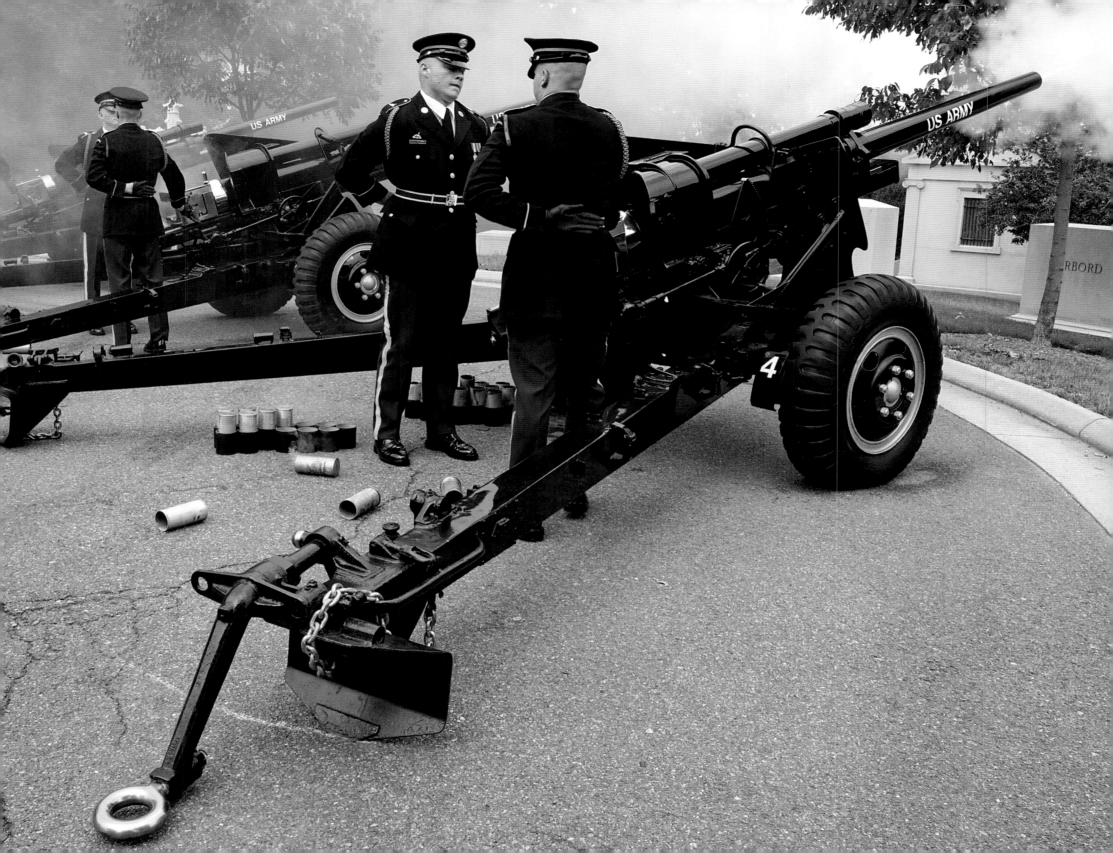

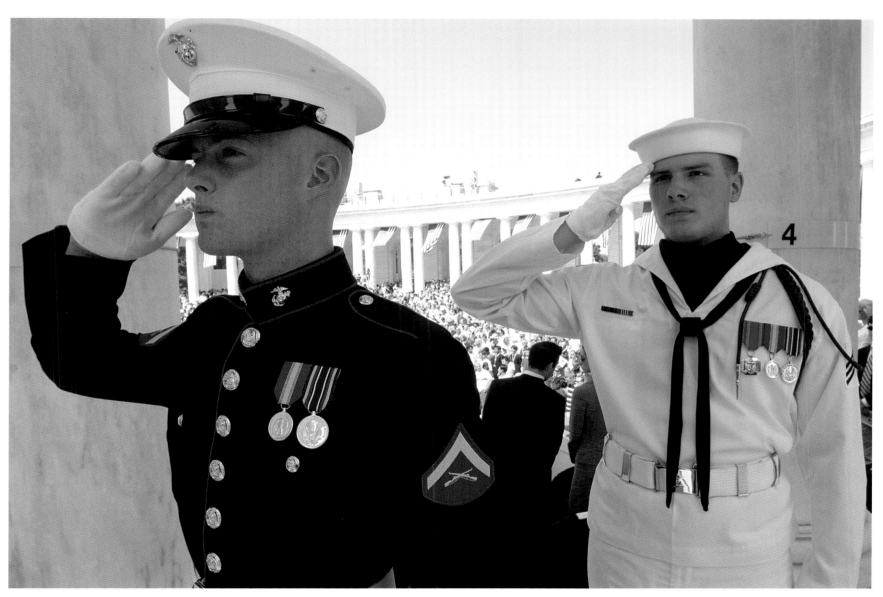

Among the Memorial Day observances, members of the Old Guard, the Army's official ceremonial unit, fire a cannon salute (opposite). Armed forces representatives such as Marine Stephen J. Jones and Navy Seaman Adam Daly (above) render honors during the playing of "Taps" at the Memorial Amphitheater.

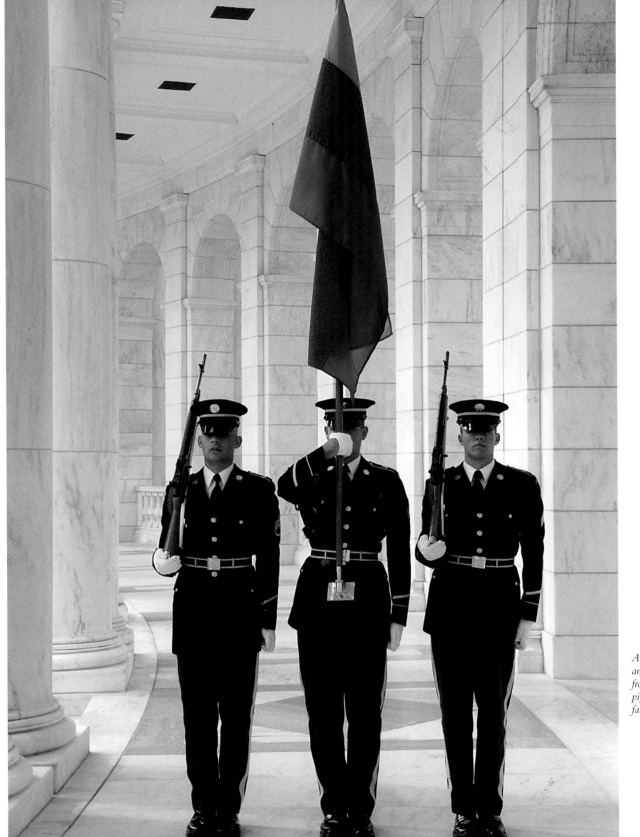

An Army Color Guard stands at attention in the amphitheater's portico. Tuscarora Chief Johnny Rocca, from nearby Leesburg, Virginia, raises a ceremonial pipe (opposite) in honor of the Creator and his friend, fallen Navy Capt. Russell Harry Mitchell, M.D.

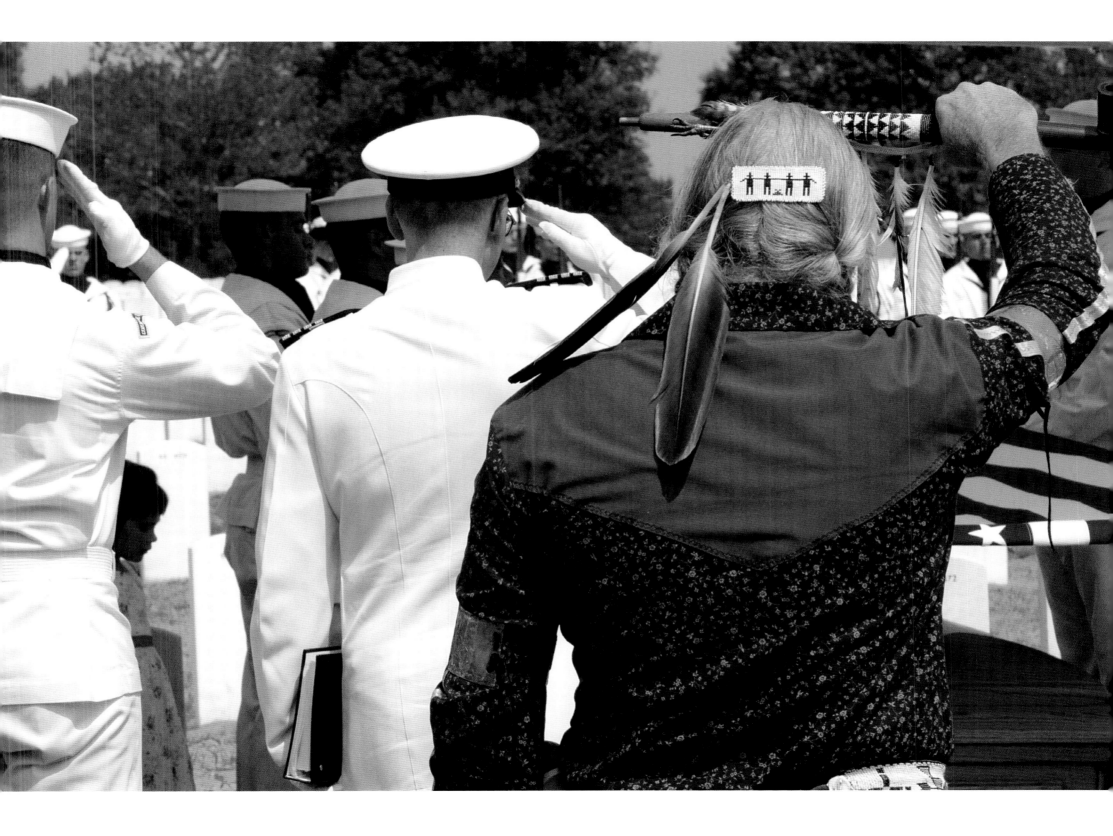

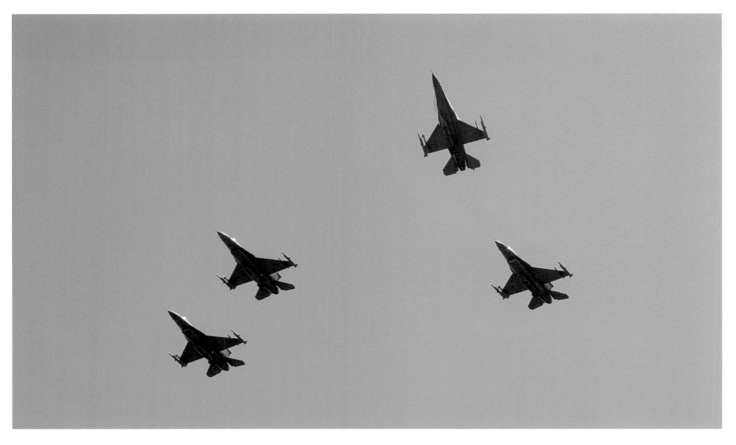

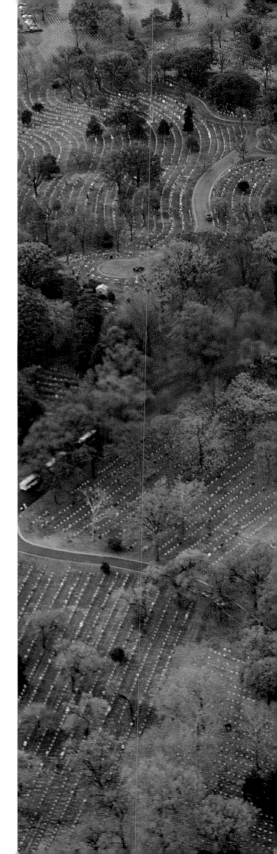

As one plane pulls straight up and away from the others, the "missing man formation"—seen here from below and from above—ranks as the Air Force's most impressive aerial display.

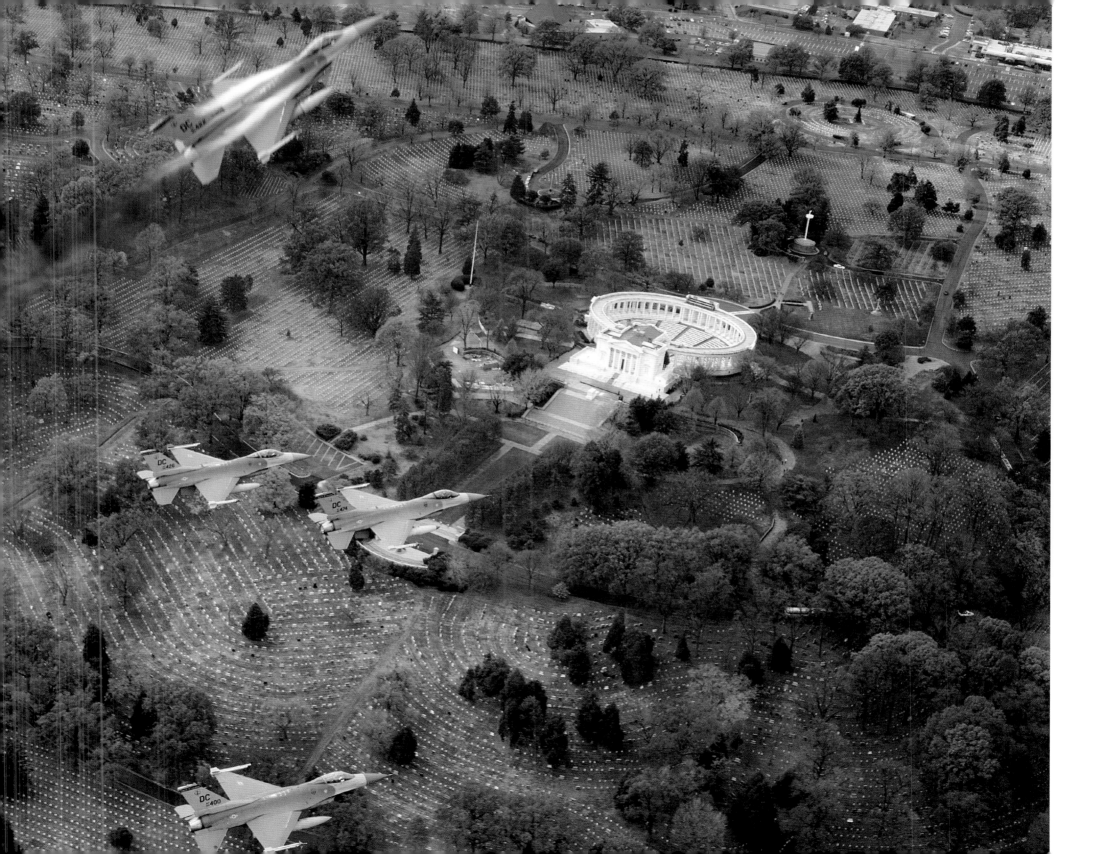

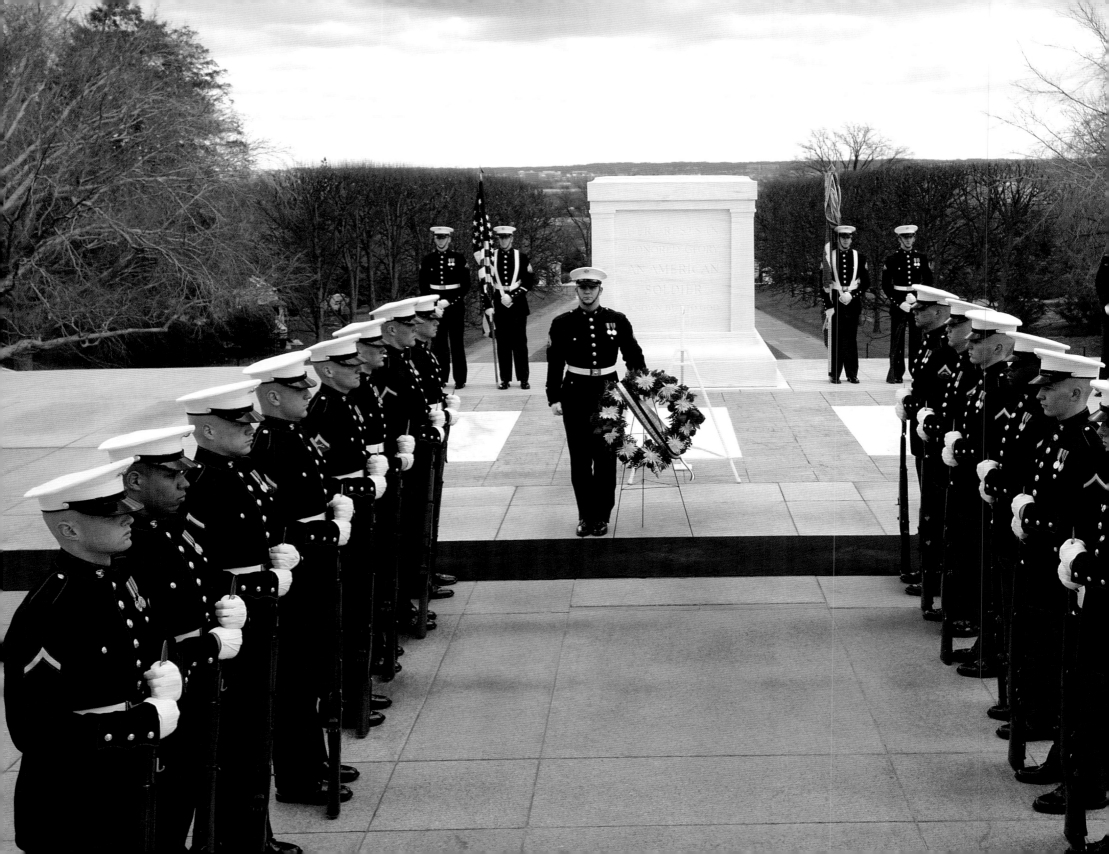

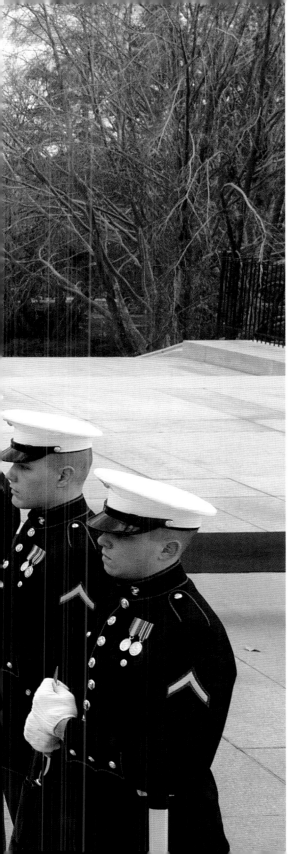

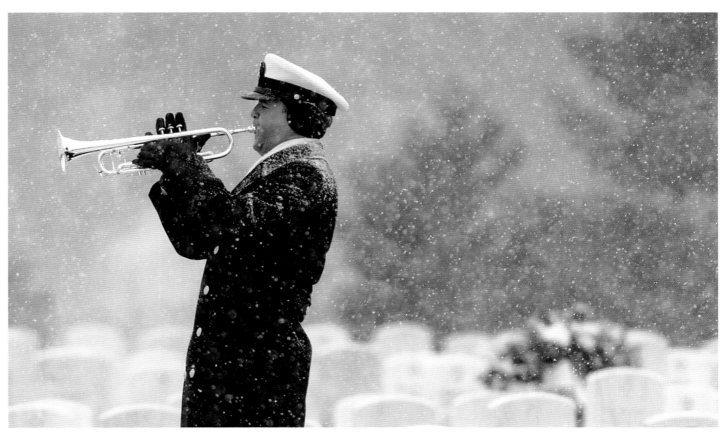

Marines (left) prepare for a wreath-laying ceremony at the Tomb of the Unknown Soldier.
Musician 1 Timothy Stanley (above) plays "Taps" for a Navy funeral.

Memorial Day is Arlington's annual moment in the national spotlight, when mourners and veterans by the thousands convene at the Memorial Amphitheater to pay respects to their fallen comrades and to witness the **CEREMONY**

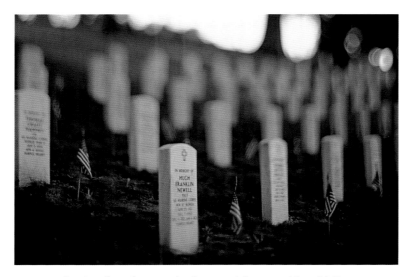

American flags adorn every headstone at Arlington on Memorial Day.

VISITING ARLINGTON, LIKE visiting the White House, never fails to strike a deep emotional chord. Attendance at the annual Memorial Day observance resonates with particular profundity. The holiday began here in 1868, when Gen. John A. Logan, commander of the Grand Army of the Republic, dedicated the 30th of May "for the purpose of strewing with flowers or otherwise decorating the graves. . . . of our heroic dead, who made their breasts a barricade between our country and its foes." The flowers have since been replaced by small American flags placed in front of each of Arlington's more than 260,000 grave markers by soldiers of the 3rd U.S. Infantry, who patrol 24 hours a day during the weekend to ensure that each flag remains standing. Members of every military branch participate in the solemn pageantry and colors presentations. The president places a wreath at the Tomb of the Unknown Soldier before addressing the assemblage. The military band plays. Color guards present. And wave upon wave of tourists silently marvel at the precisely orchestrated changing of the Tomb's sentinels. As chronicled during a recent Memorial Day, even on the hottest, brightest spring morning, these rituals of remembrance fill Arlington with a somber, crepuscular air, one of reverence and respect.

Photographic Essay by DAVID BURNETT AND SELECT PHOTOGRAPHERS

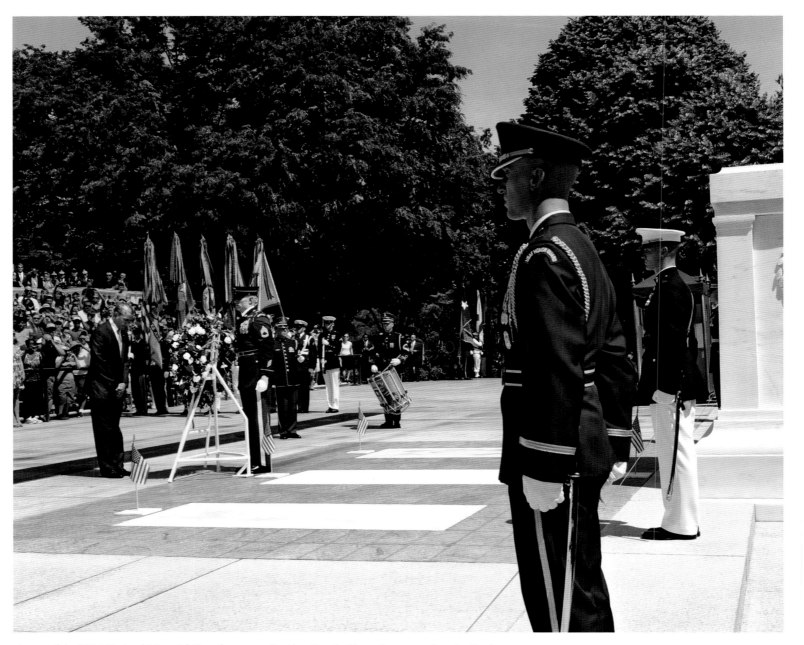

As part of the 2014 National Memorial Day observances, President Barack Obama lays a wreath at the Tomb of the Unknown Soldier at Arlington National Cemetery. The ceremony honors all those who have served in the nation's military. Ceremonial units from all military branches stand at attention around the marble sarcophagus (opposite).

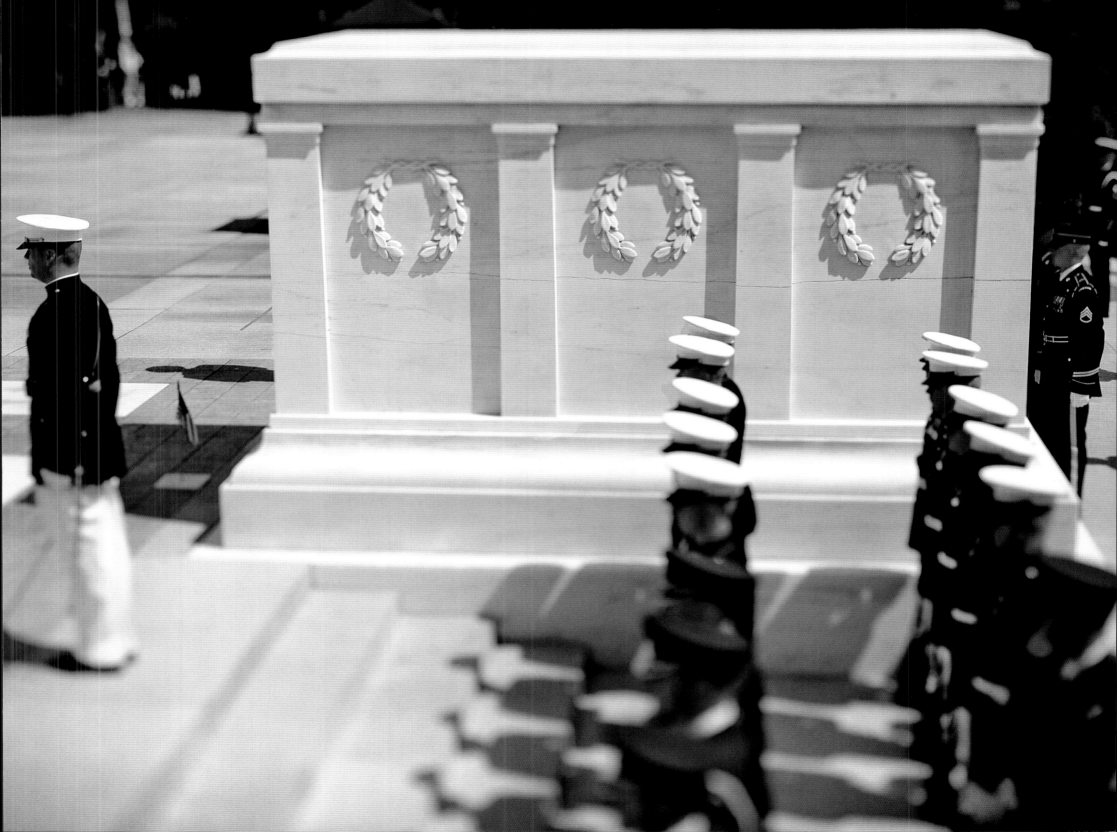

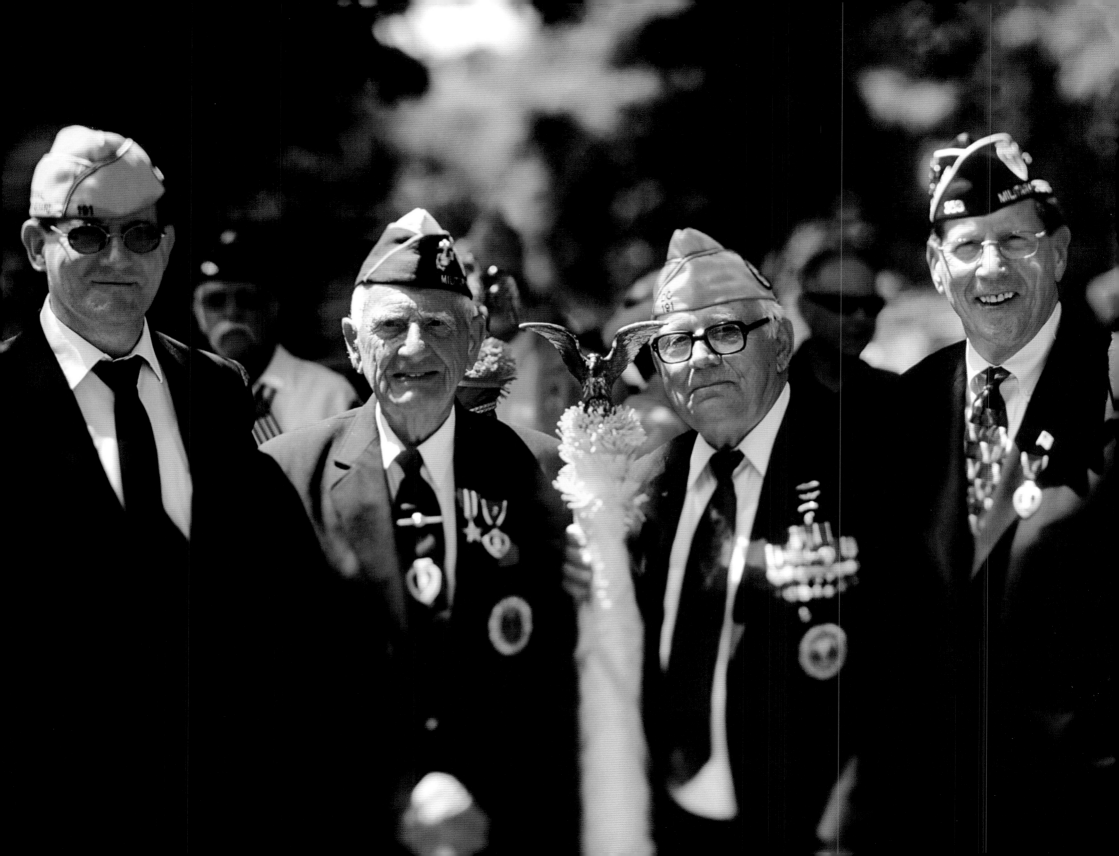

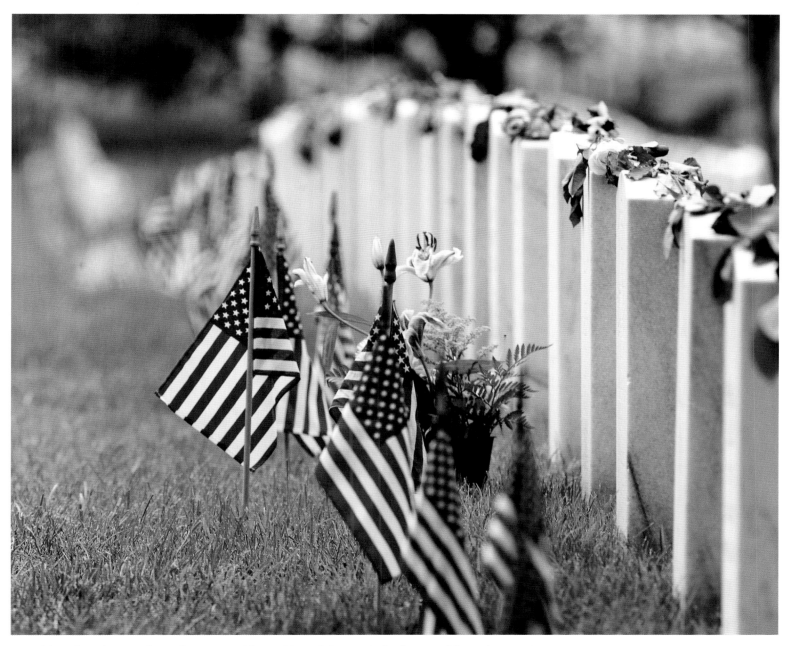

One of the traditional Memorial Day observances at Arlington National Cemetery is the placement of flags and roses to decorate graves. These are in Section 60, where members of the military who served in Iraq and Afghanistan are buried (above). Purple-capped Ed Schnug and John Weis, color bearers from the Military Order of the Purple Heart, stand alongside color bearers (opposite) from another veteran's service organization on Memorial Day in 2006.

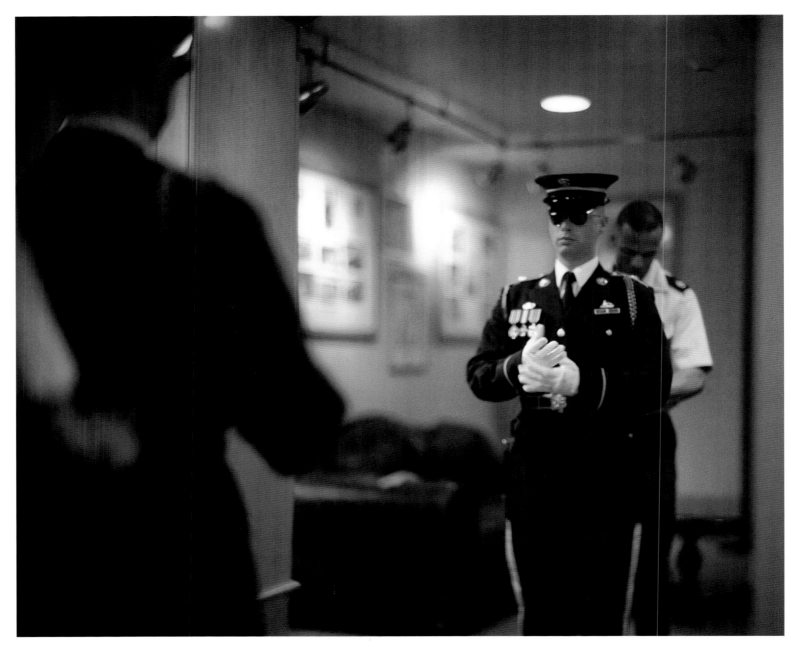

In the quarters beneath the memorial amphitheater known as the "Catacombs," one Tomb Sentinel assists another in the meticulous, hours-long preparation of his uniform before he "walks the mat" in front of the Tomb. On Memorial Day, like every day between April and October, guards change in front of the Tomb (opposite) every half hour on the half hour in a precise ritual.

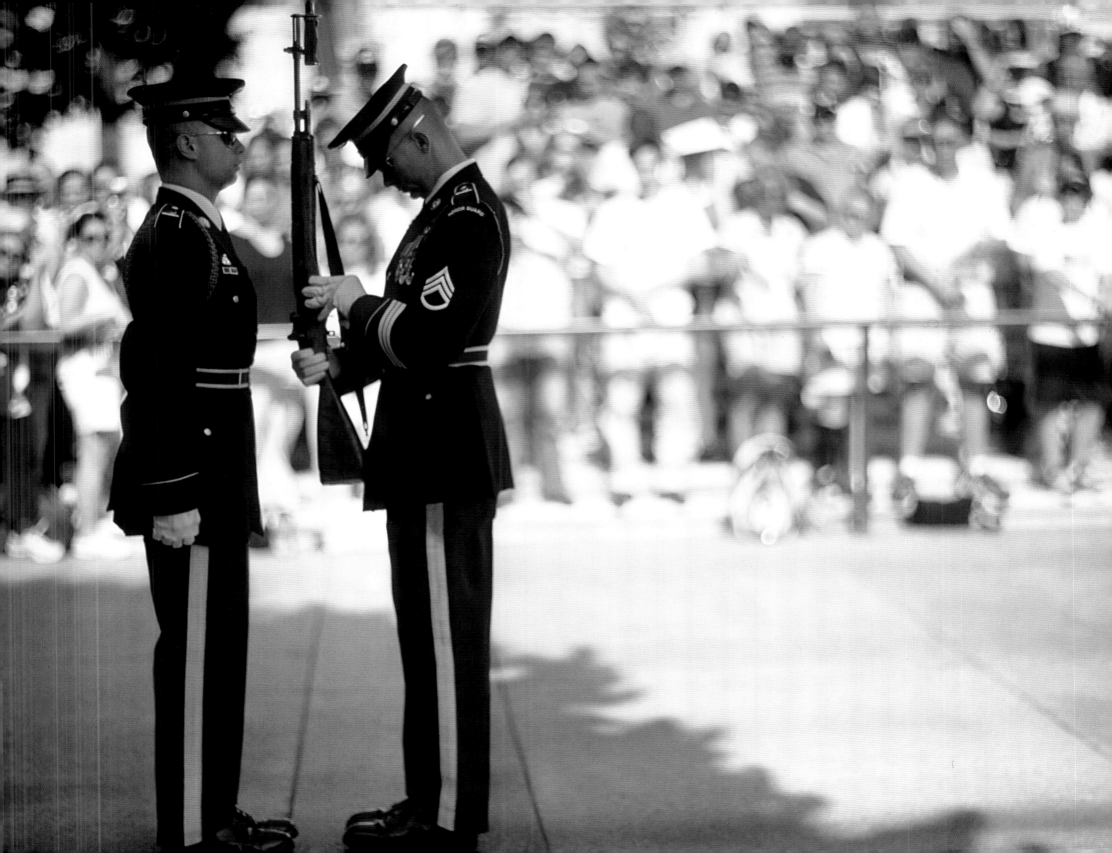

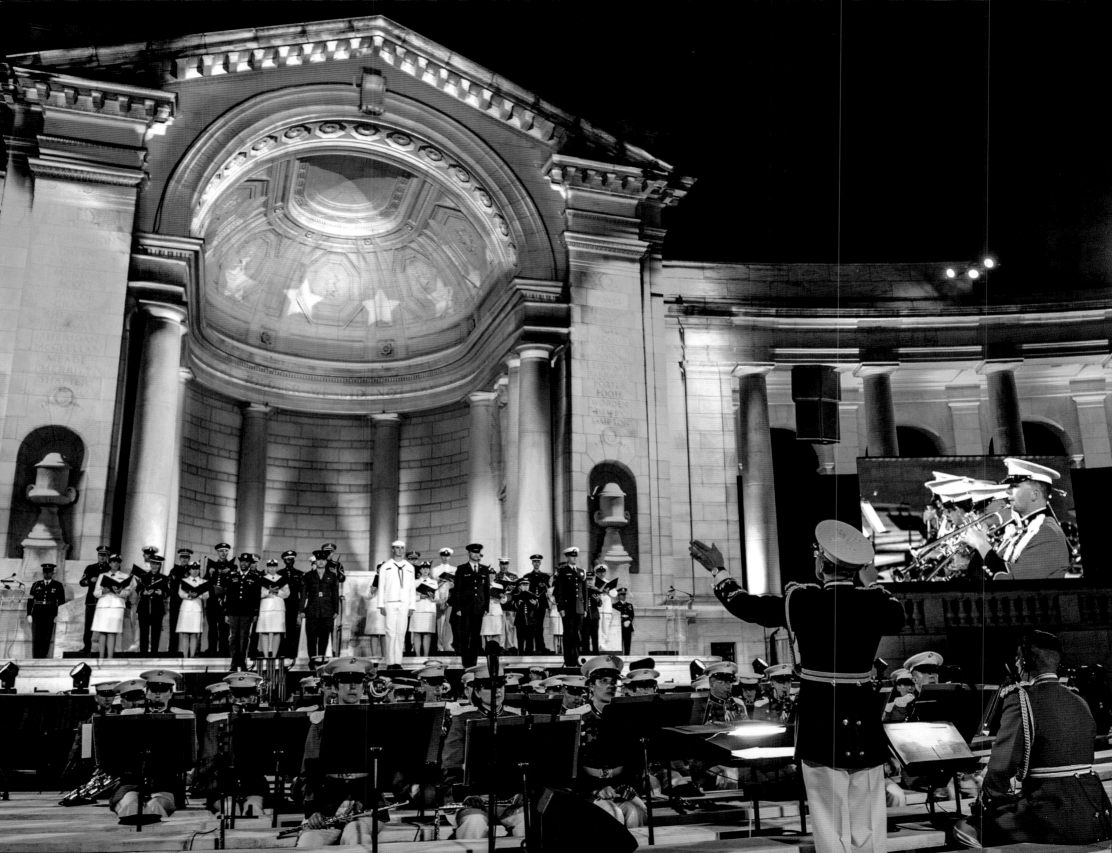

Stones, flowers, and other symbols of remembrance grace the grave of Army Sgt. Michael J. Bordelon (above), a Louisianan who was killed in action, May 2005. A colored light display (opposite) highlights an evening musical tribute at the Arlington National Cemetery memorial amphitheater on June 15, 2014. This was the culmination of the events marking the 150th anniversary of the cemetery. The staged presentations featured the history of the cemetery, military service songs, the changing of the Honor Guard at the Tomb of the Unknown Soldier, and a wreath ceremony. The amphitheater was renamed the James Tanner Amphitheater as a part of the cemetery's commemorations. James R. Tanner was a Union soldier who lost both legs at the Second Battle of Bull Run but survived to become a leading advocate for veterans' rights after the war.

Bound by a sense of duty and a willingness to fight for timeless ideals, the soldiers buried here never really die; nor do they just fade away. They endure, thanks to the presence of the countless veterans who pay homage to the SACRIFICE

The elite Laotian Airborne Division, who fought alongside U.S. troops against the Vietcong

BENEATH ARLINGTON'S FINELY manicured greenswards lie the remains of men and women of every stripe: colonels and corporals, rich and poor, black and white. In death they know no rank, and throughout the year, and most conspicuously on Memorial Day, veterans of battles fought in Europe, Asia, Africa, and the Middle East arrive to pay homage to their fallen comrades. They come wearing garrison caps and the vestments of their units, of the American Legion, Veterans of Foreign Wars, and numerous other veterans' societies. Witnesses to history, they consecrate those who perished in the shaping of it. To survive is to keep alive memories of the dead, their valor, fidelity, and sacrifice, and the noble ideals of freedom and liberty for which they died. Just as the fallen give silent witness to the price of those ideals, those veterans with whom they fought and the loved ones whose pictures they carried salute them as heroes who put service above self. Honoring their sacrifice is a ritual as old as the cemetery itself. The following photographs, taken during recent ceremonies, movingly portray what the poet Laurence Binyon so eloquently penned from the trenches during World War I: "They shall grow not old, as we that are left grow old / Age shall not weary them, nor the years condemn / At the going down of the sun and in the morning / We will remember them."

Photographs by SELECT PHOTOGRAPHERS

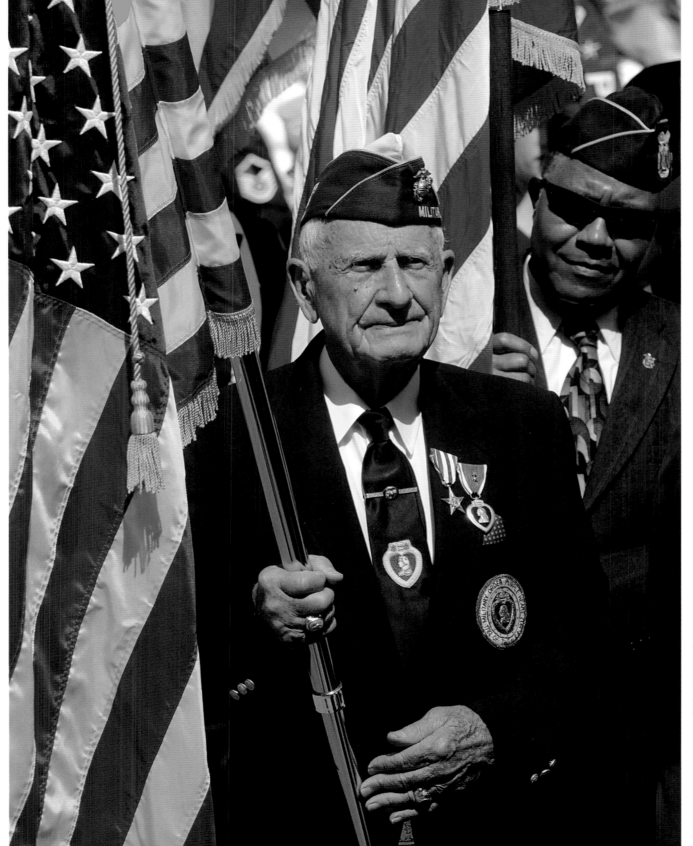

For World War II veterans like Purple Heart and Silver Star Medal recipient Ed Schnug, Memorial Day ceremonies carry heavy emotions. Those who represent the Veterans of Foreign Wars National Honor Guard (opposite) do so with a sense of pride and loss.

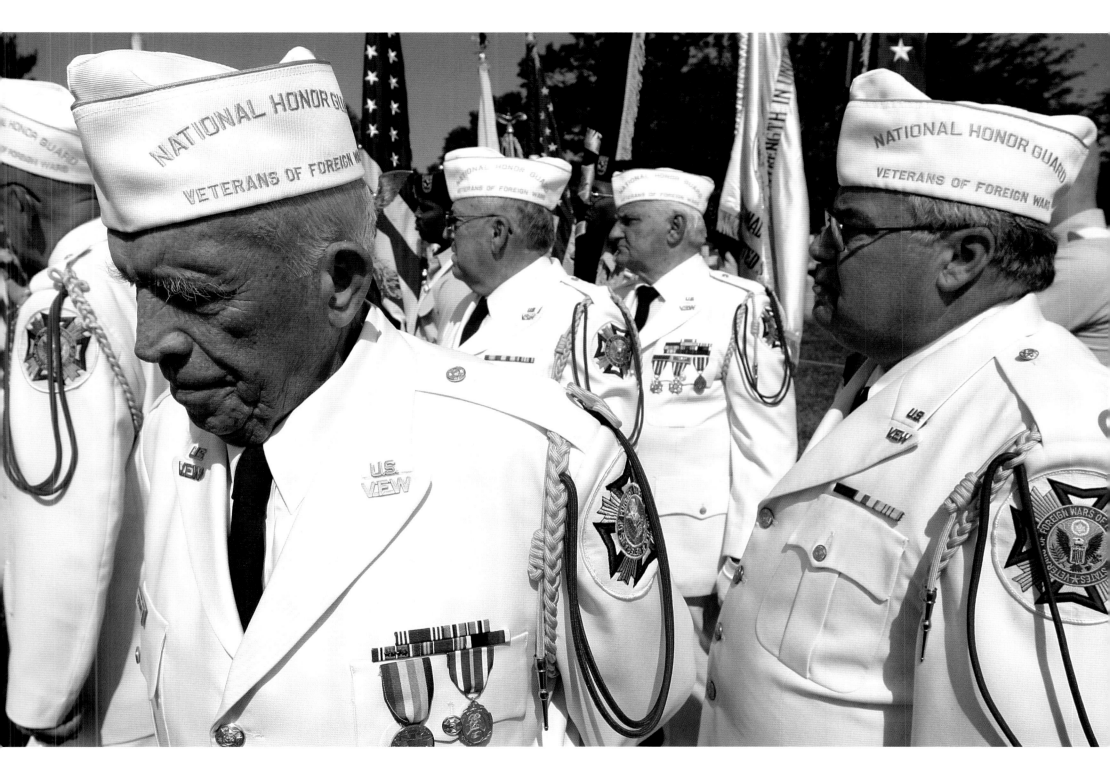

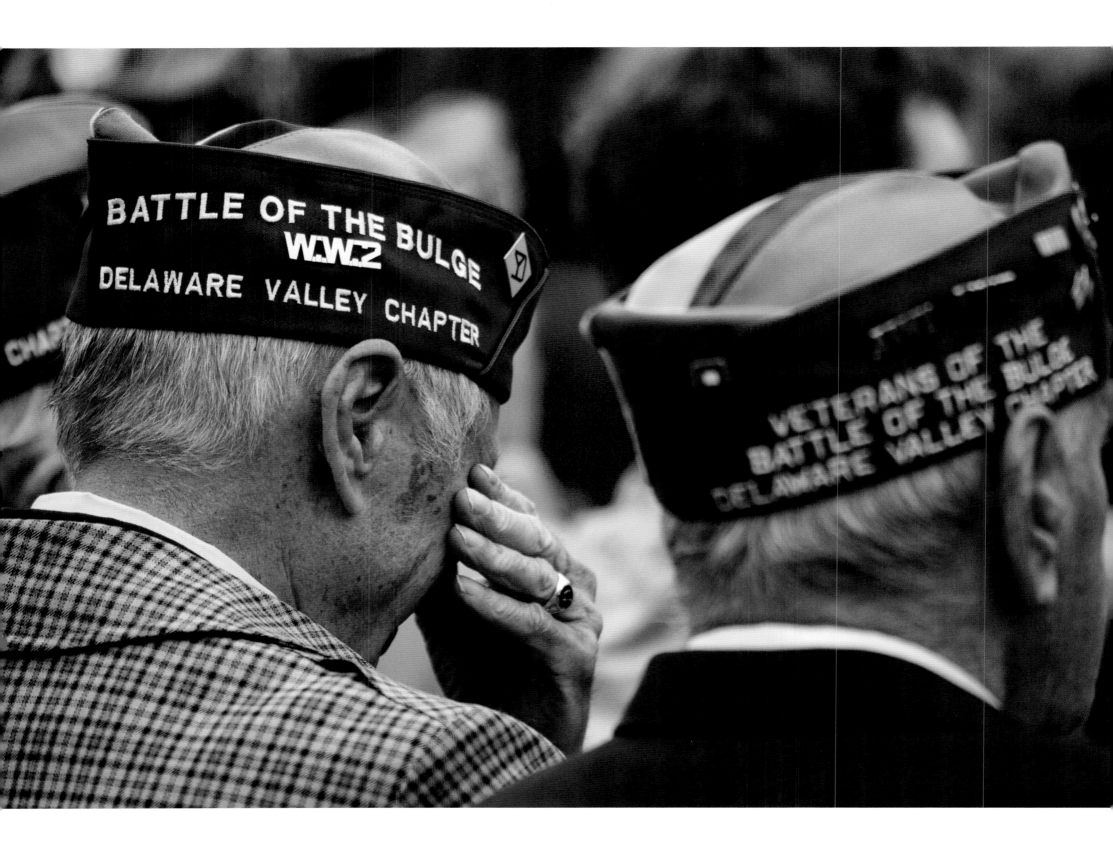

World War II veterans who turned back the Nazis weep openly during the dedication ceremony at Arlington's Battle of the Bulge monument. Virginian Greg Majesky (above) of the Disabled American Veterans Association, Chapter 10, carries the national colors into the Amphitheater during the 2005 Veterans Day ceremonies.

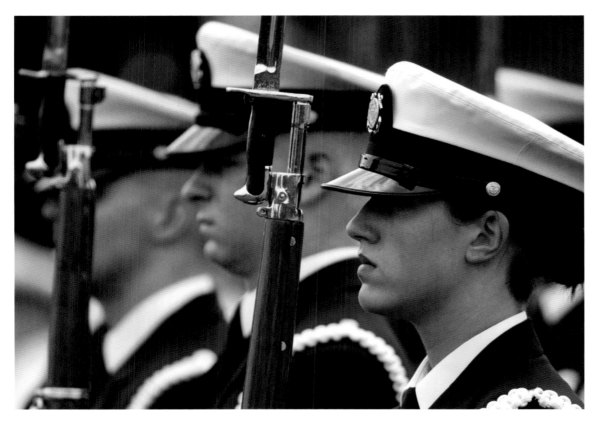

Bayonets at the ready, Seaman Cara Warner (above) and other members of the U.S. Coast Guard Firing Party line up in formation to perform a three-round salute. Alfred Vitali (opposite), an Army corporal during World War II, quietly reflects during the May 8, 2006, dedication of the Battle of the Bulge Memorial.

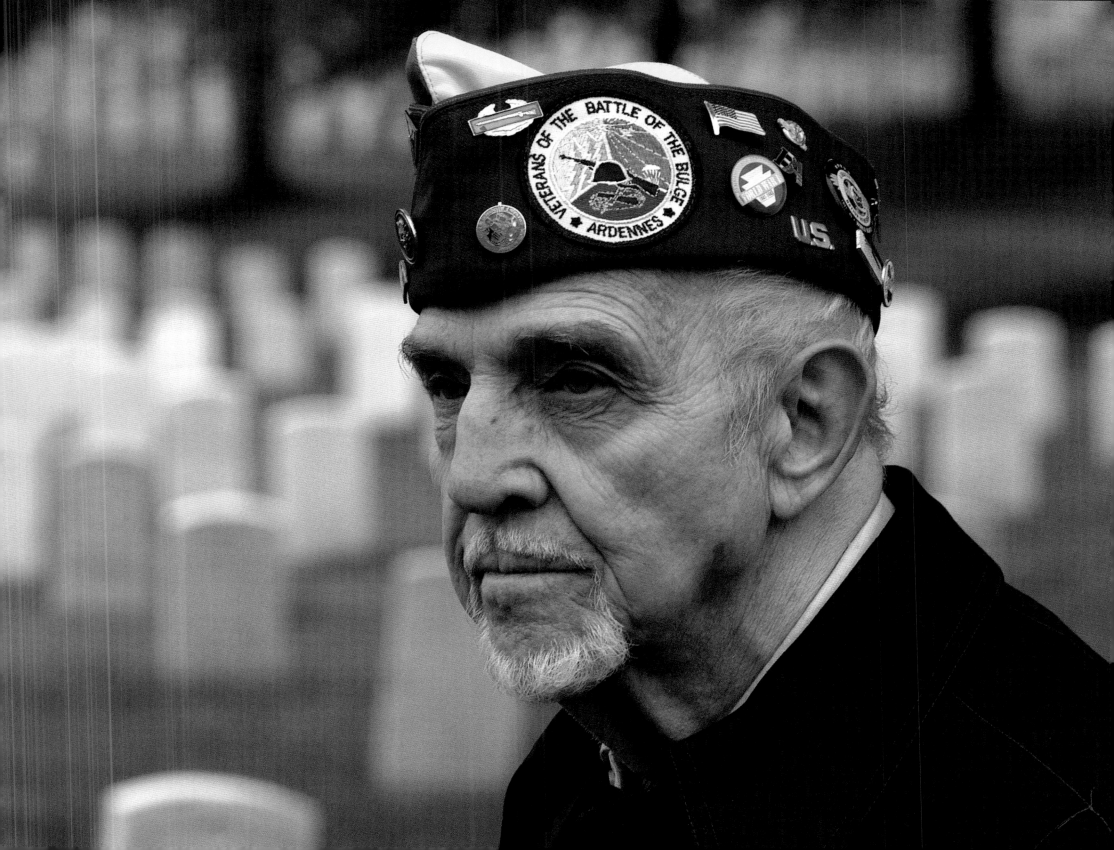

60

Hosp...

2 or...

36 mon

23 n3

9t

(Child) 1st Bat

Sergt 22 V-a

Corpl 4 Oneida

Prvt 6 Wils...

Thomas W Hawley 10

John Hawley

Fanley Rider

Leg of James E Beasly

Wm R Ward

1. Egbert Rathburn 17 14

2. J. G. Shepard 5

3. J. J. M. Salisbury 18

4. Geo F Curtis

5. Lyman E Bees...

6. F A Frire

8. John Dean

38th June 1864

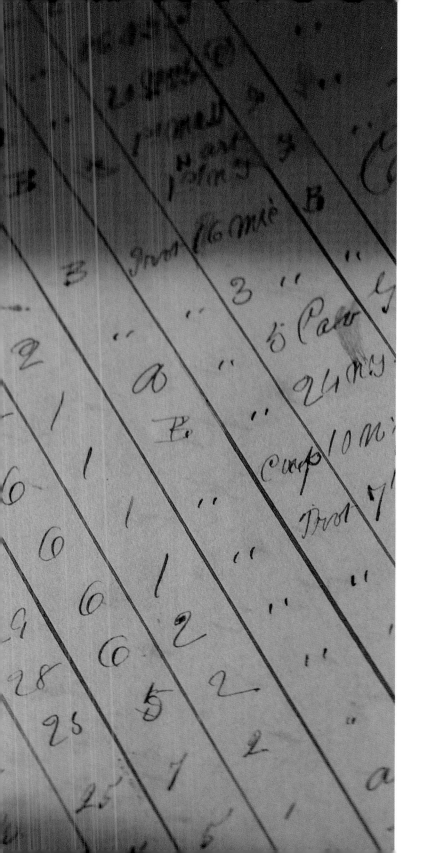

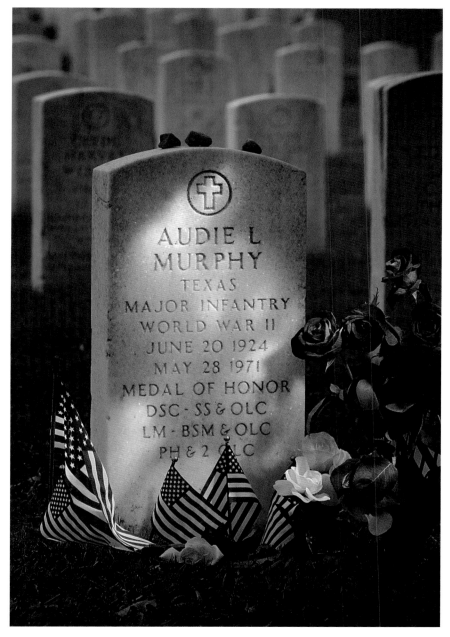

Dating from the Civil War, Arlington's original necrology serves as both artifact and atlas. The grave (above) of America's highly decorated World War II soldier, Audie Murphy, remains as bedecked in death as he was in life.

The Jewish tradition of placing stones atop a gravestone transcends faith at Arlington. Air Force Lt. Col. Robert D. Falkner's grave inscription (right) is one of the cemetery's most elaborate.

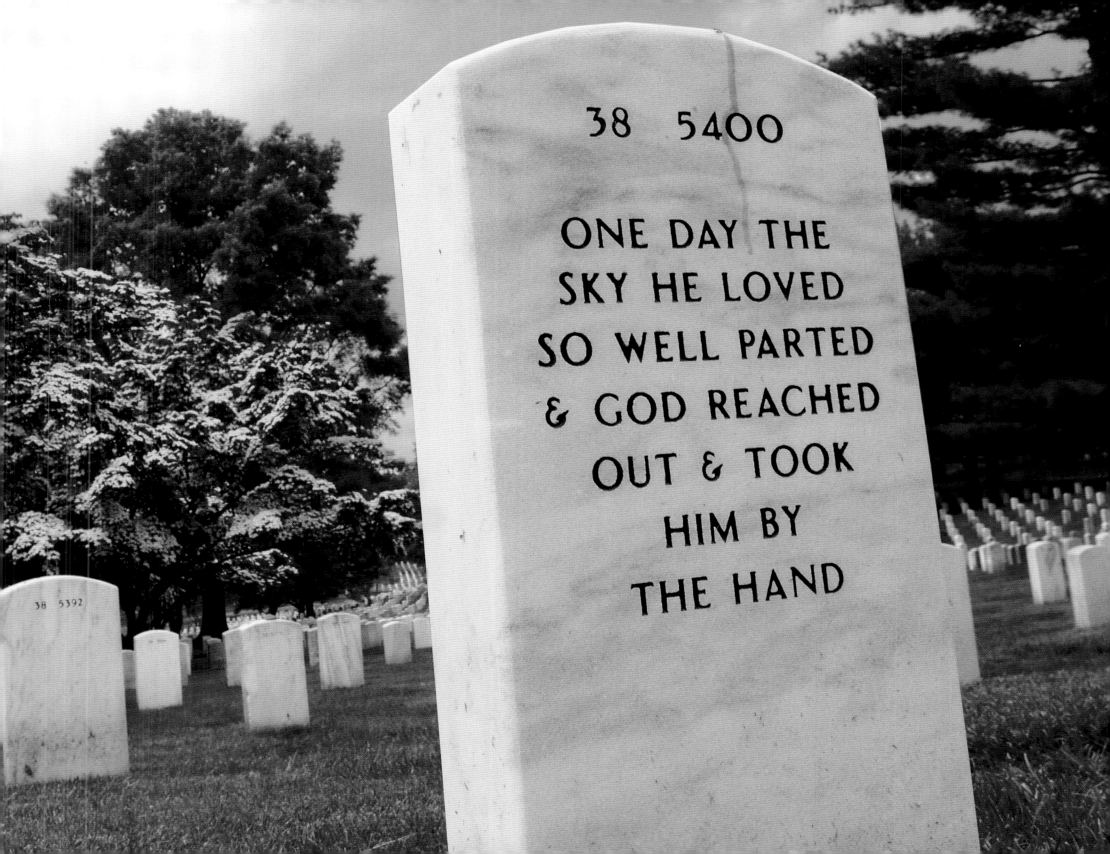

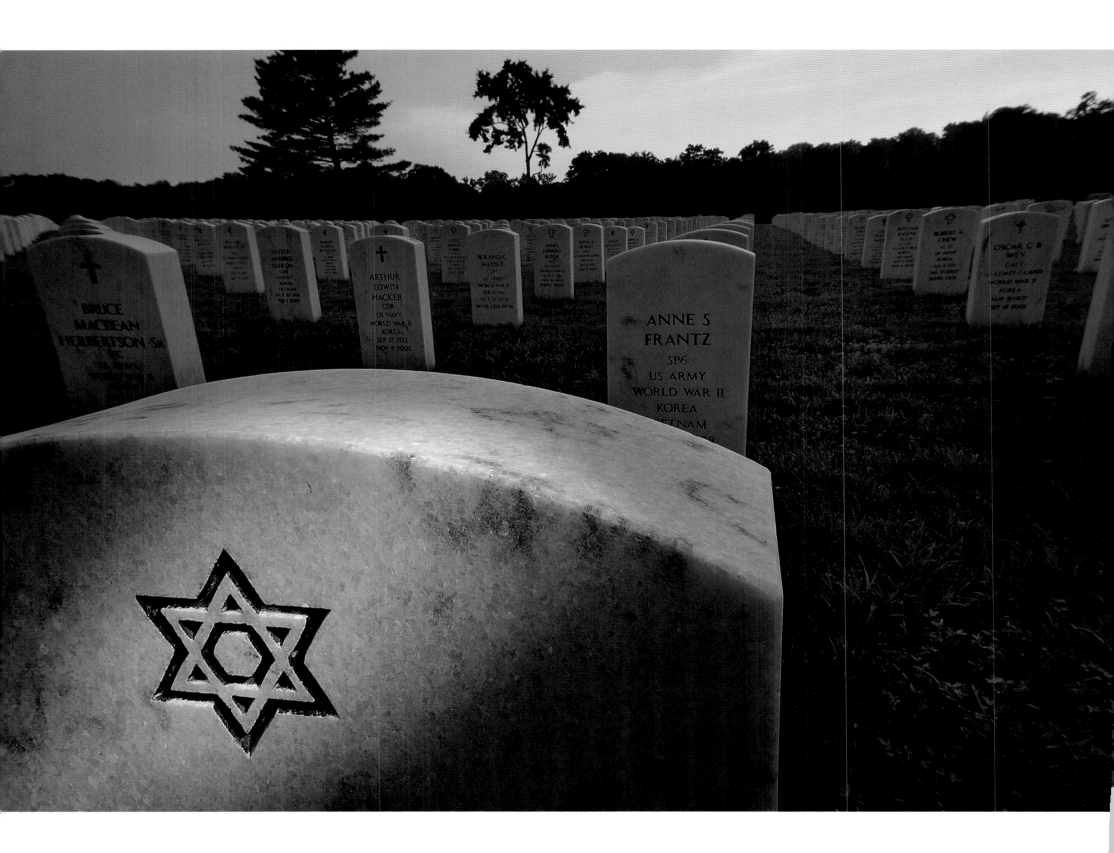

Followers of many different faiths have died under the same flag—and now lie beneath the same ground. Surviving loved ones leave intimate symbols of love and faith (above).

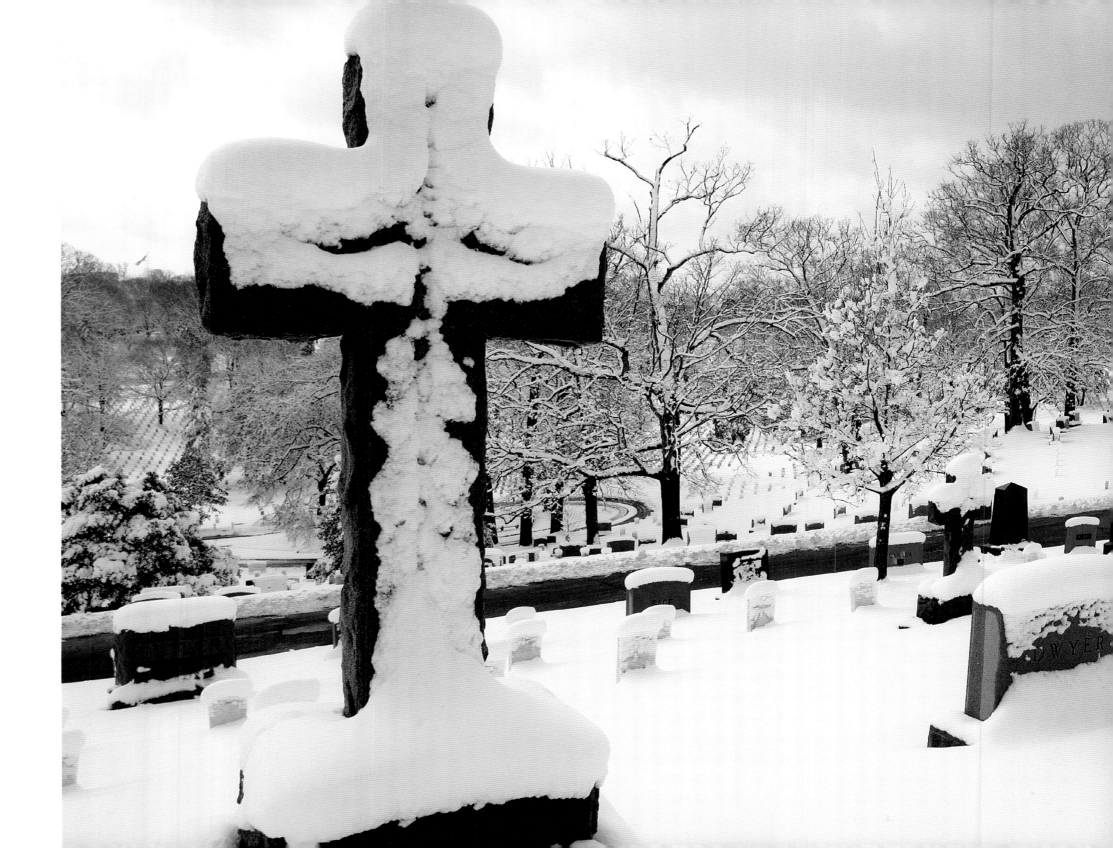

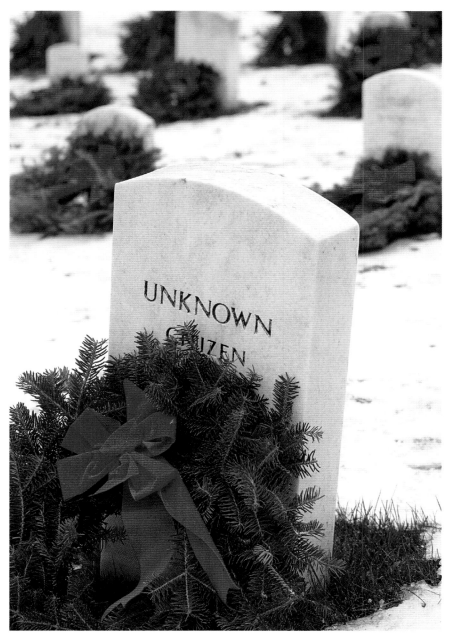

Winter brings to Section 27 both the shrouding of snow and the laying of thousands of wreaths donated by the nonprofit Wreaths Across America Foundation. Cloaked in whiteness, the grave of Civil War Brig. Gen. Jacob Kline (left) overlooks the ranks of headstones from Section E.

If you can gauge a nation's character by how it treats its war dead, then the Tomb of the Unknown Soldier and its sentinels embody the height of American pride and dignity. Perfection is the only acceptable standard for **TOMB GUARDS**

The arrangement of Tomb Guard accouterments follows precise organization.

FOR EVERY MINUTE of every day since July 2, 1937, a uniformed sentinel has marched an unvarying, gliding march in front of the Tomb of the Unknown Soldier, a 79-ton marble sarcophagus erected in 1921 to honor all American service members "Known But to God." Made up since 1948 of soldiers in Company E, 3rd U.S. Infantry (the Old Guard), tomb guards make up the second most exclusive military group in the U.S. Army. Only the Astronaut Badge has been awarded fewer times than the sterling silver Guard, Tomb of the Unknown Soldier Identification Badge, testifying to the rigorous testing criteria used to qualify—and retain—volunteers for the post. Occurring at regular intervals, the Changing of the Guard is an elaborate ceremony annually viewed by millions. But the spectacle they see—the white-gloved rifle inspection, 21-step march-and-turn, and recitation of orders—is only part of the world of the tomb guards. Belowground, in the catacomb-like tomb guard quarters, these dedicated sentinels spend untold hours polishing their brass and boots, pressing their shirts, removing lint and singeing stray threads from their uniforms, and oiling their weapons. Photographed during the chill of early winter, even in "unguarded" moments, the eternal vigilance of these soldiers shines through.

Photographic Essay by DAVID ALAN HARVEY

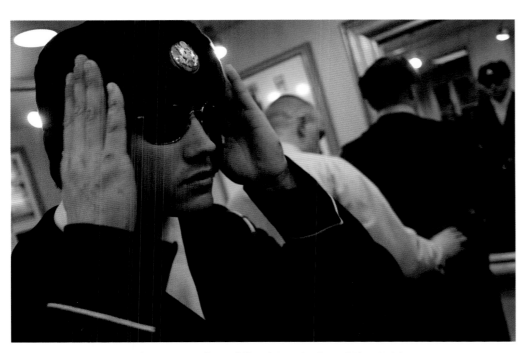

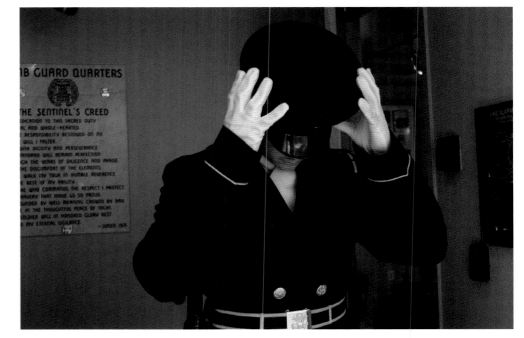

No matter the weather, Specialist James Henderson (left) and Specialist Justin Bickett (right) meticulously align their caps and every other item on their uniforms. Before donning a wool overcoat, Staff Sgt. Steve Kuehn (opposite) puts on a white scarf, secured at the chest to prevent movement.

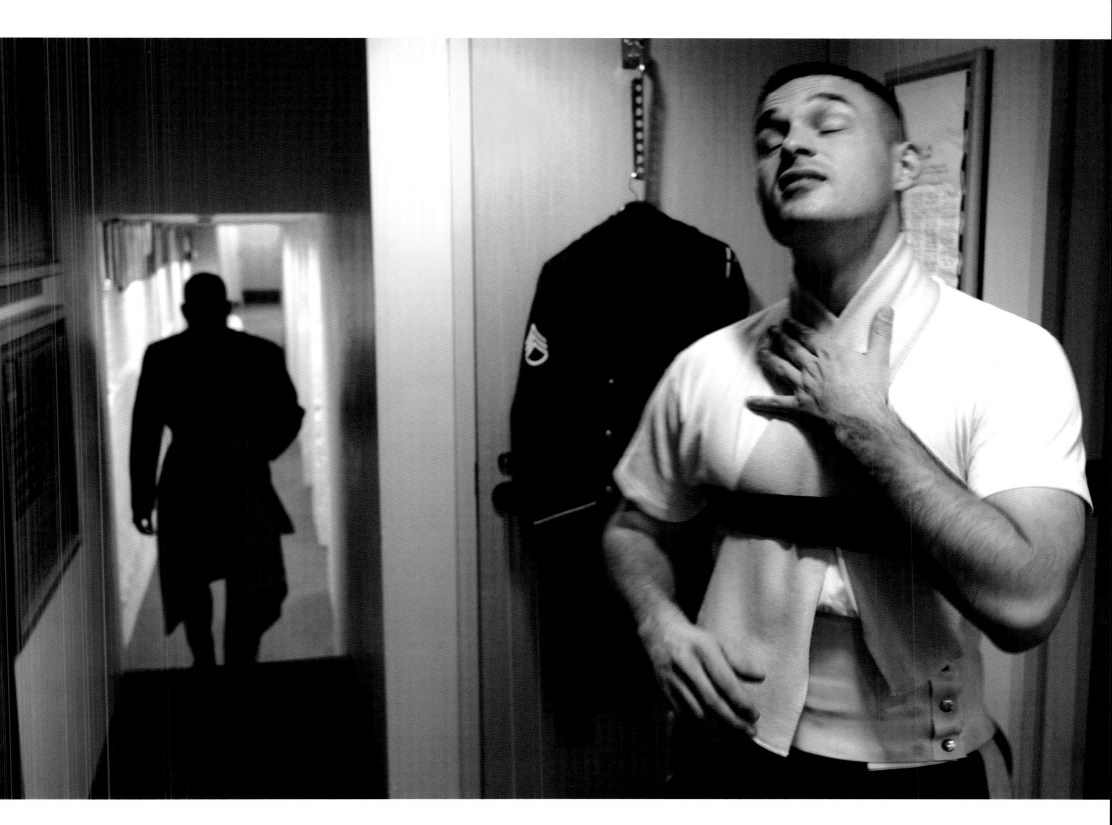

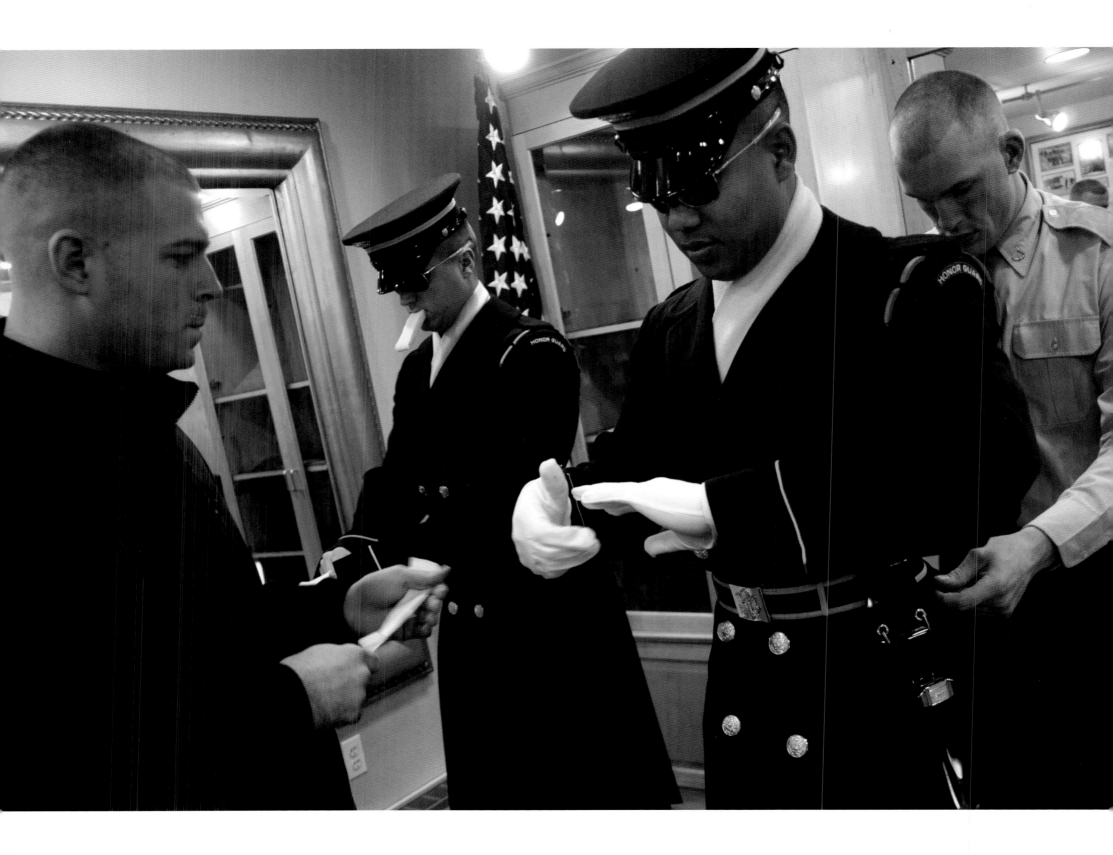

Tomb guards (opposite), such as Specialist Matt Perovich, Specialist Justin Bickett, Specialist Bruce Bryant, and Pvt. 1st Class Kyle Obrosky, never dress alone and wear moistened gloves for a better grip on their M14 rifles and M6 bayonets. Above, clockwise from left, Capt. Jonathan Murphy, Specialist Adam Cook, Sgt. Chris Moore, Specialist Matt Perovich, Staff Sgt. Steve Kuehn, Sgt. 1st Class Derek Dotson, and Specialist Justin Bickett tend to the details of their station.

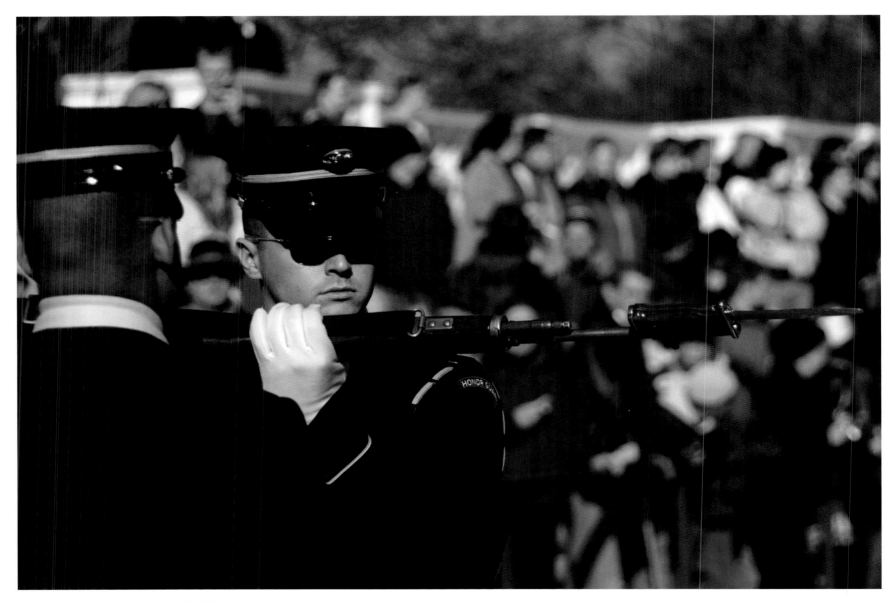

During the Changing of the Guard (left) relief commander Specialist Justin Bickett conducts a white-glove inspection of the relieving sentinel's weapon, checking each part of the M14 once. As two visitors look on, Pvt. 1st Class Kyle Obrosky (opposite) executes his watch with stoic precision.

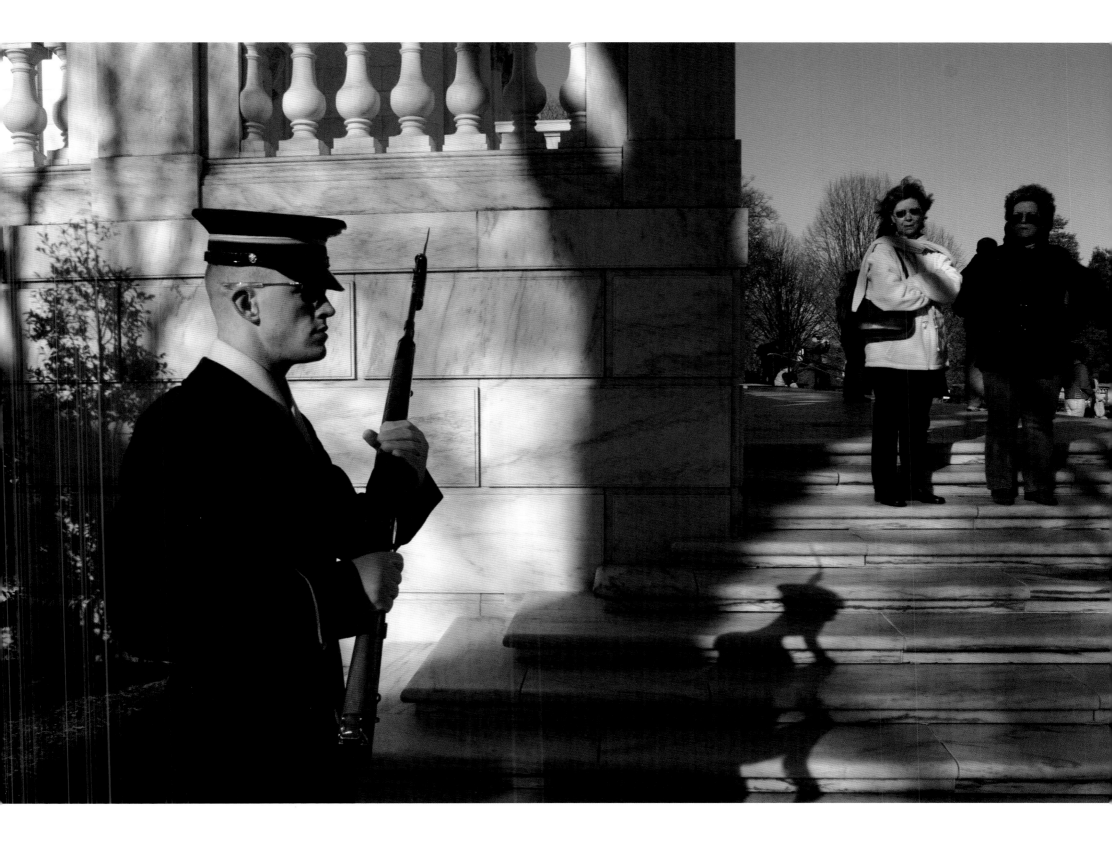

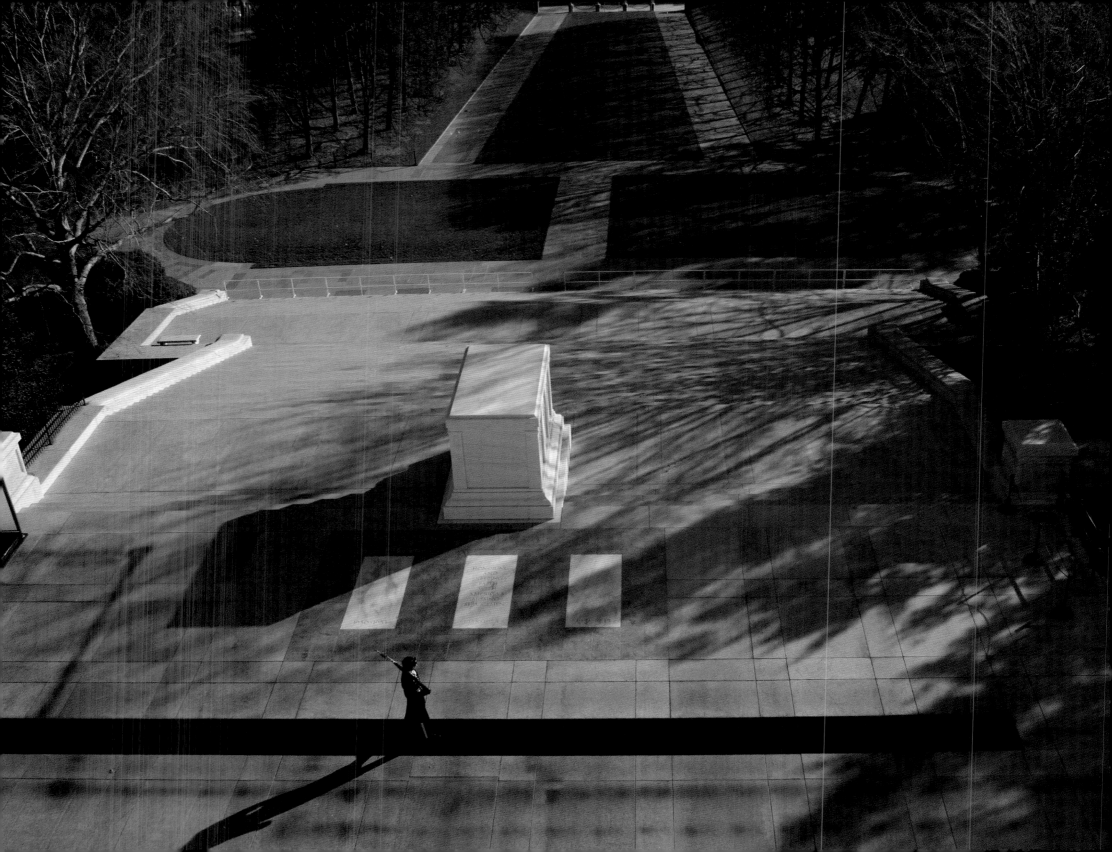

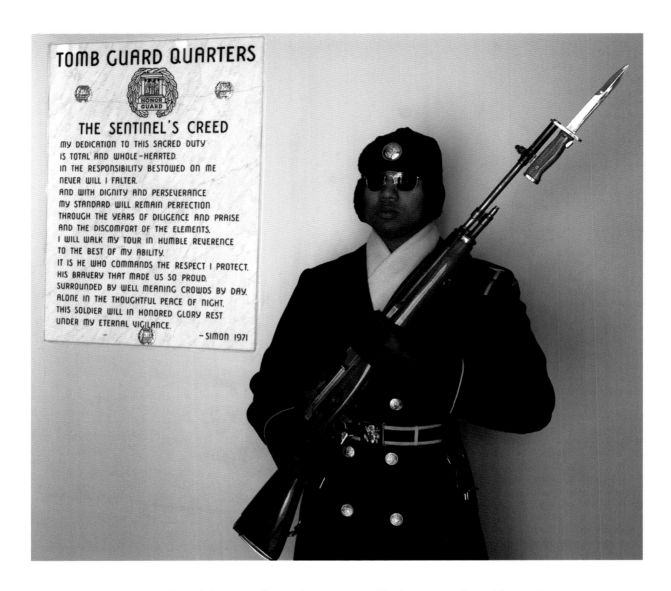

TOMB GUARD QUARTERS

HONOR GUARD

THE SENTINEL'S CREED

MY DEDICATION TO THIS SACRED DUTY
IS TOTAL AND WHOLE-HEARTED.
IN THE RESPONSIBILITY BESTOWED ON ME
NEVER WILL I FALTER.
AND WITH DIGNITY AND PERSEVERANCE
MY STANDARD WILL REMAIN PERFECTION
THROUGH THE YEARS OF DILIGENCE AND PRAISE
AND THE DISCOMFORT OF THE ELEMENTS.
I WILL WALK MY TOUR IN HUMBLE REVERENCE
TO THE BEST OF MY ABILITY.
IT IS HE WHO COMMANDS THE RESPECT I PROTECT.
HIS BRAVERY THAT MADE US SO PROUD.
SURROUNDED BY WELL MEANING CROWDS BY DAY,
ALONE IN THE THOUGHTFUL PEACE OF NIGHT,
THIS SOLDIER WILL IN HONORED GLORY REST
UNDER MY ETERNAL VIGILANCE.
— SIMON 1971

Standing alongside the creed to which he has dedicated himself, Specialist Bruce Bryant (above) prepares to relieve a fellow guard. Members of this exclusive detail don't need an audience as they "walk the mat" at the Tomb of the Unknown Soldier (left).

A willingness to make the ultimate patriotic sacrifice ennobles the lives of all military men and women. At Arlington, families know their loved ones belonged not just to them, but also to the nation. They take solace in the SERVICES

The Coast Guard Ceremonial Honor Guard stands at attention.

SERVICES ARE RENDERED at no cost to families of active or honorably discharged service members. However, the emotional tab is high. For although the Latin inscription over the west entrance to Arlington's Memorial Amphitheater may translate into "It is sweet and honorable to die for one's country," as the photographs on the following pages tearfully show, for the spouses, parents, children, and siblings of those killed in action, the loss is more bitter than sweet, no matter how honorable the purpose. Not every soldier perishes on the battlefield, of course, and retired officers receive the same honors as active-duty casualties. But as Army Chaplain Capt. Charles Hamlin, who has presided over thousands of funerals, admits, "Active duty are the toughest services because you see a lot of young people and realize that the soldier didn't get to experience the fullness of life." After the ritualized march to the grave site or columbarium and a brief eulogy, the six body bearers present the next of kin with the flag—folded 13 times into a trim triangle, stars out—that covered the casket. The firing party discharges its salute, followed by the haunting notes of "Taps" and a procession from the grave. What happens next adheres to no script, ritual or protocol; it is when sadness intrudes on ceremony and even the most stoic soldier finds himself struggling to stay strong.

Photographs by SELECT PHOTOGRAPHERS

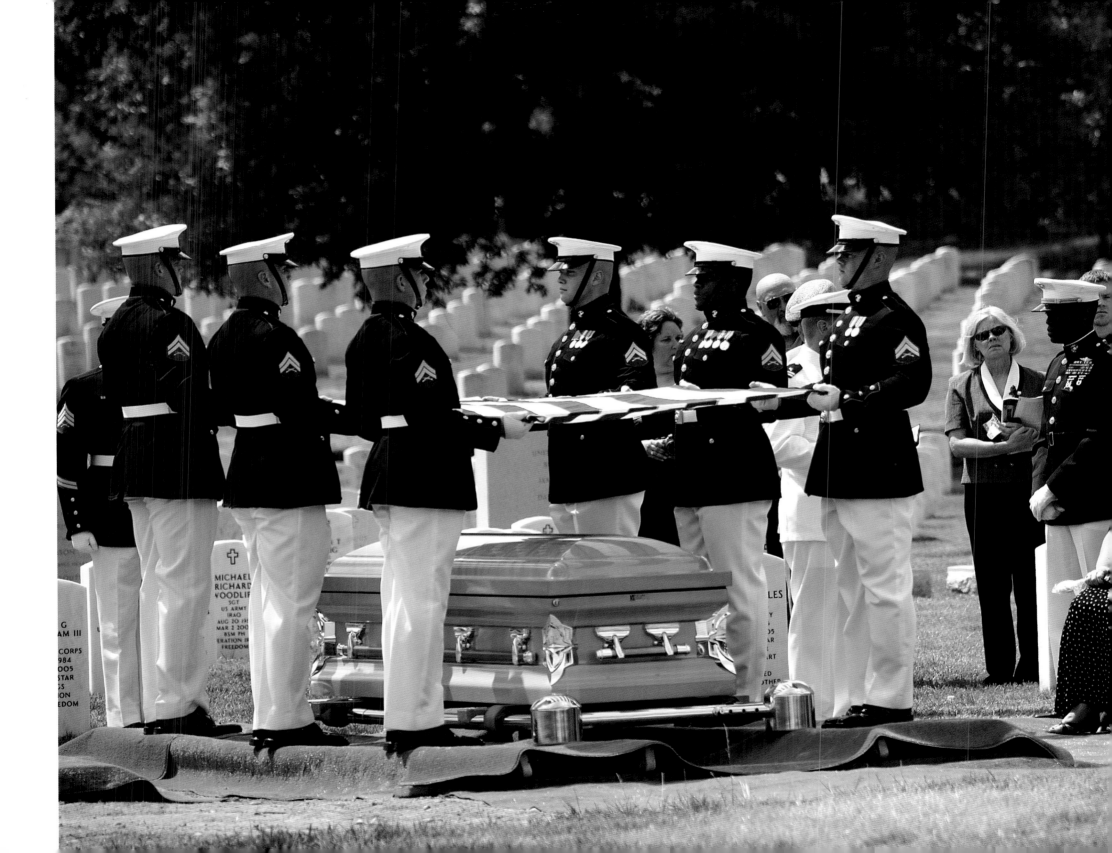

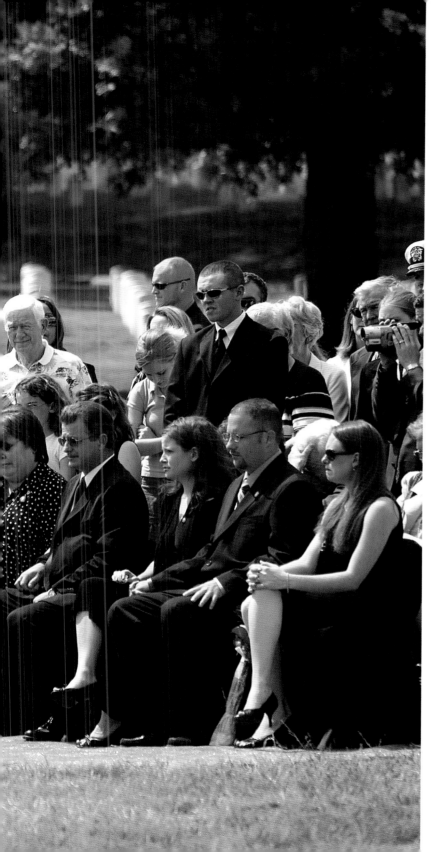

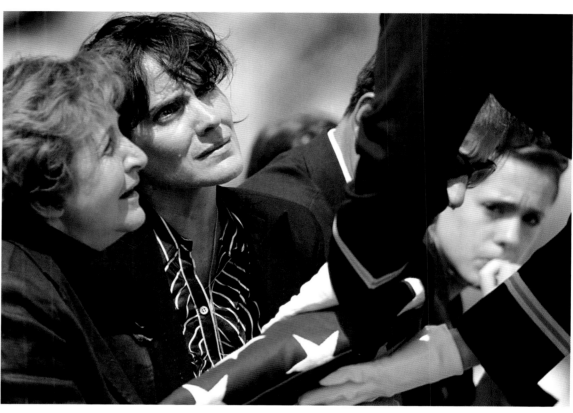

Marine body bearers ceremonially remove the flag from the casket of Cpl. Kevin Adam Lucas, who died in Iraq on May 26, 2006. At the funeral (above) for Chief Warrant Officer José Antonio Suarez, a senior Army officer presents the flag, folded into a taut triangle, to his wife, Margarite, in a ritual that takes place for all service branches.

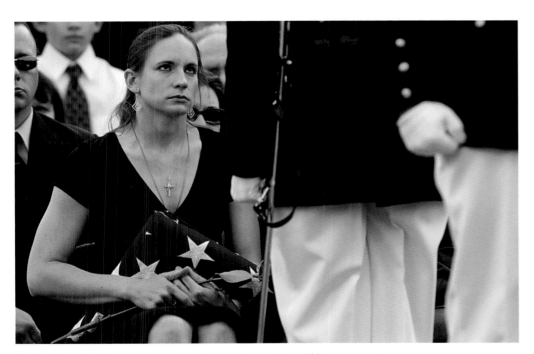
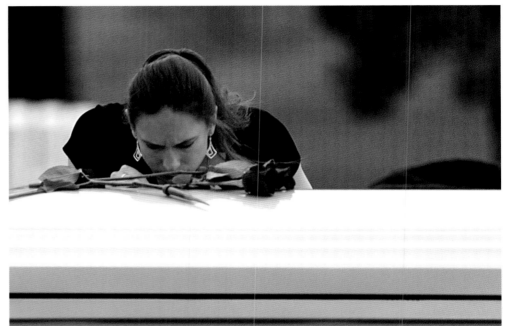

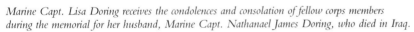
Marine Capt. Lisa Doring receives the condolences and consolation of fellow corps members during the memorial for her husband, Marine Capt. Nathanael James Doring, who died in Iraq.

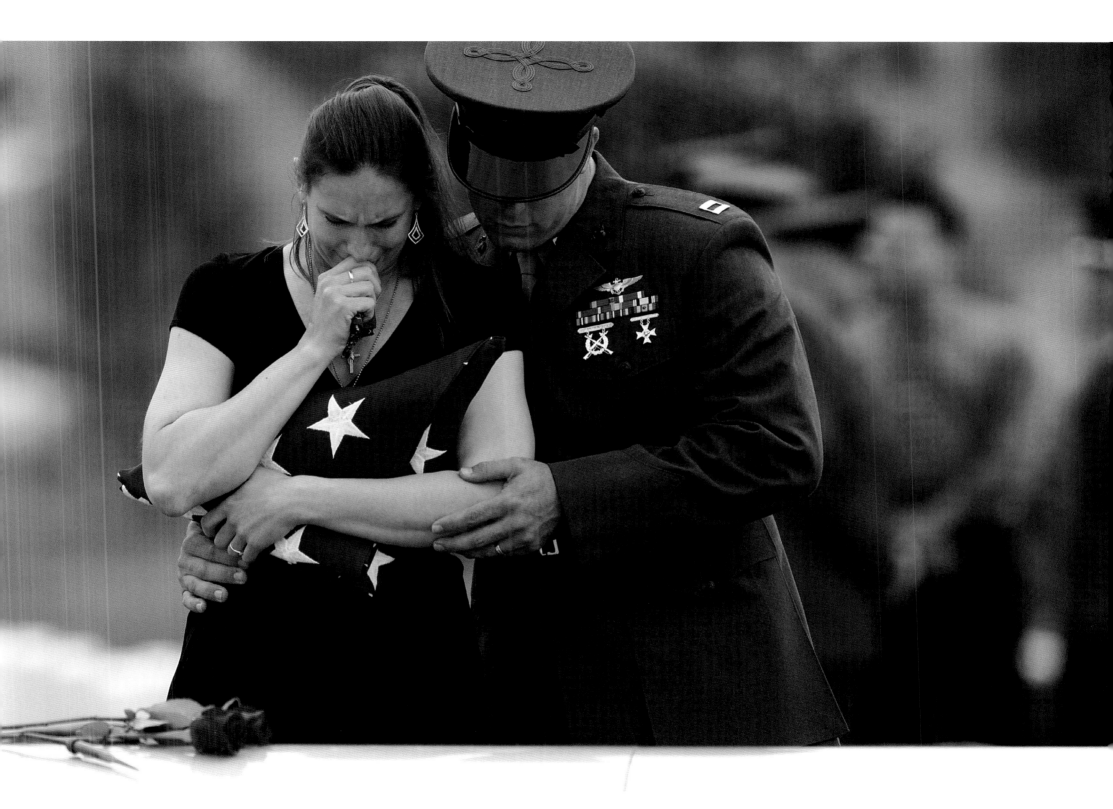

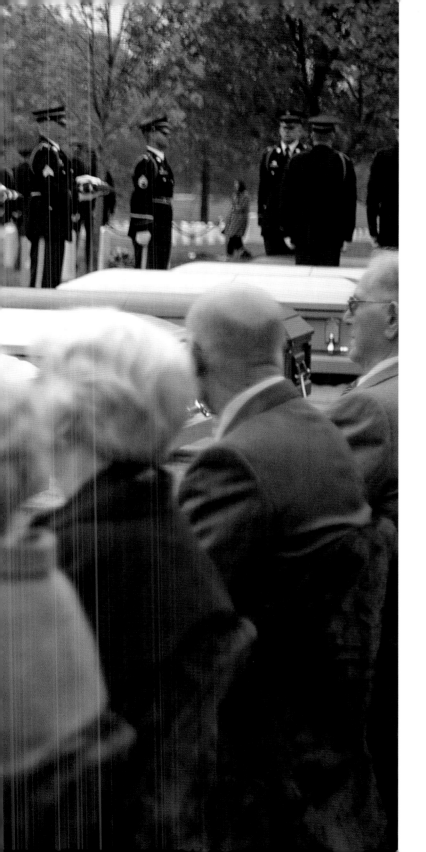

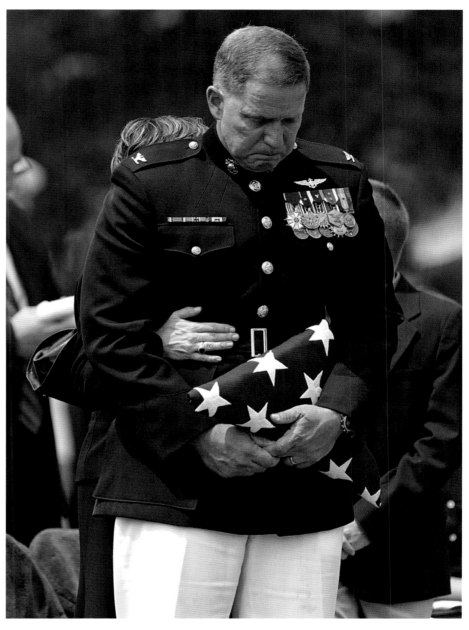

Full military honors are rendered for 7 of 11 MIAs from World War II whose remains had finally been identified. They were 1st Lt. J. P. Gullionn, Sgt. Walter G. Harm, Staff Sgt. William Lowery, Staff Sgt. Elgin J. Luckenbach, Staff Sgt. Marion B. May, Capt. Thomas C. Paschal, and 2nd Lt. Leland A. Rehmet. Marine Col. Robert Deforge (above) grieves as his son, Brian, a Marine first lieutenant, is laid to rest.

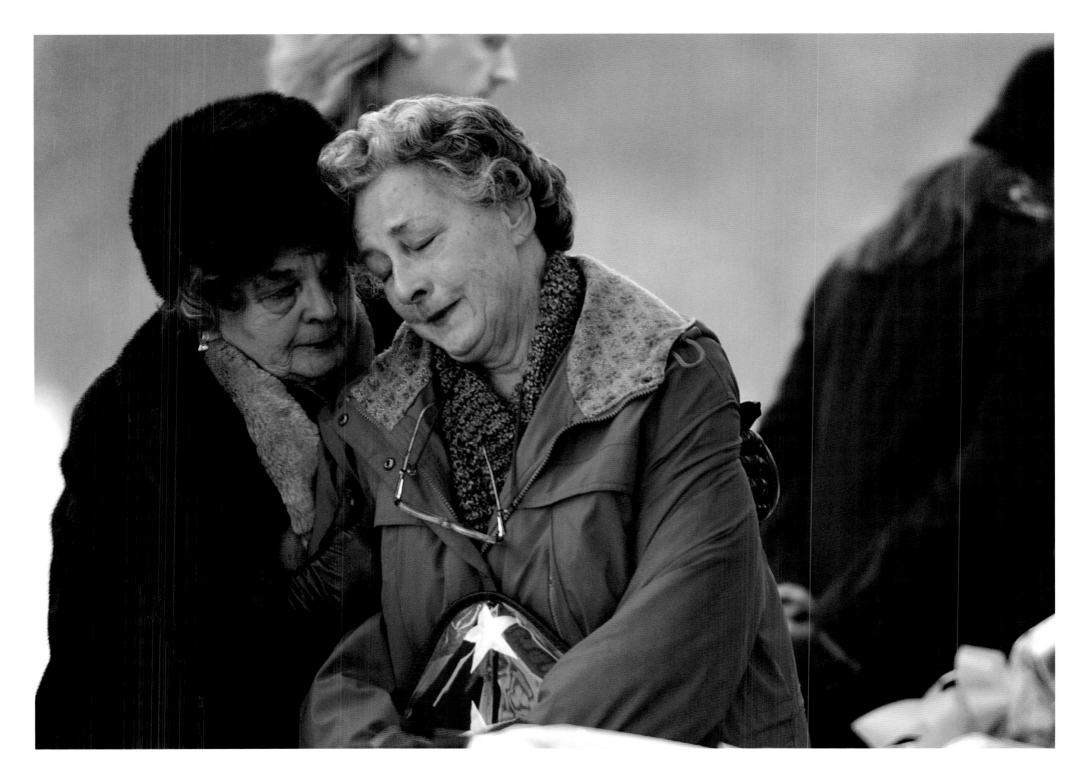

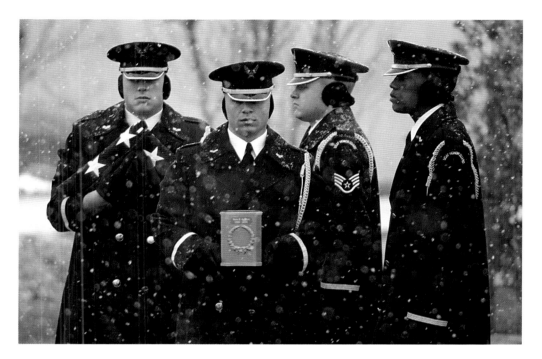

Elsie Eltzroth, widow of retired Air Force Lt. Col. Merlin Eltzroth, receives comfort (opposite) during a January service. Neither cold nor snow (above) deters the rendering of honors for Air Force Master Sgt. Mario R. Aguilera, who, like more than half of Arlington's dead, was cremated. Inurnments receive the same honors and now outnumber interments at Arlington.

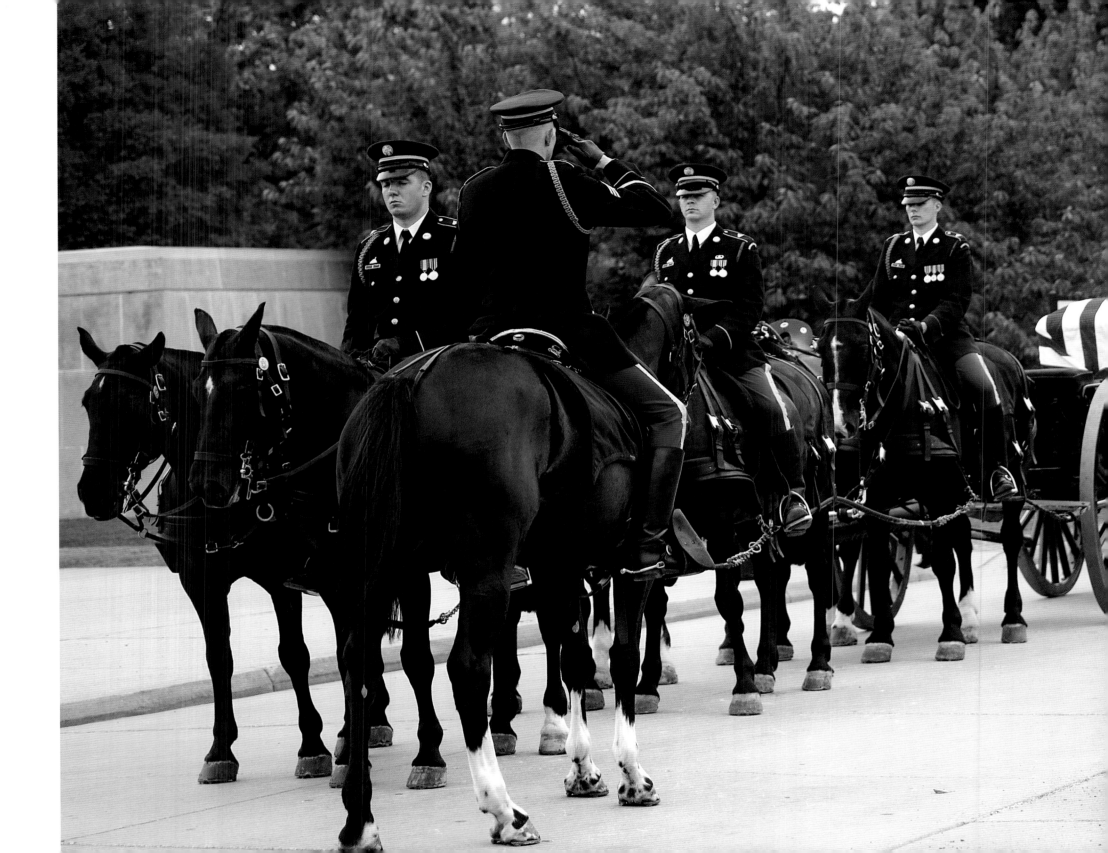

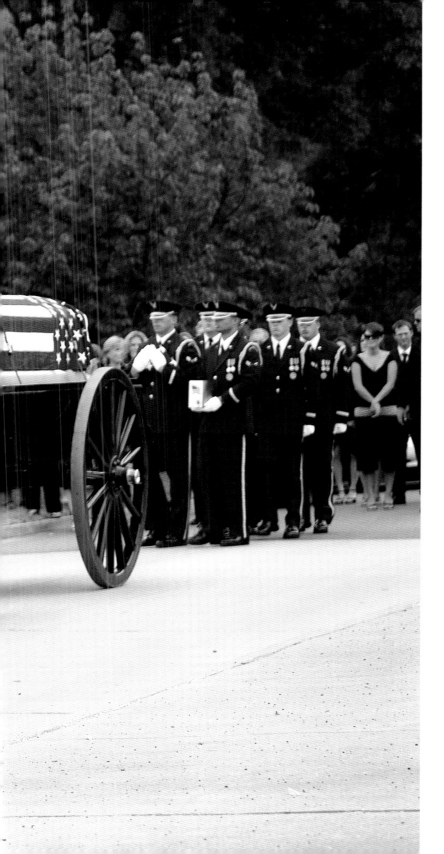

Certain types of full honors funerals bring together ceremonial guards from different service branches, such as the Army and Air Force. A full honors funeral for a soldier killed in action (above) can draw hundreds of mourners to Arlington.

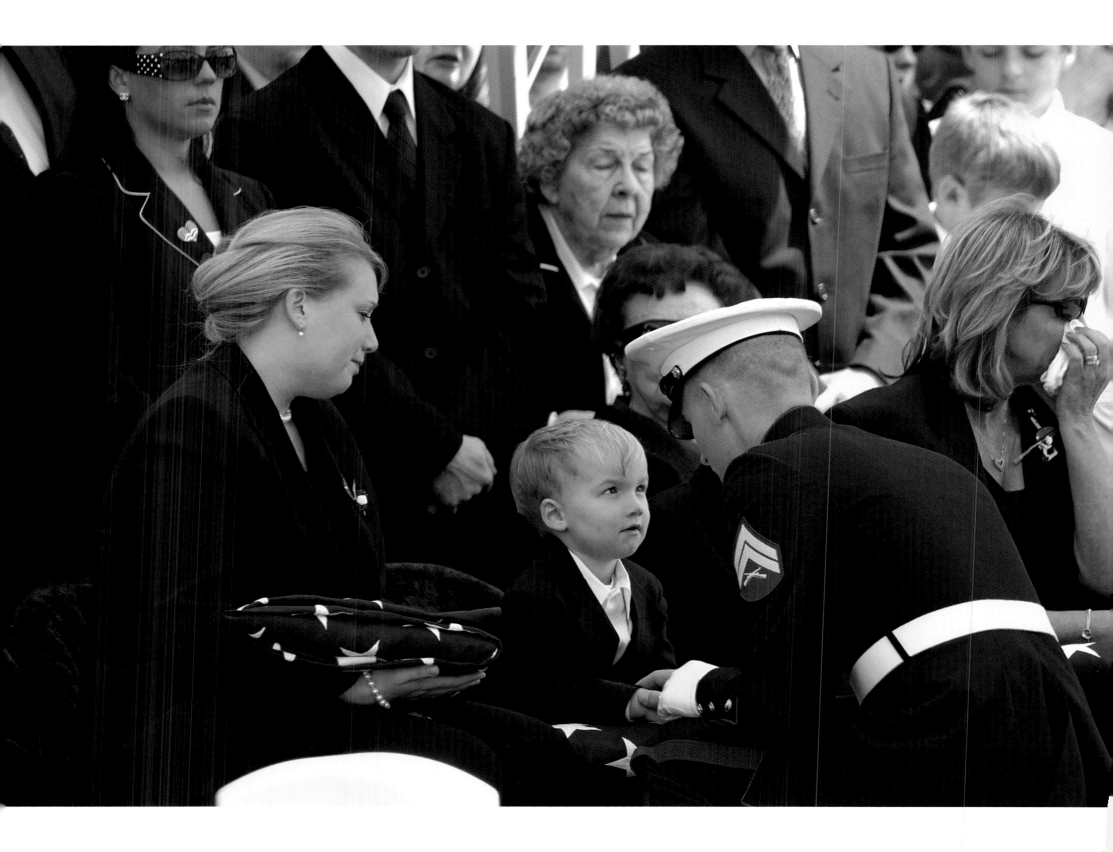

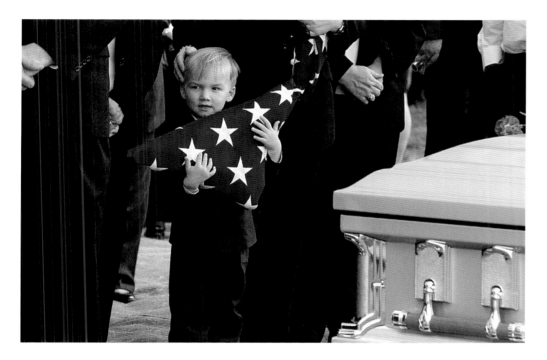

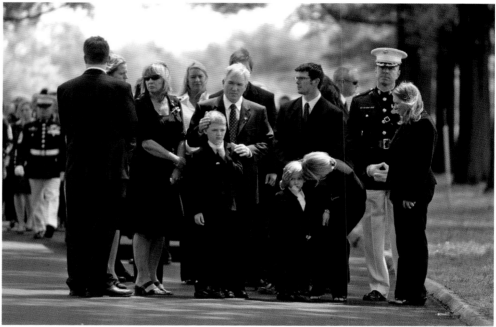

Flanked by his mother, Autumn, and his extended family, three-year-old Dillon Letendre receives consolation from his uncle, Marine Corporal Justin Letendre, after receiving the flag that draped the casket of his father, Marine Capt. Brian S. Letendre, who died in Iraq on May 3, 2006.

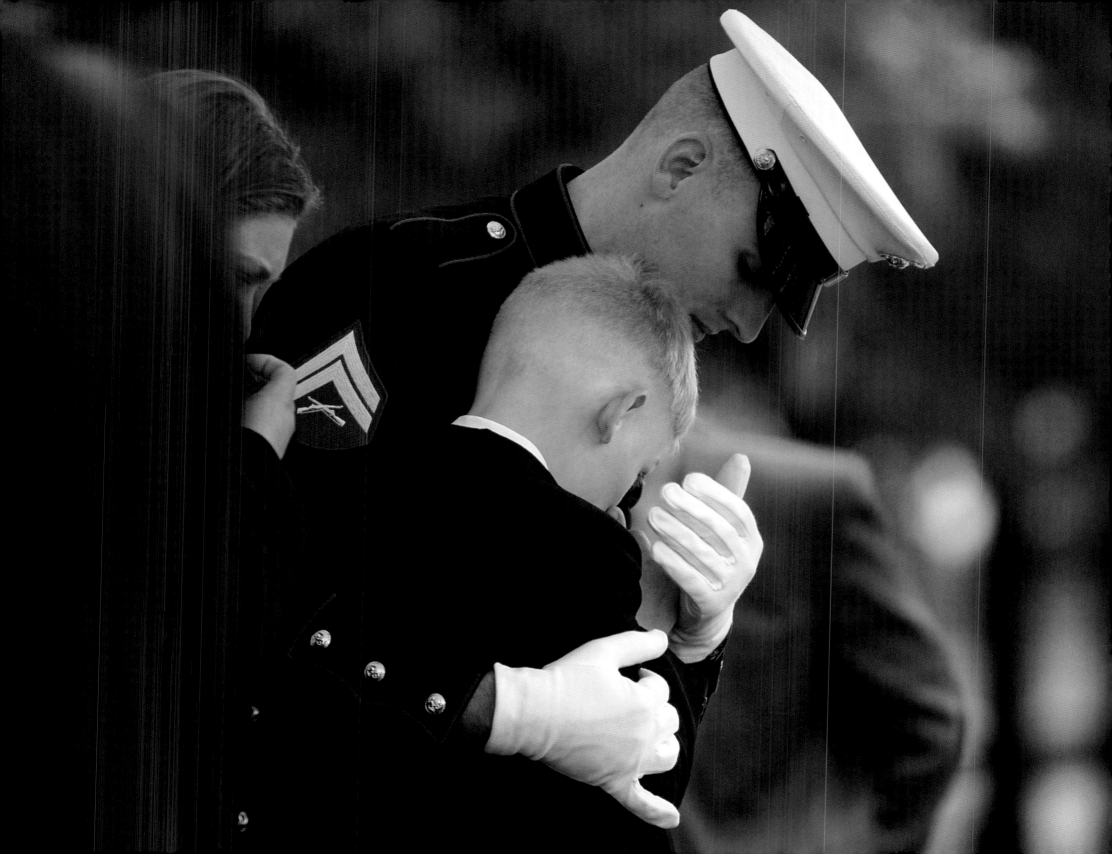

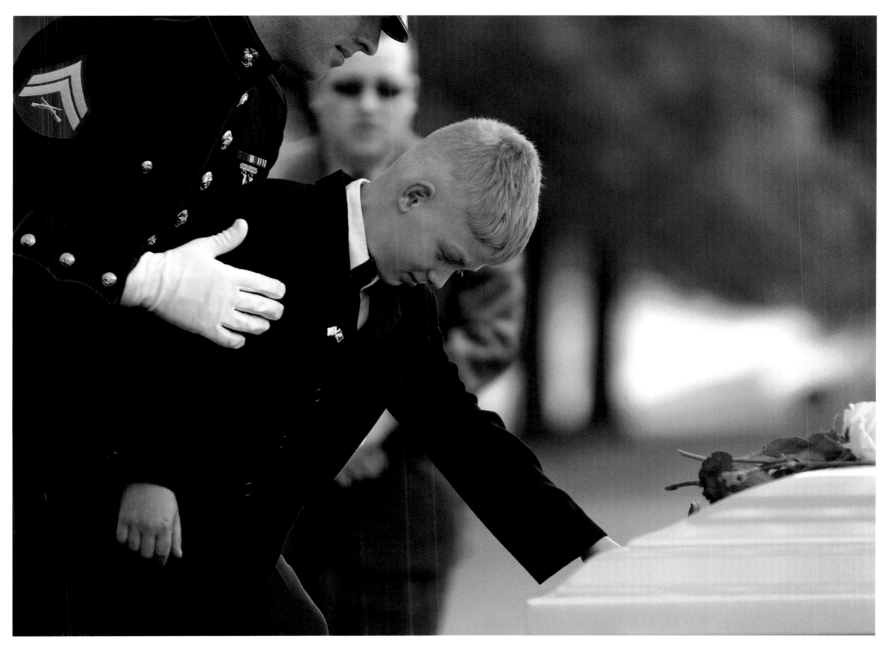

Compassion hits home as Marine Corporal Justin Letendre consoles his son, Tristan, during a service for Marine Captain Brian S. Letendre, Corporal Letendre's brother.

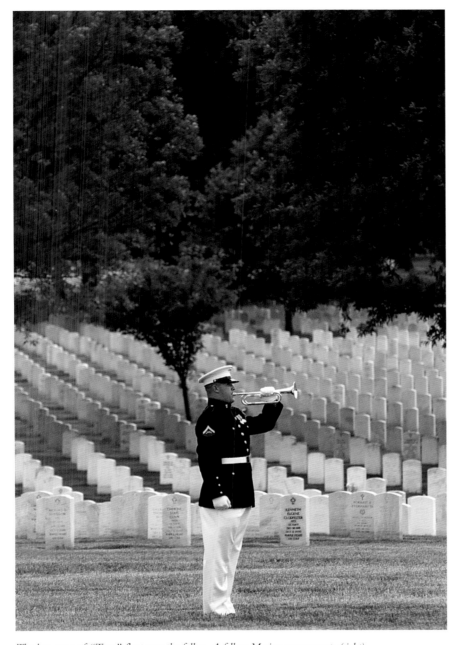

The last notes of "Taps" float over the fallen. A fellow Marine pays respects (right) to Gunnery Sgt. Terry W. Ball, Jr., who died in Iraq in 2005.

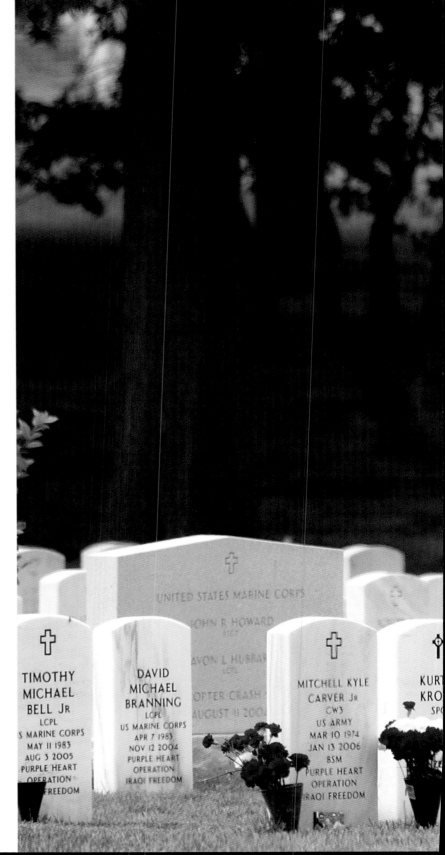

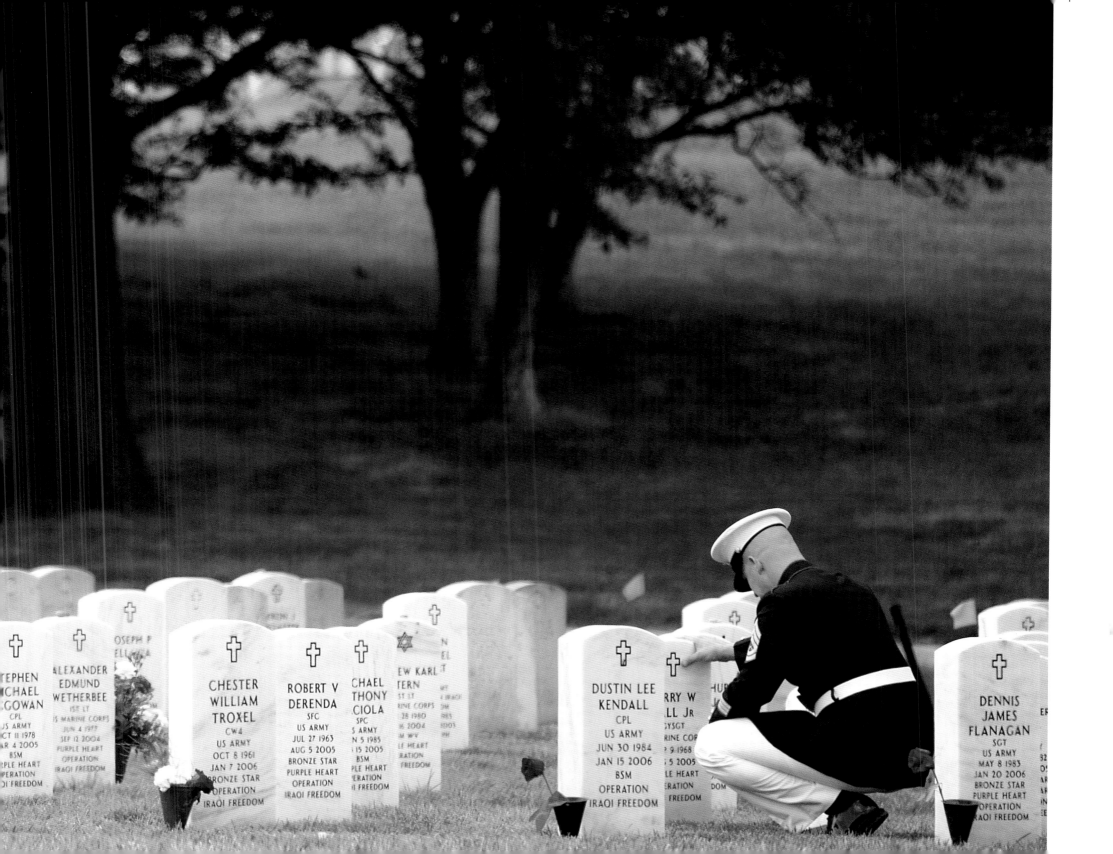

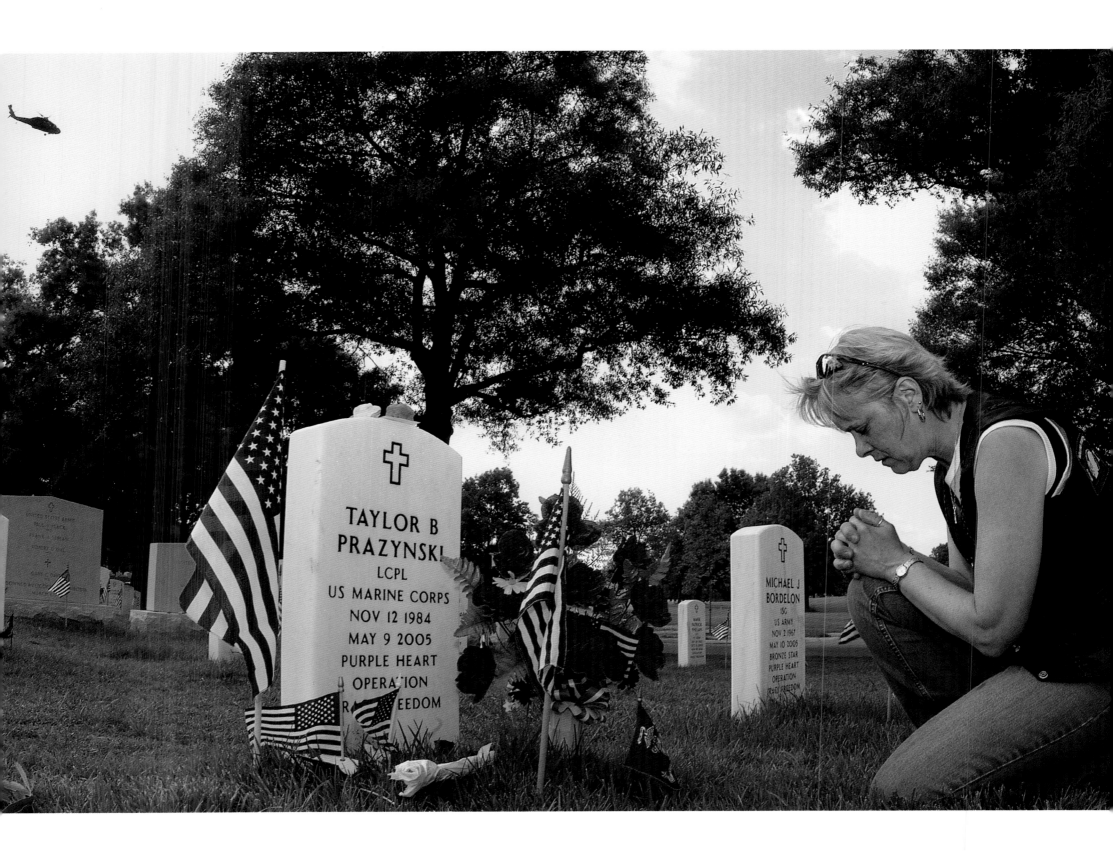

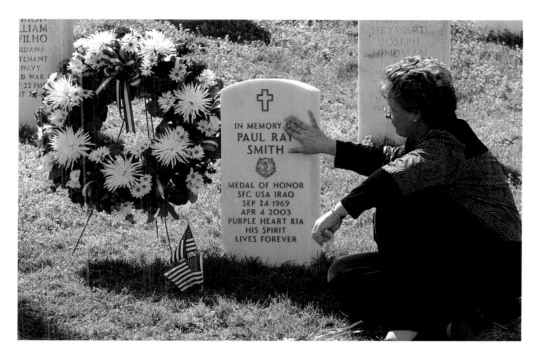

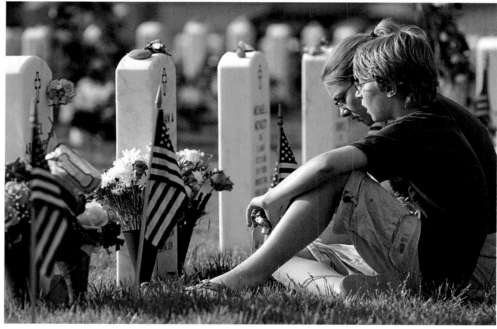

A mourner (opposite) kneels in prayer at the decorated grave of Lance Corporal Taylor Prazynski in Section 60. After posthumously receiving the Medal of Honor, Birgit Smith's husband, Paul, was honored with a headstone (left) in May 2005. Connor and Bryanna Fenton, siblings of Cpl. William A. Long, visit on Memorial Day.

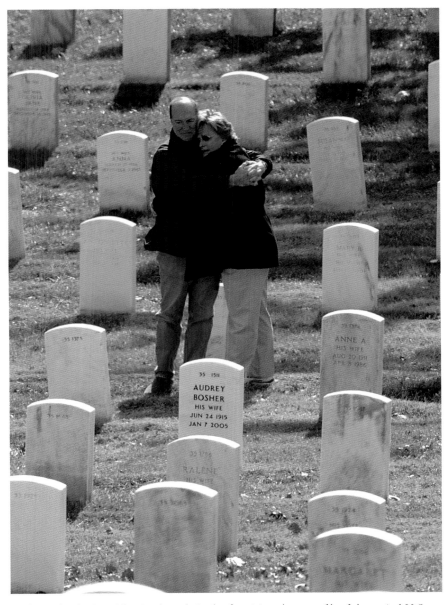

Andrea and Mike Pope (above) embrace during her first visit to the grave of her father, retired U.S. Navy Lt. Cdr. Charles Lang, who died in 1964. Nearby tombstones list qualified family members interred in a service member's grave. Retired Marine Col. Charles Gallina (right) places flowers at the grave of his wife, Caroline Havel.

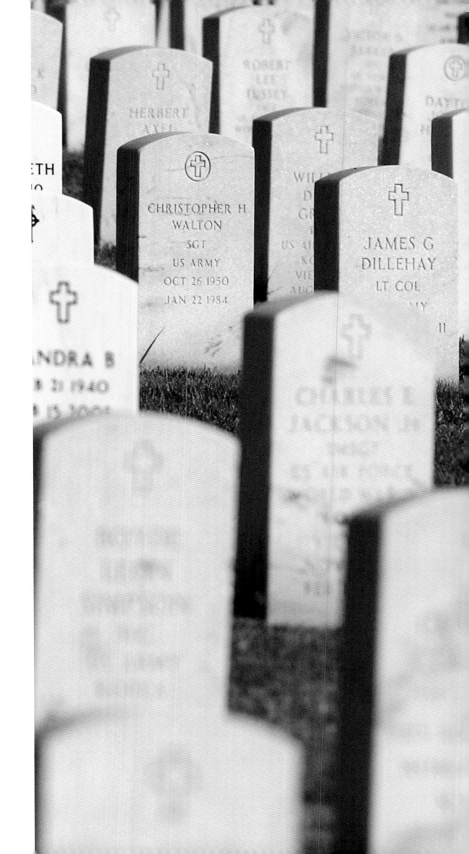

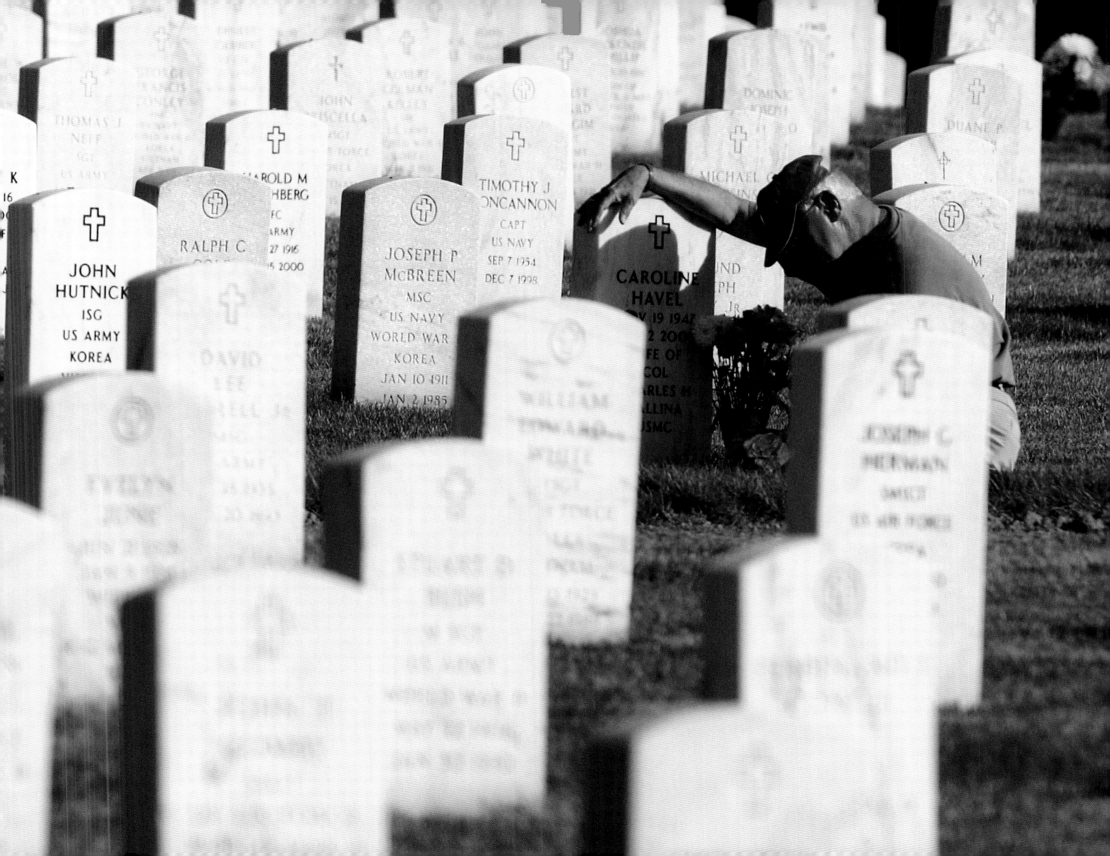

Arlington seldom shows its private, nocturnal side. It is only after the visitors have dispersed and serenity returns that the cemetery's spiritual aura can most profoundly manifest itself, revealing, in the pitch of night, the **AFTERGLOW**

The Washington Monument keeps watch over Arlington.

NIGHT IS WHEN the honored dead have Arlington to themselves. Peace returns. Valor can indeed rest. Only the occasional birdcall and the blare of distant Klaxons crack the silence. Liminal by day, Arlington turns numinous at night, inspiring an abiding curiosity about what transpires amid the graves and ghosts. On a slope just below Arlington House, the eternal flame of the John F. Kennedy Memorial dances unattended in the reflected light of the metropolis he once called home. Soft breezes waft through the thick-limbed trees above the grave markers and swirl around the Memorial Amphitheater. Nearby, the cemetery's lone corporeal presence, an Old Guard sentinel in fatigues, protects the Tomb of the Unknown Soldier, performing a ritual as precise, measured, and invariable as time itself. A sepulchral darkness cloaks the land, but through the photographic technique of light painting, the shroud delicately lifts, unveiling a beauty both haunting and serene. Taken between dusk and dawn, these selectively illuminated images capture the everlasting radiance of the valiant souls whose sacrifice consecrates every acre. They illustrate what the poet Theodore O'Hara meant when he wrote that not even "time's remorseless doom shall dim one ray of holy light / That gilds your glorious tomb."

Photographic Essay by DAVE BLACK

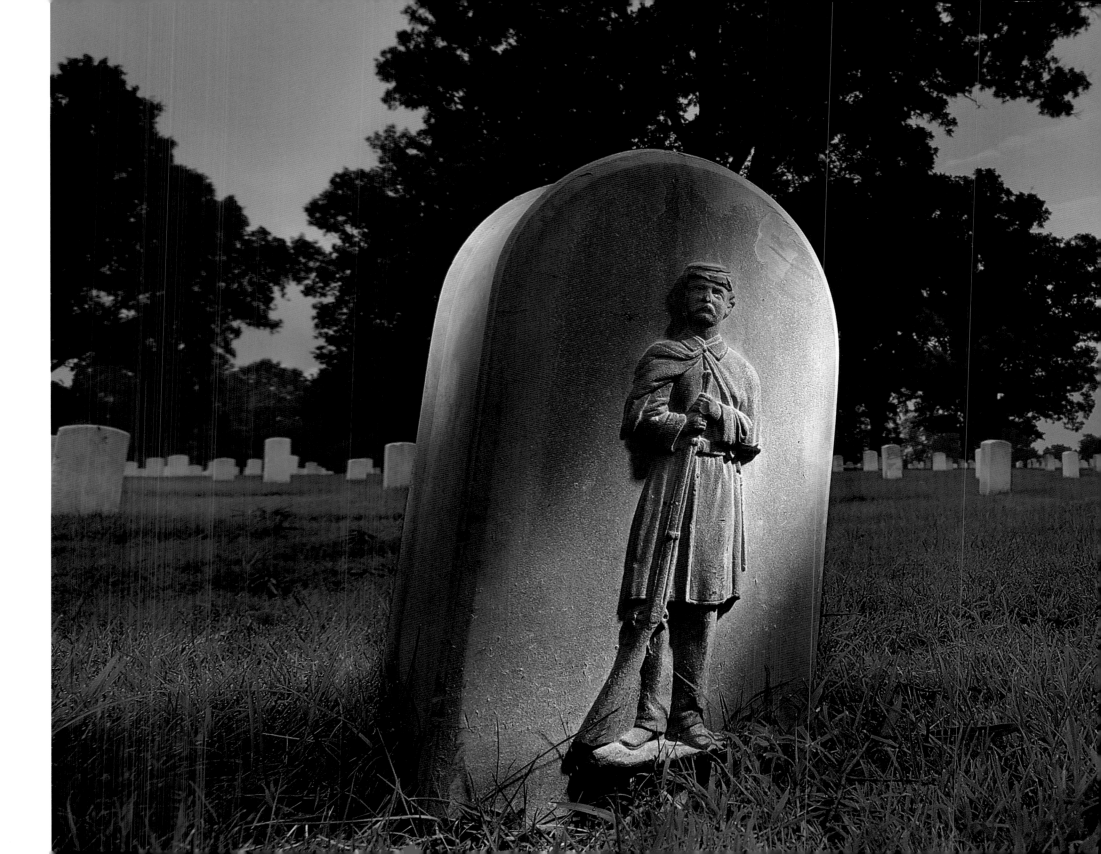

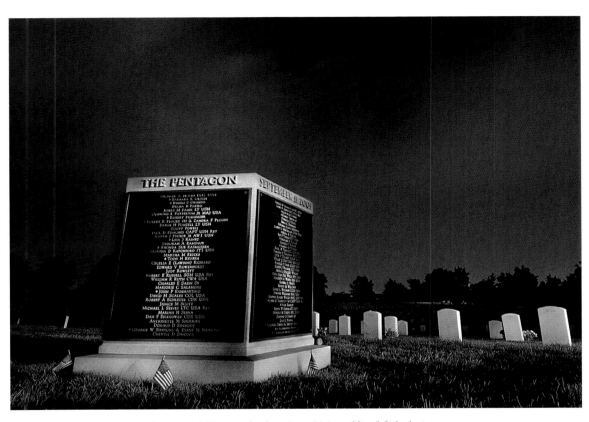

Dating from the 1870s, a 20-inch cast metal Meigs marker honoring a Union soldier (left) basks in the gloaming. The names of some of the 184 victims who died on the September 11, 2001, crash of American Airlines Flight 77 (above) radiate from the Pentagon Group Burial Marker.

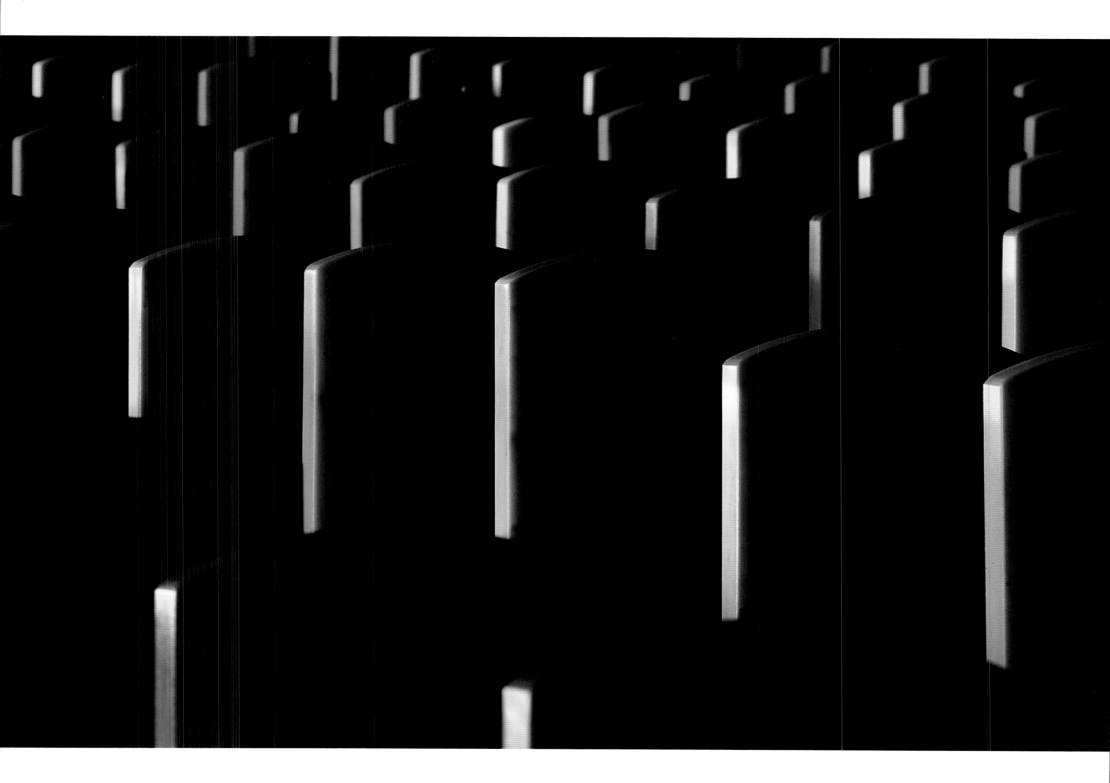

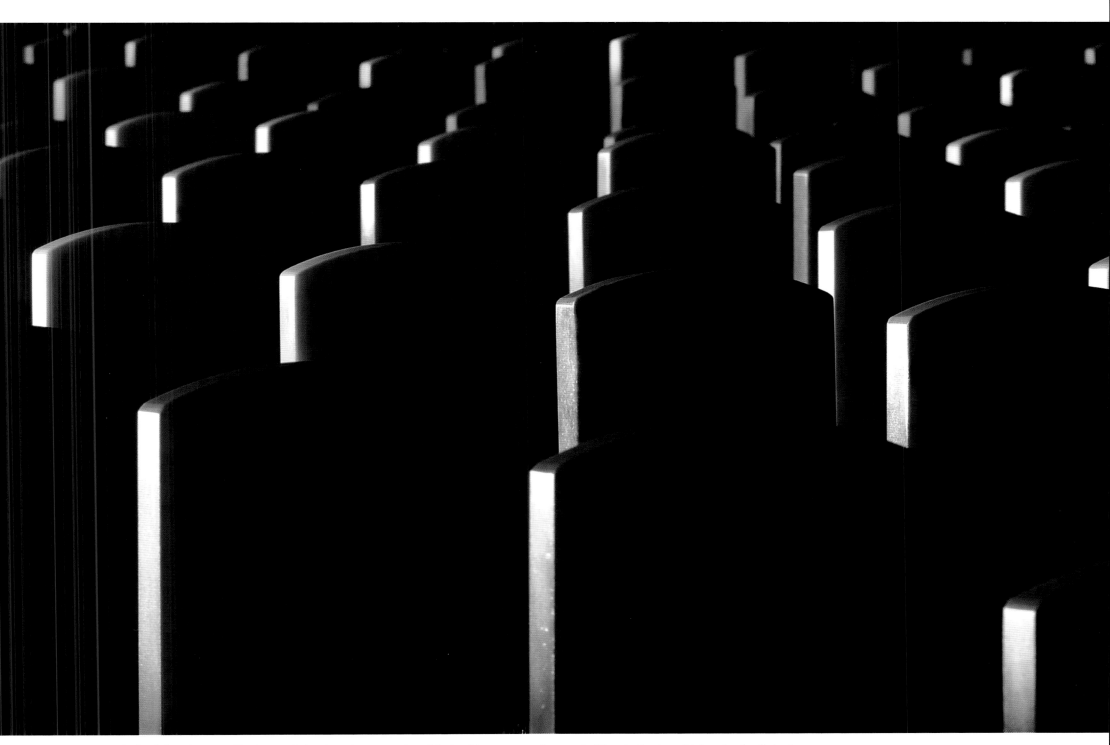

Edged in light and compacted by the use of a long lens, the grave markers of Section 54 suggest an endless sea of soldiers standing in perfect formation for all eternity.

Storm clouds gather over an illuminated Arlington House (above) evoking its turbulent history. A combination of strobes and light-painting (opposite) captures the gliding, rhythmic strides of Specialist Ethan Morse, one of the elite Honor Guard who provide round-the-clock protection of the Tomb of the Unknown Soldier.

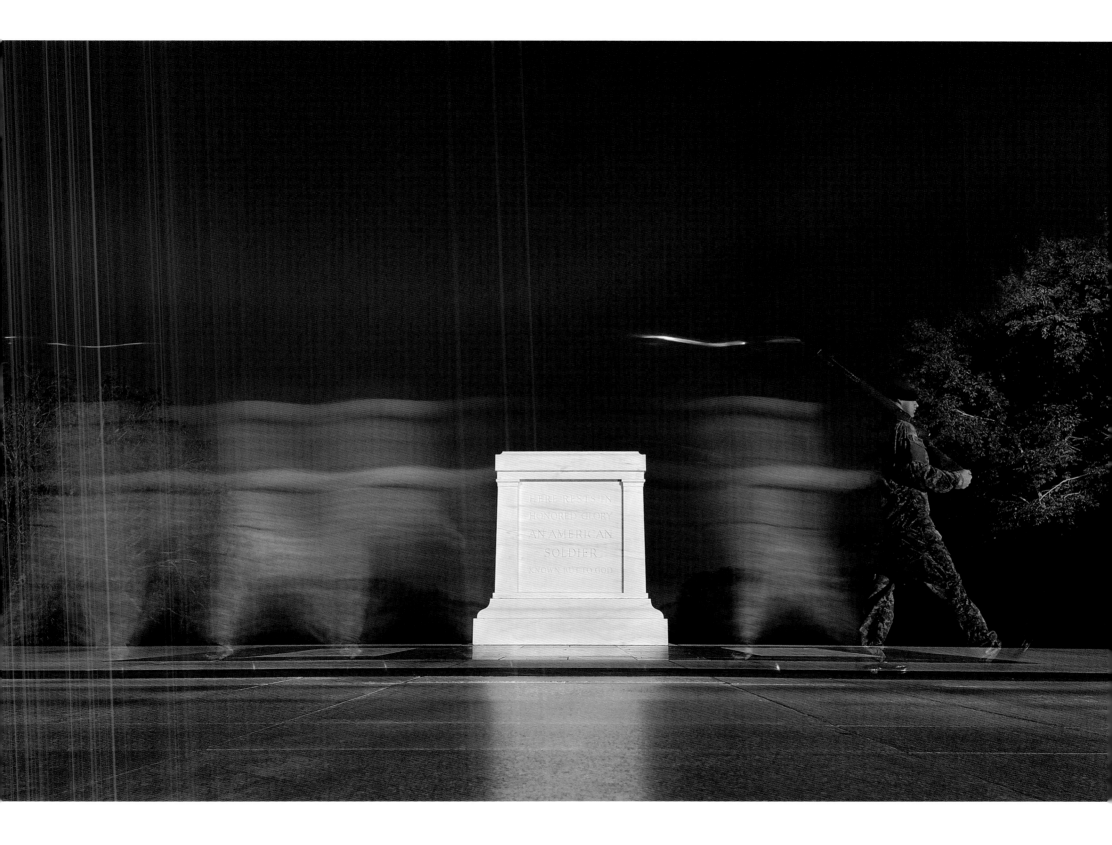

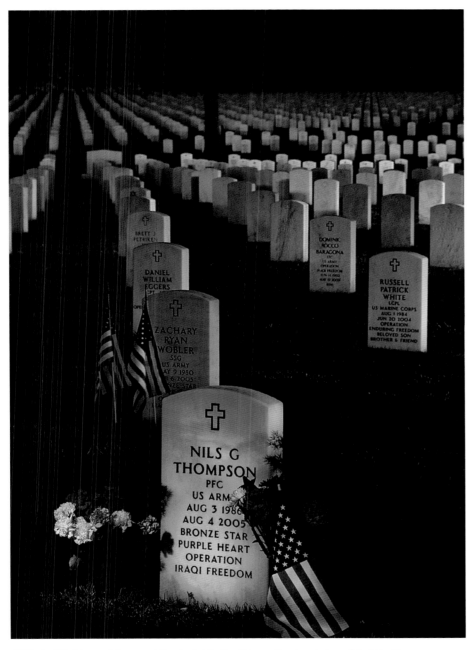

With the Washington Monument illuminated in the distance, the eternal glow of the John F. Kennedy Memorial (right) symbolizes a historic continuum that carries into Section 60 (above), where flags and flowers adorn the graves of service members killed in Iraq and Afghanistan.

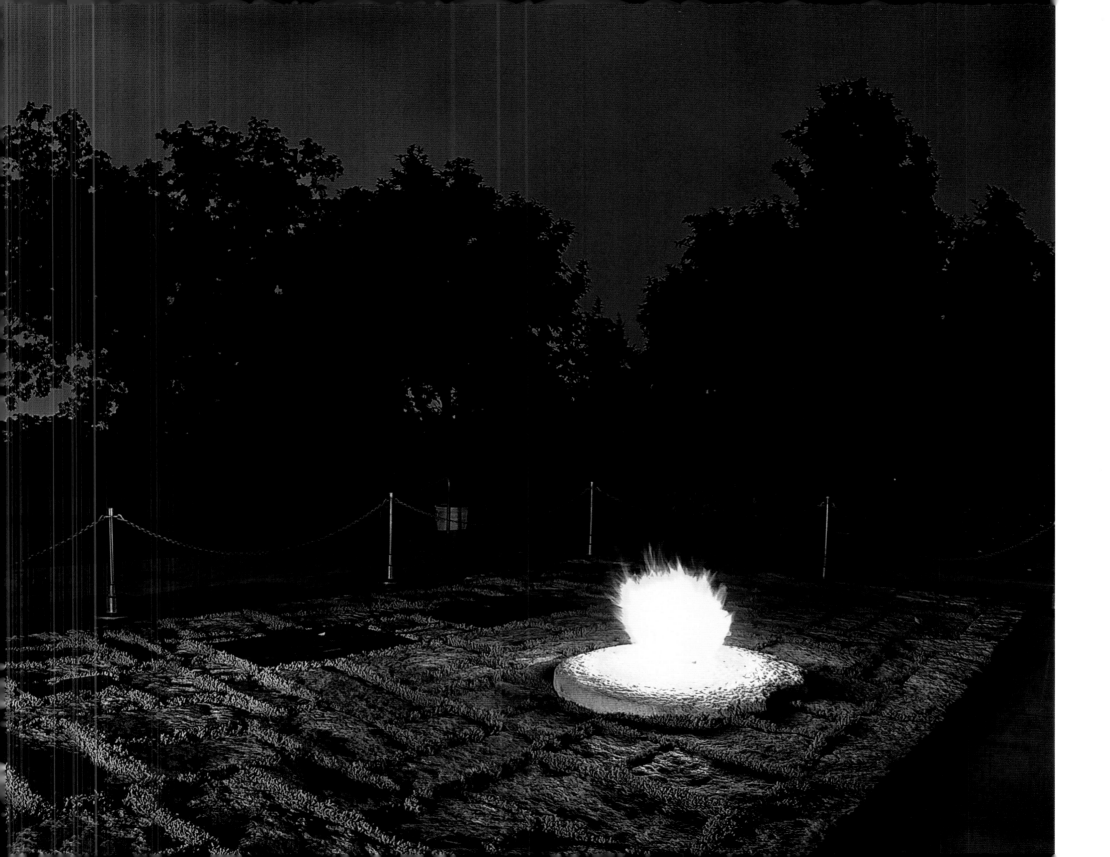

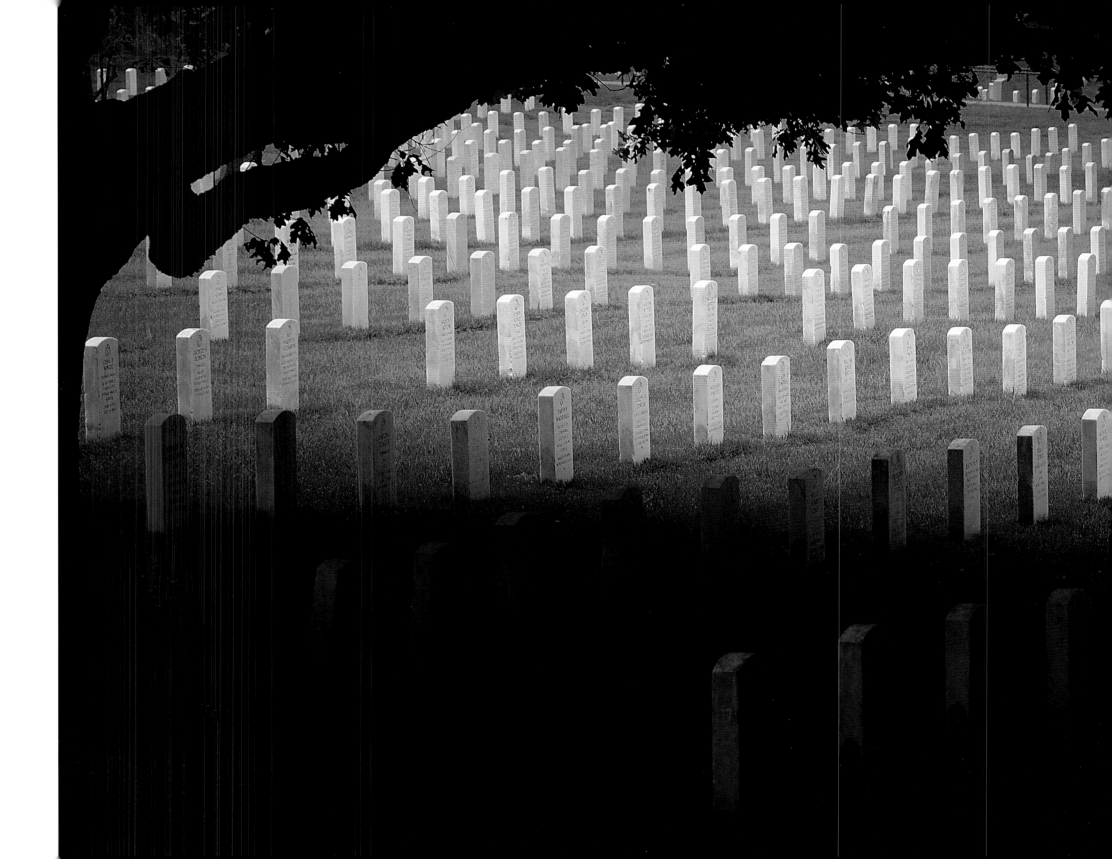

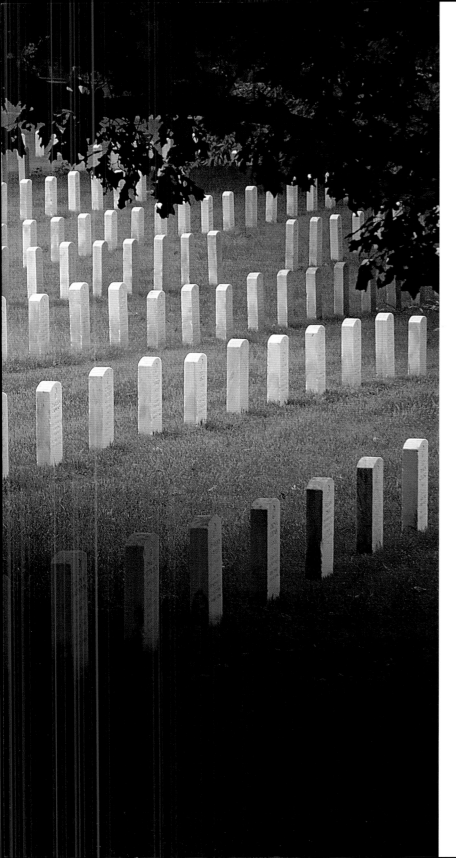

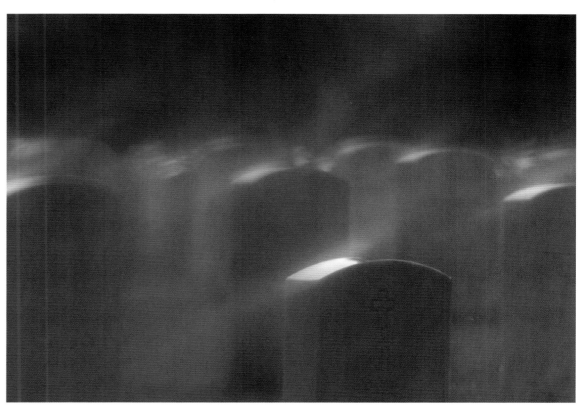

A mighty oak limb (left) shades rows of graves from the dawn's early light. During a sudden summer thunderstorm, a splash of sunshine paints the markers with an appropriately ethereal aura.

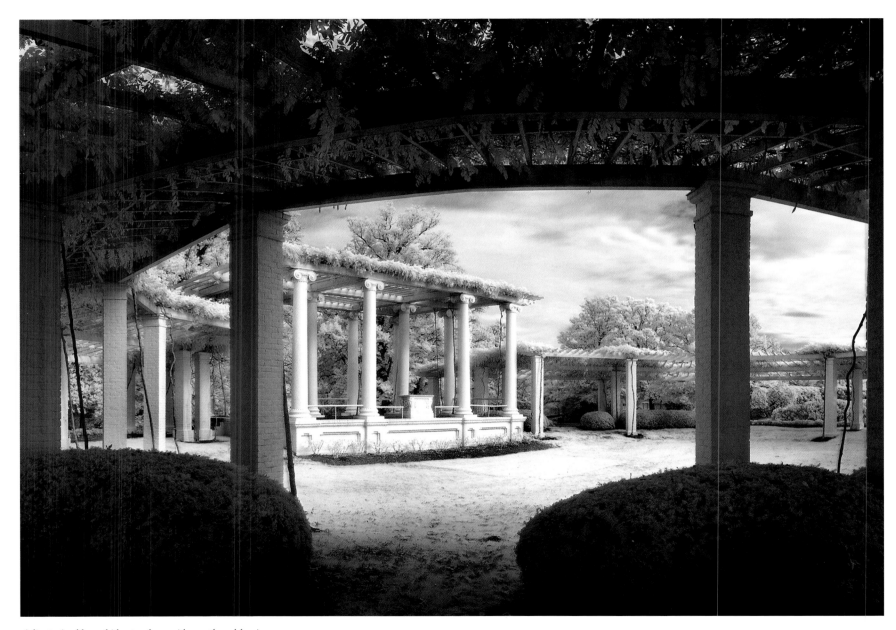

Arlington's old amphitheater glows with an ethereal luminescence.

Afterword CREIGHTON ABRAMS

A LIVING MONUMENT TO VALOR

AS ARLINGTON NATIONAL CEMETERY commemorates its 150th year, it's important to remember how this serene resting place of our honored dead has been transformed over those years to what it is today. The Cemetery was one of several born in 1864 out of wartime necessity. When Union Army Quartermaster Gen. Montgomery Meigs needed more burial space for local war casualties, he picked Arlington, the Confederate Lee family estate, an attractive and convenient site in Virginia directly across the Potomac River from Washington, D.C. Meigs, a close friend of Robert E. Lee's until Lee joined the South, saw this use as retribution for Lee's action.

As the scenes in this book confirm, Meigs could not have made a better choice, and the land has only improved in beauty over the past 150 years. Under the Army's care a rough cemetery born in bitterness has been transformed. Skillful landscaping, loving maintenance, and keen attention to details of appearance have created a magnificent, one-of-a-kind living memorial to our fallen.

I have attended many funerals, including those of my parents, at Arlington National Cemetery, and I have visited there even more often. When I stand in front of the former Lee mansion and look around, I gaze east past the ordered rows of white headstones to the city of Washington. Spread to the horizon is a remarkable tableau of the nation's history—a history linked directly to those honored dead buried around me. I can see the Capitol, the Washington Monument, the Lincoln Memorial, our most prominent war memorials, and in the Cemetery to my right, Section 60, where the latest war casualties are buried. These are powerful reminders that our freedom really isn't free and that so many buried in Arlington National Cemetery gave their lives—the "last full measure of devotion" so eloquently stated by Abraham Lincoln—to preserve for their children the uniquely American ideals. They served and sacrificed not for themselves but for future generations to ensure that the world's first "government of the people, by the people, for the people shall not perish from this earth." Arlington National Cemetery shall always be a reminder of that precious gift.

A visit to Arlington National Cemetery never fails to move me. This book has only deepened my affection for this place of extraordinary national significance and natural beauty.

ABOUT THE CONTRIBUTORS

RICK ATKINSON

Three-time Pulitzer Prize winner Rick Atkinson is a former senior editor at the *Washington Post* and an acclaimed military historian. His seven previously published books include the best-selling *The Guns of Last Light* and *An Army at Dawn: The War in North Africa, 1942-1943,* for which he won the 2003 Pulitzer for history. This followed a 1982 Pulitzer Prize for national reporting and the 1999 Pulitzer Prize for public service, awarded to the *Post* for a series of investigative articles he conceived, directed, and edited about shootings by the District of Columbia Police Department. Other awards include the 1983 Livingston Award for international reporting, the 1990 George Polk Award for national reporting, and a 1990 PEN special citation for nonfiction. Atkinson has covered the Persian Gulf War, and as the *Post*'s Berlin bureau chief filed dispatches from Somalia, Bosnia, and throughout Europe. Before joining the national staff of the *Post* in 1983, Atkinson worked at the *Morning Sun* in Pittsburg, Kansas, and the *Kansas City Star. The Guns of Last Light* is the final volume of his Liberation Trilogy, a narrative history of the American Army in North Africa, Italy, and Western Europe during World War II.

JAMES BALOG

This Colorado-based photographer is as comfortable on a Himalayan peak as he is on a whitewater rapids, the African savanna or a polar ice cap. His eight books, each of which concerns the environment, include the highly praised *Survivor: A New Look at the World's Endangered Species* and *Tree: A New Vision of the American Forest.* Balog has mounted more than 100 exhibitions of his works around the world. His photographic study of glaciers, The Extreme Ice Survey, was featured in the highly acclaimed documentary *Chasing Ice.* He was also the first photographer ever commissioned to create a full plate of stamps for the U.S. Postal Service, the popular 1996 Endangered Species series. A contributing editor to *National Geographic,* he has also contributed photography to such other magazines as *Vanity Fair, The New Yorker, Life,* the *New York Times Magazine, Audubon,* and *Outside.*

SUSAN BIDDLE

After 13 years as a staff photographer at the *Washington Post,* Susan Biddle now freelances for the *Post* as well as a variety of other publications. She began her photographic career heading the photo unit during the early years of the Peace Corps. She also served as a staff photographer at the *Topeka Capital-Journal* and the *Denver Post,* and spent five years on the White House photographic staff documenting the administrations of Ronald Reagan and George Bush. Biddle's work has appeared in numerous magazines and books.

CHIEF PHOTOGRAPHER'S MATE JOHNNY BIVERA

With more than 20 years of naval service, Chief Petty Officer Bivera has received numerous awards for his documentary photography. Recently retired, he served as the personal photographer to the Chief of Naval Operations.

DAVE BLACK

Known for much of his career as a sports photographer, Black has photographed 12 Olympic games for *Newsweek* and is one of the world's foremost chroniclers of figure skating and gymnastics. He has also turned his lens on sporting events such as the Kentucky Derby and the Masters golf tournament. One of the first professional photographers to convert to all-digital cameras and techniques, Black also took the seldom-used photographic technique of light-painting out of the studio and applied it to buildings, landscapes, and panoramic vistas, providing a unique look across Arlington in the twilight and darkness of night. Graduated with a degree in graphic design and studio drawing from Southern Illinois University, Black regularly lectures and teaches at photography workshops and conferences.

DAVID BURNETT

In a career that has spanned more than 40 years, David Burnett has received virtually every major photojournalism prize, including Magazine Photographer of the Year, the Overseas Press Club's Robert Capa Gold Medal, and World Press Photo premier award. The Colorado College graduate earned an internship at *Time* magazine and, later, a spot as the last *Life* magazine photographer to cover the

Vietnam War. He has worked in more than 60 countries, documenting the coup in Chile (1973), revolution in Iran (1979), famine in Ethiopia (1984), the fall of the Berlin Wall (1989), and the U.S. military intervention in Haiti (1994). Based in Washington, D.C., Burnett continues to contribute regularly to *Time.* His memorable photographs include the Ayatollah Khomeini's return to Tehran and Mary Decker's anguished fall during the 1984 Olympics. Burnett co-founded the world-renowned photographic agency Contact Press Images and has also published two books, *44 Days: Iran and the Remaking of the World* and *Soul Rebel: An Intimate Portrait of Bob Marley in Jamaica and Beyond.*

MICHEL DU CILLE

A three-time winner of the Pulitzer Prize in both photography and public service, Michel du Cille coordinated and edited the work of the military photographers for this project. Currently associate editor/photography for the *Washington Post,* where he has worked since 1988, du Cille holds a journalism degree from Indiana University and a master's degree in journalism from Ohio University. While at the *Miami Herald* in 1985 he shared the Pulitzer with Carol Guzy for their coverage of the eruption of Colombia's Nevado Del Ruiz volcano, and won his second award for a 1988 essay on crack cocaine addicts in *Tropic* magazine. He received his third Pulitzer, along with his *Washington Post* colleagues Dana Priest and Anne Hull, for coverage of mistreated wounded veterans at Walter Reed Army Medical Center.

BRUCE DALE

Bruce Dale has had more than 2,000 of his photographs appear in *National Geographic.* He was twice named Magazine Photographer of the Year and White House Photographer of the Year. More recently, his innovative work with digital imaging brought him honors from the Smithsonian Institution as well as from NASA, which placed one of his photographs on board the Voyager spacecraft as testimony about planet Earth. Dale has photographed in more than 75 countries throughout the

world including ten trips to China. His oeuvre ranges from sensitive people studies of Gypsies and American mountain people to highly technical work with pulsed laser photography that helped produce a hologram of an exploding crystal ball for *National Geographic*'s 100th Anniversary cover.

Lt. Col. Michael Edrington (U.S. Army, Ret.)
Currently the director of the Defense Imagery Management Operations Center, Edrington was formerly the project director for the Army and Arlington National Cemetery. Lt. Col. Michael Edrington is an accomplished photographer whose more than 30 years in the military included many command and staff positions relating to photography, publishing, and visual communications. He was commander of the Army's 55th Signal Company (Combat Camera), deputy commander and publisher of *Stars & Stripes Pacific* in Tokyo, and commander of the American Forces Network Europe in Frankfurt. He co-curated the photo exhibit "Desert Storm, A Photographic Diary" at the Smithsonian's American History Museum and has received the National Press Photographers Association Morris Berman Award and the President's Medal for service to photojournalism.

Wendy Galietta
Wendy Galietta is manager of photo operations at the *Washington Post* and an accomplished and published photographer. A graduate of the Corcoran College of Art and Design in photography, she has won numerous photography awards while at the *Post*, including first place in the Pictures of the Year International Competition for feature story editing.

Lt. Haraz Ghanbari
A military liaison at the University of Toledo and a U.S. Navy public affairs officer, Lieutenant Ghanbari has also served as a photojournalist for the Associated Press in Washington. His résumé includes citations as student photographer of the year by both the Ohio Press Photographers Association and the National Press Photographers Association.

David Alan Harvey
A member of the prestigious Magnum group of photographers, David Alan Harvey combines journalistic storytelling with a distinctive artistry that makes him one of the world's most sought-after photographers. He has spent much of his career producing memorable stories for *National Geographic*, where he currently serves as a contributor. His many books include *Cuba* and *Divided Soul*, both of which have earned inclusion among the best photographic books of the year by *American Photo* magazine, and his more recent work, titled *(based on a true story)*. A native Virginian, he entered the graduate program of the University of Missouri School of Journalism and was a staff member of the *Topeka Capital-Journal* before returning to work on a documentary grant in Virginia.

Brian Lanker
Brian Lanker won the Pulitzer Prize in feature photography while at the *Topeka Capital-Journal* in 1973 and was twice named Newspaper Photographer of the Year by the National Press Photographers Association and the University of Missouri School of Journalism. He was director of photography at the *Register-Guard* in Eugene, Oregon, before leaving to produce major photographic essays for *Life* and *Sports Illustrated* in the 1980s. *I Dream a World*, his award-winning book and traveling exhibition of photographs of great African-American women was a runaway bestseller. He also produced the PBS documentary and accompanying book *They Drew Fire*, which tells the story of the American combat artists of World War II. Lanker died at his home in Eugene, Oregon, in 2011.

Tech. Sgt. Staci McKee
Assigned to the Office of Special Investigations Headquarters at Andrews Air Force Base, Tech. Sgt. Staci McKee is a member of the Air Force Reserve Security Forces. She worked for ten years as a photographer and picture editor for the Associated Press and as a photo editor and homepage editor for washingtonpost.com. She also served as assistant news director for usatoday.com before becoming deputy director of photography for the Army

Times Publishing Company. She graduated with a journalism degree from the University of Nebraska at Lincoln.

Jon Rizzi
Jon Rizzi began his two decades in magazine publishing at *Esquire* magazine. He went on to serve as managing editor of six different titles—among them *Town & Country, Woman's Day, ESPN The Magazine,* and *Travel & Leisure Golf*—before founding and editing the award-winning *Colorado AvidGolfer* magazine. His byline has appeared in *The American Lawyer, Popular Science, Luxury Living,* and *Golf*. He graduated from Vassar College with honors.

Sgt. Ferdinand Thomas
Sgt. Ferdinand Thomas is assigned to the 214th Mobile Public Affairs Detachment of the U.S. Army Reserve and is also one of the founding members of Made 7 Productions, a multimedia company. He has deployed to Iraq twice to cover conflict and document the life of U.S. and coalition troops through photos and video.

Thomas's photos have been published on many websites including those of National Geographic, the *Washington Post,* the *L.A. Times,* the *New York Times, Army Times,* and *Soldiers* magazine. His video work has been broadcast by such major media outlets as CNN, Fox News, ABC, NBC, NATO TV, and the Pentagon Channel. Thomas is also currently pursuing a computer engineering degree at Louisiana State University.

Master Sgt. James Varhegyi (U.S. Air Force, Ret.)
After 21 years in active duty, Jim Varhegyi is currently a civilian staff photographer for Headquarters Air Force Media Services in the Pentagon, where he provides photographic support to the Air Force's senior leadership. Such support includes shooting official portraits, documenting senior leader activities both in the National Capitol Region and throughout their travels, etc. Varhegyi has served in various photographic capacities for two decades. A graduate of the military photojournalism program at the S.I. Newhouse School of Communications at Syracuse University, he also served with the Air Force's First Combat Camera Squadron.

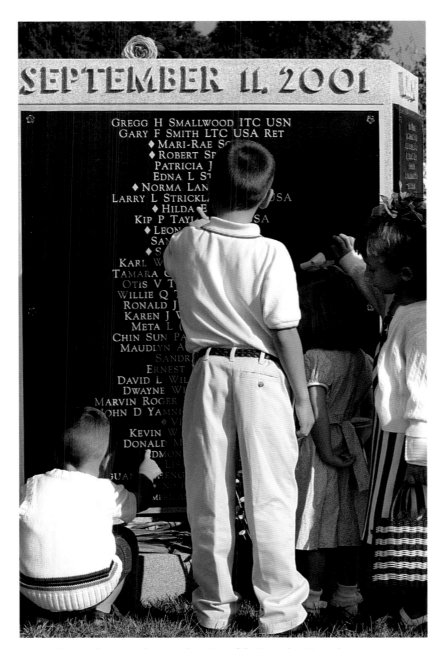

During the annual ceremony honoring the victims of the September 11 attack on the Pentagon, Liam and Meaghan Vauk and Patrick and Saoirse Deboy remember their father and uncle, Lt. Cmdr. Ronald J. Vauk USN, who perished that day.

ADDITIONAL READING

OWEN ANDREWS
Arlington National Cemetery: A Moment of Silence
Washington, D.C.: Preservation Press, 1994

PETER ANDREWS
In Honored Glory: The Story of Arlington
New York: G.P. Putnam's Sons, 1966

PHILIP BIGLER
In Honored Glory: Arlington National Cemetery: The Final Post
St. Petersburg, Florida: Vandamere Press, 2005

JOHN VINCENT HINKEL
Arlington: Monument to Heroes
Englewood Cliffs, New Jersey: Prentice-Hall, 1965

JAMES EDWARD PETERS
Arlington National Cemetery: Shrine to America's Heroes
Bethesda, Maryland: Woodbine House, 2000

TIM WARREN
"Hallowed Ground"
Washingtonian 34, no. 9 (June 1999)

National Park Service website: http://www.nps.gov/nr/travel/national_cemeteries/
Virginia/Arlington_National_Cemetery.html
Arlington National Cemetery website: www.arlingtoncemetery.org/
Buglers website: www.tapsbugler.com/24NotesExcerpt/Page1.html
Army Historical Foundation website: www.armyhistory.org

PHOTOGRAPHY CREDITS

PRESERVE THE PAST . . . EDUCATE THE FUTURE

THE ARMY HISTORICAL FOUNDATION is honored and pleased to sponsor this beautiful and touching tribute to Arlington National Cemetery and the men and women who are buried or interred there. It is particularly fitting that the Foundation sponsor this book. Since it was founded more than 30 years ago, the Foundation has sought to promote and preserve the history and traditions of the U.S. Army and the American Soldier for future generations. A nonprofit 501(c)(3), member-based organization, the Foundation is funded entirely by donations. Its members take seriously the mission to *Preserve the Past . . . Educate the Future* concerning the role of the American soldier in establishing, developing, and defending this nation since 1775. To do this, the Foundation conducts a number of activities in support of Army history. These include supporting restoration of historical artifacts; presentation of annual awards of excellence to local Army museums; encouragement of narrative historians with book awards; and conduct of educational historical tours. Its award-winning quarterly magazine, *On Point*, is entirely devoted to Army history. The largest and most significant project is the Foundation's ongoing campaign to raise money to build a National Museum of the U.S. Army—a multimillion-dollar partnership with the U.S. Army. To learn more about joining the Foundation, its activities, and how to support the museum campaign, go to www.armyhistory.org.

WHERE VALOR RESTS
Arlington National Cemetery

Published by the National Geographic Society

Gary E. Knell, President and Chief Executive Officer

John M. Fahey, Chairman of the Board

Declan Moore, Chief Media Officer

Chris Johns, Chief Content Officer

Prepared by the Book Division

Hector Sierra, Senior Vice President and General Manager

Janet Goldstein, Senior Vice President and Editorial Director

Jonathan Halling, Creative Director

Marianne R. Koszorus, Design Director

R. Gary Colbert, Production Director

Jennifer A. Thornton, Director of Managing Editorial

Susan S. Blair, Director of Photography

Meredith C. Wilcox, Director, Administration and Rights Clearance

Staff for This Book

Susan Straight, Editor

Zachary Galasi, Researcher

Marshall Kiker, Associate Managing Editor

Judith Klein, Production Editor

Mike Horenstein, Production Manager

Galen Young, Rights Clearance Specialist

Katie Olsen, Production Design Assistant

George Bounelis, Manager, Production Services

Additional Staff for Original Edition

Staff at Rich Clarkson and Associates

Staff for Arlington National Cemetery

Stephen A. Carney, Historian

Staff for Army Historical Foundation

Creighton W. Abrams, Jr., Brig. Gen. USA Ret., Executive Director

Raymond K. Bluhm, Jr., Col. USA Ret., Editor/Historian

The National Geographic Society is one of the world's largest nonprofit scientific and educational organizations. Its mission is to inspire people to care about the planet. Founded in 1888, the Society is member supported and offers a community for members to get closer to explorers, connect with other members, and help make a difference. The Society reaches more than 450 million people worldwide each month through *National Geographic* and other magazines; National Geographic Channel; television documentaries; music; radio; films; books; DVDs; maps; exhibitions; live events; school publishing programs; interactive media; and merchandise. National Geographic has funded more than 10,000 scientific research, conservation, and exploration projects and supports an education program promoting geographic literacy. For more information, visit www.nationalgeographic.com.

For more information, please call
1-800-NGS LINE (647-5463)
or write to the following address:

NATIONAL GEOGRAPHIC SOCIETY
1145 17th Street N.W.
Washington, D.C. 20036-4688
U.S.A.

For information about special discounts
for bulk purchases, please contact
National Geographic Books Special Sales:
ngspecsales@ngs.org

For rights or permissions inquiries,
please contact National Geographic Books Subsidiary Rights:
ngbookrights@ngs.org

ISBN: 978-1-4262-1481-3

The Library of Congress has cataloged the 2007 edition as follows:

Where Valor Rests : Arlington National Cemetery.
 p. cm.
 Includes essay by Rick Atkinson.
 Includes bibliographical references.
 ISBN 978-1-4262-0089-2 (hardcover : alk. paper)
 1. Arlington National Cemetery (Arlington, Va.)—Pictorial works. 2. Arlington National Cemetery (Arlington, Va.)—History. 3. Seasons—Virginia—Arlington—Pictorial works. 4. Arlington (Va.)—Biography. I. Atkinson, Rick. II. National Geographic Society (U.S.).
 F234.A7W48 2007
 973'.099—dc22

 2006038340

Printed in China

14/RRDS/1

FRENCH

delicious classic cuisine made easy

FRENCH

delicious classic cuisine made easy

CAROLE CLEMENTS & ELIZABETH WOLF-COHEN

HERMES HOUSE

This edition is published by Hermes House

Hermes House is an imprint of Anness Publishing Ltd
Hermes House, 88–89 Blackfriars Road, London SE1 8HA
tel. 020 7401 2077; fax 020 7633 9499; info@anness.com

© Anness Publishing Ltd 1995, 1997, 2001, 2002, 2003, 2004, 2005

Publisher: Joanna Lorenz
Senior Editor: Linda Fraser
Copy Editor: Christine Ingram
Indexer: Alex Corrin
Designer: Sheila Volpe
Photography and Styling: Amanda Heywood
Food for Photography: Elizabeth Wolf-Cohen assisted by Janet Brinkworth

The publishers would also like to thank Sopexa UK for the photographs appearing on pages 1, 6, 7, 8, 9, 11, 37, 65, 87, 117, 151,1 87, 215

Front cover shows an adapted version of Twice-baked soufflés. For recipe see page 74

Also published as *The French Recipe Cookbook*
1 3 5 7 9 10 8 6 4 2

NOTES

Standard spoon and cup measures are level.
Large eggs are used unless otherwise stated.

CONTENTS

THE FRENCH AND THEIR FOOD

The joys of the table are everything to the French and fundamental to their way of life. Food is a constant topic of conversation, talked about everywhere, on the Metro, in stores, in the office and at school. Mealtimes are sacrosanct – why do you think it is that at one o'clock, the traffic suddenly becomes much lighter? The French have their feet under the table.

In France, family meals are an occasion. An everyday event becomes a celebration of one of life's most basic pleasures, and special occasions, birthdays and holidays are lavishly enjoyed with food and wine.

It is therefore not surprising to learn that a French family spends a greater proportion of its budget on food than do many families elsewhere in the world. And money spent is rarely for convenience foods, but for top quality meat and poultry, fresh fish and shellfish and fine cheeses.

French cuisine is universally revered and is often seen as a benchmark for the cooking of other countries. But what makes it so special? Part of what distinguishes French cuisine is simply the attitude of the French towards food.

One element is the pride that the French have in their country, craftsmen and products. Chefs, cheesemakers, winemakers, pastry chefs and bakers are respected and even revered in a way unheard of elsewhere. At the foundation is a reverence for the raw material – the basic ingredient.

France is and always has been primarily an agricultural economy and fresh seasonal ingredients are widely available. In the past, the French housewife would shop twice a day for the two main meals. The constraints of modern life have brought change but it is characteristic that the French are

still prepared to spend time seeking out fine fresh products, rather than stocking up on processed food.

Similarly, the classic techniques of French cooking have been developed with a high regard for the ingredients, from the preparation of an onion to the cooking of exotic shellfish. The repertoire of techniques that forms the foundation of French cooking is not as extensive as you might think. Perhaps surprisingly, its variety and finesse rest on a

relatively small number of basic techniques. For example, sautéed chicken breasts with a wine and cream sauce require essentially the same cooking method as pan-fried trout with a lemon and butter sauce. This book will help you

The French pride themselves on cooking with the freshest and best ingredients, like these eggs on a Breton stall (above). Shrimps netted by a fisherman (right) are likely to be eaten within a day.

gain a basic knowledge of these techniques, so you too can cook "the French way".

French cuisine is not just one style of cooking. In restaurants particularly, it covers a wide spectrum of food. At the top, *haute cuisine* restaurants have several chefs, a large staff and well-equipped professional kitchens to make the elaborate recipes and complex sauces that are beyond the capabilities of untrained cooks. Traditional home cooking, which is centred on hearty stews, quick sautés and comforting desserts, can also be found in small, family restaurants. Many visitors to France are as

delighted with the food in these simple restaurants as in their more sophisticated counterparts. The common factor is the use of fresh ingredients and the pride and pleasure in making the most of them.

France is a land of variety and contrast, with a rich array of home-grown produce. Every region has its own specialities which reflect the local products and traditions. This regional food, *cuisine regionale*, has its roots in the home – cooking characterized by simple techniques and few ingredients – quite different from *haute cuisine*. Regional cuisine really came into its own after the

First World War when popular French food writers such as Curnonsky began to document it, going miles in search of the best *cassoulet* or *choucroute*.

The basic respect for the ingredients which characterizes French cooking was behind the *nouvelle cuisine* movement. The term was coined by the journalists Henri Gault and Christian Millau in the 1970s, to describe the dramatic changes taking place in the preparation of restaurant food, including simplified procedures, reduced cooking times, constantly changing menus offering the best of the marketplace, an emphasis on creativity and a rejection of marinating and flour-based sauces, so that the essential characteristics of the ingredients could be fully appreciated. Since then, the excesses of the movement, like over-decorated plates and minute portions, have thankfully all but disappeared, but the benefits of emphasizing the natural ingredients have remained an important part of a more heart-warming style of cooking. Escoffier's watchword, "*faites simple*", "keep it simple", may be surprising to those who think of French food as complicated and elaborate, but the essence of French cooking is simplicity – bringing out the best in the ingredients.

The French style of serving a meal differs from many other countries and for foreigners part of the enjoyment of French food is in eating "the French way", – in separate courses. Whether it is simply a fresh egg perfectly fried in butter or an extravagantly rich layered meringue cake, each part of a meal is savored separately.

Today, as in the past, most French people consider the midday meal the main one, although the demands of modern urban life make it more difficult to realize.

An informal family meal is likely to be two courses, a starter and main course, plus cheese and perhaps fresh fruit. If a dessert is served, the starter will be very light, but it is rarely omitted.

The starter sets the tone for the rest of the meal. Cooked vegetables, such as asparagus or artichokes with a flavorful dressing, or a slice of ham or pâté from the local *charcuterie*, are popular starters, as are composed salads or *crudités*. Soup has always been a traditional starter at supper, followed, perhaps, by a vegetable gratin or quiche. Egg

Geese wandering through a farmyard (above), a rustic weathered barn (right) and enthusiastic shoppers at a market (left) all capture the essence of country life in France.

and cheese dishes make more substantial starters and may also be served as a light lunch or as a main course for supper.

A rich or filling starter should be followed by a more spartan main course, such as steamed or poached fish. A plain green salad is often served with or after the main course, followed by a cheese course. Desserts are reserved for special meals and celebrations, and with the superb creations available in *pâtisseries*, a special dessert is more often bought than homemade.

Formal menus are more elaborate and offer five or sometimes more courses, each served with a wine to complement it. The meal might start with, for instance, a shellfish *hors d'oeuvre*, followed by a fish course, then a roast of meat or poultry, cheese and finally a dessert. *Petits fours*, small cakes and sweetmeats, might

be offered with the coffee. Restaurants often feature a *menu de dégustation*, a sort of sampler meal with multiple small courses highlighting the chef's specialities.

Sauces are perhaps the best known elements of French cuisine. The union of good ingredients and a skilfully made sauce elevates the simplest of dishes. A sauce can be as quick and easy as deglazing a pan with a few tablespoons of wine, or more elaborate like Béarnaise. Either way, the point is to make the food taste even better.

A good sauce should enhance food and not disguise it and some thought must be given, as well, to balancing the courses. A starter of asparagus with a rich hollandaise should not be followed by chicken breasts with a creamy sauce – a simple pan-fried sole or broiled lamb chop would be more appropriate.

For the French, wine is an

integral part of the meal. Just as a sauce is designed to complement the meat or vegetable it accompanies, so the wines are chosen to complement the whole meal. Many of the world's great wines come from France and French wine, like French cuisine, remains the standard for all others. In wine-producing regions people drink the wines of that area, and these wines almost invariably enhance the regional foods. In areas where wine is not produced, as in Normandy and Brittany, the local products – apples and pears – are made into other drinks, such as sparkling dry cider or Calvados.

You don't have to live in France to cook and eat "the French way". This book offers a tempting range of recipes from all over the country and these provide the key to unlocking the secrets of French cooking and enjoying it in your own home.

SOUPS
AND
SALADS

Soups and salads form two of the cornerstones of French cooking. Soup is the traditional evening meal – in fact, supper comes from the word *souper*, which means 'to take soup'. However, soups are also eaten at lunch and even at breakfast in some rural homes! Once merely a slice of bread with hot liquid, now the choice is immense and there are soups of every kind, from delicate consommés to hearty regional recipes. French salads are equally diverse, varying according to the seasons and regions. They range from the classic green salad to heartier combinations of vegetables, salad greens, meat, poultry and fish.

FRENCH ONION SOUP

Soupe à l'Oignon Gratinée

In France, this standard bistro fare is served so frequently, it is simply referred to as gratinée.

SERVES 6–8

1 tbsp butter
2 tbsp olive oil
4 large onions (about 1½ pounds),
 thinly sliced
2–4 garlic cloves, finely chopped
1 tsp sugar
½ tsp dried thyme
2 tbsp flour
½ cup dry white wine
8 cups chicken or beef broth
2 tbsp brandy (optional)
6–8 thick slices French bread, toasted
1 garlic clove
12 ounces Swiss cheese, grated

1 ▼ In a large heavy saucepan or flameproof casserole, heat the butter and oil over medium-high heat. Add the onions and cook for 10–12 minutes until they are softened and beginning to brown. Add the garlic, sugar and thyme and continue cooking over medium heat for 30–35 minutes until the onions are well browned, stirring frequently.

2 ▲ Sprinkle over the flour and stir until well blended. Stir in the white wine and broth and bring to a boil. Skim off any foam that rises to the surface, then reduce the heat and simmer gently for 45 minutes. Stir in the brandy, if using.

3 ▲ Preheat the broiler. Rub each slice of toasted French bread with the garlic clove. Place six or eight ovenproof soup bowls on a baking sheet and fill about three-quarters full with the onion soup.

4 ▲ Float a piece of toast in each bowl. Top with grated cheese, dividing it evenly, and broil about 6 inches from the heat for about 3–4 minutes until the cheese begins to melt and bubble.

ORIENTAL DUCK CONSOMMÉ *Consommé de Canard Orientale*

The Vietnamese community in France has had a profound influence on French cooking, as in this soup – light and rich at the same time, with its intriguing flavors of the Orient.

SERVES 4

1 duck carcass (raw or cooked), plus 2 legs or any giblets, trimmed of as much fat as possible
1 large onion, unpeeled, with root end trimmed
2 carrots, cut into 2 inch pieces
1 parsnip, cut into 2 inch pieces
1 leek, cut into 2 inch pieces
2–4 garlic cloves, crushed
1 inch piece fresh ginger root, peeled and sliced
1 tbsp black peppercorns
4–6 thyme sprigs, or 1 tsp dried thyme
1 small bunch cilantro (6–8 sprigs), leaves and stems separated

FOR THE GARNISH
1 small carrot
1 small leek, halved lengthwise
4–6 shiitake mushrooms, thinly sliced
soy sauce
2 scallions, thinly sliced
finely shredded watercress or Chinese cabbage
freshly ground black pepper

1 ▲ Put the duck carcass, the legs or giblets, the onion, carrots, parsnip, leek and garlic in a large heavy saucepan or flameproof casserole. Add the ginger, peppercorns, thyme and cilantro stems, cover with cold water and bring to a boil over medium-high heat, skimming any foam that rises to the surface.

2 Reduce the heat and simmer gently for 1½–2 hours, then strain through a cheesecloth-lined strainer into a bowl, discarding the bones and vegetables. Cool the broth and chill for several hours or overnight. Skim off any congealed fat and blot the surface with paper towels to remove any traces of fat.

3 ▲ To make the garnish, cut the carrot and leek into 2-inch pieces. Cut each piece lengthwise in thin slices, then stack and slice into thin julienne strips. Place in a large saucepan with the mushrooms.

4 ▲ Pour over the broth and add a few dashes of soy sauce and some pepper. Bring to a boil over medium-high heat, skimming any foam that rises to the surface. Adjust the seasoning. Stir in the scallions and watercress or Chinese cabbage. Ladle the consommé into warmed bowls and sprinkle with the cilantro leaves.

PROVENÇAL VEGETABLE SOUP

Soupe au Pistou

This satisfying soup captures all the flavors of a summer in Provence. The basil and garlic purée, pistou, *gives it extra color and a wonderful aroma – so don't omit it.*

SERVES 6–8

1½ cups fresh fava beans, shelled,
 or ¾ cup dried navy beans,
 soaked overnight
½ tsp dried herbes de Provence
2 garlic cloves, finely chopped
1 tbsp olive oil
1 onion, finely chopped
2 small or 1 large leek, finely sliced
1 celery stalk, finely sliced
2 carrots, finely diced
2 small potatoes, finely diced
4 ounces green beans
5 cups water
2 small zucchini, finely chopped
3 medium tomatoes, peeled, seeded and
 finely chopped
1 cup shelled garden peas, fresh
 or frozen
handful of spinach leaves, cut into thin
 ribbons
salt and freshly ground black pepper
sprigs of fresh basil, to garnish

FOR THE PISTOU
1 or 2 garlic cloves, finely chopped
½ cup (packed) basil leaves
4 tbsp grated Parmesan cheese
4 tbsp extra virgin olive oil

1 ▲ To make the *pistou*, put the garlic, basil and Parmesan cheese in a food processor and process until smooth, scraping down the sides once. With the machine running, slowly add the olive oil through the feed tube. Or, alternatively, pound the garlic, basil and cheese in a mortar and pestle and stir in the oil.

2 ▲ To make the soup, if using dried navy beans, place them in a saucepan and cover with water. Boil vigorously for 10 minutes and drain. Place the parboiled beans, or fresh beans if using, in a saucepan with the herbes de Provence and one of the garlic cloves. Add water to cover by 1 inch. Bring to the boil, reduce the heat and simmer over a medium-low heat until tender, about 10 minutes for fresh beans and about 1 hour for dried beans. Set aside in the cooking liquid.

3 ▲ In a large saucepan or flameproof casserole heat the oil. Add the onion and leeks, and cook for 5 minutes, stirring occasionally, until the onion just softens.

COOK'S TIP

Both the *pistou* and the soup can be made one or two days in advance and chilled. To serve, reheat gently, stirring occasionally.

4 ▲ Add the celery, carrots and the other garlic clove and cook, covered, for 10 minutes, stirring.

5 ▲ Add the potatoes, green beans and water, then season lightly with salt and pepper. Bring to a boil, skimming any foam that rises to the surface, then reduce the heat, cover and simmer gently for 10 minutes.

6 ▲ Add the zucchini, tomatoes and peas together with the reserved beans and their cooking liquid and simmer for 25–30 minutes, or until all the vegetables are tender. Add the spinach and simmer for 5 minutes. Season the soup and swirl a spoonful of *pistou* into each bowl. Garnish with basil and serve.

COLD LEEK AND POTATO SOUP

Vichyssoise

Serve this flavorful soup with a dollop of crème fraîche or sour cream and sprinkle with a few snipped fresh chives – or, on very special occasions, garnish with a small spoonful of caviar.

SERVES 6–8

1 pound potatoes (about 3 large),
 peeled and cubed
6 cups chicken broth
4 medium leeks, trimmed
2/3 cup crème fraîche or
 sour cream
salt and freshly ground black pepper
3 tbsp chopped fresh chives,
 to garnish

1 Put the potatoes and broth in a saucepan or flameproof casserole and bring to a boil. Reduce the heat and simmer for 15–20 minutes.

2 ▼ Make a slit along the length of each leek and rinse well under cold running water. Slice thinly.

3 ▲ When the potatoes are barely tender, stir in the leeks. Season with salt and pepper and simmer for 10–15 minutes until the vegetables are soft, stirring occasionally. If the soup appears too thick, thin it down with a little more broth or water.

4 ▲ Purée the soup in a blender or food processor, in batches if necessary. If you would prefer a very smooth soup, pass it through a food mill or press through a coarse sieve. Stir in most of the cream, cool and then chill. To serve, ladle into chilled bowls and garnish with a swirl of cream and chopped chives.

VARIATION

To make a low-fat soup, use low-fat sour cream. Alternatively, leave out the cream altogether and thin the soup with a little skim milk.

FRESH PEA SOUP

Potage Saint-Germain

This soup takes its name from a suburb of Paris where peas used to be cultivated in market gardens.
If fresh peas are not available, use frozen peas, but thaw and rinse them before use.

<u>SERVES 2–3</u>

pat of butter
2 or 3 shallots, finely chopped
3 cups shelled fresh peas (from
* about 3 pounds garden peas)*
* or thawed frozen peas*
2 cups water
3–4 tbsp whipping cream
* (optional)*
salt and freshly ground black pepper
croûtons or crumbled crisp bacon,
* to garnish*

1 ▲ Melt the butter in a heavy saucepan or flameproof casserole. Add the shallots and cook for about 3 minutes, stirring occasionally.

2 ▲ Add the peas and water and season with salt and a little pepper. Cover and simmer for about 12 minutes for young or frozen peas and up to 18 minutes for large or older peas, stirring occasionally.

3 ▲ When the peas are tender, ladle them into a food processor or blender with a little of the cooking liquid and process until smooth.

4 ▼ Strain the soup into the saucepan or casserole, stir in the cream, if using, and heat through without boiling. Add seasoning and serve hot, garnished with croûtons or bacon.

ASPARAGUS SOUP WITH CRAB *Crème d'Argenteuil au Crabe*

The word Argenteuil in any French recipe almost always indicates asparagus. It refers to the town in north central France famed for this superb seasonal delicacy.

SERVES 6–8

3 pounds fresh asparagus
2 tbsp butter
6 cups chicken broth
2 tbsp cornstarch
½ cup whipping cream
salt and freshly ground black pepper
6–7 ounces white crab meat,
 to garnish

1 Trim the woody ends from the bottom of the asparagus spears and cut the spears into 1 inch pieces.

2 ▼ Melt the butter in a heavy saucepan or flameproof casserole over medium-high heat. Add the asparagus and cook for 5–6 minutes, stirring frequently, until they are bright green, but not browned.

3 ▲ Add the broth and bring to a boil over a high heat, skimming off any foam that rises to the surface. Simmer over medium heat for 3–5 minutes until the asparagus is tender, yet crisp. Reserve 12–16 of the asparagus tips for garnishing. Season with salt and pepper, cover and continue cooking for about 15–20 minutes until very tender.

4 ▲ Purée the soup in a blender or food processor and pass the mixture through the fine blade of a food mill back into the saucepan. Bring the soup back to a boil over medium-high heat. Blend the cornstarch with 2–3 tbsp of cold water and whisk into the boiling soup to thicken it. Stir in the cream and adjust the seasoning.

5 To serve, ladle the soup into bowls and top each with a spoonful of the crab meat and a few of the reserved asparagus tips.

WILD MUSHROOM SOUP *Velouté de Champignons Sauvages*

In France, many people pick their own wild mushrooms, taking them to a pharmacist to be checked before using them in all sorts of delicious dishes. The dried mushrooms bring an earthy flavor to this soup, but use 6 ounces fresh wild mushrooms instead when available.

SERVES 6–8

1 ounce dried wild mushrooms, such as morels, cèpes or porcini
6 cups chicken broth
2 tbsp butter
2 onions, coarsely chopped
2 garlic cloves, chopped
2 pounds button or other cultivated mushrooms, trimmed and sliced
½ tsp dried thyme
¼ tsp ground nutmeg
2–3 tbsp flour
½ cup Madeira or dry sherry
½ cup crème fraîche or sour cream
salt and freshly ground black pepper
snipped fresh chives, to garnish

1 ▲ Put the dried mushrooms in a strainer and rinse well under cold running water, shaking to remove as much sand as possible. Place them in a saucepan with 1 cup of the broth and bring to a boil over medium-high heat. Remove the pan from the heat and set aside for 30–40 minutes to soak.

COOK'S TIP

Serve the soup with a little extra cream swirled on top, if you like.

2 Meanwhile, in a large heavy saucepan or flameproof casserole, melt the butter over medium-high heat. Add the onions and cook for 5–7 minutes until they are well softened and just golden.

3 ▲ Stir in the garlic and fresh mushrooms and cook for 4–5 minutes until they begin to soften, then add the salt and pepper, thyme and nutmeg and sprinkle over the flour. Cook for 3–5 minutes, stirring frequently, until blended.

4 ▲ Add the Madeira or sherry, the remaining chicken broth, the dried mushrooms and their soaking liquid and cook, covered, over medium heat for 30–40 minutes until the mushrooms are very tender.

5 Purée the soup in batches in a blender or food processor. Strain it back into the saucepan, pressing firmly to force the purée through the sieve. Stir in the crème fraîche or sour cream and sprinkle with the snipped chives just before serving.

SUMMER TOMATO SOUP

Soupe de Tomates Fraîches

The success of this soup depends on having ripe, full-flavored tomatoes, such as the plum variety, so make it when the tomato season is at its peak. It is equally delicious served cold.

SERVES 4

1 tbsp olive oil
1 large onion, chopped
1 carrot, chopped
2¼ pounds ripe tomatoes, cored and
 quartered
2 garlic cloves, chopped
5 thyme sprigs, or ¼ tsp dried
 thyme
4 or 5 marjoram sprigs, or ¼ tsp
 dried marjoram
1 bay leaf
3 tbsp crème fraîche, sour cream
 or yogurt, plus a little extra
 to garnish
salt and freshly ground black pepper

1 Heat the olive oil in a large preferably stainless steel saucepan or flameproof casserole.

2 ▼ Add the onion and carrot and cook over a medium heat for 3–4 minutes, until just softened, stirring occasionally.

VARIATION

To serve the soup cold, omit the cream or yogurt and leave to cool, then chill.

3 ▲ Add the tomatoes, garlic and herbs. Reduce the heat and simmer, covered, for 30 minutes.

4 Pass the soup through a food mill or press through a sieve into the pan. Stir in the cream or yogurt and season. Reheat gently and serve garnished with a spoonful of cream or yogurt and a sprig of marjoram.

PUMPKIN SOUP

Crème de Citrouille

When the first frosts of autumn chill the air, large bright orange pumpkins are a vivid sight at local markets all over France and provide the basis for some warm and comforting soups.

SERVES 6–8

2 tbsp butter
1 large onion, chopped
2 shallots, chopped
2 medium potatoes, peeled and cubed
6 cups cubed pumpkin
8 cups chicken or vegetable broth
½ tsp ground cumin
pinch of ground nutmeg
salt and freshly ground black pepper
fresh parsley or chives, to garnish

1 Melt the butter in a large saucepan. Add the onion and shallots to the pan and cook for 4–5 minutes until just softened.

2 ▲ Add the potatoes, pumpkin, broth and spices to the pan, and season with a little salt and black pepper. Reduce the heat to low and simmer, covered, for about 1 hour, stirring occasionally.

3 ▼ With a slotted spoon, transfer the cooked vegetables to a food processor and process until smooth, adding a little of the cooking liquid if needed. Return the purée to the pan and stir into the cooking liquid. Adjust the seasoning and reheat gently. Garnish with the fresh herbs.

SAFFRON MUSSEL SOUP

Soupe de Moules Safranée

This is one of France's most delicious seafood soups – for day-to-day eating, the French would normally serve all the mussels in their shells. Serve with plenty of French bread.

SERVES 4–6

3 tbsp unsalted butter
8 shallots, finely chopped
1 bouquet garni
1 tsp black peppercorns
1½ cups dry white wine
2¼ pounds mussels, scrubbed and
 debearded
2 medium leeks, trimmed and finely
 chopped
1 fennel bulb, finely chopped
1 carrot, finely chopped
several saffron strands
4 cups fish or chicken broth
½ cup whipping cream
2–3 tbsp cornstarch, blended with
 3 tbsp cold water
½ cup whipping cream
1 medium tomato, peeled, seeded and
 finely chopped
2 tbsp Pernod (optional)
salt and freshly ground black pepper

1 ▲ In a large heavy pan, melt half the butter over a medium-high heat. Add half the shallots and cook for 1–2 minutes until softened but not colored. Add the bouquet garni, peppercorns and white wine and bring to a boil. Add the mussels, cover tightly and cook over a high heat for 3–5 minutes, shaking the pan occasionally, until the mussels have opened.

2 With a slotted spoon, transfer the mussels to a bowl. Strain the liquid through a cheesecloth-lined strainer and reserve.

3 ▲ When the mussel shells are cool enough to handle, pull open and remove most of the mussels, adding any extra juices to the reserved liquid. Discard any closed mussels.

4 Rinse the saucepan and melt the remaining butter over medium heat. Add the remaining shallots and cook for 1–2 minutes. Add the leeks, fennel, carrot and saffron and cook for 3–5 minutes until softened.

5 Stir in the reserved cooking liquid, bring to a boil and cook for 5 minutes until the vegetables are tender and the liquid is slightly reduced. Add the broth and bring to a boil, skimming any foam that rises to the surface. Season with salt, if needed, and black pepper and cook for 5 minutes more.

6 ▲ Stir the blended cornstarch into the soup. Simmer for 2–3 minutes until the soup is slightly thickened, then add the cream, mussels and chopped tomato. Stir in Pernod, if using, and cook for 1–2 minutes until hot, then serve at once.

SHRIMP BISQUE

Bisque de Crevettes

The classic French method for making a bisque requires pushing the shellfish through a tamis, or drum sieve. This is much simpler and the result is just as smooth.

<u>SERVES 6–8</u>

1½ pounds small or medium cooked
 shrimp in the shell
1½ tbsp vegetable oil
2 onions, halved and sliced
1 large carrot, sliced
2 celery stalks, sliced
8 cups water
a few drops of lemon juice
2 tbsp tomato paste
bouquet garni
4 tbsp butter
⅓ cup flour
3–4 tbsp brandy
⅔ cup whipping cream
salt and white pepper

1 Remove the heads from the shrimp and peel away the shells, reserving the heads and shells for the stock. Chill the peeled shrimp.

2 ▲ Heat the oil in a large saucepan, add the shrimp heads and shells and cook over high heat, stirring frequently, until they start to brown. Reduce the heat to medium, add the onions, carrot and celery and fry gently, stirring occasionally, for about 5 minutes until the onions start to soften.

3 Add the water, lemon juice, tomato paste and bouquet garni. Bring the broth to a boil, then reduce the heat, cover and simmer gently for 25 minutes. Strain the broth through a sieve.

4 ▼ Melt the butter in a heavy saucepan over medium heat. Stir in the flour and cook until just golden, stirring occasionally. Add the brandy and gradually pour in about half of the shrimp broth, whisking vigorously until smooth, then whisk in the remaining liquid. Season with salt, if necessary, and white pepper. Reduce the heat, cover and simmer for 5 minutes, stirring frequently.

5 ▲ Strain the soup into a clean saucepan. Add the cream and a little extra lemon juice to taste, then stir in most of the reserved shrimp and cook over medium heat, stirring frequently, until hot. Serve at once garnished with the reserved shrimp.

CRUDITÉS

A colorful selection of raw vegetables, or crudités, *is often served in France as a quick and easy accompaniment to drinks or as small starters before lunch, especially in warm weather.*

The term *crudités* is used both for small pieces of vegetables served with a tasty dip and for a selection of vegetable salads presented in separate dishes. Country-style restaurants often feature a selection of *crudités* and sometimes a whole trolley of individual vegetables salads in small *raviers*, or shallow dishes, arrives. At a family lunch, at least two or three salads would be served. Their appeal lies in the use of fresh uncomplicated ingredients and a selection which offers visual and textural contrasts.

By choosing contrasting colors, any combination of vegetables, raw or lightly cooked, attractively arranged on a platter or in baskets and served with a tangy dip, such as *aïoli* or *tapenade*, can make a beautiful presentation. Allow 3–4 ounces of each vegetable per person. Remember, leftovers can be used in soups or a stir-fry. Add fruits, cold meats or seafood and a pretty herb or flower garnish – anything goes as long as you like it.

Aïoli (Garlic mayonnaise)

Put 4 crushed garlic cloves (or more or less to taste) in a small bowl with a pinch of salt and crush with the back of a spoon. Add 2 egg yolks and beat for 30 seconds with an electric mixer until creamy. Beat in 1 cup extra virgin olive oil, by drops

until the mixture thickens. As it begins to thicken, the oil can be added in a thin stream until the mixture is thick. Thin the sauce with a little lemon juice and season to taste. Chill for up to 2 days; bring to room temperature and stir before serving.

Tapenade (Provençal olive paste)
Put 7 ounces pitted black olives, 6 anchovy fillets, 2 tbsp capers, rinsed, 1 or 2 garlic cloves, 1 tsp fresh thyme leaves, 1 tbsp Dijon mustard, juice of half a lemon, freshly ground black pepper and, if you like, 1 tbsp brandy in a food processor fitted with the metal blade. Process for 15–30 seconds until smooth, scraping down the sides of the bowl. With the machine running, slowly pour in 4–6 tbsp extra virgin olive oil to make a smooth firm paste. Store in an airtight container.

Raw Vegetable Platter
Assiette de crudités

SERVES 6–8
2 red and yellow bell peppers, sliced lengthwise
8 ounces fresh baby corn, blanched
1 chicory head (red or white), trimmed and leaves separated
6–8 ounces thin asparagus, trimmed and blanched
small bunch radishes with small leaves attached, washed
6 ounces cherry tomatoes, washed
12 quail's eggs, boiled for 3 minutes, drained, refreshed and peeled
aïoli or tapenade, for dipping

Arrange a selection of prepared vegetables, such as those above, on a serving plate. Cover with a damp dish towel until ready to serve.

Tomato and Cucumber Salad
Salade de tomates et concombre

SERVES 4–6
1 medium cucumber, peeled and thinly sliced
2 tbsp white wine vinegar
⅓ cup crème fraîche or sour cream
2 tbsp chopped fresh mint
4 or 5 ripe tomatoes, sliced
salt and freshly ground black pepper

Arrange the tomato slices on a serving plate, sprinkle with the remaining vinegar, and spoon the cucumber slices into the center.

Place the cucumber in a bowl, sprinkle with a little salt and 1 tbsp of the vinegar and toss with 5 or 6 ice cubes. Chill for 1 hour to crisp, then rinse, drain and pat dry. Return to the bowl, add the cream, pepper and mint and stir to mix well.

Carrot and Orange Salad
Carottes rapées à l'orange

SERVES 4–6
1 garlic clove, crushed
grated rind and juice of 1 large orange
2–3 tbsp grapeseed or peanut oil
1 pound carrots, cut into very fine
 julienne strips
2–3 tbsp chopped fresh parsley
salt and freshly ground black pepper

Rub a bowl with the garlic and leave in the bowl. Add the orange rind and juice and salt and pepper. Whisk in the oil until blended then remove the garlic. Add the carrots, half of the parsley and toss well. Garnish with the remaining parsley.

MIXED GREEN SALAD

Salade de Mesclun

Mesclun is a ready-mixed Provençal green salad composed of several kinds of salad greens and herbs. A typical combination might include arugula, radicchio, lamb's lettuce and curly endive with herbs such as chervil, basil, parsley and tarragon.

<u>SERVES 4–6</u>

1 garlic clove, peeled
2 tbsp red wine or sherry vinegar
1 tsp Dijon mustard (optional)
5–8 tbsp extra virgin olive oil
7–8 ounces mixed salad greens and herbs
salt and freshly ground black pepper

VARIATION

Mesclun always contains some pungent leaves. When dandelion leaves are in season, they are usually found in the mixture, so use them when available.

1 Rub a large salad bowl with the garlic clove and leave in the bowl.

2 ▼ Add the vinegar, salt and pepper and mustard, if using. Stir to mix the ingredients and dissolve the salt, then whisk in the oil slowly.

3 ▲ Remove the garlic clove and stir the vinaigrette to combine. Add the greens and herbs to the bowl and toss well. Serve the salad at once.

APPLE AND CELERY ROOT SALAD

Pommes et Celeriac Remoulade

Celery root, despite its coarse appearance, has a sweet and subtle flavor. Traditionally parboiled in lemony water, in this salad it is served raw, allowing its unique taste and texture to come through.

<u>SERVES 3–4</u>

1 celery root (about 1½ pounds), peeled
2–3 tsp lemon juice
1 tsp walnut oil (optional)
1 apple
3 tbsp mayonnaise
2 tsp Dijon mustard
1 tbsp chopped fresh parsley
salt and freshly ground black pepper

1 Using a food processor or coarse cheese grater, shred the celery root. Alternatively, cut it into very thin julienne strips. Place the celery root in a bowl and sprinkle with the lemon juice and the walnut oil, if using. Stir well to mix.

2 ▲ Peel the apple, if you like, and cut into quarters and remove the core. Slice thinly crosswise and toss with the celery root.

3 ▼ Mix together the mayonnaise, mustard, parsley and salt and pepper to taste. Stir into the celery root mixture and mix well. Chill for several hours until ready to serve.

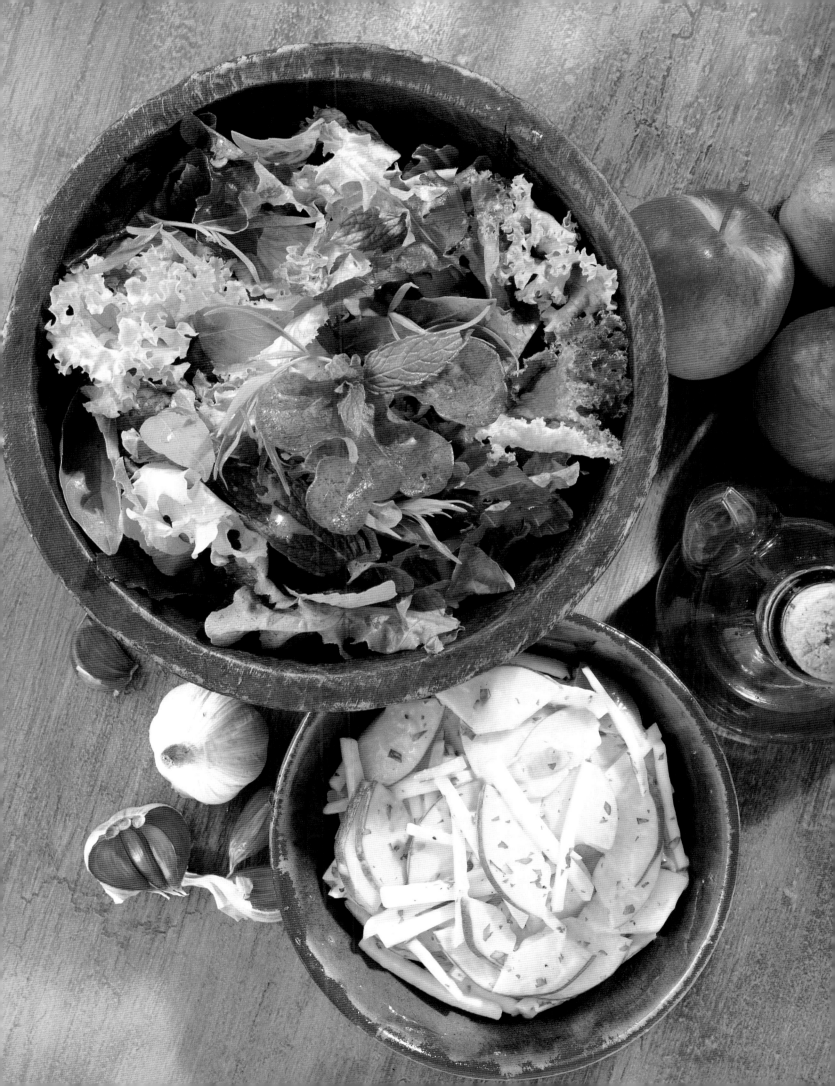

PROVENÇAL SALAD

Salade Niçoise

There are probably as many versions of this salad as there are cooks in Provence. With good French bread, this regional classic makes a wonderful summer lunch or light supper.

SERVES 4–6

8 ounces green beans
1 pound new potatoes, peeled and cut into 1 inch pieces
white wine vinegar and olive oil, for sprinkling
1 small Romaine or Boston lettuce, washed, dried and torn into bite-size pieces
4 ripe plum tomatoes, quartered
1 small cucumber, peeled, seeded and diced
1 green or red bell pepper, thinly sliced
4 hard-boiled eggs, peeled and quartered
24 Niçoise or black olives
8 ounce can tuna in water, drained
2 ounce can anchovy fillets in olive oil, drained
basil leaves, to garnish
garlic croûtons, to serve
FOR THE ANCHOVY VINAIGRETTE
1 heaping tbsp Dijon mustard
2 ounces can anchovy fillets in olive oil, drained
1 garlic clove, crushed
4 tbsp lemon juice or white wine vinegar
½ cup sunflower oil
½ cup extra virgin olive oil
freshly ground black pepper

COOK'S TIP

To make garlic croûtons, thinly slice a baguette or cut larger loaves, such as rustic country bread, into 1 inch cubes. Place the bread in a single layer on a baking sheet and bake in a 350°F oven for 7–10 minutes or until golden, turning once. Rub the toast with a garlic clove and serve hot, or cool then store in an airtight container to serve at room temperature.

1 ▲ First make the anchovy vinaigrette. Place the mustard, anchovies and garlic in a bowl and blend together by pressing the garlic and anchovies against the sides of the bowl. Season generously with pepper. Using a small whisk, blend in the lemon juice or wine vinegar. Slowly whisk in the sunflower oil in a thin stream and then the olive oil, whisking until the dressing is smooth and creamy.

2 Alternatively, put all the ingredients except the oil in a food processor fitted with the metal blade and process to combine. With the machine running, slowly add the oils in a thin stream until the vinaigrette is thick and creamy.

3 ▲ Drop the green beans into a large saucepan of boiling water and boil for 3 minutes until tender, yet crisp. Transfer the beans to a colander with a slotted spoon, then rinse under cold running water. Drain again and set aside.

4 ▲ Add the potatoes to the same boiling water, reduce the heat and simmer for 10–15 minutes until just tender, then drain. Sprinkle with a little vinegar and olive oil and a spoonful of the vinaigrette.

5 ▲ Arrange the lettuce on a platter, top with the tomatoes, cucumber and pepper, then add the green beans and potatoes.

6 ▲ Arrange the eggs, olives, tuna and anchovies on top and garnish with the basil leaves. Drizzle with the remaining vinaigrette and serve with garlic croûtons.

POTATO SALAD WITH SAUSAGE

Salade de Pommes de Terre

This salad is often served in bistros and cafés as a starter. Sometimes the potatoes are served on their own, simply dressed with vinaigrette and perhaps accompanied by marinated herring.

SERVES 4

1 pound small waxy potatoes
2–3 tbsp dry white wine
2 shallots, finely chopped
1 tbsp chopped fresh parsley
1 tbsp chopped fresh tarragon
6 ounces cooked garlic sausage, such as
 kielbasa
a sprig of parsley, to garnish
FOR THE VINAIGRETTE
2 tsp Dijon mustard
1 tbsp tarragon vinegar or white
 wine vinegar
5 tbsp extra virgin olive oil
salt and freshly ground black pepper

1 ▼ In a medium saucepan, cover the potatoes with cold salted water and bring to a boil. Reduce the heat to medium and simmer for 10–12 minutes until tender. Drain the potatoes and refresh under cold running water.

2 ▼ Peel the potatoes if you like or leave in their skins and cut into ¼ inch slices. Sprinkle with the wine and shallots.

3 ▲ To make the vinaigrette, mix the mustard and vinegar in a small bowl, then whisk in the oil, 1 tbsp at a time. Season and pour over the potatoes.

4 ▲ Add the herbs to the potatoes and toss until well mixed.

5 ▲ Slice the sausage thinly and toss with the potatoes. Season with salt and pepper to taste and serve at room temperature garnished with a parsley sprig.

CURLY ENDIVE SALAD WITH BACON *Frisée aux Lardons*

This country-style salad is popular all over France. When they are in season, dandelion leaves often replace the endive and the salad is sometimes sprinkled with chopped hard-boiled egg.

SERVES 4

6 cups curly endive or escarole leaves
5–6 tbsp extra virgin olive oil
6 ounce piece of smoked bacon, diced, or
 6 thick-cut bacon slices, cut crosswise
 into thin strips
1 cup white bread cubes
1 small garlic clove, finely chopped
1 tbsp red wine vinegar
2 tsp Dijon mustard
salt and freshly ground black pepper

1 ▲ Tear the lettuce into bite-size pieces and put in a salad bowl.

2 ▲ Heat 1 tbsp of the oil in a medium non-stick frying pan over a medium-low heat and add the bacon. Fry gently until well browned, stirring occasionally. Remove the bacon with a slotted spoon and drain on paper towels.

3 ▼ Add another 2 tbsp of oil to the pan and fry the bread cubes over medium-high heat, turning frequently, until evenly browned. Remove the bread cubes with a slotted spoon and drain on paper towels. Discard any remaining fat.

4 ▲ Stir the garlic, vinegar and mustard into the pan with the remaining oil and heat until just warm, whisking to combine. Season to taste, then pour the dressing over the salad and sprinkle with the fried bacon and croûtons.

31

MUSHROOM SALAD *Salade de Champignons à la Crème*

This simple refreshing salad is often served as part of a selection of vegetable salads, or crudités. *Letting it stand before serving brings out the inherent sweetness of the mushrooms.*

SERVES 4

6 ounces white mushrooms, trimmed
grated rind and juice of ½ lemon
about 2–3 tbsp crème fraîche or
 sour cream
salt and white pepper
1 tbsp snipped fresh chives,
 to garnish

VARIATION

If you prefer, toss the mushrooms
in a little vinaigrette – made by
whisking 4 tbsp walnut oil or
extra virgin olive oil into
the lemon juice.

1 ▼ Slice the mushrooms thinly
and place in a bowl. Add the lemon
rind and juice and the cream, adding
a little more cream if needed. Stir
gently to mix, then season with salt
and pepper.

2 ▲ Let the salad stand for at least
1 hour, stirring occasionally.

3 Sprinkle the salad with snipped
chives before serving.

LAMB'S LETTUCE AND BEETS *Salade de Mache aux Betteraves*

This salad makes a colorful and unusual starter – the delicate flavor of the lamb's lettuce is perfect with the tangyness of the beets. If you like, sprinkle with chopped walnuts before serving.

SERVES 4

3–4 cups lamb's lettuce, washed and
 roots trimmed
3 or 4 small beets, cooked, peeled and
 diced
2 tbsp chopped fresh parsley
FOR THE VINAIGRETTE
2–3 tbsp white wine vinegar or
 lemon juice
1 heaping tbsp Dijon mustard
2 garlic cloves, finely chopped
½ tsp sugar
½ cup sunflower or grapeseed oil
½ cup crème fraîche or heavy cream
salt and freshly ground black pepper

1 First make the vinaigrette. Mix
the vinegar or lemon juice, mustard,
garlic, sugar, salt and pepper in a
small bowl, then slowly whisk in the
oil until the sauce thickens.

3 ▲ Toss the lettuce with a little of
the vinaigrette and arrange on a
serving plate or in a bowl.

4 Spoon the beets into the center of
the lettuce and drizzle over the
remaining vinaigrette. Sprinkle with
chopped parsley and serve at once.

2 ▲ Lightly beat the crème fraîche
or heavy cream to lighten it slightly,
then whisk it into the dressing.

COMPOSED SALADS *Salade Composée*

Composed salads make perfect starters. They are light and colorful and lend themselves to endless variation – and the components can often be prepared ahead for quick assembly.

The French are masters of the composed salad. Any combination of ingredients can be used – let your imagination and your palate guide you. Arranged attractively on a plate or in a bowl, this type of salad offers contrasting flavors, textures and colors. Raw or cooked vegetables, fresh fruits, hard-boiled chicken or quail eggs, smoked or cooked poultry, meat, fish or shellfish can all be used, but it is important that the dressing or other seasoning unite all the elements harmoniously.

Unlike a tossed salad such as *Salade de Mesclun*, in which the leaves are tossed together with a simple vinaigrette, the components of a composed salad are kept more separate. The ingredients might be arranged in groups, sometimes on a base of lettuce or other leaves, or simply arranged in circles on the plate. Composed salads, like *Salade Niçoise* or any of the following salads, are often served as a first course or a light main course, especially in warm weather. A tossed green salad is frequently eaten after the main course and is generally thought to clear the palate for the cheese course or dessert.

Shrimp, Avocado and Citrus Salad
Salade de crevettes aux agrumes

SERVES 6
1 tbsp fresh lemon juice
1 tbsp fresh lime juice
1 tbsp honey
3 tbsp olive oil
2–3 tbsp walnut oil
2 tbsp chopped fresh chives
1 pound cooked large shrimp, shelled and deveined
1 avocado, peeled, pitted and cut into tiny dice
1 pink grapefruit, peeled and segmented
1 large navel orange, peeled and segmented
2 tbsp toasted pine nuts (optional)
salt and freshly ground black pepper

Blend the lemon and lime juices, salt and pepper and honey in a small bowl. Slowly whisk in the olive oil, then the walnut oil to make a creamy sauce, then stir in the chopped chives. Arrange the shrimp with the avocado slices, grapefruit and orange segments on individual plates. Drizzle over the dressing and sprinkle with the toasted pine nuts, if using.

Smoked Salmon Salad with Dill
Salade de saumon fumé à l'aneth

SERVES 4
2 tbsp fresh lemon juice
½ cup extra virgin olive oil
2 tbsp chopped fresh dill, plus a few sprigs for garnishing
8 ounces smoked salmon, thinly sliced
1 fennel bulb, thinly sliced
1 medium cucumber, seeded and cut into julienne strips
black pepper
caviar, to garnish (optional)

Arrange the salmon slices on four individual plates and arrange the slices of fennel on top, then scatter the cucumber julienne over. Mix together the lemon juice and pepper in a small bowl. Slowly whisk in the olive oil to make a creamy vinaigrette. Stir in the chopped dill. Spoon a little vinaigrette over the fennel and cucumber slices. Drizzle the remaining vinaigrette over the salmon and garnish with sprigs of dill. Top each salad with a spoonful of caviar if desired.

Belgian Endive Salad with Roquefort
Salade aux endives et au Roquefort

SERVES 4
2 tbsp red wine vinegar
1 tsp Dijon mustard
¼ cup walnut oil
1–2 tbsp sunflower oil
2 Belgian Endive heads, white or red
1 celery heart or 4 celery stalks, peeled and cut into julienne strips
1 cup walnut halves, lightly toasted
2 tbsp chopped fresh parsley
4 ounces Roquefort cheese, crumbled
salt and freshly ground black pepper

Whisk together the vinegar, mustard, salt and pepper to taste in a small bowl. Slowly whisk in the walnut oil, then the sunflower oil. Arrange the endive on individual plates. Scatter the celery, walnut halves and parsley over. Crumble equal amounts of Roquefort cheese over each plate and drizzle a little vinaigrette over each.

VEGETABLES AND SIDE DISHES

If you visit any French market, you will be struck by the abundance of fresh vegetables. The selection will depend on the region and the time of year, but the French cook can always make the most of what's available. Vegetables are so highly regarded that, except for potatoes, they are very often served on a separate plate, or even as a separate course, so that they can be savored and appreciated for their own sake. In many homes, a family lunch would also include vegetables as a first course – this might be in the form of *crudités*, as a colorful composed salad, or cooked and served with a sauce.

ARTICHOKES WITH VINAIGRETTE *Artichauts Vinaigrette*

The French enjoy artichokes prepared in many different ways. Simply cooked and eaten leaf by leaf is one of the best ways to savor the delicate flavor of the large artichokes.

SERVES 2

2 globe artichokes (about 9–12 ounces each)
½ lemon
FOR THE VINAIGRETTE
1 shallot, very finely chopped
1½ tsp Dijon mustard
2 tsp lemon juice
2 tbsp extra virgin olive oil
2 tbsp vegetable oil
salt and freshly ground black pepper

1 Cut off about 1½ inches from the top of each artichoke. Using kitchen scissors, trim the tops of the remaining leaves to remove the sharp points and browned edges. Rub the cut surfaces with lemon juice to prevent discoloration, then cut the stem level with the base.

2 ▼ Wrap each artichoke in microwavable plastic wrap and stand on a large plate in the microwave or place directly on to the turntable. Microwave on High (full power) for about 10 minutes (7 minutes for one) until tender when the base is pressed; continue cooking at 1 minute intervals, if necessary. Let stand for 5 minutes, then prick the plastic to release the steam and unwrap.

3 ▲ Let the artichokes cool slightly, then, using a small sharp spoon, scrape out the "choke" (the prickly inner leaves and the fuzzy layer underneath).

4 ▲ To make the vinaigrette, place the shallot, mustard, lemon juice and salt and pepper in a small bowl and stir to mix. Gradually add the oil, 1 tbsp at a time, whisking until thickened.

5 Fill the center of each artichoke with the vinaigrette and serve.

COOK'S TIP

Cooking artichokes in the microwave saves a lot of bother. Or, cook them in a large saucepan of boiling water with a few tablespoons each of vinegar and flour, with a heat resistant plate resting on top of them to keep them submerged.

STUFFED ARTICHOKE BOTTOMS *Fonds d'Artichauts aux Duxelles*

This recipe is a partnership of two favorites of classic French cuisine: duxelles *– the savory chopped mushrooms used in the filling – and the artichoke with its distinctive delicate flavor.*

SERVES 4–6

8 ounces button mushrooms
1 tbsp butter
2 shallots, finely chopped
2 ounces full- or medium-fat soft cheese
2 tbsp chopped walnuts
3 tbsp grated Swiss cheese
4 large or 6 small artichoke bottoms
 (from cooked artichokes, leaves and
 choke removed, or cooked frozen or
 canned artichoke bottoms)
salt and freshly ground black pepper
fresh parsley sprigs, to garnish

1 ▲ Wipe or rinse the mushrooms and pat dry. Put them in a food processor fitted with the metal blade and pulse until finely chopped.

2 ▲ Melt the butter in a non-stick frying pan and cook the shallots over medium heat for 2–3 minutes until just softened. Add the mushrooms, raise the heat slightly, and cook for 5–7 minutes until they have rendered and reabsorbed their liquid and are almost dry, stirring frequently. Season with salt and pepper.

3 Preheat the oven to 400°F. Lightly grease a shallow baking pan or dish.

4 ▼ In a small bowl, combine the soft cheese and mushrooms. Add the walnuts and half the grated cheese.

5 ▲ Divide the mushroom mixture among the artichoke bottoms and arrange them in the baking pan or dish. Sprinkle over the remaining cheese and bake for 12–15 minutes, or until bubbly and browned. Serve hot, garnished with parsley sprigs.

WARM LEEKS WITH VINAIGRETTE *Poireaux à la Vinaigrette*

In France, leeks are sometimes called "poor man's asparagus," as they are cooked in similar ways and, like asparagus, are very good to eat. Use tender baby leeks if you can find them.

<u>SERVES 6</u>

12 small leeks (3 pounds)
2 hard-boiled eggs
1 tbsp Dijon mustard
2 tbsp white wine vinegar or lemon juice
6 tbsp sunflower oil
6 tbsp extra virgin olive oil, plus more
 if needed
salt and freshly ground black pepper
1–2 tbsp snipped fresh chives,
 to garnish

1 ▼ Remove the dark tough outer leaves of the leeks, then cut the leeks to the same length, and trim the dark green tops. Trim the root end, leaving enough to hold the leek together, then split the top half of the leeks lengthwise and rinse well under cold running water.

2 ▲ Lay the leeks flat in a large frying pan, pour over enough boiling water to just cover them and add a little salt. Cook the leeks over medium-high heat for 7–10 minutes until just tender. Carefully transfer to a large colander to drain, then lay the leeks on a paper towel and press them gently to remove as much liquid as possible.

3 ▲ In a bowl, mash together the hard-boiled egg yolks and mustard to form a smooth paste. Season with salt and pepper and add the vinegar or lemon juice, stirring until smooth. Slowly whisk in the sunflower oil, then the olive oil to make a thick creamy vinaigrette.

4 Arrange the leeks in a serving dish and pour over the vinaigrette while the leeks are still warm. Chop the egg whites and sprinkle them over the leeks, then scatter over the snipped chives and serve warm or at room temperature.

ASPARAGUS WITH ORANGE SAUCE · *Asperges Sauce Maltaise*

The white asparagus found in France is considered a delicacy by many, although it doesn't have the intense flavor of the green. White and large green spears are best peeled.

SERVES 6

3/4 cup unsalted butter, diced
3 egg yolks
1 tbsp cold water
1 tbsp fresh lemon juice
grated rind and juice of 1 unwaxed
 orange
salt and cayenne pepper, to taste
30–36 thick asparagus spears
a few shreds of orange zest,
 to garnish

1 ▲ Melt the butter in a small saucepan over low heat; do not boil. Skim off any foam and set aside.

2 ▲ In a heatproof bowl set over a saucepan of barely simmering water or in the top of a double boiler, whisk together the egg yolks, water, lemon juice, 1 tbsp of the orange juice and season with salt. Place the saucepan or double boiler over very low heat and whisk constantly until the mixture begins to thicken and the whisk begins to leave tracks on the base of the pan. Remove the pan from the heat.

3 Whisk in the melted butter, drop by drop until the sauce begins to thicken, then pour it in a little more quickly, leaving behind the milky solids at the base of the pan. Whisk in the orange rind and 2–4 tbsp of the orange juice. Season with salt and cayenne pepper and keep warm, stirring occasionally.

4 ▲ Cut off the tough ends from the asparagus spears and trim to the same length. If peeling, hold each spear gently by the tip, then using a vegetable peeler, strip off the peel and scales from just below the tip to the end. Rinse in cold water.

5 Fill a large deep frying pan or wok with 2 inches of water and bring to a boil over a medium-high heat. Add the asparagus and bring back to a boil, then simmer for 4–7 minutes, until just tender.

6 Carefully transfer the spears to a large colander to drain, then lay them on a paper towel and pat dry. Arrange on a large serving platter or individual plates and spoon over a little sauce. Scatter the orange zest over the sauce and serve at once.

COOK'S TIP

This sauce is a kind of hollandaise and needs gentle treatment. If the egg yolk mixture thickens too quickly, remove from the heat and plunge the base of the pan into cold water to prevent the sauce from curdling. The sauce should keep over hot water for 1 hour, but don't let it get too hot.

GLAZED CARROTS AND TURNIPS

Navets à la Nivernaise

In France when a dish is described on a menu as "à la nivernaise," it indicates the presence of carrots and onions. Here the addition of turnips adds a bittersweet contrast.

SERVES 6

3 tbsp butter
1 pound baby carrots, well-scrubbed, or
 medium carrots, cut into 1 inch sticks
1 pound young turnips, peeled and cut
 into quarters or eighths
½ pound pearl onions, peeled
½ cup beef or chicken broth
 or water
1–2 tbsp sugar
¼ tsp dried thyme
1–2 tbsp chopped fresh parsley

1 In a large heavy frying pan, melt 2 tbsp of the butter over a medium heat. Add the carrots, turnips and onions and toss to coat, then add the broth or water and stir in the sugar and thyme.

2 ▲ Bring the vegetables to a boil over medium-high heat, then cover and simmer over medium heat for 8–10 minutes until they begin to soften, shaking the pan occasionally to prevent the vegetables from sticking. Check the pan once or twice during cooking and add a little more liquid if needed.

3 ▼ Uncover the pan and increase the heat to evaporate any remaining liquid, stirring frequently, until vegetables are lightly coated with the glaze. Add the remaining butter and the chopped parsley to the pan and stir until the butter melts.

CREAMY SPINACH PURÉE

Purée d'Epinards

Crème fraîche, the thick French sour cream, or béchamel sauce usually give this spinach recipe its creamy richness, but try this quick, light alternative.

SERVES 4

1½ pounds leaf spinach, stems removed
4 ounces full- or medium-fat soft cheese
milk (if needed)
ground nutmeg
salt and freshly ground black pepper

1 Rinse the spinach, spin or shake lightly and place in a deep frying pan or wok with just the water clinging to the leaves. Cook, uncovered, over medium heat for 3–4 minutes until wilted. Drain the spinach in a colander, pressing with the back of a spoon to help extract the moisture; the spinach doesn't need to be completely dry.

2 ▼ In a food processor fitted with the metal blade, purée the spinach and soft cheese until well blended, then transfer to a bowl. If the purée is too thick to fall easily from a spoon, add a little milk, spoonful by spoonful.

3 ▲ Season the spinach with salt, pepper and nutmeg. Transfer the spinach to a heavy pan and reheat gently over low heat. Serve hot.

CABBAGE CHARLOTTE *Charlotte de Chou et de Pommes de Terre*

This delicious dish takes its name from the steep-sided container with heart-shaped handles in which it is cooked, but any straight-sided dish, such as a soufflé dish, will do.

SERVES 6

1 pound green or savoy cabbage
2 tbsp butter
1 medium onion, chopped
1¼ pounds potatoes, peeled and
 quartered
1 large egg, beaten
1–2 tbsp milk, if needed
salt and freshly ground black pepper

1 Preheat the oven to 375°F. Lightly butter a 5 cup charlotte mold or soufflé dish. Line the base with wax paper and butter again. Set the mold aside.

2 Bring a large saucepan of salted water to a boil. Remove 5–6 large leaves from the cabbage and add to the pan. Cook the leaves for about 2 minutes until softened and bright green, then plunge them into cold water. Chop the remaining cabbage.

3 Melt the butter in a heavy frying pan and cook the onion for 2–3 minutes until just softened. Stir in the chopped cabbage and cook, covered, over a medium heat for 10–15 minutes until tender and pale golden, stirring frequently.

4 ▲ Put the potatoes in a large saucepan and add enough cold water to cover. Salt the water generously and bring to a boil over medium-high heat. Cook until the potatoes are tender, then drain. Mash them with the beaten egg and a little milk, if needed, until smooth and creamy, then stir in the cabbage mixture. Season with salt and pepper.

5 ▲ Dry the cabbage leaves and cut out the thickest part of the center vein. Use the leaves to line the mold, saving one leaf for the top. Spoon the potato mixture into the dish, smoothing it evenly, then cover with the remaining cabbage leaf. Cover tightly with foil. Put the mold in a shallow roasting pan or a baking dish and pour in boiling water to come halfway up the side of the mold. Bake for 40 minutes.

6 To serve, remove the foil and place a serving plate over the mold. Holding the plate tightly against the mold, turn over together. Lift off the mold and peel off the paper.

BRAISED RED CABBAGE

Chou Rouge Braisé

The combination of red wine vinegar and sugar gives this dish a sweet, yet tart flavor. In France it is often served with game, but it is also delicious with pork, duck or cold sliced meats.

SERVES 6–8

2 tbsp vegetable oil
2 medium onions, thinly sliced
2 eating apples, peeled, cored and thinly
 sliced
1 head red cabbage (about 2–2½
 pounds), trimmed, cored, halved and
 thinly sliced
4 tbsp red wine vinegar
1–2 tbsp sugar
¼ tsp ground cloves
1–2 tsp mustard seeds
⅓ cup raisins or currants
about ½ cup red wine or water
1–2 tbsp red currant jelly (optional)
salt and freshly ground black pepper

1 ▲ In a large stainless steel saucepan or flameproof casserole, heat the oil over medium heat. Add the onions and cook for 7–10 minutes until golden.

2 ▲ Stir in the apples and cook, stirring, for 2–3 minutes until they are just softened.

3 ▲ Add the cabbage, red wine vinegar, sugar, cloves, mustard seeds, raisins or currants, red wine or water and salt and pepper, stirring until well mixed. Bring to a boil over medium-high heat, stirring occasionally.

4 ▼ Cover and cook over medium-low heat for 35–40 minutes until the cabbage is tender and the liquid is just absorbed, stirring occasionally. Add a little more red wine or water if the liquid evaporates before the cabbage is tender. Just before serving, stir in the red currant jelly, if using, to sweeten and glaze the cabbage.

Festive Brussels Sprouts

Choux de Bruxelles Braisées

In this recipe Brussels sprouts are braised with chestnuts, which are very popular in France.

Serves 4–6

½ pound chestnuts
½ cup milk
4 cups small tender Brussels sprouts
2 tbsp butter
1 shallot, finely chopped
2–3 tbsp dry white wine or water

Cook's tip

Fresh chestnuts have a wonderful texture and flavor, but bottled or canned unsweetened whole chestnuts make an adequate substitute. They are available in specialty stores and many supermarkets.

1 Using a small knife, score a cross in the base of each chestnut. Over medium-high heat, bring a saucepan of water to a boil, drop in the chestnuts and boil for 6–8 minutes. Remove the pan from the heat.

2 ▲ Using a slotted spoon, remove a few chestnuts, leaving the others immersed in water until ready to peel. Hold in a paper towel, remove the outer shell with a knife and then peel off the inner skin.

3 Rinse the pan, return the peeled chestnuts to the pan and add the milk. Add enough water to completely cover the chestnuts. Simmer over medium heat for 12–15 minutes until the chestnuts are just tender. Drain and set aside.

4 Remove any wilted or yellow leaves from the Brussels sprouts. Trim the root end but leave intact or the leaves will separate. Using a small knife, score a cross in the base of each sprout so they cook evenly.

5 ▲ In a large heavy frying pan, melt the butter over medium heat. Stir in the chopped shallot and cook for 1–2 minutes until just softened, then add the Brussels sprouts and wine or water. Cook, covered, over medium heat for 6–8 minutes, shaking the pan and stirring occasionally, adding a little more water if necessary.

6 ▲ Add the poached chestnuts and toss gently to combine, then cover and cook for 3–5 minutes more until the chestnuts and Brussels sprouts are tender.

GREEN BEANS WITH TOMATOES *Haricots Verts à la Provençale*

*This colorful combination of Provençal flavors makes a pleasant change from plain green beans.
Served cool or at room temperature, it is good as a first course or* hors d'oeuvre.

SERVES 4

1 pound ripe tomatoes
1 tbsp olive oil
1 shallot, finely chopped
1 or 2 garlic cloves, very finely chopped
½ pound green beans, trimmed and cut
 into 2 or 3 pieces
2 tbsp chopped fresh basil
salt and freshly ground black pepper

1 ▲ Bring a large saucepan of water to a boil. Score a shallow cross in the base of each tomato and plunge them into the boiling water for about 45 seconds, then plunge into cold water. Peel off the skin, halve the tomatoes and scoop out and discard the seeds. Chop coarsely.

2 ▲ Heat the oil in a heavy saucepan over medium heat, add the shallot and garlic and cook for 2–3 minutes until just softened.

3 ▼ Add the chopped tomatoes and continue cooking for about 10 minutes until the liquid has evaporated and the tomatoes are soft, stirring frequently. Season to taste with salt and pepper.

4 ▲ Bring a large saucepan of salted water to a boil, then add the beans and cook for 4–6 minutes until just tender. Drain the beans and stir into the tomato mixture with the basil, then cook for 1–2 minutes until heated through. Serve immediately or, if you like, allow to cool for an hour or two and serve at room temperature.

PEAS WITH LETTUCE AND ONION

Petits Pois à la Française

Fresh peas vary enormously in the time they take to cook – the tastiest and sweetest will be young and just picked. Frozen peas normally need less cooking time than fresh.

SERVES 4–6

1 tbsp butter
1 small onion, finely chopped
1 small round lettuce
3½ cups shelled fresh peas (from about 3½ pounds peas), or thawed frozen peas
3 tbsp water
salt and freshly ground black pepper

1 Melt the butter in a heavy saucepan. Add the onion and cook over medium-low heat for about 3 minutes until just softened.

2 ▼ Cut the lettuce in half through the core, then place cut side down on a board and slice into thin strips. Place the lettuce strips on top of the onion and add the peas and water. Season lightly with salt and pepper.

3 ▲ Cover the pan tightly and cook the lettuce and peas over low heat until the peas are tender – fresh peas will take 10–20 minutes, frozen peas about 10 minutes.

FAVA BEANS WITH CREAM

Fèves à la Crème

In France, tiny new fava beans are eaten raw with a little salt, just like radishes. More mature fava beans are usually cooked and skinned, revealing the bright green kernel inside.

SERVES 4–6

1 pound shelled fava beans (from about 4½ pounds fava beans)
6 tbsp crème fraîche or heavy cream
salt and freshly ground black pepper
finely snipped chives, to garnish

1 ▼ Bring a large pan of salted water to a boil over medium-high heat and add the beans.

2 Bring back to the boil, then reduce the heat slightly and boil the beans gently for about 8 minutes until just tender. Drain and refresh in cold water, then drain again.

3 ▲ To remove the skins, make an opening along one side of each bean with the tip of a knife and gently squeeze out the kernel.

4 ▲ Put the skinned beans in a saucepan with the cream and seasoning, cover and heat through gently. Sprinkle with the snipped chives and serve.

VARIATION

Young, tender fresh lima beans are delicious served in the same way.

LENTILS WITH BACON

Lentilles Braisées aux Lardons

The best lentils grown in France come from Le Puy, in the Auvergne. They are very small and the color of dark slate – look for them in specialty stores and supermarkets.

SERVES 6–8

2½ cups brown or green lentils, well
* rinsed and picked over*
1 tbsp olive oil
½ pound bacon, diced
1 onion, finely chopped
2 garlic cloves, finely chopped
2 tomatoes, peeled, seeded and chopped
½ tsp dried thyme
1 bay leaf
about 1½ cups beef or chicken broth
2–3 tbsp heavy cream (optional)
salt and freshly ground black pepper
1–2 tbsp chopped fresh parsley,
* to garnish*

1 ▼ Put the lentils in a large saucepan and cover with cold water. Bring to a boil over high heat and boil gently for 15 minutes. Drain and set aside.

2 In a heavy frying pan, heat the oil over medium heat. Add the bacon and cook for 5–7 minutes until crisp, then transfer the bacon to a plate.

3 ▲ Stir the onion into the fat in the pan and cook for 2–3 minutes until just softened. Add the garlic and cook for 1 minute, then stir in the tomatoes, thyme, salt and pepper, bay leaf and lentils.

4 ▲ Add the broth and cover the pan. Cook over a medium-low heat for 25–45 minutes, until the lentils are just tender, stirring occasionally. Add a little more broth or water to the pan, if needed.

5 ▲ Uncover the pan and allow any excess liquid to evaporate. Add the reserved bacon, and cream, if using, and heat through for 1–2 minutes. Serve hot, with a scattering of chopped parsley on top.

FRENCH SCALLOPED POTATOES *Pommes de Terre Dauphinoise*

These potatoes taste far richer than you would expect even with only a little cream – they are delicious with just about everything, but in France, they are nearly always served with roast lamb.

SERVES 6

2¼ pounds potatoes
3⅔ cups milk
pinch of ground nutmeg
1 bay leaf
1–2 tbsp butter, softened
2 or 3 garlic cloves, very finely chopped
3–4 tbsp crème fraîche or heavy cream
 (optional)
salt and freshly ground black pepper

1 ▲ Preheat the oven to 350°F. Cut the potatoes into fairly thin slices.

2 ▲ Put the potatoes in a large saucepan and pour over the milk, adding more to cover if needed. Add the salt and pepper, nutmeg and the bay leaf. Bring slowly to a boil over medium heat and simmer for about 15 minutes until the potatoes just start to soften, but are not completely cooked, and the milk has thickened.

3 ▼ Generously butter a 14 inch oval gratin dish or an 8 cup shallow baking dish and sprinkle the garlic over the base.

COOK'S TIP

If cooked ahead, this dish will keep hot in a warm oven for an hour or so, if necessary, without suffering; moisten the top with a little extra cream, if you like.

4 ▲ Using a slotted spoon, transfer the potatoes to the gratin or baking dish. Taste the milk and adjust the seasoning, then pour over enough of the milk to come just to the surface of the potatoes, but not cover them. Spoon a thin layer of cream over the top, or, if you prefer, add more of the thickened milk to cover.

5 Bake the potatoes for about 1 hour until the milk is absorbed and the top is a deep golden brown.

SAUTÉED POTATOES

Pommes de Terre Sautées au Romarin

These rosemary-scented, crisp golden potatoes are a favorite in French households.

SERVES 6

3 pounds baking potatoes
4–6 tbsp oil, bacon drippings or
 clarified butter
2 or 3 fresh rosemary sprigs, leaves
 removed and chopped
salt and freshly ground black pepper

1 Peel the potatoes and cut into 1 inch pieces. Place them in a bowl, cover with cold water and let soak for 10–15 minutes. Drain, rinse and drain again, then dry thoroughly in a kitchen towel.

2 In a nonstick large heavy frying pan or wok, heat about 4 tbsp of the oil, drippings or butter over a medium-high heat, until very hot, but not smoking.

3 ▲ Add the potatoes and cook for 2 minutes without stirring so that they seal completely and brown on one side.

4 Shake the pan and toss the potatoes to brown on another side and continue to stir and shake the pan until potatoes are evenly browned on all sides. Season with salt and pepper.

5 ▼ Add a little more oil, drippings or butter and continue cooking the potatoes over medium-low to low heat for 20–25 minutes until tender when pierced with a knife, stirring and shaking the pan frequently. About 5 minutes before the potatoes are done, sprinkle them with the chopped rosemary.

STRAW POTATO CAKE

Pommes Paillasson

These potatoes are so named in France because of their resemblance to a woven straw doormat. You could make several small cakes instead of a large one – just adjust the cooking time accordingly.

SERVES 4

1 pound baking potatoes
1½ tbsp melted butter
1 tbsp vegetable oil, plus more
 if needed
salt and freshly ground black pepper

1 Peel the potatoes and grate them coarsely, then immediately toss them with the melted butter and season with salt and pepper.

2 ▲ Heat the oil in a large frying pan. Add the potato mixture and press down to form an even layer that covers the pan. Cook over medium heat for 7–10 minutes until the base is well browned.

3 Loosen the potato cake by shaking the pan or running a thin spatula under it.

4 ▼ To turn it over, invert a large baking tray over the frying pan and, holding it tightly against the pan, turn them both over together. Lift off the frying pan, return it to the heat and add a little oil if it looks dry. Slide the potato cake into the frying pan and continue cooking until crisp and browned on both sides. Serve hot.

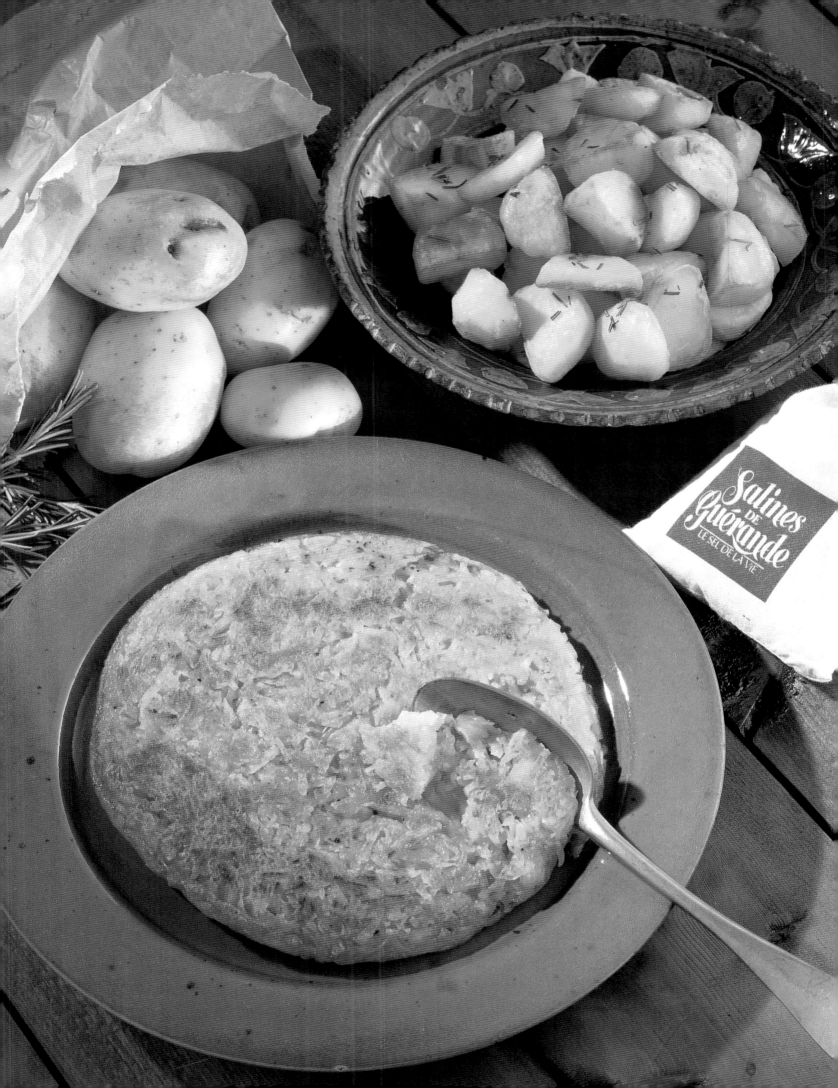

GARLIC MASHED POTATOES *Purée de Pommes de Terre à l'Ail*

These creamy mashed potatoes are perfect with all kinds of roasted or sautéed meats – and although it seems like a lot of garlic, the flavor is sweet and subtle when the garlic is cooked in this way.

SERVES 6–8

2 garlic bulbs, separated into cloves,
* unpeeled*
½ cup unsalted butter
3 pounds baking potatoes
½–¾ cup milk
salt and white pepper

COOK'S TIP

This recipe makes a very light, creamy purée. Use less milk to achieve a firmer purée, more for a softer purée. Be sure the milk is almost boiling or it will cool the potato mixture. Keep the potato purée warm in a bowl over simmering water.

1 Bring a small saucepan of water to a boil over high heat. Add the garlic cloves and boil for 2 minutes, then drain and peel.

2 ▲ In a heavy frying pan, melt half the butter over low heat. Add the blanched garlic cloves, then cover and cook gently for 20–25 minutes until very tender and just golden, shaking the pan and stirring occasionally. Do not allow the garlic to scorch or brown.

3 ▲ Remove the pan from the heat to cool slightly. Spoon the garlic and any butter into a blender or a food processor fitted with the metal blade and process until smooth. Pour into a small bowl, press plastic wrap onto the surface to prevent a skin from forming and set aside.

4 Peel and quarter the potatoes, place in a large saucepan and add enough cold water to just cover them. Salt the water generously and bring to a boil over high heat. Cook the potatoes until tender, then drain and work through a food mill or press through a sieve back into the saucepan. Return the pan to medium heat and, using a wooden spoon, stir the potatoes for 1–2 minutes to dry out completely. Remove the pan from the heat.

5 ▲ Warm the milk over medium-high heat until bubbles form around the edge. Gradually beat the milk, remaining butter and reserved garlic purée into the potatoes, then season with salt, if needed, and a little white pepper.

PROVENÇAL VEGETABLE STEW

Ratatouille

This classic combination of the vegetables that grow abundantly in the south of France is infinitely flexible. Use the recipe as a guide for making the most of what you have on hand.

SERVES 6

2 medium eggplants (about 1 pound total)
4–5 tbsp olive oil
1 large onion, halved and sliced
2 or 3 garlic cloves, very finely chopped
1 large red or yellow bell pepper, seeded and cut into thin strips
2 large zucchini, cut into ½ inch slices
1½ pounds ripe tomatoes, peeled, seeded and chopped, or 2 cups canned crushed tomatoes
1 tsp dried herbes de Provence
salt and freshly ground black pepper

1 ▲ Preheat the broiler. Cut the eggplant into ¾ inch slices, then brush the slices with olive oil on both sides and broil until lightly browned, turning once. Cut the slices into cubes.

VARIATION

To remove the pepper skin and add flavor to the ratatouille, quarter the pepper and grill, skin-side up, until blackened. Enclose in a brown paper bag and set aside until cool. Peel off the skin, then remove the core and seeds and cut into strips. Add to the mixture with the cooked eggplant.

2 ▲ Heat 1 tbsp of the olive oil in a large heavy saucepan or flameproof casserole and cook the onion over medium-low heat for about 10 minutes until lightly golden, stirring frequently. Add the garlic, pepper and zucchini and cook for 10 minutes more, stirring occasionally.

3 ▼ Add the tomatoes and eggplant cubes, dried herbs and salt and pepper and simmer gently, covered, over low heat for about 20 minutes, stirring occasionally. Uncover and continue cooking for 20–25 minutes more, stirring occasionally, until all the vegetables are tender and the cooking liquid has thickened slightly. Serve hot or at room temperature.

ZUCCHINI AND TOMATO BAKE *Tian Provençal*

This dish has been made for centuries in Provence and it gets its name from the shallow casserole, tian, *in which it is traditionally cooked. In the days before home kitchens had ovens, the assembled dish was carried to the bakery to make use of the heat remaining after the bread was baked.*

<u>SERVES 4</u>

1 tbsp olive oil, plus more for
 drizzling
1 large onion (about 8 ounces), sliced
1 garlic clove, finely chopped
1 pound tomatoes
1 pound zucchini
1 tsp dried herbes de Provence
2 tbsp grated Parmesan cheese
salt and freshly ground black pepper

1 Preheat the oven to 350°F. Heat the oil in a heavy saucepan over low heat and cook the onion and garlic for about 20 minutes until soft and golden. Spread over the base of a 12 inch shallow baking dish.

2 ▲ Cut the tomatoes crosswise into ¼ inch thick slices. (If the tomatoes are very large, cut the slices in half.)

3 Cut the zucchini diagonally into slices about ½ inch thick.

4 ▼ Arrange alternating rows of zucchini and tomatoes over the onion mixture and sprinkle with herbs, cheese and salt and pepper. Drizzle with olive oil, then bake for 25 minutes until the vegetables are tender. Serve hot or warm.

BAKED TOMATOES WITH GARLIC *Tomates à la Provençale*

These tomatoes, epitomizing the flavor of Provence, are perfect with roast meat or poultry. You can prepare them a few hours ahead, then cook them while carving the roast.

<u>SERVES 4</u>

2 large tomatoes
3 tbsp dry breadcrumbs
2 garlic cloves, very finely chopped
2 tbsp chopped fresh parsley
2–3 tbsp olive oil
salt and freshly ground black pepper
flat leaf parsley sprigs, to garnish

1 Preheat the oven to 425°F. Cut the tomatoes in half crosswise and arrange them cut side up on a foil-lined baking sheet.

2 ▲ Mix together the breadcrumbs, garlic, parsley and salt and pepper and spoon over the tomato halves.

3 ▼ Drizzle generously with olive oil and bake the tomatoes at the top of the oven for about 8–10 minutes until lightly browned. Serve at once, garnished with parsley sprigs.

BROCCOLI MOLDS

Timbales de Brocoli

This elegant but easy to make dish can be made with almost any puréed vegetable, such as carrot or celery root. To avoid last-minute fuss, make the molds a few hours ahead and cook while the first course is being eaten. Or, serve them on their own as an hors d'oeuvre with a butter sauce.

SERVES 4

¾ pound broccoli florets
3 tbsp crème fraîche or heavy cream
1 egg, plus 1 egg yolk
1 tbsp chopped scallion
pinch of ground nutmeg
salt and freshly ground black pepper
butter sauce, to serve
 (optional)
fresh chives, to garnish

1 ▼ Preheat the oven to 375°F. Lightly butter four 1 cup ramekins. Line the bases with wax paper or nonstick baking paper and butter the paper well.

2 Steam the broccoli florets over boiling water for 8–10 minutes until they are very tender.

3 ▲ Put the broccoli in a food processor fitted with the metal blade and process with the cream, egg and egg yolk until smooth.

4 ▲ Add the scallion and season with salt, pepper and nutmeg. Pulse to mix.

5 ▲ Spoon the purée into the ramekins and place them in a baking dish. Add boiling water to come halfway up the sides, then bake for 25 minutes, until just set. Invert on to warmed plates and peel off the paper. If serving as an hors d'oeuvre, pour a little sauce around each mold and garnish with chives.

CAULIFLOWER AU GRATIN

Choufleur au Gratin

A vegetable gratin is a classic supper dish in French homes. It also makes a great accompaniment to plain roast meat or chicken. If you wish, prepare it in individual gratin dishes.

SERVES 4–6

1 pound cauliflower, broken into florets
3 tbsp butter
4 tbsp flour
1½ cups milk
1 bay leaf
pinch of ground nutmeg
1 tbsp Dijon mustard
1½ cups grated Swiss cheese
salt and freshly ground black pepper

1 ▲ Preheat the oven to 350°F. Lightly butter a large gratin dish or shallow baking dish.

2 ▲ Bring a large saucepan of salted water to a boil, add the cauliflower florets and cook for 6–8 minutes until just tender. Alternatively, bring water to a boil in the base of a covered steamer and steam the cauliflower over boiling water for 12–15 minutes until just tender.

3 ▲ Melt the butter in a heavy saucepan over medium heat, add the flour and cook until just golden, stirring constantly. Pour in half the milk, stirring until smooth, then stir in the remaining milk and add the bay leaf. Season with salt, pepper and nutmeg. Reduce the heat to medium-low, cover and simmer for about 5 minutes, stirring occasionally, then remove the pan from the heat. Discard the bay leaf, add the mustard and half the cheese and stir until melted.

4 ▼ Arrange the cauliflower in the dish. Pour over the cheese sauce and sprinkle with the remaining cheese. Bake for about 20 minutes until bubbly and well browned.

VARIATIONS

If you wish, add diced ham or cooked bacon to the cauliflower before covering with the cheese sauce, or use broccoli florets in place of cauliflower.

OVEN-BRAISED BELGIAN ENDIVE *Endives Braisées au Four*

Belgian endive is often used raw in salads, yet it is delicious cooked, too. Slow-braising accentuates its unique flavor, giving it a rich, slightly bittersweet taste – perfect with pork and veal.

SERVES 6

4 tbsp butter, softened
6 large or 12 small heads Belgian endive
1 tbsp sugar
1–2 tbsp fresh lemon juice
4 tbsp chicken broth or water

VARIATION

To make Belgian Endive au Gratin, prepare as above. Preheat the broiler. Stir ⅓ cup grated Swiss cheese into 4 tbsp heavy cream. Spoon over the top and broil until golden and bubbly.

1 Preheat the oven to 325°F. Spread about half the butter over the base of a shallow baking dish just large enough to hold the endive heads in a single layer.

2 ▲ Discard any wilted or bruised outer leaves from the endive and, using a stainless steel knife, trim the root ends. For particularly large endive, remove the bitter center stem of the root. Wipe with paper towels (do not wash them).

3 ▲ Place the endive in the dish. Spread over the remaining butter, sprinkle with sugar and a little lemon juice and pour over the broth or water. Cover with foil and bake for 30–45 minutes until tender.

4 Serve immediately or, if you like, arrange the endive in a warmed serving dish and reduce the juices over a high heat, pour the juices over the endive and serve.

CELERY ROOT PURÉE *Purée de Céleri-rave*

Many chefs add potato to celery root purée, but this recipe highlights the pure flavor of the vegetable. If you have any leftovers, thin with stock or milk to make a lovely soup!

SERVES 4

1 large celery root (about 1¾ pounds), peeled
1 tbsp butter
pinch of ground nutmeg
salt and freshly ground black pepper

1 Cut the celeriac into large cubes, put in a saucepan with enough cold water to cover and add a little salt. Bring to a boil over medium–high heat and cook gently for 10–15 minutes until tender.

2 ▲ Drain the celery root, reserving a little of the cooking liquid, and place in a food processor fitted with the metal blade. Process until smooth, adding a little of the cooking liquid if it needs thinning.

3 ▼ Stir in the butter and season to taste with salt, pepper and nutmeg. Reheat, if necessary, before serving.

RICE PILAF

Riz Pilaf

In France the word pilaf refers to the cooking method of sautéing food in fat before adding liquid. This method produces perfect rice every time.

SERVES 6–8

3 tbsp butter or 3–4 tbsp oil
1 medium onion, finely chopped
2 cups long grain rice
3 cups chicken broth or water
½ tsp dried thyme
1 small bay leaf
salt and freshly ground black pepper
1–2 tbsp chopped fresh parsley, dill or
 chives, to garnish

COOK'S TIP

Once cooked, the rice will remain
hot for half an hour, tightly
covered. Or, spoon into a
microwave-safe bowl, cover and
microwave on High (full power)
for about 5 minutes until hot.

1 ▼ In a large heavy saucepan,
melt the butter or heat the oil over
medium heat. Add the onion and
cook for 2–3 minutes until just
softened, stirring constantly. Add
the rice and cook for 1–2 minutes
until the rice becomes translucent
but does not begin to brown,
stirring frequently.

2 ▲ Add the broth or water, dried
thyme and bay leaf and season with
salt and pepper. Bring to a boil over
high heat, stirring frequently. Just as
the rice begins to boil, cover the
surface with a round of foil or a wax
paper circle and cover the saucepan.
Reduce the heat to very low and
cook for 20 minutes (do not lift the
cover or stir). Serve hot, garnished
with fresh herbs.

SAUTÉED WILD MUSHROOMS *Champignons Sauvages à la Bordelaise*

This is a quick dish to prepare and makes an ideal accompaniment to all kinds of roast and grilled meats. Use any combination of wild or "cultivated wild" mushrooms you can find.

SERVES 6

2 pounds mixed fresh wild and cultivated
 mushrooms, such as morels, porcini,
 chanterelles, oyster or shiitake
2 tbsp olive oil
2 tbsp unsalted butter
2 garlic cloves, finely chopped
3 or 4 shallots, finely chopped
3–4 tbsp chopped fresh parsley, or a
 mixture of fresh herbs
salt and freshly ground black pepper

1 Wash and carefully dry any very
dirty mushrooms. Trim the stems
and cut the mushrooms into quarters
or slice if very large.

2 ▲ In a large heavy frying pan,
heat the oil over medium-high heat.
Add the butter and swirl to melt,
then stir in the mushrooms and cook
for 4–5 minutes until they begin to
brown.

3 ▼ Add the garlic and shallots and
cook for 4–5 minutes more until the
mushrooms are tender and any
liquid given off has evaporated.
Season with salt and pepper and stir
in the parsley or mixed herbs.

EGGS AND CHEESE

In French households eggs and cheese form a basic part of everyday meals. They are absolutely essential in French cooking – not only as cooking ingredients, but also as separate courses in their own right. Eggs are popular as a first course for lunch or for a supper dish, often served baked or made into creamy omelettes, or combined with cheese to make a soufflé or quiche. Cheese, as a separate course, is always served after the main course, and before any dessert. The choice is huge – France produces more kinds of cheeses than any other country, and every region has its own varieties.

OMELETTE WITH HERBS

Omelette aux Fines Herbes

Omelettes are often served as a first course or supper dish in France and fines herbes, *combined with tangy, delicate sour cream make a simple but delicious filling.*

<u>SERVES 1</u>

2 eggs
1 tbsp butter
1 tbsp crème fraîche or sour cream
1 tsp chopped fresh mixed herbs
(such as tarragon, chives, parsley
or marjoram)
salt and freshly ground black pepper

1 Beat together the eggs and salt and pepper until well mixed.

VARIATIONS

Other omelette fillings could include sautéed sliced mushrooms, diced ham or crumbled crisp bacon, creamed spinach or thick tomato sauce and grated cheese.

2 ▲ Melt the butter in an omelette pan or small non-stick frying pan over medium-high heat until foamy and light nutty brown, then pour in the eggs.

3 As the egg mixture starts to set on the base of the pan, lift up the sides using a fork or palette knife and tilt the pan to allow the uncooked egg to run underneath.

4 ▲ When the egg is too set to run but still soft, spoon the crème fraîche or soured cream down the center and sprinkle with the herbs.

5 To serve the omelette, hold the pan over a warmed plate. With a fork or spatula lift one edge of the omelette and fold it over the middle. Tilt the pan to help the omelette fold over on itself in thirds and slide it out onto the plate.

EGG-STUFFED TOMATOES

Tomates Farcies d'Oeuf

This simple, attractive presentation is just the kind of thing you might find in charcuteries all over France. It is easy to make at home and makes a delicious first course or a light lunch.

<u>SERVES 4</u>

¾ cup mayonnaise
2 tbsp chopped fresh chives
2 tbsp chopped fresh basil
2 tbsp chopped fresh parsley
4 hard-boiled eggs
4 ripe medium tomatoes
salt
lettuce, to serve

1 In a small bowl, blend together the mayonnaise and herbs and set aside.

2 Using an egg slicer or sharp knife, cut the eggs into thin slices.

3 ▼ Place the tomatoes core-end down and make deep cuts to within ½ inch of the base. (There should be the same number of cuts in each tomato as there are slices of egg; the white ends of the eggs can be discarded.)

4 ▲ Fan open the tomatoes and sprinkle with salt, then insert an egg slice into each slit.

5 Place each stuffed tomato on a plate with lettuce and serve with the herb mayonnaise.

PROVENÇAL SWISS CHARD OMELETTE *Trouchia*

This traditional flat omelette can also be made with fresh spinach, but Swiss chard leaves are typical in Provence. It is delicious served with small black Niçoise olives.

SERVES 6

1½ pounds Swiss chard leaves without
 stalks
4 tbsp olive oil
1 large onion, sliced
5 eggs
salt and freshly ground black pepper

1 Wash the Swiss chard well in several changes of water and pat dry. Stack four or five leaves at a time and slice across into thin ribbons. Steam the chard until wilted, then drain in a strainer and press out any liquid with the back of a spoon.

2 ▼ Heat 2 tbsp of the olive oil in a large frying pan. Add the onion and cook over medium-low heat for about 10 minutes until soft, stirring occasionally. Add the chard and cook for 2–4 minutes more until the leaves are tender.

3 ▲ In a large bowl, beat the eggs and season with salt and pepper, then stir in the cooked vegetables.

4 Heat the remaining 2 tbsp of oil in a large non-stick frying pan over medium-high heat. Pour in the egg mixture and reduce the heat to medium-low. Cook the omelette, covered, for 5–7 minutes until the egg mixture is set around the edges and almost set on top.

5 ▲ To turn the omelette over, loosen the edges and slide it onto a large plate. Place the frying pan over the omelette and, holding them tightly, carefully invert the pan and plate together. Lift off the plate and continue cooking for 2–3 minutes more. Slide the omelette onto a serving plate and serve hot or at room temperature, cut into wedges.

BAKED EGGS WITH CREAMY LEEKS *Oeufs en Cocotte aux Poireaux*

The French have traditionally enjoyed eggs prepared in many different ways. Vary this simple yet elegant dish by using other vegetables, such as puréed spinach, or ratatouille, as a base.

SERVES 4

1 tbsp butter, plus extra for greasing
½ pound small leeks, thinly sliced
 (about 2 cups)
5–6 tbsp heavy cream
ground nutmeg
4 eggs
salt and freshly ground black pepper

1 ▲ Preheat the oven to 375°F. Generously butter the base and sides of four small ramekins or individual soufflé dishes.

2 ▲ Melt the butter in a small frying pan and cook the leeks over medium heat, stirring frequently, until softened but not browned.

3 ▼ Add 3 tbsp of the cream and cook gently for about 5 minutes until the leeks are very soft and the cream has thickened a little. Season with salt, pepper and nutmeg.

VARIATION

For an even quicker dish, put 1 tbsp of cream in each dish with some chopped herbs. Break in the eggs, add 1 tbsp cream and a little grated cheese, then bake.

4 ▲ Arrange the ramekins in a shallow baking dish and divide the leeks among them. Break an egg into each, spoon 1–2 tsp of the remaining cream over each egg and season lightly.

5 Pour boiling water into the baking dish to come halfway up the sides of the ramekins or soufflé dishes. Bake for about 10 minutes, until the whites are set and the yolks are still soft, or a little longer if you prefer them more well done.

Scrambled Eggs with Peppers *Pipérade à la Basquaise*

This dish comes from the Basque country in the Pyrenees, piper *being Basquaise for pepper.*

Serves 4

4 tbsp bacon fat, duck fat or
 olive oil
2 onions, coarsely chopped
3 or 4 green or red bell peppers
 (or mixed), cored and chopped
2 garlic cloves, finely chopped
small pinch of chili powder or cayenne
 pepper, to taste
2 pounds ripe tomatoes, peeled, seeded
 and chopped
½ tsp dried oregano or thyme
8 eggs, lightly beaten
salt and freshly ground black pepper
chopped fresh parsley, to garnish

1 Heat the fat or oil in a large heavy
frying pan over medium-low heat.
Add the onions and cook, stirring
occasionally, for 5–7 minutes until
they are softened but not browned.

2 ▲ Stir in the peppers, garlic and
chili powder or cayenne. Cook for
5 minutes more until the peppers
soften, stirring frequently.

Cook's tip

Make sure that you cook the
peppers until the pan is almost
completely dry before adding
the eggs, otherwise the finished
dish will be too wet.

3 Stir in the tomatoes and season
with salt and pepper and the oregano
or thyme. Cook over medium heat
for 15–20 minutes until the peppers
are soft, the liquid has evaporated
and the mixture is thick. Stir
occasionally to prevent the mixture
burning and sticking to the pan.

4 ▲ Add the beaten eggs to the
vegetables and stir over low heat for
5–8 minutes until the mixture is
thickened and softly set. Scatter over
the parsley and serve.

Scrambled Eggs with Caviar *Oeufs Brouillés au Caviar*

In France, scrambled eggs are cooked slowly so they are smooth and rich – creamy and never dry.

Serves 4

3 tbsp butter, cut into small pieces
8 eggs, plus 1 egg yolk
1 tbsp crème fraîche, sour cream or heavy
 cream
1–2 tbsp chopped fresh chives
4 slices lightly toasted brioche, buttered,
 plus more to serve
2 ounces caviar
salt and white pepper
chopped fresh chives, to garnish

1 In a large heavy frying pan or
saucepan, melt half the butter over
medium-low heat.

2 ▲ Beat the eggs and egg yolk well
and season with salt and pepper.
Pour into the pan and cook gently,
stirring constantly until the mixture
begins to thicken and set; this may
take 10–12 minutes or longer.
Gradually stir in the remaining
butter, lifting the pan from the heat
occasionally to slow the cooking.

3 ▼ When the eggs are just set, take
the pan off the heat and stir in the
cream and chives. Arrange the
buttered brioche slices on plates and
divide the scrambled egg among them.
Top each serving with a spoonful
of caviar. Garnish with chives and
serve with extra toasted brioche.

POACHED EGGS WITH SPINACH

Oeufs Pochés à la Florentine

This classic recipe may be served as a first course, but is also excellent for a light lunch or brunch.

SERVES 4

2 tbsp butter
1 pound young spinach leaves
½ tsp vinegar
4 eggs
salt and freshly ground black pepper
FOR THE HOLLANDAISE SAUCE
¾ cup butter, cut into pieces
2 egg yolks
1 tbsp lemon juice
1 tbsp water
salt and white pepper

COOK'S TIP

Hollandaise sauce is quick and easy to make in a blender or food processor. If you wish, you can make it an hour or two in advance and keep it warm in a wide-mouthed Thermos.

1 To make the hollandaise sauce, melt the butter in a small saucepan over medium heat until it bubbles, then remove from the heat.

2 ▲ Put the egg yolks, lemon juice and water into a blender or food processor and blend. With the machine running, slowly pour in the hot butter in a thin stream. Stop pouring when you reach the milky solids at the bottom. Season with salt and pepper and more lemon juice if needed. Transfer to a serving bowl, cover and keep warm.

3 ▲ Melt the butter in a heavy frying pan or saucepan over a medium heat. Add the spinach and cook until wilted, stirring occasionally. Season and keep warm.

4 ▲ To poach the eggs, bring a medium pan of lightly salted water to a boil and add the vinegar. Break an egg into a saucer and slide the egg into the water. Reduce the heat and simmer for a few minutes until the white is set and the yolk is still soft. Remove with a slotted spoon and drain. Trim any rough edges with scissors and keep warm. Cook the remaining eggs in the same way.

5 To serve, spoon the spinach on to warmed plates and make an indentation in each mound. Place the eggs on top and pour over a little hollandaise sauce.

GOAT CHEESE SOUFFLÉ

Soufflé au Fromage de Chèvre

Make sure everyone is seated before the soufflé comes out of the oven because it will begin to deflate almost immediately. This recipe works equally well with strong blue cheeses such as Roquefort.

SERVES 4–6

2 tbsp butter
3 tbsp flour
¾ cup milk
1 bay leaf
ground nutmeg
grated Parmesan cheese, for
 sprinkling
1½ ounces herb and garlic soft cheese
5 ounces firm goat cheese, diced
6 egg whites, at room temperature
¼ tsp cream of tartar
salt and freshly ground black pepper

1 Melt the butter in a heavy saucepan over medium heat. Add the flour and cook until slightly golden, stirring occasionally. Pour in half the milk, stirring vigorously until smooth, then stir in the remaining milk and add the bay leaf. Season with a pinch of salt and plenty of pepper and nutmeg. Reduce the heat to medium-low, cover and simmer gently for about 5 minutes, stirring occasionally.

3 ▼ Remove the sauce from the heat and discard the bay leaf. Stir in both cheeses.

2 ▲ Preheat the oven to 375°F. Generously butter a 5 cup soufflé dish and sprinkle with the grated Parmesan cheese.

4 In a clean greasefree bowl, using an electric mixer or balloon whisk, beat the egg whites slowly until they become frothy. Add the cream of tartar, increase the speed and continue beating until they form soft peaks, then stiffer peaks that just flop over a little at the top.

5 ▲ Stir a spoonful of beaten egg whites into the cheese sauce to lighten it, then pour the cheese sauce over the remaining whites. Using a rubber spatula or large metal spoon, gently fold the sauce into the whites until the mixtures are just combined, cutting down through the center to the bottom, then along the side of the bowl and up to the top.

6 Gently pour the soufflé mixture into the prepared dish and bake for 25–30 minutes until puffed and golden brown. Serve at once.

TWICE-BAKED SOUFFLÉS

Soufflés Renversés

These little soufflés are served upside-down! They are remarkably easy to make and can be prepared up to a day in advance, then reheated in the sauce – perfect for easy entertaining.

SERVES 6

1½ tbsp butter
2 tbsp flour
⅔ cup milk
1 small bay leaf
ground nutmeg
2 eggs, separated, plus 1 egg white, at
 room temperature
⅔ cup grated Swiss cheese
¼ tsp cream of tartar
salt and freshly ground black pepper
FOR THE TOMATO CREAM SAUCE
1¼ cups heavy cream
2 tsp tomato purée
1 ripe tomato, peeled, seeded and
 finely diced
salt and cayenne pepper

1 Preheat the oven to 375°F. Generously butter six ¾ cup ramekins, then line the bases with buttered wax paper or non-stick baking paper. Set aside.

2 ▲ In a heavy saucepan over medium heat, melt the butter, stir in the flour and cook until just golden, stirring occasionally. Pour in about half the milk, whisking vigorously until smooth, then whisk in the remaining milk and add the bay leaf. Season with a little salt and plenty of pepper and nutmeg. Bring to a boil and cook, stirring constantly, for about 1 minute.

3 ▲ Remove the sauce from the heat and discard the bay leaf. Beat the egg yolks, one at a time, into the hot sauce, then stir in the cheese until it is melted. Set aside.

4 In a large, clean greasefree bowl, whisk the egg whites slowly until they become frothy. Add the cream of tartar, then increase the speed and whisk until they form peaks that just flop over at the top.

5 ▲ Stir a spoonful of beaten egg whites into the cheese sauce to lighten it. Pour the cheese sauce over the remaining whites. Using a rubber spatula or large metal spoon, gently fold the sauce into the whites.

COOK'S TIP

If making ahead, cool the cooked soufflés, then cover and chill. Bring the soufflés back to room temperature before reheating.

6 ▲ Spoon the soufflé mixture into the prepared dishes, filling them about three-quarters full. Put the dishes in a shallow baking dish and pour in boiling water to come halfway up the sides of the dishes. Bake for about 18 minutes until puffed and golden brown. Let the soufflés cool in the dishes long enough to deflate.

7 ▲ To make the sauce, bring the cream just to a boil in a small saucepan. Reduce the heat, stir in the tomato purée and diced tomato and cook for 2–3 minutes. Season with salt and cayenne pepper. Spoon a thin layer of sauce into a gratin dish just large enough to hold the soufflés. Run a knife around the edge of the soufflés and invert to unmold. Remove the lining paper if necessary. Pour the remaining sauce over the soufflés and bake for 12–15 minutes until well browned.

ALSATIAN LEEK AND ONION TARTLETS *Tartlettes Alsaciennes*

The savory filling in these tartlets is traditional to northeastern France where many types of quiche are popular. Baking in individual pans makes for easier serving and looks attractive too.

SERVES 6

2 tbsp butter, cut into 8 pieces
l onion, thinly sliced
½ tsp dried thyme
1 pound leeks, thinly sliced
5 tbsp grated Swiss cheese
3 eggs
1¼ cups light cream
pinch of ground nutmeg
salt and freshly ground black pepper
lettuce and parsley leaves and cherry
 tomatoes, to serve
FOR THE PASTRY
1⅓ cup flour
6 tbsp cold butter
1 egg yolk
2–3 tbsp cold water
½ tsp salt

1 To make the pastry, sift the flour into a bowl and add the butter. Using your fingertips or a pastry blender, rub or cut the butter into the flour until the mixture resembles fine breadcrumbs.

2 ▲ Make a well in the flour mixture. In a small bowl, beat together the egg yolk, water and salt. Pour into the well and, using a fork, lightly combine the flour and liquid until the dough begins to stick together. Form into a flattened ball. Wrap and chill for 30 minutes.

3 ▲ Lightly butter six 4 inch tartlet pans. On a lightly floured surface, roll out the dough until about ⅛ inch thick, then using a 5 inch cutter, cut as many rounds as possible. Gently ease the pastry rounds into the pans, pressing the pastry firmly into the base and sides. Reroll the trimmings and line the remaining pans. Prick the bases and chill for 30 minutes.

4 ▲ Preheat the oven to 375°F. Line the pastry cases with foil and fill with baking beans. Place them on a baking sheet and bake for 6–8 minutes until the pastry edges are golden. Lift out the foil and beans and bake the pastry cases for 2 minutes more until the bases appear dry. Transfer to a wire rack to cool. Reduce temperature of the oven to 350°F.

5 ▲ In a large frying pan, melt the butter over medium heat, then add the onion and thyme and cook for 3–5 minutes until the onion is just softened, stirring frequently. Add the leeks and cook for 10–12 minutes until they are soft and tender. Divide the mixture among the pastry cases and sprinkle each with cheese, dividing it evenly.

6 ▲ In a medium bowl, beat together the eggs, cream, nutmeg and salt and pepper. Place the pastry cases on a baking sheet and pour in the egg mixture. Bake for 15–20 minutes until set and golden. Transfer the tartlets to a wire rack to cool slightly, then remove them from the pans and serve warm or at room temperature with lettuce and parsley leaves and cherry tomatoes.

CHEESE AND ONION FLAN
Flamiche au Fromage

A strong-flavored, washed rind cheese such as Epoisses, Maroilles, *or* Livarot *is traditional in this tart but* Munster *or* Port Salut *will also produce a pleasant, if milder, result.*

SERVES 4

1 tbsp butter
1 onion, halved and sliced
2 eggs
1 cup light cream
8 ounces strong-flavored semi-soft cheese, rind removed (about 6 ounces without rind), sliced
salt and freshly ground black pepper
lettuce and parsley leaves, to serve

FOR THE YEAST DOUGH

2 tsp active dry yeast
½ cup milk
1 tsp sugar
1 egg yolk
1¾ cups flour, plus more for kneading
½ tsp salt
4 tbsp butter, softened

1 First make the yeast dough. Place the yeast in a small bowl. Warm the milk in a saucepan until it is lukewarm and stir into the yeast with the sugar, stirring until the yeast has dissolved. Leave the yeast mixture to stand for 3 minutes, then beat in the egg yolk.

2 Put the flour and salt in a food processor fitted with the metal blade and pulse twice to combine. With the machine running, slowly pour in the yeast mixture. Scrape down the sides and continue processing for 2–3 minutes. Add the butter and process for another 30 seconds.

3 Transfer the dough to a lightly oiled bowl. Cover with a cloth and allow to rise in a warm place for about 1 hour until doubled in bulk, then punch down.

4 On a lightly floured surface, roll the dough into a 12 inch round. Use to line a 9 inch quiche pan or dish. Trim any overhanging dough so that it is about ½ inch outside the rim of the pan or dish. Set aside and leave the dough to rise again for about ½ hour, or until puffy.

5 ▲ Meanwhile, melt the butter in a heavy saucepan and fry the onion, covered, over medium–low heat for about 15 minutes, until softened, stirring occasionally. Uncover the pan and continue cooking, stirring frequently, until the onion is very soft and caramelized.

6 Preheat the oven to 350°F. Beat together the eggs and cream. Season with salt and pepper and stir in the cooked onion.

7 ▲ Arrange the cheese on the base of the dough. Pour over the egg mixture and bake for 30–35 minutes until the bread base is golden and the center just set. Cool on a wire rack before serving hot or warm with lettuce and parsley leaves.

CHEESE AND BACON QUICHE *Quiche Savoyarde*

Gruyère is probably the most important French cheese for cooking. Made in the rugged Alpine dairy country of the Savoie, it is firm and has a rich nutty flavor.

SERVES 6–8

12 ounces shortcrust pastry
1 tbsp Dijon mustard
6 bacon slices, chopped
1 onion, chopped
3 eggs
1½ cups light cream
5 ounces Swiss cheese, diced
salt and freshly ground black pepper
fresh parsley, to garnish

1 ▲ Preheat the oven to 400°F. Roll out the pastry thinly and use to line a 9 inch quiche pan. Prick the base of the pastry shell and line with foil. Fill with baking beans and bake for 15 minutes. Remove the foil and beans, brush the case evenly with mustard and bake for 5 minutes more, then transfer to a wire rack. Reduce the oven temperature to 350°F.

2 ▲ In a frying pan, cook the bacon over medium heat, until crisp and browned, stirring occasionally.

3 ▲ Remove the bacon with a slotted spoon and drain on a paper towel. Pour off most of the fat from the pan, add the onion and cook over medium–low heat for about 15 minutes until very soft and golden, stirring occasionally.

4 Beat together the eggs and cream and season with salt and pepper.

5 ▼ Sprinkle half the cheese over the pastry, spread the onion over the cheese and add the bacon, then top with the remaining cheese.

6 Pour on the egg mixture and bake for 35–45 minutes until set. Transfer to a wire rack to cool slightly. Serve warm, garnished with parsley.

CHEESE AND HAM CROISSANTS *Croissants au Fromage et Jambon*

These hot croissant "sandwiches" are an upscale version of croque monsieur, *classic café fare.*
They make a simple tasty lunch – try using different combinations of ham and cheese.

SERVES 2

2 large croissants
2 tbsp butter, softened
Dijon mustard
2 slices prosciutto
2–3 ounces Camembert or Brie (rind removed), sliced ½ inch thick
lettuce, tomatoes and chives, to serve

1 Preheat the oven to 400°F. Split the croissants lengthwise and spread each side with butter and a little mustard.

2 ▼ Place a piece of ham on the bottom half of each croissant, trimming to fit. Place slices of cheese on the ham and cover with the croissant tops.

3 ▲ Place the croissants on a baking sheet and cover them loosely with foil, then bake for 3–5 minutes until the cheese begins to melt. Serve with lettuce, tomatoes and chives.

CHEESE PUFF RING *Gougère*

This light savory pastry comes from Burgundy, where it is traditionally served with red wine.

SERVES 6–8

¾ cup flour
¼ tsp salt
pinch of cayenne pepper
pinch of ground nutmeg
¾ cup water
6 tbsp butter, cut into pieces
3 eggs
3 ounces Swiss cheese, cut into ¼ inch cubes

1 Preheat the oven to 400°F. Lightly grease a baking sheet. Sift together the flour, salt, cayenne pepper and nutmeg.

> ### VARIATION
>
> Stir in 1–2 tbsp chopped fresh parsley or chives, or chopped scallions before baking.

2 ▲ In a medium saucepan, bring the water and butter to a boil. Remove from the heat and add the dry ingredients all at once. Beat with a wooden spoon for about 1 minute until the mixture is well blended and starts to pull away from the sides of the pan.

3 Place the pan over low heat and cook for 2 minutes, beating constantly, then remove the pan from the heat.

4 Beat the eggs together in a small bowl and then very gradually (one tablespoon at a time), beat into the mixture, beating thoroughly after each addition until the dough is smooth and shiny. It should pull away and fall slowly when dropped from a spoon – you may not need all the beaten egg. Add the cubed cheese and stir to mix well.

5 ▲ Using two large tablespoons, drop adjoining mounds of dough onto the baking sheet to form a 10 inch circle. Bake for 25–30 minutes until well browned. Cool slightly on a wire rack and serve warm.

BROILED GOAT CHEESE SALAD

Salade de Chèvre

Here is the salad and cheese course on one plate – or serve it as a quick and satisfying first course or light lunch. The fresh tangy flavor of goat cheese contrasts with the mild salad leaves.

<u>SERVES 4</u>

2 firm round whole goat cheeses, such as
Crottin de Chavignol *or* Coach
Farm Chèvre *(about 2½–4 ounces
each)*
4 slices French bread
extra virgin olive oil, for drizzling
5–6 cups mixed salad leaves
chopped fresh chives, to garnish
FOR THE VINAIGRETTE DRESSING
½ garlic clove
1 tsp Dijon mustard
1 tsp white wine vinegar
1 tsp dry white wine
3 tbsp extra virgin olive oil
salt and freshly ground black pepper

1 ▼ To make the dressing, rub a large salad bowl with the cut side of the garlic clove. Combine the mustard, vinegar and wine, salt and pepper in the bowl. Whisk in the olive oil, 1 tbsp at a time, to form a thick vinaigrette.

2 ▲ Cut the goat cheeses in half crosswise using a sharp knife.

3 ▲ Preheat the broiler. Arrange the bread slices on a baking sheet and toast the bread on one side. Turn over and place a piece of cheese, cut side up, on each slice. Drizzle with olive oil and broil until the cheese is lightly browned.

4 ▲ Add the greens to the salad bowl and toss to coat them with the dressing. Divide the salad among four plates, top each with a goat cheese croûton and serve, garnished with chives.

82

ROQUEFORT AND CUCUMBER MOUSSE *Mousse au Roquefort*

This cool and refreshing mousse makes a perfect summer first course. Other blue-veined cheeses, such as bleu d'Auvergne *or* fourme d'Ambert, *may be used instead of* Roquefort.

SERVES 6

7 inch piece cucumber
2 tsp powdered gelatin
5 tbsp cold water
3½ ounces Roquefort cheese
7 ounces full-, medium- or low-fat soft
 cheese
3 tbsp crème fraîche or sour cream
cayenne or white pepper
seedless red and green grapes and mint
 leaves, to garnish

4 ▼ Rinse a 6¼ cup dish or mold with cold water. Carefully spoon the mixture into the dish or mold and tap gently to remove air bubbles. Chill for 4–6 hours or overnight until well set.

5 ▲ To turn out, run a knife around the edge of the dish or mold, dip in hot water for 10–15 seconds and wipe the wet base. Place a large plate over the top of the dish and invert both together, shaking firmly to release the mousse. Garnish with grapes and mint leaves.

1 ▲ Peel the cucumber and cut lengthwise into quarters. Remove the seeds and cut the cucumber strips into 1 inch pieces.

2 Sprinkle the gelatin over the cold water in a small heatproof bowl. Let the gelatin stand to soften for about 2 minutes, then place the bowl in a shallow pan of simmering water. Heat until the gelatin is dissolved, stirring occasionally.

3 In a food processor fitted with the metal blade, process the cheeses and cream until smooth. Add the dissolved gelatin and process to blend. Add the cucumber and pulse to chop finely without completely reducing it to a purée. Season with cayenne or white pepper.

THE CHEESEBOARD

Le plateau de fromages

Although all cheese is made from milk, the end products vary enormously. The different methods of cheesemaking, and types of milk, produce different textures, flavors and characteristics.

Charles De Gaulle once said "How can I govern a country which produces more than 300 cheeses?". The French perhaps more than any other country are a nation of cheese lovers, each region produces a variety of cheeses reflecting the local tastes and, appropriately enough, they seem to marry well with the local wines, as well as the fruit and nuts of the area.

Cheeses are made from cow, goat and ewe milk and vary from fine fresh creamy cheeses such as those from Normandy like *Brillat Savarin* or *Explorateur*, to blues like *Roquefort* from the mountains of the Causses and *Bleu d'Auvergne* to hard cheeses of the Alps, *Gruyère* and *Emmenthal*, which are much used in quiches and ideal for cooking.

In most homes, the daily meal ends with cheese and perhaps some fruit, but unless it is a special occasion or a restaurant meal, dessert is less common – cheese is the dessert. A cheeseboard need not contain a bewildering selection; far better to search out one or two really good cheeses in perfect condition and present them with good fruit and bread, as the French do.

Some government regulations prohibit the entry of cheese made from unpasteurized milk and aged less than 60 days, but nonetheless, a few importers have managed to offer "raw milk" or "farmhouse" *Brie*, *Camembert* and other regional cheeses. It is unfortunate that while pasteurization makes cheese safer, it also neutralizes the flavor slightly, producing less tasty imitations of what may be available in France.

Ideally cheese should be stored in a cool cellar, offering conditions much like those in which they are aged. However, most of us have to make do with the refrigerator. Store cheese, wrapped in plastic wrap, in the part of the refrigerator where it is least cold, or in the specified area. Before serving, remove from the refrigerator and unwrap. Allow about 1 hour for the cheese to come to room temperature.

CHEESE AND FRUIT COMBINATIONS

Semi-firm cheeses such as *Gruyère*, *Emmenthal*, *Cantal*, *Comté* and *Mimolette* are delicious with almost all varieties of crisp apples and with walnuts.

Serve semi-soft cheeses such as *Morbier*, *Munster*, *Port-Salut*, *Gaperon*, *Doux de Montagne*, *Tomme de Savoie*, *Raclette* and *Reblochon*, with apricots, ripe red, yellow or purple plums, slices of ripe cantaloupe melon or, better still, slices of mango and papaya.

Blue cheeses such as *Roquefort*, *Bleu de Bresse* or *Bleu d'Auvergne* classically go with fresh fruit, but also go well with fresh figs or with dried fruit such as apricots, dates and figs.

Soft ripening cheeses such as *Brie*, *Camembert*, *Chaource*, *Coulommiers* and *Vacherin Mont d'Or* pair well with black or white grapes, mangoes and cherries.

Double- and triple-cream cheeses such as *Brillat-Savarin*, *Explorateur*, *St. André*, *Belle Etoile* and *Gratte-Paille* are good with melon, kiwi, ripe papaya, apricots, wild strawberries and toasted nuts and are especially good served with walnut bread.

Cheeses made from goat or sheep milk can be mild and creamy or strong and tangy. They go well with pears, grapes, peaches and figs as well as strawberries and blackberries.

Offer a balanced selection when serving several cheeses, varying the colors, flavors and textures; perhaps a soft creamy white cheese such as a *Neufchâtel*, a more distinctive cheese with a nutty flavor like the orange-rinded *Chaumes* from Bordeaux, an ash covered goat cheese such as *Montrachet* or *St. Maure* from Burgundy and a strong blue like *Roquefort* or *Fourme d'Ambert*.

If you don't have access to a special gourmet store with French cheeses you can put together a selection using what is available. Feta, Havarti, a sharp Cheddar and a wedge of Saga Blue provide a delicious range of flavor and texture. Use your imagination and the resources you have. Otherwise when cutting portions of cheese, remember to keep the shape of the cheese. For example, cut thin wedges from a wedge shaped piece, rectangular pieces from a square cheese and cut wedges from a round or pyramid.

Marinated Goat Cheese
Chèvre mariné

This makes a delicious and unusual cheese course – serve while the marinade is still warm. If you can find them, small individual goat cheeses are ideal.

SERVES 6–8
2 or 3 garlic cloves, thinly sliced
2 small bay leaves
1 or 2 rosemary sprigs, leaves removed
½ tsp dried thyme
1 tbsp black, white, green and pink peppercorns, lightly crushed
½ tsp mustard seeds, lightly crushed
½ tsp fennel seeds, lightly crushed
½ cup extra virgin olive oil
6–8 individual goat cheeses or 2 Montrachet logs or other soft mild goat cheese (1 pound total weight), cut into 6 or 8 pieces each
French bread, sliced and toasted, to serve

Mix together the garlic, herbs, peppercorns, mustard and fennel seeds and oil in a small bowl. Place over a medium-low heat for about 5 minutes and then set aside for 5–10 minutes, for the flavors to infuse. Arrange the goat cheese rounds on a platter and pour the marinade over. Serve warm with toasted French bread.

FISH
AND
SHELLFISH

With a coastline bordering two seas and a vast network of rivers, fish and shellfish play a leading role in French cuisine. Coastal areas are rightly renowned for their fish and shellfish, but fish is enjoyed all over France, and a great deal of effort is spent in making sure that fresh fish is available in markets throughout the country. Despite their reputation for rich, complicated cooking, the French tend to treat fish and shellfish fairly simply, usually poaching, baking, sautéing or grilling it. And, of course, nothing is wasted from the catch – even small bony fish are used to make *bouillon* for soups, sauces and stews.

TROUT WITH ALMONDS *Truites aux Amandes*

This simple and quick recipe doubles easily – you can cook the trout in two frying pans or in batches. In Normandy, hazelnuts might be used in place of almonds.

SERVES 2

2 trout (about 12 ounces each), cleaned
⅓ cup flour
4 tbsp butter
¼ cup slivered or sliced almonds
2 tbsp dry white wine
salt and freshly ground black pepper

1 Rinse the trout and pat dry. Put the flour in a large plastic bag and season with salt and pepper. Place the trout, one at a time, in the bag and shake to coat with flour. Shake off the excess flour from the fish and discard the remaining flour.

2 ▲ Melt half the butter in a large frying pan over medium heat. When it is foamy, add the trout and cook for 6–7 minutes on each side, until golden brown and the flesh next to the bone is opaque. Transfer the fish to warmed plates and cover to keep warm.

3 ▼ Add the remaining butter to the pan and cook the almonds until just lightly browned. Add the wine to the pan and boil for 1 minute, stirring constantly, until slightly syrupy. Pour or spoon over the fish and serve at once.

TUNA WITH GARLIC, TOMATOES AND HERBS *Thon St Remy*

St Remy is a beautiful village in Provence in the South of France. Herbs, such as thyme, rosemary and oregano, grow wild on the nearby hillsides and feature in many of the recipes from this area.

SERVES 4

4 tuna steaks, about 1 inch thick
 (6–7 ounces each)
2–3 tbsp olive oil
3 or 4 garlic cloves, finely chopped
4 tbsp dry white wine
3 ripe plum tomatoes, peeled, seeded
 and chopped
1 tsp dried herbes de Provence
salt and freshly ground black pepper
fresh basil leaves, to garnish

COOK'S TIP

Tuna is often served pink in the middle like beef. If you prefer it cooked through, reduce the heat and cook for an extra few minutes.

1 ▼ Season the tuna steaks with salt and pepper. Heat a heavy frying pan over high heat until very hot, add the oil and swirl to coat. Add the tuna steaks and press down gently, then reduce the heat to medium and cook for 6–8 minutes, turning once, until just slightly pink in the center.

2 ▲ Transfer the steaks to a serving plate and cover to keep warm. Add the garlic to the pan and fry for 15–20 seconds, stirring constantly, then pour in the wine and boil until it is reduced by half. Add the tomatoes and dried herbs and cook for 2–3 minutes until the sauce is bubbly. Season with pepper and pour over the fish steaks. Serve, garnished with fresh basil leaves.

HALIBUT WITH TOMATO VINAIGRETTE *Flétan Sauce Vièrge*

Sauce vièrge, *an uncooked mixture of tomatoes, aromatic fresh herbs and olive oil, can either be served at room temperature or, as in this dish,* tiède *(slightly warm).*

SERVES 2

3 large ripe beefsteak tomatoes, peeled,
 seeded and chopped
2 shallots or 1 small red onion, finely
 chopped
1 garlic clove, crushed
6 tbsp chopped mixed fresh herbs, such as
 parsley, cilantro, basil, tarragon,
 chervil or chives
½ cup extra virgin olive oil
4 halibut fillets or steaks
 (6–7 ounces each)
salt and freshly ground black pepper
green salad, to serve

1 ▼ In a medium bowl, mix together the tomatoes, shallots or onion, garlic and herbs. Stir in the oil and season with salt and freshly ground pepper. Cover the bowl and let the sauce stand at room temperature for about 1 hour to allow the flavors to blend.

2 ▲ Preheat the broiler. Line a broiler pan with foil and brush the foil lightly with oil.

3 ▲ Season the fish with salt and pepper. Place the fish on the foil and brush with a little extra oil. Broil for 5–6 minutes until the flesh is opaque and the top lightly browned.

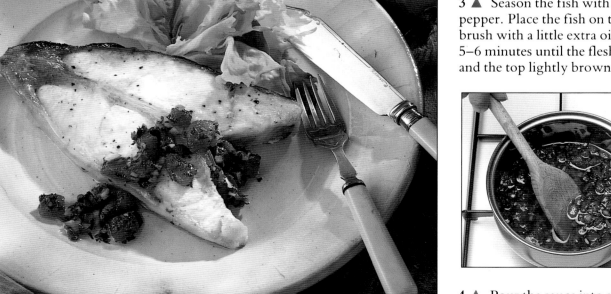

4 ▲ Pour the sauce into a saucepan and heat gently for a few minutes. Serve the fish with the sauce and a green salad.

SALMON WITH GREEN PEPPERCORNS *Saumon au Poivre Vert*

A fashionable discovery of nouvelle cuisine, *green peppercorns add piquancy to all kinds of sauces and stews. Available pickled in jars or cans, they are great to keep on hand in your pantry.*

<u>SERVES 4</u>

1 tbsp butter
2 or 3 shallots, finely chopped
1 tbsp brandy (optional)
4 tbsp dry white wine
6 tbsp fish or chicken broth
½ cup heavy cream
2–3 tbsp green peppercorns in brine,
 rinsed
1–2 tbsp vegetable oil
4 salmon fillets (6–7 ounces each)
salt and freshly ground black pepper
fresh parsley, to garnish

3 ▲ Reduce the heat, then add the cream and half the peppercorns, crushing them slightly with the back of a spoon. Cook very gently for 4–5 minutes until the sauce is slightly thickened, then strain and stir in the remaining peppercorns. Keep the sauce warm over very low heat, stirring occasionally, while you cook the salmon.

4 ▼ In a large heavy frying pan, heat the oil over medium-high heat until very hot. Lightly season the salmon and cook for 3–4 minutes, until the flesh is opaque throughout. To check, pierce the fish with the tip of a sharp knife; the juices should run clear. Arrange the fish on warmed plates and pour over the sauce. Garnish with parsley.

1 ▲ Melt the butter in a heavy saucepan over medium heat. Add the shallots and cook for about 1–2 minutes until just softened.

2 ▲ Add the brandy, if using, and the white wine, then add the broth and boil to reduce by three-quarters, stirring occasionally.

GRILLED RED SNAPPER WITH HERBS *Rouget Grillé aux Herbes*

In Provence this fish is often charcoal-grilled with herbs from the region or dried fennel branches.

<u>SERVES 4</u>

olive oil, for brushing
4 red snapper (8–10 ounces each),
 cleaned and scaled
fresh herb sprigs, such as parsley, dill,
 basil or thyme
dried fennel branches
2–3 tbsp Pernod (or other anise-flavored
 liqueur)

1 About one hour before cooking, light a charcoal fire: when ready the coals should be gray with no flames. Generously brush a hinged grilling rack with olive oil.

2 ▲ Brush each fish with a little olive oil and stuff the cavity with a few herb sprigs, breaking them to fit if necessary. Secure the fish in the grilling rack. Lay the dried fennel branches over the coals and grill the fish for about 15–20 minutes, turning once during cooking.

3 ▼ Remove the fish to a warmed, flameproof serving dish. Pour the liqueur into a small saucepan and heat for a moment or two, then tilt the pan and carefully ignite with a long match. Pour evenly over the fish and serve at once.

SALMON STEAKS WITH SORREL SAUCE *Saumon à l'Oseille*

Salmon and sorrel are traditionally paired in France – the sharp flavor of the sorrel balances the richness of the fish. If sorrel is not available, use finely chopped watercress instead.

<u>SERVES 2</u>

2 salmon steaks (about 8 ounces each)
1 tsp olive oil
1 tbsp butter
2 shallots, finely chopped
3 tbsp heavy cream
3½ ounces fresh sorrel leaves, washed
 and patted dry
salt and freshly ground black pepper
fresh sage, to garnish

COOK'S TIP

If preferred, cook the salmon steaks in a microwave oven for about 4–5 minutes, tightly covered, or according to the manufacturer's guidelines.

1 Season the salmon steaks with salt and pepper. Brush a non-stick frying pan with the oil.

2 ▲ In a small saucepan, melt the butter over medium heat and fry the shallots, stirring frequently, until just softened. Add the cream and the sorrel to the shallots and cook until the sorrel is completely wilted, stirring constantly.

3 ▲ Meanwhile, heat the frying pan over medium heat until hot. Add the salmon steaks and cook for about 5 minutes, turning once, until the flesh is opaque next to the bone. If you're not sure, pierce with the tip of a sharp knife; the juices should run clear. Arrange the salmon steaks on two warmed plates, garnish with sage and serve with the sorrel sauce.

SEA BASS WITH CITRUS FRUIT *Bar Rôti aux Agrumes*

Along the Mediterranean coast, sea bass is called loup de mer; *elsewhere in France it is known as* bar. *Its delicate flavor is complemented by citrus fruits and fruity French olive oil.*

SERVES 6

1 small grapefruit
1 orange
1 lemon
1 sea bass (about 3 pounds), cleaned and
 scaled
6 fresh basil sprigs
6 fresh dill sprigs
flour, for dusting
3 tbsp olive oil
4–6 shallots, peeled and halved
4 tbsp dry white wine
1 tbsp butter
salt and freshly ground black pepper
fresh dill, to garnish

1 ▲ With a vegetable peeler, remove the rind from the grapefruit, orange and lemon. Cut into thin julienne strips, cover and set aside. Peel off the white pith from the fruits and, working over a bowl to catch the juices, cut out the segments from the grapefruit and orange and set aside for the garnish. Slice the lemon thickly.

2 Preheat the oven to 375°F. Wipe the fish dry inside and out and season the cavity with salt and pepper. Make three diagonal slashes on each side. Reserve a few basil sprigs for the garnish and fill the cavity with the remaining basil, the lemon slices and half the julienne strips of citrus rind.

3 ▲ Dust the fish lightly with flour. In a roasting pan or flameproof casserole large enough to hold the fish, heat 2 tbsp of the olive oil over medium-high heat and cook the fish for about 1 minute until the skin just crisps and browns on one side. Add the shallots.

4 Place the fish in the oven and bake for about 15 minutes, then carefully turn the fish over and stir the shallots. Drizzle the fish with the remaining oil and bake for 10–15 minutes more until the flesh is opaque throughout.

5 Carefully transfer the fish to a heated serving dish and remove and discard the cavity stuffing. Pour off any excess oil and add the wine and 2–3 tbsp of the fruit juices to the pan. Bring to a boil over high heat, stirring. Stir in the remaining julienne strips of citrus rind and boil for 2–3 minutes, then whisk in the butter. Spoon the shallots and sauce around the fish and garnish with dill and the reserved basil and grapefruit and orange segments.

MONKFISH WITH TOMATOES

Lotte à la Provençale

Monkfish was once scorned by fisherman because of its huge ugly head, yet now it is prized for its rich meaty texture – and is sometimes called "poor man's lobster."

SERVES 4

1¾ pounds monkfish tail, skinned and filleted
flour, for dusting
3–4 tbsp olive oil
½ cup dry white wine or fish stock
3 ripe tomatoes, peeled, seeded and chopped
½ tsp dried thyme
16 black olives (preferably Niçoise), pitted
1–2 tbsp capers, rinsed and drained
1 tbsp chopped fresh basil
salt and freshly ground black pepper
pine nuts, to garnish

1 ▲ Using a thin, sharp knife, remove any pinkish membrane from the monkfish tail. Holding the knife at a 45° angle, cut the fillets diagonally into 12 slices.

2 ▲ Season the slices with salt and pepper and dust lightly with flour, shaking off any excess.

3 ▲ Heat a large heavy frying pan over high heat until very hot. Add 3 tbsp of the oil and swirl to coat. Add the monkfish slices and reduce the heat to medium-high. Cook the monkfish for 1–2 minutes on each side, adding a little more oil if necessary, until lightly browned and the flesh is opaque. Transfer the fish to a warmed plate and keep warm while you make the sauce.

4 ▼ Add the wine or fish stock to the pan and boil for 1–2 minutes, stirring constantly. Add the tomatoes and thyme and cook for 2 minutes, then stir in the olives, capers and basil and cook for 1 minute more to heat through. Arrange three pieces of fish on each of four warmed plates. Spoon over the sauce and garnish with pine nuts.

95

PAN-FRIED SOLE

Sole Meunière

This simple recipe is perfect for fresh Dover sole and makes the most of its delicate flavor – lemon sole fillets are a less expensive, but an equally tasty alternative.

SERVES 2

*¾ pound skinless Dover sole or
 lemon sole fillets
½ cup milk
⅓ cup flour
1 tbsp vegetable oil, plus more
 if needed
1 tbsp butter
1 tbsp chopped fresh parsley
salt and freshly ground black pepper
lemon wedges, to serve*

1 ▼ Rinse the fish fillets and pat dry using paper towels.

2 ▲ Put the milk into a shallow dish about the same size as a fish fillet. Put the flour in another shallow dish and season with salt and freshly ground black pepper.

3 ▲ Heat the oil in a large frying pan over medium-high heat and add the butter. Dip a fish fillet into the milk, then into the flour, turning to coat well, then shake off excess.

4 ▲ Put the coated fillets into the pan in a single layer. (Do not crowd the pan; cook in batches, if necessary.) Fry the fish gently for 3–4 minutes until lightly browned, turning once. Sprinkle the fish with chopped parsley and serve with wedges of lemon.

BREADED SOLE BATONS

Goujonettes de Sole

Goujons are tiny fish that are fried until crisp and eaten whole. In this dish, sole fillets are cut into strips that, when cooked, resemble goujons. The French even bring a sense of style to fish fingers!

SERVES 4

10 ounces lemon sole fillets,
* skinned*
2 eggs
1½ cups fine fresh breadcrumbs
6 tbsp flour
salt and freshly ground black pepper
vegetable oil, for frying
tartar sauce and lemon, to serve

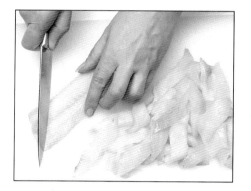

1 ▲ Cut the fish fillets into long diagonal strips about ¾ inch wide.

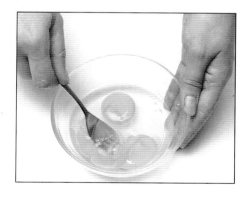

2 ▲ Break the eggs into a shallow dish and beat well with a fork. Place the breadcrumbs in another shallow dish. Put the flour in a large plastic bag and season with salt and freshly ground black pepper.

3 ▼ Dip the fish strips in the egg, turning to coat well. Place on a plate and then taking a few at a time, shake them in the bag of flour. Dip the fish strips in the egg again and then in the breadcrumbs, turning to coat well. Place on a tray in a single layer, not touching. Let the coating set for at least 10 minutes.

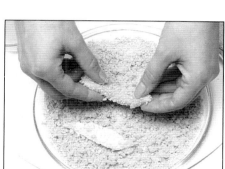

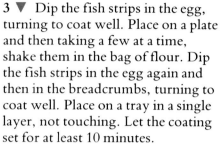

4 ▲ Heat ⅜ inch oil in a large frying pan over medium–high heat. When the oil is hot (a cube of bread will sizzle) fry the fish strips for about 2–2½ minutes in batches, turning once, taking care not to overcrowd the pan. Drain on paper towels and keep warm. Serve the fish with tartar sauce and lemon.

97

SOLE WITH SHRIMP AND MUSSELS *Filets de Sole à la Dieppoise*

This classic regional specialty takes its name from the Normandy port of Dieppe, renowned for fish and seafood. The recipe incorporates another great product of the region – cream.

SERVES 6

6 tbsp butter
8 shallots, finely chopped
1¼ cups dry white wine
2¼ pounds mussels, scrubbed and
　debearded
8 ounces button mushrooms, quartered
1 cup fish stock
12 skinless lemon or Dover sole fillets
　(about 3–5 ounces each)
2 tbsp flour
4 tbsp crème fraîche or heavy cream
8 ounces cooked, peeled shrimp
salt and white pepper
fresh parsley sprigs, to garnish

2 ▲ Transfer the mussels to a large bowl. Strain the mussel cooking liquid through a cheesecloth-lined colander and set aside. When cool enough to handle, reserve a few mussels in their shells for the garnish. Then remove the rest from their shells and set aside, covered.

4 ▲ Melt the remaining butter in a small saucepan over medium heat. Add the flour and cook for 1–2 minutes, stirring constantly; do not allow the flour mixture to brown. Gradually whisk in the reduced fish cooking liquid, the reserved mussel liquid and pour in any liquid from the fish, then bring to a boil, stirring constantly.

1 ▲ In a large heavy flameproof casserole, melt 1 tbsp of the butter over medium–high heat. Add half the shallots and cook for about 2 minutes until just softened, stirring frequently. Add the white wine and bring to a boil, then add the mussels and cover tightly. Cook the mussels over high heat, shaking and tossing the pan occasionally, for 4–5 minutes until the shells open. Discard any mussels that do not open.

3 ▲ Melt half the remaining butter in a large heavy frying pan over medium heat. Add the remaining shallots and cook for 2 minutes until just softened, stirring frequently. Add the mushrooms and fish stock and bring just to the simmer. Season the fish fillets with salt and pepper. Fold or roll them and slide gently into the stock. Cover and poach for 5–7 minutes until the flesh is opaque. Transfer the fillets to a warmed serving dish and cover to keep warm. Increase the heat and boil the liquid until reduced by one-third.

5 ▲ Reduce the heat to medium-low and cook the sauce for 5–7 minutes, stirring frequently. Whisk in the crème fraîche or heavy cream and keep stirring over low heat until well blended. Adjust the seasoning then add the reserved mussels and the shrimp to the sauce. Cook gently for 2–3 minutes to heat through then spoon the sauce over the fish and serve garnished with fresh parsley sprigs.

TURBOT IN PARCHMENT

Turbot en Papillote

Cooking in parchment is not new, but it is an ideal way to cook fish. Serve this dish plain or with a little hollandaise sauce and let each person open their own package to savor the aroma.

SERVES 4

2 carrots, cut into thin julienne strips
2 zucchini, cut into thin julienne strips
2 leeks, cut into thin julienne strips
1 fennel bulb, cut into thin
 julienne strips
2 tomatoes, peeled, seeded and diced
2 tbsp chopped fresh dill, tarragon, or
 chervil
4 turbot fillets (about 7 ounces each), cut
 in half
4 tsp olive oil
4 tbsp white wine or fish stock
salt and freshly ground black pepper

1 ▼ Preheat the oven to 375°F. Cut four pieces of nonstick baking paper, about 18 inches long. Fold each piece of baking paper in half and cut into a heart shape.

2 ▲ Open the paper hearts. Arrange one quarter of each of the vegetables next to the fold of each heart. Sprinkle with salt and pepper and half the chopped herbs. Arrange two pieces of turbot fillet over each bed of vegetables, overlapping the thin end of one piece and the thicker end of the other. Sprinkle the remaining herbs, the olive oil and wine or stock evenly over the fish.

3 ▲ Fold the top half of one of the paper hearts over the fish and vegetables and, beginning at the rounded end, fold the edges of the paper over, twisting and folding to form an airtight package. Repeat with the remaining three. (The packages may be assembled up to 4 hours ahead and chilled.)

4 Slide the packages onto one or two baking sheets and bake for about 10 minutes, or until the paper is lightly browned and well puffed. Slide each package onto a warmed plate and serve immediately.

COD WITH LENTILS AND LEEKS *Morue aux Lentilles et Poireaux*

This unusual dish, discovered in a Parisian charcuterie, is great for entertaining. You can cook the vegetables ahead of time and let it bake while the first course is served.

SERVES 4

1 cup green lentils
1 bay leaf
1 garlic clove, finely chopped
grated rind of 1 orange
grated rind of 1 lemon
pinch of ground cumin
1 tbsp butter
1 pound leeks, thinly sliced or cut into
 julienne strips
1¼ cups heavy cream
1 tbsp lemon juice, or to taste
1¾ pounds thick skinless cod or
 haddock fillets
salt and freshly ground black pepper

1 Rinse the lentils and put them in a large saucepan with the bay leaf and garlic. Add enough water to cover by 2 inches. Bring to a boil, and boil gently for 10 minutes, then reduce the heat and simmer for 15–30 minutes more until the lentils are just tender.

2 ▲ Drain the lentils and discard the bay leaf, then stir in half the orange rind and all the lemon rind and season with ground cumin and salt and pepper. Transfer to a shallow baking dish or gratin dish. Preheat the oven to 375°F.

3 ▼ Melt the butter in a medium saucepan over medium heat, then add the leeks and cook, stirring frequently, until just softened. Add 1 cup of the cream and the remaining orange rind and cook gently for 15–20 minutes until the leeks are completely soft and the cream has thickened slightly. Stir in the lemon juice and season with salt and plenty of pepper.

4 ▲ Cut the fish into four pieces, then, with your fingertips, locate and pull out any small bones. Season the fish with salt and pepper, place on top of the lentil mixture and press down slightly into the lentils. Cover each piece of fish with a quarter of the leek mixture and pour 1 tbsp of the remaining cream over each. Bake for about 30 minutes until the fish is cooked through and the topping is lightly golden.

MEDITERRANEAN BAKED FISH

Poisson au Suquet

This informal fish bake is said to have originated with the fishermen on the Côte d'Azur who would cook the remains of their catch for lunch in the still-warm baker's oven.

SERVES 4

3 medium potatoes
2 onions, halved and sliced
2 tbsp olive oil, plus more for
 drizzling
2 garlic cloves, very finely chopped
1½ pounds thick skinless fish fillets,
 such as turbot or sea bass
1 bay leaf
1 thyme sprig
3 tomatoes, peeled and thinly sliced
2 tbsp orange juice
4 tbsp dry white wine
½ tsp saffron threads, steeped in 4 tbsp
 boiling water
salt and freshly ground black pepper

1 ▼ Cook the potatoes in boiling salted water for 15 minutes, then drain. When the potatoes are cool enough to handle, peel off the skins and slice them thinly.

2 ▲ Meanwhile, in a heavy frying pan, fry the onions in the oil over medium-low heat for about 10 minutes, stirring frequently. Add the garlic and continue cooking for a few minutes until the onions are soft and golden.

3 Preheat the oven to 375°F. Layer half the potato slices in an 8 cup baking dish. Cover with half the onions. Season with salt and pepper.

4 ▲ Place the fish fillets on top of the vegetables and tuck in the herbs between them. Top with the tomato slices and then the remaining onions and potatoes.

5 Pour over the orange juice, wine and saffron liquid, season with salt and pepper and drizzle a little extra olive oil on top. Bake uncovered for about 30 minutes until the potatoes are tender and the fish is cooked.

FISH WITH BUTTER SAUCE

Filets de Poisson Beurre Blanc

This classic French butter sauce livens up steamed or poached fish. For a dinner party, make it just before the guests arrive and keep warm in a Thermos flask until ready to serve.

SERVES 4

1¾ pounds skinless white fish fillets,
 such as sole, flounder, sea bass
 or perch
salt and white pepper
FOR THE BUTTER SAUCE
2 shallots, finely chopped
6 tbsp white wine vinegar
1 tbsp heavy cream
¾ cup unsalted butter, cut into 12 pieces
1 tbsp chopped fresh tarragon
 or chives
fresh tarragon sprigs, to garnish

1 ▲ To make the sauce, put the shallots and vinegar in a small heavy saucepan and boil over high heat until the liquid has almost evaporated, leaving only about 1 tbsp, then stir in the cream.

2 ▲ Reduce the heat to medium and add the butter, one piece at a time, whisking constantly until it melts before adding the next (lift the pan off the heat if the butter melts faster than it can be incorporated).

3 ▲ Season the sauce with salt and pepper to taste and whisk in the tarragon or chives. (If you prefer a smooth sauce, strain before adding the herbs.) Cover the pan and set aside in a warm place.

4 ▼ Bring some water to a boil in the bottom of a covered steamer. Season the fish fillets with salt and pepper, then steam for 3–5 minutes until the flesh is opaque. The time will depend on the thickness of the fish. Serve the fish with the sauce, garnished with fresh tarragon.

FISH TERRINE

Terrine de Poisson

This colorful layered terrine makes a spectacular presentation for a special occasion. It is typical of those found in the best charcuteries in France and great for entertaining since it is prepared ahead.

SERVES 6

1 pound skinless white fish fillets
8–10 ounces thinly sliced smoked salmon
2 cold egg whites
¼ tsp each salt and white pepper
pinch of ground nutmeg
1 cup heavy cream
2 cups (packed) small tender spinach
 leaves
lemon mayonnaise, to serve

1 Cut the white fish fillets into 1 inch pieces, removing any bones as you work. Spread out the fish pieces on a plate, cover with plastic wrap. Place in the freezer for about 15 minutes until very cold.

2 ▲ Lightly grease a 5 cup terrine or loaf pan and line the base with nonstick baking paper, then line the base and sides of the pan with smoked salmon slices, letting them overhang the edge. Preheat the oven to 350°F.

3 Remove the fish from the freezer, then process in a food processor until it is a very smooth purée, stopping the machine and scraping down the sides two or three times.

4 Add the egg whites, one at a time, then add the salt, pepper and nutmeg. With the machine running, pour in the cream and stop as soon as it is blended. (If overprocessed, the cream will thicken too much.)

5 Transfer the fish mixture to a large glass bowl. Put the spinach leaves into the food processor and purée. Add one-third of the fish mixture to the spinach and process until just combined, scraping down the sides once or twice.

6 ▲ Spread half the plain fish mixture in the base of the pan and smooth it level. Spoon the green fish mixture over the top and smooth the surface, then cover with the remaining plain mixture and smooth the top. Fold the overhanging pieces of salmon over the top to enclose the mixture. Tap the pan to settle the mixture and remove any air pockets, then cover the terrine with a double layer of foil.

7 Put the terrine in a roasting pan and pour in enough boiling water to come halfway up the sides of the terrine. Bake for about 1 hour, until a skewer inserted in the center comes out clean. Allow to cool, wrap well and chill until firm or overnight.

8 To serve the terrine, turn out onto a board and slice. Arrange slices on individual plates and serve with lemon mayonnaise.

MUSSELS STEAMED IN WHITE WINE *Moules Marinières*

This is the best and easiest way to serve the small tender mussels, bouchots, *that are farmed along much of the French coast line. In Normandy the local sparkling dry cider is often used instead of white wine. Serve with plenty of crusty French bread to dip in the juices.*

SERVES 4

4½ pounds mussels
1¼ cups dry white wine
4–6 large shallots, finely chopped
bouquet garni
freshly ground black pepper

1 ▲ Discard any broken mussels and those with open shells that refuse to close when tapped. Under cold running water, scrape the mussel shells with a knife to remove any barnacles and pull out the stringy "beards." Soak the mussels in several changes of cold water for at least 1 hour.

2 ▲ In a large heavy flameproof casserole combine the wine, shallots, bouquet garni and plenty of pepper. Bring to a boil over medium-high heat and cook for 2 minutes.

3 ▲ Add the mussels and cook, tightly covered, for 5 minutes, or until the mussels open, shaking and tossing the pan occasionally. Discard any mussels that do not open.

4 Using a slotted spoon, divide the mussels among warmed soup plates. Tilt the casserole a little and hold for a few seconds to allow any sand to settle to the bottom.

5 Spoon or pour the cooking liquid over the mussels, dividing it evenly, then serve at once.

VARIATION

For Mussels with Cream Sauce (*Moules à la Crème*), cook as above, but transfer the mussels to a warmed bowl and cover to keep warm. Strain the cooking liquid through a cheesecloth-lined colander into a large saucepan and boil for about 7–10 minutes to reduce by half. Stir in 6 tbsp heavy cream and 2 tbsp chopped parsley, then add the mussels. Cook for about 1 minute more to reheat the mussels.

MEDITERRANEAN FISH STEW

Bouillabaisse

Different variations of bouillabaisse *abound along the Mediterranean coast – every village seems to have its own version – and almost any combination of fish and shellfish can be used.*

SERVES 8

6 pounds white fish, such as sea bass,
 snapper or monkfish, filleted and
 skinned (choose thick fish)
3 tbsp extra virgin olive oil
grated rind of 1 orange
1 garlic clove, very finely chopped
pinch of saffron threads
2 tbsp Pernod (or other anise-flavored
 liqueur)
1 small fennel bulb, finely chopped
1 large onion, finely chopped
½ pound small new potatoes, sliced
2 pounds large raw Mediterranean
 shrimp, peeled
croûtons, to serve
FOR THE STOCK
2–3 pounds fish heads, bones and
 trimmings
2 tbsp olive oil
2 leeks, sliced
1 onion, halved and sliced
1 red bell pepper, cored and sliced
1½ pounds ripe tomatoes, cored and
 quartered
4 garlic cloves, sliced
bouquet garni
rind of ½ orange, removed with a
 vegetable peeler
2 or 3 pinches saffron threads
FOR THE ROUILLE
⅔ cup soft white breadcrumbs
1 or 2 garlic cloves, very finely chopped
½ red bell pepper, roasted
1 tsp tomato paste
½ cup extra virgin olive oil

COOK'S TIP

Be sure to ask the fish seller for
the heads, tails and trimmings
from your fish fillets and avoid
strong-flavored oily fish, such as
mackerel. To reduce last-minute
work, you can make the *rouille*,
croûtons and stock early in the
day while the fish marinates.

1 ▲ Cut the fish fillets into serving pieces, then trim off any thin parts and reserve for the stock. Put the fish in a bowl with 2 tbsp of the olive oil, the orange rind, garlic, saffron and liqueur. Turn to coat well, cover and chill.

2 ▲ To make the stock, rinse the fish heads and bones under cold running water. Heat the olive oil in a large, preferably stainless steel, saucepan or flameproof casserole. Add the leeks, onion and pepper and cook over medium heat for about 5 minutes until the onion starts to soften, stirring occasionally. Add the fish heads, bones and trimmings, with any heads or shells from the shrimp. Then add the tomatoes, garlic, bouquet garni, orange rind, saffron and enough cold water to cover the ingredients by 1 inch.

3 Bring to a boil, skimming any foam that rises to the surface, then reduce the heat and simmer, covered, for ½ hour, skimming once or twice more. Strain the stock.

4 ▲ To make the *rouille*, soak the breadcrumbs in water then squeeze dry. Put the breadcrumbs in a food processor with the garlic, roasted red bell pepper and tomato paste and process until smooth. With the machine running, slowly pour the oil through the feed tube, scraping down the sides once or twice.

5 ▲ To finish the bouillabaise, heat the remaining 1 tbsp of olive oil in a wide flameproof casserole over a medium heat. Cook the fennel and onion for about 5 minutes until the onion just softens, then add the stock. Bring to a boil, add the potatoes and cook for 5–7 minutes. Reduce the heat to medium and add the fish, starting with the thickest pieces and adding the thinner ones after 2 or 3 minutes. Add the shrimp and continue simmering gently until all the fish and shellfish is cooked.

6 Transfer the fish, shellfish and potatoes to a heated tureen or soup plates. Adjust the seasoning and ladle the soup over. Serve with croûtons spread with *rouille*.

SAUTÉED SCALLOPS *Coquilles Saint Jacques Meunières*

Scallops go well with all sorts of sauces, but simple cooking is the best way to enjoy their flavor.

SERVES 2

1 pound shelled scallops
2 tbsp butter
·2 tbsp dry white vermouth
1 tbsp finely chopped fresh parsley
salt and freshly ground black pepper

1 Rinse the scallops under cold running water to remove any sand or grit and pat dry using paper towels. Season them lightly with salt and pepper.

2 ▼ In a frying pan large enough to hold the scallops in one layer, heat half the butter until it begins to color. Sauté the scallops for 3–5 minutes, turning, until golden brown on both sides and just firm to the touch. Remove to a serving platter and cover to keep warm.

3 ▲ Add the vermouth to the hot frying pan, swirl in the remaining butter, add the parsley and pour the sauce over the scallops. Serve immediately.

GARLICKY SCALLOPS AND SHRIMP *Fruits de Mer à la Provençale*

Scallops and shrimp are found all along the Atlantic and Mediterranean coasts of France and are enjoyed in every region. This method of cooking is typical in Provence.

SERVES 2–4

6 large sea scallops
6–8 large shrimp, peeled
flour, for dusting
2–3 tbsp olive oil
1 garlic clove, finely chopped
1 tbsp chopped fresh basil
2–3 tbsp lemon juice
salt and freshly ground black pepper

VARIATION

To make a richer sauce, transfer the cooked scallops and prawns to a warmed plate. Pour in 4 tbsp dry white wine and boil to reduce by half. Add 1 tbsp unsalted butter, whisking until it melts and the sauce thickens slightly. Pour over the scallops and shrimp.

1 ▼ Rinse the scallops under cold running water to remove any sand or grit. Pat them dry using paper towels and cut in half crosswise. Season the scallops and shrimp with salt and pepper and dust lightly with flour, shaking off the excess.

2 Heat the oil in a large frying pan over high heat and add the scallops and shrimp.

3 ▲ Reduce heat to medium-high and cook for 2 minutes, then turn the scallops and shrimp and add the garlic and basil, shaking pan to distribute them evenly. Cook for 2 minutes more until golden and just firm to the touch. Sprinkle over the lemon juice and toss to blend.

SCALLOPS WITH MUSHROOMS *Coquilles Saint Jacques au Gratin*

This dish has been a classic on bistro menus since Hemingway's days in Paris – it makes an appealing appetizer, or serve it as a rich and elegant main course.

<u>SERVES 2–4</u>

1 cup dry white wine
½ cup water
2 shallots, finely chopped
1 bay leaf
1 pound shelled scallops, rinsed
3 tbsp butter
3 tbsp flour
6 tbsp heavy cream
ground nutmeg
6 ounces mushrooms, thinly sliced
3–4 tbsp dry breadcrumbs
salt and freshly ground black pepper

1 ▼ Combine the wine, water, shallots and bay leaf in a medium saucepan. Bring to a boil, then reduce the heat to medium-low and simmer for 10 minutes. Add the scallops, cover and simmer for 3–4 minutes until they are opaque.

2 Remove the scallops from the cooking liquid with a slotted spoon and boil the liquid until reduced to ¾ cup. Strain the liquid.

3 ▲ Carefully pull off the tough muscle from the side of the scallops and discard. Slice the scallops in half crosswise.

4 ▲ Melt 2 tbsp of the butter in a heavy saucepan over medium–high heat. Stir in the flour and cook for 2 minutes. Add the reserved cooking liquid, whisking vigorously until smooth, then whisk in the cream and season with salt, pepper and nutmeg. Reduce the heat to low and simmer for 10 minutes, stirring frequently.

5 Melt the remaining butter in a frying pan over medium–high heat. Add the mushrooms and cook for about 5 minutes until lightly browned, stirring frequently. Stir the mushrooms into the sauce.

6 Preheat the broiler. Add the scallops to the sauce and adjust the seasoning. Spoon the mixture into four individual gratin dishes, large scallop shells or a flameproof baking dish and sprinkle with breadcrumbs. Broil until golden brown and bubbly.

SHRIMP WITH CURRY SAUCE

Crevettes en Brochette à l'Indienne

In France any dish called à l'Indienne *contains Indian spices. This sauce is great with broiled shrimp, but you can make it with chicken broth for serving with chicken, game, veal or pork.*

SERVES 4

16 large shrimp, peeled
grated rind and juice of 1 orange
juice of 1 lemon or lime
2 tbsp olive oil
1 garlic clove, crushed
1 tsp hot chili sauce or curry powder, or
 to taste
½ tsp ground coriander
½ tsp ground cumin

FOR THE CURRY SAUCE
1 tbsp olive oil
2 shallots, finely chopped
1 or 2 garlic cloves, crushed
1 tsp curry powder or paste
¼ tsp ground coriander
¼ tsp ground cumin
4 tbsp fish stock
1 cup heavy cream
1 tbsp chopped fresh cilantro
 or mint

1 ▲ Put the shrimp in a bowl with the orange rind and juice, lemon or lime juice, oil, garlic, chili sauce or curry powder, ground coriander and cumin. Stir well, then cover and marinate for 30 minutes.

2 To make the curry sauce, heat the oil in a medium saucepan over medium heat. Add the shallots and cook for 1–2 minutes, stirring, until just softened. Stir in the garlic and curry powder or paste, ground coriander and cumin and cook for 1–2 minutes, stirring constantly.

3 ▲ Add the fish stock and bring to a boil. Reduce by half, then add the cream and simmer for 8–10 minutes until slightly thickened. Stir in the fresh cilantro or mint. Reduce the heat to low and keep warm, stirring occasionally.

4 ▼ Preheat the broiler and line a broiler pan with foil. Thread the shrimp on to four metal or damp wooden skewers. Place the skewers on the broiling pan and broil for 3–4 minutes, turning once. Spoon a little sauce on to four plates. Place a skewer on each, and serve at once.

111

SEAFOOD IN PUFF PASTRY

Feuilletés aux Fruits de Mer

This classic combination of seafood in a creamy sauce served in a puff pastry case is found as an appetizer on the menus of many elegant restaurants in France.

SERVES 6

12 ounces puff pastry
1 egg beaten with 1 tbsp water,
* to glaze*
4 tbsp dry white wine
2 shallots, finely chopped
1 pound mussels, scrubbed and debearded
1 tbsp butter
1 pound sea scallops, cut in half
* crosswise*
1 pound raw shrimp, peeled
6 ounces cooked lobster meat, sliced
FOR THE SAUCE
1 cup unsalted butter, diced
2 shallots, finely chopped
1 cup fish stock
6 tbsp dry white wine
1–2 tbsp cream
lemon juice
salt and white pepper
fresh dill sprigs, to garnish

1 ▼ Lightly grease a large baking sheet and sprinkle with a little water. On a lightly floured surface, roll out the pastry into a rectangle slightly less than ¼ inch thick. Using a sharp knife, cut into six diamond shapes about 5 inches long. Transfer to the baking sheet. Brush pastry with egg glaze. Using the tip of a knife, score a line ½ inch from the edge, then lightly mark the center in a criss-cross pattern.

2 Chill the pastry for 30 minutes. Preheat the oven to 425°F. Bake for about 20 minutes until puffed and brown. Transfer to a wire rack and, while still hot, remove each lid, cutting along the scored line to free it. Scoop out any uncooked dough from the bases and discard, then leave the pastry to cool completely.

3 In a large saucepan, bring the dry white wine and shallots to a boil over a high heat. Add the mussels to the pan and cook, tightly covered, for 4–6 minutes until the shells open, shaking the pan occasionally. Remove any mussels that do not open. Reserve six mussels for the garnish, then remove the rest from their shells and set aside in a bowl, covered. Strain the cooking liquid through a cheesecloth-lined strainer and reserve for the sauce.

4 ▲ In a heavy frying pan, melt the butter over medium heat. Add the scallops and shrimp, cover tightly and cook for 3–4 minutes, shaking and stirring occasionally, until they feel just firm to the touch; do not overcook.

5 Using a slotted spoon, transfer the scallops and shrimp to the bowl with the mussels and add any cooking juices to the mussel liquid.

6 ▲ To make the sauce, melt 2 tbsp of the butter in a heavy saucepan. Add the shallots and cook for 2 minutes. Pour in the fish stock and boil for about 15 minutes over high heat until reduced by three-quarters. Add the white wine and reserved mussel liquid and boil for 5–7 minutes until reduced by half. Lower the heat to medium and whisk in the remaining butter, a little at a time, to make a smooth thick sauce (lift the pan from the heat if the sauce begins to boil). Whisk in the cream and season with salt, if needed, pepper and lemon juice. Keep warm over very low heat, stirring frequently.

7 Warm the pastry bases in a warm oven for about 10 minutes. Put the mussels, scallops and shrimp in a large saucepan. Stir in a quarter of the sauce and reheat gently over low heat. Gently stir in the lobster meat and cook for 1 minute more.

8 Arrange the pastry bases on individual plates. Divide the seafood mixture equally among them and top with the lids. Garnish each with a mussel and a dill sprig and spoon the remaining sauce around the edges or serve separately.

SHELLFISH WITH SEASONED BROTH *Fruits de Mer à la Nage*

Leave one or two mussels and shrimp in their shells to add a flamboyant touch to this elegant dish.

SERVES 4

1½ pounds mussels, scrubbed and
 debearded
1 small fennel bulb, thinly sliced
1 onion, finely sliced
1 leek, thinly sliced
1 small carrot, cut in julienne strips
1 garlic clove
4 cups water
pinch of curry powder
pinch of saffron
1 bay leaf
1 pound large shrimp, peeled
1 pound scallops
6 ounces cooked lobster meat, sliced
 (optional)
1–2 tbsp chopped fresh chervil
 or parsley
salt and freshly ground black pepper

1 ▼ Put the mussels in a large heavy saucepan or flameproof casserole and cook, tightly covered, over high heat for 4–6 minutes until the shells open, shaking the pan or casserole occasionally. When cool enough to handle, discard any mussels that did not open and remove the rest from their shells. Strain the cooking liquid through a cheesecloth-lined strainer and reserve.

2 ▲ Put the fennel, onion, leek, carrot and garlic in a saucepan and add the water, reserved mussel liquid, spices and bay leaf. Bring to a boil, skimming any foam that rises to the surface, then reduce the heat and simmer gently, covered, for 20 minutes until the vegetables are tender. Remove the garlic clove.

3 ▲ Add the shrimp, scallops and lobster meat, if using, then after 1 minute, add the mussels. Simmer gently for about 3 minutes until the scallops are opaque and all the shellfish is heated through. Adjust the seasoning, then ladle into a heated tureen or shallow soup plates and sprinkle with herbs.

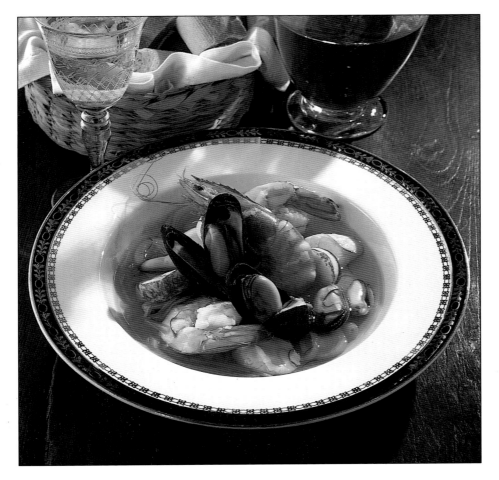

COOK'S TIP

If you like, you can cook and shell the mussels and simmer the vegetables in the broth ahead of time, then finish the dish just before serving.

LOBSTER THERMIDOR

Homard Thermidor

Lobster Thermidor takes its name from the 11th month of the French Revolutionary calendar, which falls in midsummer, although this rich dish is equally delicious in cooler weather, too. Serve one lobster per person as a main course or one filled shell each for a first course.

SERVES 2–4

2 live lobsters (about 1½ pounds each)
1½ tbsp butter
2 tbsp flour
2 tbsp brandy
½ cup milk
6 tbsp heavy cream
1 tbsp Dijon mustard
lemon juice
salt and white pepper
grated Parmesan cheese, for sprinkling
fresh parsley and dill, to garnish

1 ▲ Bring a large saucepan of salted water to a boil. Put the lobsters into the pan head first and cook for 8–10 minutes.

2 ▲ Cut the lobsters in half lengthwise and discard the dark sac behind the eyes, then pull out the string-like intestine from the tail. Remove the meat from the shells, reserving the coral and liver, then rinse the shells and wipe dry. Cut the meat into bite-size pieces.

3 ▲ Melt the butter in a heavy saucepan over medium-high heat. Stir in the flour and cook, stirring, until slightly golden. Pour in the brandy and milk, whisking vigorously until smooth, then whisk in the cream and mustard.

4 Push the lobster coral and liver through a sieve into the sauce and whisk to blend. Reduce the heat to low and simmer gently for about 10 minutes, stirring frequently, until thickened. Season with salt, if needed, pepper and lemon juice.

5 Preheat the broiler. Arrange the lobster shells in a gratin dish or shallow flameproof baking dish.

6 Stir the lobster meat into the sauce and divide the mixture evenly among the shells. Sprinkle lightly with Parmesan and grill until golden. Serve garnished with herbs.

POULTRY AND GAME

Poultry is immensely popular in France and fresh, free-range birds, like the excellent chickens from Bresse, are widely prized. These birds are expensive, but with their usual regard for quality, the French are prepared to pay a little more for something special. The very best are often cooked simply by roasting or sautéing so that their quality can be appreciated. There is a huge variety of other poultry, too – capons, squab, different sizes of chickens, several kinds of ducks, geese, guinea hens, as well as feathered game such as quail, partridge and mallard, which can often be seen hanging outside the poulterer's shop.

ROAST CHICKEN WITH LEMON AND HERBS *Poulet Rôti*

In France, the evocative sight and smell of chickens roasting on their spits can often be found in charcuteries. A well-flavored chicken is essential – use a free-range or corn-fed bird, if possible.

SERVES 4

3 pound chicken
1 unwaxed lemon, halved
small bunch thyme sprigs
1 bay leaf
1 tbsp butter, softened
4–6 tbsp chicken broth or water
salt and freshly ground black pepper

COOK'S TIP

Be sure to save the carcasses of roast poultry for broth. Freeze them until you have several, then simmer with aromatic vegetables, herbs and water.

1 Preheat the oven to 400°F. Season the chicken inside and out with salt and pepper.

2 ▲ Squeeze the juice of one lemon half and then place the juice, the squeezed lemon half, the thyme and bay leaf in the chicken cavity. Tie the legs with string and rub the breast with butter.

3 ▲ Place the chicken on a rack in a roasting pan. Squeeze over the juice of the other lemon half. Roast the chicken for 1 hour, basting two or three times, until the juices run clear when the thickest part of the thigh is pierced with a knife.

4 ▲ Pour the juices from the cavity into the roasting pan and transfer the chicken to a carving board. Cover loosely with foil and let stand for 10–15 minutes before carving.

5 ▲ Skim off the fat from the cooking juices. Add the broth or water and boil over medium heat, stirring and scraping the base of the pan, until slightly reduced. Strain and serve with the chicken.

BROILED SQUAB CHICKEN

Poussins Grillés

This recipe is suitable for many kinds of small birds, including squab chickens, Cornish game hens and partridges. It would also work with quail, but decrease the cooking time and spread the citrus mixture over, rather than under, the fragile skin.

SERVES 4

2 squab chickens (about 1½ pounds each)
4 tbsp butter, softened
2 tbsp olive oil
2 garlic cloves, crushed
½ tsp dried thyme
¼ tsp cayenne pepper, or to taste
grated rind and juice of 1 unwaxed lemon
grated rind and juice of 1 unwaxed lime
2 tbsp honey
salt and freshly ground black pepper
tomato salad, to serve
fresh dill, to garnish

1 ▲ Using kitchen scissors, cut along both sides of the backbone of each bird; remove and discard. Cut the birds in half along the the breast bone, then using a rolling pin, press down to flatten.

2 ▲ Beat the butter in a small bowl, then beat in 1 tbsp of the olive oil, the garlic, thyme, cayenne, salt and pepper, half the lemon and lime rind and 1 tbsp each of the lemon and lime juice.

3 ▼ Using your fingertips, carefully loosen the skin of each squab chicken breast. With a round-bladed knife or small spatula, spread the butter mixture evenly between the skin and breast meat.

COOK'S TIP

If smaller birds, about 1 pound each, are available, serve one per person. Increase the butter to 6 tbsp, if necessary.

4 ▲ Preheat the broiler and line a broiler pan with foil. In a small bowl, mix together the remaining olive oil, lemon and lime juices and the honey. Place the bird halves, skin side up, on the broiler pan and brush with the juice mixture.

5 Broil for 10–12 minutes, basting once or twice with the juices. Turn over and broil for 7–10 minutes, basting once, or until juices run clear when the thigh is pierced with a knife. Serve with the tomato salad, garnished with dill.

OLD-FASHIONED CHICKEN FRICASSÉE *Fricassée de Poulet*

A fricassée *is a classic dish in which poultry or meat is first seared in fat, then braised with liquid until cooked. This recipe is finished with a little cream – leave it out if you wish.*

SERVES 4–6

2½–3 pounds chicken, cut into pieces
4 tbsp butter
2 tbsp vegetable oil
3 tbsp flour
1 cup dry white wine
3 cups chicken broth
bouquet garni
¼ tsp white pepper
8 ounces button mushrooms, trimmed
1 tsp lemon juice
16–24 small white onions, peeled
½ cup water
1 tsp sugar
6 tbsp heavy cream
salt
2 tbsp chopped fresh parsley,
 to garnish

1 ▲ Wash the chicken pieces, then pat dry with paper towels. Melt half the butter with the oil in a large, heavy flameproof casserole over medium heat. Add half the chicken pieces and cook for 10 minutes, turning occasionally, or until just golden in color. Transfer to a plate, then cook the remaining pieces in the same way.

COOK'S TIP

This dish can be made ahead and kept hot in a warm oven for up to an hour before serving.

2 ▲ Return the seared chicken pieces to the casserole. Sprinkle with the flour, turning the pieces to coat. Cook over low heat for about 4 minutes, turning occasionally.

3 ▲ Pour in the wine, bring to a boil and add the broth. Push the chicken pieces to one side and scrape the base of the casserole, stirring until well blended.

4 ▲ Bring the liquid to a boil, add the bouquet garni and season with a pinch of salt and white pepper. Cover and simmer over medium heat for 25–30 minutes until the chicken is tender and the juices run clear when the thickest part of the meat is pierced with a knife.

5 ▲ Meanwhile, in a frying pan, heat the remaining butter over medium-high heat. Add the mushrooms and lemon juice and cook for 3–4 minutes until the mushrooms are golden, stirring. Transfer the mushrooms to a bowl, add the onions, water and sugar to the pan, swirling to dissolve the sugar. Simmer for about 10 minutes, until just tender. Pour the onions and any juices into the bowl with the mushrooms and set aside.

6 When the chicken is cooked, transfer the pieces to a deep serving dish and cover with foil to keep warm. Discard the bouquet garni. Add any cooking juices from the vegetables to the casserole. Bring to a boil and boil, stirring frequently, until the sauce is reduced by half.

7 ▲ Whisk the cream into the sauce and cook for 2 minutes. Add the mushrooms and onions and cook for 2 minutes more. Adjust the seasoning, then pour the sauce over the chicken, sprinkle with parsley and serve.

CHICKEN WITH GARLIC

Poulet à l'Ail

Use fresh garlic if you can find it – there's no need to peel the cloves if the skin is not papery. In France, sometimes the cooked garlic cloves are spread on toasted country bread.

SERVES 8

4½ pounds chicken pieces
1 large onion, halved and sliced
3 large garlic bulbs (about 7 ounces),
 separated into cloves and peeled
⅔ cup dry white wine
¾ cup chicken broth
4–5 thyme sprigs, or ½ tsp dried thyme
1 small rosemary sprig, or a pinch of
 ground rosemary
1 bay leaf
salt and freshly ground black pepper

1 Preheat the oven to 375°F.
Pat the chicken pieces dry and season
with salt and pepper.

2 ▼ Put the chicken, skin side
down, in a large flameproof casserole
and set over medium-high heat.
Turn frequently and transfer the
chicken to a plate when browned.
Cook in batches if necessary and
pour off the fat after browning.

3 ▲ Add the onion and garlic to the
casserole and cook over medium-
low heat, covered, until lightly
browned, stirring frequently.

4 Add the wine to the casserole,
bring to a boil and return the chicken
to the casserole. Add the broth and
herbs and bring back to a boil.
Cover and transfer to the oven.
Cook for 25 minutes, or until the
chicken is tender and the juices run
clear when the thickest part of the
thigh is pierced with a knife.

5 ▲ Remove the chicken pieces
from the pan and strain the cooking
liquid. Discard the herbs, transfer
the solids to a food processor and
purée until smooth. Remove any fat
from the cooking liquid and return
to the casserole. Stir in the garlic and
onion purée, return the chicken to
the casserole and reheat gently for
3–4 minutes before serving.

CHICKEN CHASSEUR

Poulet Sauté Chasseur

A chicken sauté is one of the classics of French cooking. Quick to prepare, it lends itself to endless variation. Since this dish reheats successfully, it is also convenient for entertaining.

SERVES 4

¼ cup flour
2½ pounds chicken pieces
1 tbsp olive oil
3 small onions or large shallots, sliced
6 ounces mushrooms, quartered
1 garlic clove, crushed
4 tbsp dry white wine
½ cup chicken broth
¾ pound tomatoes, peeled, seeded and
　　chopped, or 1 cup canned crushed
　　tomatoes
salt and freshly ground black pepper
fresh parsley, to garnish

1 ▲ Put the flour into a plastic bag and season with salt and pepper. One at a time, drop the chicken pieces into the bag and shake to coat with flour. Carefully tap off the excess flour.

2 ▲ Heat the oil in a heavy flameproof casserole. Fry the chicken over medium-high heat until golden brown, turning once. Transfer to a plate and keep warm.

3 ▲ Pour off all but 1 tbsp of fat from the pan. Add the onions or shallots, mushrooms and garlic. Cook until golden, stirring frequently.

COOK'S TIP

To prepare ahead, reduce the cooking time by 5 minutes. Let cool and chill. Reheat gently for 15–20 minutes.

4 ▼ Return the chicken to the casserole with any juices. Add the wine and bring to a boil, then stir in the broth and tomatoes. Bring back to a boil, reduce the heat, cover and simmer over low heat for about 20 minutes until the chicken is tender and the juices run clear when the thickest part of the meat is pierced with a knife. Tilt the pan and skim off any fat that has risen to the surface, then adjust the seasoning before serving.

CHICKEN WITH SHRIMP *Poulet aux Crevettes*

This unusual combination of ingredients has its origins in Burgundy, where it is traditionally made with crayfish. Shrimp give a similar result and are often easier to obtain.

SERVES 4

3 pound chicken, cut into 8 pieces
2 tsp vegetable oil
12 large shrimp or live crayfish, with
　heads if possible
1 small onion, halved and sliced
2 tbsp flour
¾ cup dry white wine
2 tbsp brandy
1¼ cups chicken broth
3 medium tomatoes, cored
　and quartered
1 or 2 garlic cloves, finely chopped
bouquet garni
6 tbsp heavy cream
salt and freshly ground black pepper
fresh parsley, to garnish

1　Wash the chicken pieces, then pat dry with paper towels and season with salt and pepper.

2 ▲　Heat the oil in a large flameproof casserole and cook the shrimp or crayfish over high heat until they turn a bright color. Remove the shrimp or crayfish, cool slightly and then peel away the heads and shells and reserve. Chill the peeled tails.

3 ▲　Add the chicken to the casserole, skin side down, and cook over medium-high heat for 10–12 minutes until golden brown, turning to color evenly and cooking in batches if necessary. Transfer the chicken to a plate and pour off all but 1 tbsp of the fat.

4 ▲　In the same casserole, cook the onion over medium-high heat until golden, stirring frequently. Sprinkle with flour and continue cooking for 2 minutes, stirring frequently, then add the wine and brandy and bring to the boil, stirring constantly.

COOK'S TIP

To prepare ahead, cook as directed up to step 6. Cool and chill the chicken and sauce. To serve, reheat the chicken and sauce over medium-low heat for about 30 minutes. Add the shrimp or crayfish tails and heat through.

5 ▲　Add the broth, shrimp or crayfish heads and shells, tomatoes, garlic and bouquet garni with the chicken pieces and any juices. Bring to a boil, then reduce the heat to very low. Cover the casserole and simmer for 20–25 minutes until the chicken is tender and the juices run clear when the thickest part of the meat is pierced with a knife.

6　Remove the chicken pieces from the casserole and strain the cooking liquid, pressing down on the shells and vegetables to extract as much liquid as possible. Skim off the fat from the cooking liquid and return the liquid to the pan. Add the cream and boil until it is reduced by one-third and slightly thickened.

7 ▲　Return the chicken pieces to the pan and simmer for 5 minutes. Just before serving, add the shrimp or crayfish tails and heat through. Arrange on warmed plates, pour over some of the sauce and garnish with fresh parsley.

CHICKEN BRAISED IN RED WINE

Coq au Vin

This classic dish was originally made with an old rooster, marinated then slowly braised until very tender. White wine may be used instead of red – as in Alsace, where the local riesling is used.

SERVES 4

3½–4 pound chicken, cut
 in pieces
1½ tbsp olive oil
½ pound pearl onions
1 tbsp butter
½ pound mushrooms, quartered if large
2 tbsp flour
3 cups dry red wine
1 cup chicken broth, or more to cover
bouquet garni
salt and freshly ground black pepper

COOK'S TIP

Avoid large flat mushrooms –
although they have a lovely
flavor, they will make the
sauce murky.

1 ▲ Pat the chicken pieces dry and season with salt and pepper. Put the chicken in a large heavy frying pan, skin side down, and cook over medium-high heat for 10–12 minutes, or until golden brown. Transfer to a plate.

2 Meanwhile, heat the oil in a large flameproof casserole over medium-low heat, add the onions and cook, covered, until evenly browned, stirring frequently.

3 ▲ In a heavy frying pan, melt the butter over medium heat and sauté the mushrooms, stirring, until golden brown.

4 Sprinkle the onions with flour and cook for 2 minutes, stirring frequently, then add the wine and boil for 1 minute, stirring. Add the chicken, mushrooms, broth and bouquet garni. Bring to a boil, reduce the heat to very low and simmer, covered, for 45–50 minutes until the chicken is tender and the juices run clear when the thickest part of the meat is pierced with a knife. (Alternatively, bake in a preheated 325°F oven for the same amount of time.)

5 ▲ Transfer the chicken pieces and vegetables to a plate. Strain the cooking liquid, skim off the fat and return the liquid to the pan. Boil to reduce by one-third, then return the chicken and vegetables to the casserole and simmer for 3–4 minutes to heat through.

CHICKEN AND PISTACHIO PÂTÉ *Ballotine de Volaille aux Pistaches*

This simplified version of a classic of French charcuterie can be made using a whole boned bird, or chicken pieces. Serve it for an elegant picnic or a cold buffet accompanied by an herb mayonnaise.

SERVES 10–12

2 pounds boneless chicken meat
1 skinless boneless chicken breast (about 6 ounces)
⅔ cup fresh white bread crumbs
½ cup heavy cream
1 egg white
4 scallions, finely chopped
1 garlic clove, finely chopped
3 ounces cooked ham, cut into ⅜ inch cubes
½ cup shelled pistachio nuts
3 tbsp chopped fresh tarragon
pinch of ground nutmeg
¾ tsp salt
1½ tsp pepper
green salad, to serve

1 ▲ Trim all the fat, tendons and connective tissue from the 2 pounds chicken meat and cut into 2 inch cubes. Put in a food processor fitted with the metal blade and pulse to chop the meat to a smooth purée, in two or three batches (depending on capacity). Or alternatively pass the meat through the medium or fine blade of a food mill. Remove any white stringy pieces.

2 Preheat the oven to 350°F. Using a sharp knife, cut the chicken breast fillet into ⅜ inch cubes.

3 ▼ In a large mixing bowl, soak the bread crumbs in the cream. Add the puréed chicken, egg white, scallions, garlic, ham, pistachio nuts, tarragon, nutmeg and salt and pepper. Using a wooden spoon or your fingers, mix until very well combined.

COOK'S TIP

You could use turkey meat in place of some or all of the chicken. A 4½ pound chicken or whole turkey breast yields about 2 pounds of boneless meat.

4 ▲ Lay out a piece of extra-wide strong foil about 18 inches long on a work surface and lightly brush oil on a 12 inch square in the center. Spoon the chicken mixture on to the foil to form a log shape about 12 inches long and 3½ inches thick across the width of the foil. Bring together the long sides of the foil and fold over securely to enclose. Twist the ends of the foil and tie with string.

5 Transfer to a baking dish and bake for 1½ hours. Let cool in the dish and chill until cold, preferably overnight. Serve the pâté sliced with green salad.

TARRAGON CHICKEN BREASTS *Suprêmes de Poulet à l'Estragon*

The classic French version of this dish uses a whole chicken, but boneless breasts are quick to cook and elegant. The combination of dried and fresh tarragon makes a wonderfully aromatic sauce.

SERVES 4

4 skinless boneless chicken breasts (about 5–6 ounces each)
½ cup dry white wine
about 1¼ cups chicken broth
1 tbsp dried tarragon
1 garlic clove, finely chopped
¾ cup heavy cream
1 tbsp chopped fresh tarragon
salt and freshly ground black pepper
fresh tarragon sprigs, to garnish

COOK'S TIP

Tarragon is traditionally paired with chicken, but you could of course use chopped fresh basil or parsley instead.

1 ▼ Season the chicken breasts lightly with salt and pepper and put them in a saucepan just large enough to hold them in one layer. Pour over the wine and broth, adding more broth to cover, if necessary, then add the dried tarragon and the garlic. Bring just to a simmer over medium heat and cook gently for 8–10 minutes until the juices run clear when the chicken is pierced with a knife.

2 ▲ With a slotted spoon, transfer the chicken to a plate and cover to keep warm. Strain the cooking liquid into a small saucepan, skim off any fat and boil to reduce by two-thirds.

3 Add the cream and boil to reduce by half. Stir in the fresh tarragon and adjust the seasoning. Slice the chicken breasts, spoon over a little sauce and garnish with tarragon.

CHICKEN BREASTS WITH GRAPES *Suprêmes de Volaille Veronique*

When grapes are used in a dish, it is often called "Veronique" or sometimes "à la vigneronne" after the wife of the grape grower. Here they are cooked with chicken in a creamy sauce.

SERVES 4

4 boneless chicken breasts (about 7 ounces each), well trimmed
2 tbsp butter
1 large or 2 small shallots, chopped
½ cup dry white wine
1 cup chicken broth
½ cup heavy cream
1 cup (about 30) seedless green grapes
salt and freshly ground black pepper
fresh parsley, to garnish

1 Season the chicken breasts with salt and pepper. Melt half the butter in a frying pan over medium-high heat and cook the chicken breasts until cooked through and golden.

2 ▲ Transfer the chicken breasts to a plate and cover to keep warm. Add the remaining butter and sauté the shallots until just softened, stirring frequently. Add the wine, bring to a boil and boil to reduce by half, then add the broth and continue boiling to reduce by half again.

3 ▼ Add the cream to the sauce, bring back to a boil, and add any juices from the chicken. Add the grapes and cook gently for 5 minutes. Slice the chicken breasts and serve with the sauce, garnished with parsley.

CHICKEN WITH OLIVES *Poulet à la Provençale*

*Chicken breasts or turkey, veal or pork scallops may be flattened for quick and even cooking.
You can buy them ready-prepared in France, but they are easy to do at home.*

SERVES 4

*4 skinless boneless chicken breasts (about
 5–6 ounces each)*
¼ tsp cayenne pepper
5–7 tbsp extra virgin olive oil
1 garlic clove, finely chopped
6 ripe plum tomatoes
16–24 pitted black olives
small handful fresh basil leaves
salt

1 ▼ Carefully remove the long finger-shaped muscle on the back of each breast and reserve for another use.

2 Place each chicken breast between two sheets of wax paper or plastic wrap and pound with the flat side of a mallet or roll out with a rolling pin to flatten to about ½ inch thick. Season with salt and the cayenne pepper.

3 Heat 3–4 tbsp of olive oil in a large heavy frying pan over medium-high heat. Add the chicken and cook for 4–5 minutes until golden brown and just cooked, turning them once. Transfer the chicken to warmed serving plates and keep warm while you cook the tomatoes and olives.

4 ▲ Wipe out the frying pan and return to the heat. Add another 2–3 tbsp of olive oil and fry the garlic for 1 minute until golden and fragrant. Stir in the olives, cook for 1 minute more, then stir in the tomatoes. Shred the basil leaves and stir into the olive and tomato mixture, then spoon it over the chicken and serve at once.

COOK'S TIP

If the tomato skins are at all tough, remove them by scoring the base of each tomato with a knife, then plunging them into boiling water for 45 seconds. The skin should simply peel off.

CHICKEN WITH RED WINE VINEGAR *Poulet au Vinaigre*

This dish is an easy version of the modern classic invented by one of the masters of French cooking,
the late Fernand Point of the Michelin-starred restaurant near Lyons, La Pyramide.

SERVES 4

4 skinless boneless chicken breasts
 (7 ounces each)
4 tbsp unsalted butter
freshly ground black pepper
8–12 shallots, trimmed and halved
4 tbsp red wine vinegar
2 garlic cloves, finely chopped
4 tbsp dry white wine
½ cup chicken broth
1 tbsp chopped fresh parsley
green salad, to serve

1 ▲ Cut each chicken breast in half crosswise to make eight pieces.

2 Melt half the butter in a large heavy-based frying pan over medium heat. Add the chicken and cook for 3–5 minutes until golden brown, turning once, then season with pepper.

3 ▲ Add the shallot halves to the pan, cover and cook over low heat for 5–7 minutes, shaking the pan and stirring the pieces occasionally.

4 ▲ Transfer the chicken pieces to a plate. Add the vinegar and cook, stirring frequently, for about 1 minute until the liquid is almost evaporated. Add the garlic, wine and broth and stir to blend.

5 Return the chicken to the pan with any accumulated liquid. Cover and simmer for 2–3 minutes until the chicken is tender and the juices run clear when the meat is pierced with a knife.

6 Transfer the chicken and shallots to a serving dish and cover to keep warm. Increase the heat and boil the cooking liquid until it has reduced by half.

7 Remove the pan from the heat. Gradually add the remaining butter, whisking until the sauce is slightly thickened and glossy. Stir in the parsley and pour the sauce over the chicken pieces and shallots. Serve at once with a green salad.

VARIATIONS

You could use different flavored vinegars. Try tarragon vinegar and substitute fresh tarragon for the parsley, or use raspberry vinegar and garnish with a few fresh raspberries.

131

CHICKEN WITH MORELS *Suprêmes de Volaille Farcies aux Morilles*

Morels are among the most tasty dried mushrooms and, although expensive, a little goes a long way. Of course, you can use fresh morels (about 10 ounces) in place of the dried ones, or substitute chanterelles, shiitake or oyster mushrooms.

SERVES 4

1½ ounces dried morel mushrooms
1 cup chicken broth
4 tbsp butter
5 or 6 shallots, thinly sliced
3½ ounces button mushrooms, thinly
 sliced
¼ tsp dried thyme
2–3 tbsp brandy
¾ cup heavy cream
4 skinless boneless chicken breasts (about
 7 ounces each)
1 tbsp vegetable oil
¾ cup Champagne or dry sparkling
 wine
salt and freshly ground black pepper

1 ▲ Put the morels in a strainer and rinse well under cold running water, shaking to remove as much sand as possible. Put them in a saucepan with the broth and bring to a boil over medium-high heat. Remove the pan from the heat and leave to stand for 1 hour.

2 Remove the morels from the cooking liquid and strain the liquid through a cheesecloth-lined colander and reserve for the sauce. Reserve a few whole morels and slice the rest.

3 ▲ Melt half the butter in a frying pan over medium heat. Add the shallots and cook for 2 minutes until softened, then add the morels and mushrooms and cook, stirring frequently, for 2–3 minutes. Season and add the thyme, brandy and ⅓ cup of the cream. Reduce the heat and simmer gently for 10–12 minutes until any liquid has evaporated, stirring occasionally. Remove the morel mixture from the pan and set aside to cool slightly.

4 ▲ Pull off the finger-shaped piece on the underside from the chicken breasts and reserve for another use. Make a pocket in each chicken breast by cutting a slit along the thicker edge, taking care not to cut all the way through.

5 Using a small spoon, fill each pocket with one-quarter of the mushroom mixture, then if necessary, close with a toothpick.

6 ▲ Melt the remaining butter with the oil in a heavy frying pan over medium-high heat and cook the chicken breasts on one side for 6–8 minutes until golden. Transfer the chicken breasts to a plate. Add the Champagne or sparkling wine to the pan and boil to reduce by half. Add the strained morel cooking liquid and boil to reduce by half again.

7 ▲ Add the remaining cream and cook over medium heat for 2–3 minutes until the sauce thickens slightly and coats the back of a spoon. Adjust the seasoning. Return the chicken to the pan with any accumulated juices and the reserved whole morels and simmer for 3–5 minutes over medium-low heat until the chicken breasts are hot and the juices run clear when the meat is pierced with a knife.

TURKEY SCALLOPS WITH CAPERS

Escalopes en Capilotade

A staple of bistro cooking, these thin slices of poultry or meat, called escalopes *or sometimes* paillards, *cook very quickly and can be served with all kinds of interesting sauces.*

SERVES 2

4 thin turkey breast scallops (about
 3 ounces each)
1 large unwaxed lemon
½ tsp chopped fresh sage
4–5 tbsp extra virgin
 olive oil
½ cup fine dry bread crumbs
1 tbsp capers, rinsed and drained
salt and freshly ground black pepper
sage leaves and lemon wedges, to garnish

1 ▼ Place the turkey scallops between two sheets of wax paper or plastic wrap and pound with the flat side of a mallet or roll with a rolling pin to flatten to about a ¼ inch thickness.

2 ▲ With a vegetable peeler, remove four pieces of lemon rind. Cut them into thin julienne strips, cover with plastic wrap and set aside. Grate the remainder of the lemon rind and squeeze the lemon. Put the grated rind in a large shallow dish and add the sage, salt and pepper. Stir in 1 tbsp of the lemon juice, reserving the rest, and about 1 tbsp of the olive oil, then add the turkey, turn to coat and marinate for 30 minutes.

3 ▲ Place the bread crumbs in another shallow dish and dip the scallops in the crumbs, coating both sides. In a heavy frying pan heat 2 tbsp of the olive oil over a high heat, add the scallops and cook for 2–3 minutes, turning once, until golden. Transfer to two warmed plates and keep warm.

4 Wipe out the pan, add the remaining oil, the lemon julienne and the capers, stirring, and heat through. Spoon a little sauce over the turkey and garnish with sage leaves and lemon.

GUINEA HEN WITH CABBAGE

Pintade au Chou

Guinea hen is a domesticated relative of pheasant, so you can substitute pheasant or even chicken in this recipe. In some parts of France, such as Burgundy, garlic sausage may be added.

SERVES 4

2½–3 pound guinea hen
1 tbsp vegetable oil
1 tbsp butter
1 large onion, halved and sliced
1 large carrot, halved and sliced
1 large leek, sliced
1 pound green cabbage, such as savoy,
 sliced or chopped
½ cup dry white wine
½ cup chicken broth
1 or 2 garlic cloves, finely chopped
salt and freshly ground black pepper

1 Preheat the oven to 350°F. Tie the legs of the guinea hen with string.

2 ▲ Heat half the oil in a large flameproof casserole over medium-high heat and cook the guinea hen until golden brown on all sides. Transfer to a plate.

3 Pour out the fat from the casserole and add the remaining oil with the butter. Add the onion, carrot and leek and cook over low heat, stirring occasionally, for 5 minutes. Add the cabbage and cook for about 3–4 minutes until slightly wilted, stirring occasionally. Season the vegetables with salt and pepper.

4 ▼ Place the guinea hen on its side on the vegetables. Add the wine and bring to a boil, then add the broth and garlic. Cover and transfer to the oven. Cook for 25 minutes, then turn the bird onto the other side and cook for 20–25 minutes until it is tender and the juices run clear when the thickest part of the thigh is pierced with a knife.

5 ▲ Transfer the bird to a board and let stand for 5–10 minutes, then cut into four or eight pieces. With a slotted spoon, transfer the cabbage to a warmed serving platter and place the guinea hen on top. Skim any fat from the cooking juices and serve separately.

ROAST PHEASANT WITH PORT *Faisan Rôti au Porto*

Roasting the pheasant in foil keeps the flesh particularly moist. This recipe is best for very young birds and, if you have a choice, request the more tender female birds.

<u>SERVES 4</u>

2 oven-ready hen pheasants (about 1½ pounds each)
4 tbsp unsalted butter, softened
8 fresh thyme sprigs
2 bay leaves
6 bacon slices
1 tbsp flour
¾ cup game or chicken broth, plus more if needed
1 tbsp red currant jelly
3–4 tbsp port
freshly ground black pepper

1 Preheat the oven to 450°F. Line a large roasting pan with a sheet of strong foil large enough to enclose the pheasants. Lightly brush the foil with oil.

2 ▼ Wipe the pheasants with damp paper towels and remove any extra fat or skin. Using your fingertips, carefully loosen the skin of the breasts. With a round-bladed knife or small spatula, spread the butter between the skin and breast meat of each bird. Tie the legs securely with string then lay the thyme sprigs and a bay leaf over the breast of each bird.

3 ▲ Lay bacon slices over the breasts, place the birds in the foil-lined pan and season with pepper. Bring together the long ends of the foil, fold over securely to enclose, then seal the ends.

4 Roast the birds for 20 minutes, then reduce the oven temperature to 375°F and cook for 40 minutes more. Uncover the birds and roast 10–15 minutes more or until they are browned and the juices run clear when the thigh of a bird is pierced with a knife. Transfer the birds to a board and let stand, covered with clean foil, for 10 minutes before carving.

5 ▲ Pour the juices from the foil into the roasting pan and skim off any fat. Sprinkle in the flour and cook over medium heat, stirring until smooth. Whisk in the broth and red currant jelly and bring to a boil. Simmer until the sauce thickens slightly, adding more broth if needed, then stir in the port and adjust the seasoning. Strain and serve with the pheasant.

PHEASANT BREAST WITH APPLES

Faisan à la Normande

The Normandy countryside is full of picturesque apple orchards and herds of grazing cows. Many regional dishes contain apples or Calvados and rich Normandy cream.

SERVES 2

2 boneless pheasant breasts
2 tbsp butter
1 onion, thinly sliced
1 eating apple, peeled and quartered
2 tsp sugar
4 tbsp Calvados
4 tbsp chicken broth
¼ tsp dried thyme
¼ tsp white pepper
½ cup heavy cream
salt
sautéed potatoes, to serve

1 ▲ With a sharp knife, score the thick end of each pheasant breast.

2 In a medium heavy frying pan melt half of the butter over medium heat. Add the onion and cook for 8–10 minutes until golden, stirring occasionally. Using a slotted spoon, transfer the onion to a plate.

3 Cut each apple quarter crosswise into thin slices. Melt half of the remaining butter in the pan and add the apple slices. Sprinkle with the sugar and cook the apple slices slowly for 5–7 minutes until golden and caramelized, turning occasionally. Transfer the apples to the plate with the onion, then wipe out the pan.

4 ▲ Add the remaining butter to the pan and increase the heat to medium-high. Add the pheasant breasts, skin side down, and cook for 3–4 minutes until golden. Turn and cook for 1–2 minutes more until the juices run slightly pink when the thickest part of the meat is pierced with a knife. Transfer to a board and cover to keep warm.

5 Add the Calvados to the pan and boil over high heat until reduced by half. Add the broth, thyme, a little salt and the white pepper and reduce by half again. Stir in the cream, bring to a boil and cook for about 1 minute. Add the reserved onion and apple slices to the pan and cook for 1 minute.

6 Slice each pheasant breast diagonally and arrange on warmed plates. Spoon over a little sauce with the onion and apples.

COOK'S TIP

If you can't find Calvados, substitute Cognac, applejack or cider instead.

137

QUAIL WITH FRESH FIGS

Cailles aux Figues Fraîches

The fig trees in the South of France are laden with ripe purple fruit in early autumn, coinciding with the quail shooting season.

SERVES 4

8 oven-ready quail (5 ounces each)
6 firm ripe figs, quartered
1 tbsp butter
6 tbsp dry sherry
1¼ cups chicken broth
1 garlic clove, finely chopped
2–3 thyme sprigs
1 bay leaf
1½ tsp cornstarch blended with 1 tbsp
 water
salt and freshly ground black pepper
green salad, to serve

1 ▼ Season the quail inside and out with salt and pepper. Put a fig quarter in the cavity of each quail and tie the legs with string.

2 ▲ Melt the butter in a deep frying pan or heavy flameproof casserole over medium-high heat. Add the quail and cook for 5–6 minutes, turning to brown all sides evenly; cook in batches if necessary.

3 ▲ Add the sherry and boil for 1 minute, then add the broth, garlic, thyme and bay leaf. Bring slowly to a boil, reduce the heat and simmer gently, covered, for about 20 minutes.

4 Add the remaining fig quarters and continue cooking for 5 minutes more until the juices run clear when the thigh of a quail is pierced with a knife. Transfer the quail and figs to a warmed serving dish, cut off the trussing string and cover to keep warm.

5 Bring the sauce to a boil, then stir in the blended cornstarch. Cook gently for 3 minutes, stirring frequently, until the sauce is thickened, then strain into a sauceboat. Serve the quail and figs with the sauce and a green salad.

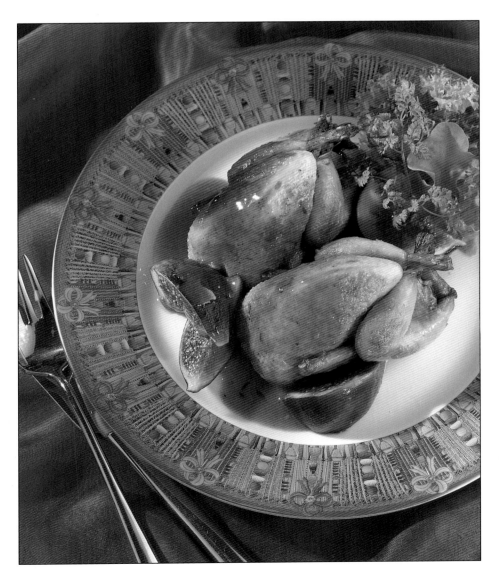

DUCK WITH ORANGE SAUCE

Canard à la Bigarade

Commercially raised ducks tend to be much fattier than wild ducks. In this recipe, the initial slow cooking and pricking the skin of the duck helps to draw out the excess fat.

SERVES 2–3

4½ pound duck
2 oranges
½ cup superfine sugar
6 tbsp white wine vinegar or cider
 vinegar
½ cup Grand Marnier or orange liqueur
salt and freshly ground black pepper
watercress and orange slices,
 to garnish

3 ▼ Place the sugar and vinegar in a small heavy saucepan and stir to dissolve the sugar. Boil over high heat, without stirring, until the mixture is a rich caramel color, remove the pan from the heat and, standing well back, carefully add the orange juice, pouring it down the side of the pan. Swirl the pan to blend, then bring back to a boil and add the orange peel and liqueur. Simmer for 2–3 minutes.

4 Remove the duck from the oven and pour off all the fat from the pan. Raise the oven temperature to 400°F and return the duck to the oven.

5 ▲ Roast the duck, uncovered, for 25–30 minutes, basting three or four times with the caramel mixture, until the duck is golden brown and the juices run clear when the thigh is pierced with a knife.

6 Pour the juices from the cavity into the casserole and transfer the duck to a carving board. Cover loosely with foil and let stand for 10–15 minutes. Pour the roasting juices into the pan with the rest of the caramel mixture, skim off the fat and simmer gently. Serve the duck, with the sauce, garnished with watercress and orange slices.

1 ▲ Preheat the oven to 300°F. Trim off all the excess fat and skin from the duck and prick the skin all over with a fork. Season the duck inside and out with salt and pepper and tie the legs with string.

2 ▲ Place the duck on a rack in a large roasting pan. Cover tightly with foil and cook in the oven for 1½ hours. With a vegetable peeler, remove the peel in wide strips from the oranges, then stack two or three strips at a time and slice into very thin julienne strips. Squeeze the juice from the oranges.

ROAST WILD DUCK WITH JUNIPER
Canard aux Genièvres

Wild duck should be served slightly underdone or the meat will be very tough. There is little meat on the leg, so one duck will serve only two people – keep the legs for making a tasty stock.

SERVES 2

1 tbsp juniper berries, fresh if
 possible
1 oven-ready wild duck (preferably
 a mallard)
2 tbsp butter, softened
3 tbsp gin
½ cup duck or chicken stock
½ cup heavy cream
salt and freshly ground black pepper
watercress, to garnish

1 Preheat the oven to 450°F. Reserve a few juniper berries for garnishing and put the remainder in a heavy plastic bag. Crush coarsely with a rolling pin.

2 ▲ Wipe the duck with damp paper towels and remove any excess fat or skin. Tie the legs with string, then spread the butter over the duck. Sprinkle with salt and pepper and press the crushed juniper berries onto the skin.

3 Place the duck in a roasting pan and roast for 20–25 minutes, basting occasionally; the juices should run slightly pink when the thigh is pierced with a knife. Pour the juices from the cavity into the roasting pan and transfer the duck to a carving board. Cover loosely with foil and let stand for 10–15 minutes.

4 ▲ Skim off as much fat as possible from the roasting pan, leaving as much of the juniper as possible, and place the pan over a medium-high heat. Add the gin and stir, scraping the base of the pan and bring to a boil. Cook until the liquid has almost evaporated, then add the stock and boil to reduce by half. Add the cream and boil for 2 minutes more, or until the sauce thickens slightly. Strain into a small saucepan and keep warm.

5 Carve the legs from the duck and separate the thigh from the drumstick. Remove the breasts and arrange the duck in a warmed serving dish. Pour a little sauce over, sprinkle with the reserved juniper berries and garnish with watercress.

COOK'S TIP

If you do not serve the legs, use the legs and duck carcass to make a duck broth for other game dishes.

DUCK STEW WITH OLIVES

Ragoût de Canard aux Olives

This method of preparing duck has its roots in Provence. The sweetness of the onions, which are not typical in all regional versions, balances the saltiness of the olives.

SERVES 6–8

2 ducks (about 3¼ pounds each), quartered, or 8 duck leg quarters
½ pound pearl onions
2 tbsp flour
1½ cups dry red wine
2 cups duck or chicken broth
bouquet garni
1 cup pitted green or black olives, or a combination
salt, if needed, and freshly ground black pepper

1 Put the duck pieces, skin side down, in a large frying pan over medium heat and cook for 10–12 minutes until well browned, turning to color evenly and cooking in batches if necessary. Pour off the fat from the pan.

2 Heat 1 tbsp of the duck fat in a large flameproof casserole and cook the onions, covered, over medium-low heat until evenly browned, stirring frequently. Sprinkle with flour and continue cooking, uncovered, for 2 minutes, stirring frequently.

3 ▲ Stir in the wine and bring to a boil, then add the duck pieces, broth and bouquet garni. Bring to a boil, then reduce the heat to very low and simmer, covered, for about 40 minutes, stirring occasionally.

4 ▼ Rinse the olives in several changes of cold water. If they are very salty, put in a saucepan, cover with water and bring to a boil, then drain and rinse. Add the olives to the casserole and continue cooking for 20 minutes more until the duck is very tender.

5 Transfer the duck pieces, onions and olives to a plate. Strain the cooking liquid, skim off all the fat and return the liquid to the pan. Boil to reduce by about one-third, then adjust the seasoning and return the duck and vegetables to the casserole. Simmer gently for a few minutes to heat through.

COOK'S TIP

If you take the breasts from whole ducks for duck breast recipes, freeze the legs until you have enough for this stew, and make stock from the carcasses.

VENISON WITH ROQUEFORT BUTTER *Chevreuil au Roquefort*

If venison is difficult to find, use beef instead.

SERVES 2

2 venison sirloin steaks, about
 5–6 ounces each
1 garlic clove, finely chopped
4 tbsp brandy
3 tbsp unsalted butter
1½ ounces Roquefort cheese
freshly ground black pepper

1 ▲ Put the steaks in a small glass dish. Sprinkle with pepper and garlic and pour over the brandy.

2 Cover the dish and marinate in a cool place, for up to 1 hour, or chill for up to 4 hours.

3 ▲ Using a fork, mash together 2 tbsp of the butter and the cheese, or blend them in a food processor. Shape the mixture into a log, wrap and chill until needed.

4 Heat the remaining butter in a heavy frying pan over medium-high heat. Drain the meat, reserving the marinade.

5 ▲ Add the steaks to the pan. Cook for about 5 minutes, turning once, until the meat is springy to the touch for medium-rare or firmer for more well done, then transfer the steaks to warmed plates.

6 Add the reserved marinade to the pan and bring to a boil, scraping the base of the pan. Pour over the meat, then top each steak with one or two slices of the Roquefort butter and serve.

DUCK WITH PEPPERCORNS *Magret de Canard aux Grains de Poivre*

Thick meaty duck breast, like steak, should be served medium-rare. Green peppercorn sauce is popular in modern French bistros, but you can also use somewhat milder pink peppercorns.

SERVES 2

1 tsp vegetable oil
2 duck breasts (about 8 ounces each),
 skinned
4 tbsp chicken or duck stock
6 tbsp whipping cream
1 tsp Dijon mustard
1 tbsp pink or green peppercorns in
 vinegar, drained
salt
fresh parsley, to garnish

1 Heat the oil in a heavy frying pan. Add the duck breasts and cook over a medium-high heat for about 3 minutes on each side.

2 ▲ Transfer the duck breasts to a plate and cover to keep warm. Pour off any fat from the pan and stir in the stock, cream, mustard and peppercorns. Boil for 2–3 minutes until the sauce thickens slightly, then season with salt.

3 ▼ Pour any accumulated juices from the duck into the sauce, then slice the breasts diagonally. Arrange them on two warmed serving plates, pour over a little of the sauce and garnish with parsley.

ROAST LEG OF VENISON *Gigot de Chevreuil Rôti*

Although young venison does not need marinating to tenderize it, the marinade forms the base for a delicious, tangy yet slightly sweet sauce. You'll need to start this recipe two to three days ahead.

SERVES 6–8

1 onion, chopped
1 carrot chopped
1 celery stick, chopped
3 or 4 garlic cloves, crushed
4–6 fresh parsley sprigs
4–6 fresh thyme sprigs or ½ tsp
 dried thyme
2 bay leaves
1 tbsp black peppercorns, lightly
 crushed
3 cups red wine
4 tbsp vegetable oil, plus more
 for brushing
1 young venison haunch (about
 6 pounds), trimmed
2 tbsp flour
1 cup beef broth
1 unwaxed orange
1 unwaxed lemon
4 tbsp red currant or raspberry jelly
4 tbsp ruby port or Madeira
1 tbsp cornstarch, blended with 2 tbsp of
 water
1 tbsp red wine vinegar
fresh herbs, to garnish
French Scalloped Potatoes,
 to serve

1 ▲ Place the onion, carrot, celery, garlic, parsley, thyme, bay leaves, peppercorns, wine and oil in a deep glass dish large enough to hold the venison, then add the venison and turn to coat. Cover the dish with plastic wrap and leave to marinate in the refrigerator for 2–3 days, turning occasionally.

2 ▲ Preheat the oven to 350°F. Remove the meat from its marinade and pour the marinade into a saucepan. Pat the meat dry with paper towels, then brush the meat with a little oil on all sides and wrap tightly in foil.

3 ▲ Roast the venison for 15–20 minutes per 1 pound for rare to medium. About 25 minutes before the end of the cooking time, remove the foil, sprinkle the venison with the flour and baste with the cooking juices.

4 Meanwhile, add the broth to the marinade and boil over medium-high heat until reduced by half, then strain and set aside.

5 Using a vegetable peeler, remove the peel from the orange and half the lemon in long pieces. Cut the pieces into thin julienne strips. Bring a small saucepan of water to a boil over high heat and add the orange and lemon strips. Simmer them for 5 minutes, then drain and rinse under cold running water.

6 ▲ Squeeze the juice of the orange into a medium saucepan. Add the jelly and cook over low heat until melted, then stir in the port or Madeira and the reduced marinade and simmer gently for 10 minutes.

7 ▲ Stir the blended cornstarch mixture into the marinade and cook, stirring frequently, until the sauce is slightly thickened. Add the vinegar and the orange and lemon strips and simmer for 2–3 minutes more. Keep warm, stirring occasionally.

8 Transfer meat to a board and let stand, covered with foil for 10 minutes before carving. Garnish with herbs and serve with the sauce and French Scalloped Potatoes.

CASSEROLED RABBIT WITH THYME *Fricassée de Lapin au Thym*

This is the sort of satisfying home cooking found in farmhouse kitchens and cozy neighbourhood restaurants in France, where rabbit is treated much like chicken and enjoyed frequently.

SERVES 4

2½ pounds rabbit
¼ cup flour
1 tbsp butter
1 tbsp olive oil
1 cup red wine
1½–2 cups chicken broth
1 tbsp fresh thyme leaves, or 2 tsp dried
 thyme
1 bay leaf
2 garlic cloves, finely chopped
2–3 tsp Dijon mustard
salt and freshly ground black pepper

1 Cut the rabbit into eight serving pieces: chop the saddle in half and separate the back legs into two pieces each; leave the front legs whole.

2 ▼ Put the flour in a plastic bag and season with salt and pepper. One at a time, drop the rabbit pieces into the bag and shake to coat them with flour. Tap off the excess, then discard any remaining flour.

3 ▲ Melt the butter with the oil over medium–high heat in a large flameproof casserole. Add the rabbit pieces and cook until golden, turning to color evenly.

4 ▲ Add the wine and boil for 1 minute then add enough of the broth just to cover the meat. Add the herbs and garlic, then simmer gently, covered, for 1 hour, or until the rabbit is very tender and the juices run clear when the thickest part of the meat is pierced with a knife.

5 ▲ Stir in the mustard, adjust the seasoning and strain the sauce. Arrange the rabbit pieces on a warmed serving platter with some sauce and serve the rest separately.

SAUTÉED FOIE GRAS

Foie Gras Chaud

Even in France, fresh **foie gras**, *the liver of specially raised and fattened geese or ducks, is not too easy to come by. If you can find it, this quick recipe brings out its rich flavor.*

SERVES 4

10 ounces small baking potatoes, peeled
1 tbsp butter
1 pound fresh foie gras, cut into 8 × ¾ inch slices
3–4 tbsp sherry vinegar or white wine vinegar
salt and freshly ground black pepper
fresh chives, to garnish

1 ▲ Cut the potatoes into ¹⁄₁₆ inch slices and cover with cold water if not using immediately.

2 ▲ Pat the potatoes dry. Melt the butter in a large frying pan over medium heat. Make four 5 inch rounds of overlapping potato slices in the pan and press them down. Season with salt and pepper and cook for 6–8 minutes until the bases are well browned. Turn and brown the other side, for 5 minutes. Transfer to a baking sheet and keep warm in a low oven.

3 ▼ Season the *foie gras* with salt and pepper. Heat a large non-stick frying pan over high heat and cook the slices, in one layer or in batches, for 3 minutes for ¾ inch slices, less for thinner slices, turning once.

4 ▲ Place the potato cakes on warmed plates and top with slices of *foie gras*. Pour the vinegar into the frying pan and boil briefly, scraping the base of the pan, then pour the sauce over the *foie gras*, dividing it evenly. Garnish with chives.

CHICKEN LIVER MOUSSE

Mousse de Foie de Volaille

This mousse makes an elegant yet easy first course. The onion marmalade makes a delicious accompaniment, along with a salad of chicory or other bitter leaves.

SERVES 6–8

1 pound chicken livers
¾ cup butter, diced
1 small onion, finely chopped
1 garlic clove, finely chopped
½ tsp dried thyme
2–3 tbsp brandy
salt and freshly ground black pepper
green salad, to serve

FOR THE ONION MARMALADE
2 tbsp butter
1 pound red onions, thinly sliced
1 garlic clove, finely chopped
½ tsp dried thyme
2–3 tbsp raspberry or red wine vinegar
1–2 tbsp clear honey
¼ cup raisins

1 Trim the chicken livers, cutting off any green spots and removing any filaments or fat.

2 ▲ In a heavy frying pan, melt 2 tbsp of the butter over a medium heat. Add the onion and cook for 5–7 minutes until soft and golden, then add the garlic and cook for 1 minute more. Increase the heat to medium-high and add the chicken livers, thyme, salt and pepper. Cook for 3–5 minutes until the livers are colored, stirring frequently; the livers should remain pink inside, but not raw. Add the brandy and cook for 1 minute more.

3 ▲ Using a slotted spoon, transfer the livers to a food processor fitted with the metal blade. Pour in the cooking juices and process for 1 minute, or until smooth, scraping down the sides once. With the machine running, add the remaining butter, a few pieces at a time, until it is incorporated.

4 ▲ Press the mousse mixture through a fine sieve with a wooden spoon or rubber spatula.

COOK'S TIP

The mousse will keep for 3–4 days. If made ahead, cover and chill until ready to use. The onion marmalade can be made up to 2 days ahead and gently reheated over a low heat or in the microwave until just warm.

5 ▲ Line a 2 cup loaf pan with plastic wrap, smoothing out as many wrinkles as possible. Carefully pour the mousse mixture into the lined pan. Cool, then cover and chill until firm, or overnight.

6 ▲ To make the onion marmalade, heat the butter in a heavy frying pan over medium-low heat, add the onions and cook for 20 minutes until softened and just colored, stirring frequently. Stir in the garlic, thyme, vinegar, honey and raisins and cook, covered, for 10–15 minutes until the onions are completely soft and jam-like, stirring occasionally. Spoon into a bowl and cool to room temperature.

7 ▲ To serve, dip the loaf pan into hot water for 5 seconds, wipe dry and invert onto a board. Lift off the pan, peel off the plastic wrap and smooth the surface with a knife. Serve sliced with a little of the onion marmalade and a green salad.

MEAT DISHES

The produce displayed in a French butcher shop is different from that in other countries. Meat is expensive, and butchers are expected to provide quality, choice and good service. The cuts, whether large or small, are always beautifully presented, and even stewing cuts, although they may be bony and gelatinous, are still carefully trimmed. There will be a wide choice of organ meats, too, as well as numerous kinds of sausages. Slow cooking methods like braising and cooking in casserole are popular and meat is often marinated, while the more tender cuts are cooked quickly to keep the full flavor and succulence of the meat.

STEAK WITH ANCHOVY SAUCE *Entrecôte au Beurre d'Anchois*

This may sound like an unusual combination, but the anchovy adds flavor without tasting fishy.

SERVES 2

3 tbsp butter
4 shallots, finely chopped
1 garlic clove, crushed
6 tbsp heavy cream
1½ tbsp anchovy paste
1 tbsp chopped fresh tarragon
2 sirloin or fillet steaks, about
7–9 ounces each
2 tsp vegetable oil
salt and freshly ground black pepper
parsley or tarragon sprigs, to garnish
sautéed potatoes, to serve

1 ▼ Melt 2 tbsp of the butter in a small saucepan and sauté the shallots and garlic until they are just soft. Stir in the cream, anchovy paste and tarragon, and simmer very gently for about 10 minutes.

2 ▲ Season the steaks. Heat the remaining butter with the oil in a heavy frying pan over medium-high heat until it begins to brown.

3 Add the meat and cook for about 6–8 minutes, turning once, until done as preferred (medium-rare meat will still be slightly soft when pressed, medium meat will be springy and well-done firm). Transfer the steaks to warmed serving plates and cover to keep warm.

4 ▲ Add 2 tbsp of water to the frying pan. Stir in the anchovy sauce and cook for 1–2 minutes, stirring and scraping the bottom of the pan. Adjust the seasoning and pour the sauce over the meat, then garnish with parsley or tarragon and serve with potatoes.

VARIATION

To make a tomato cream sauce
to serve with the steak, substitute
1–2 tsp tomato paste for
the anchovy paste.

PEPPER STEAK

Steak au Poivre

There are many versions of this French bistro classic; some omit the cream, but it helps to balance the heat of the pepper. Use fairly thick steaks, such as fillet or lean sirloin.

SERVES 2

2 tbsp black peppercorns
2 fillet or sirloin steaks, about
8 ounces each
1 tbsp butter
2 tsp vegetable oil
3 tbsp brandy
⅔ cup heavy cream
1 garlic clove, finely chopped
salt, if needed

1 ▲ Place the peppercorns in a sturdy plastic bag. Crush with a rolling pin until medium-coarse or, using the flat base of a small heavy saucepan, press down on the peppercorns, rocking the pan to crush them.

2 ▲ Put the steaks on a board and trim away any extra fat. Press the pepper onto both sides of the meat, coating it completely.

3 ▼ Melt the butter with the oil in a heavy frying pan over medium-high heat. Add the meat and cook for 6–7 minutes, turning once, until done as preferred (medium-rare meat will still be slightly soft when pressed, medium will be springy and well-done firm). Transfer the steaks to a warmed platter or plates and cover to keep warm.

4 ▲ Pour in the brandy to deglaze the pan. Allow to boil until reduced by half, scraping the base of the pan, then add the cream and garlic. Boil gently over medium heat for about 4 minutes until the cream has reduced by one-third. Stir any accumulated juices from the meat into the sauce, taste and add salt, if necessary, then serve the steaks with the sauce.

Beef Rib with Onion Sauce *Côte de Boeuf Compôte d'Oignon*

A rib of beef is a popular cut in France and a côte de boeuf, serving two, is often found on bistro menus. The cooking technique of browning first, then finishing in the oven is typically French.

Serves 2–4

1 beef rib with bone (about 2¼ pounds and about 1½ inches thick), well trimmed of fat
1 tsp lightly crushed black peppercorns
1 tbsp coarse sea salt, crushed
4 tbsp unsalted butter
For the onion sauce
1 large red onion or 8–10 shallots, sliced
½ cup fruity red wine
½ cup beef or chicken broth
1–2 tbsp red currant jelly or seedless raspberry preserves
¼ tsp dried thyme
2–3 tbsp olive oil
salt and freshly ground black pepper

1 ▼ Wipe the beef with damp paper towels. Mix the crushed peppercorns with the crushed salt and press onto both sides of the meat, coating it completely. Let stand, loosely covered, for 30 minutes.

2 ▲ To make the sauce, melt 3 tbsp of the butter in a stainless steel saucepan over medium heat. Add the onion or shallots and cook for 3–5 minutes until softened, then add the wine, broth, jelly or preserves and thyme and bring to a boil. Reduce the heat to low and simmer for 30–35 minutes until the liquid has evaporated and the sauce has thickened. Season with salt and pepper and keep warm.

3 ▲ Preheat the oven to 425°F. Melt the remaining butter with the oil in a heavy ovenproof frying pan or large flameproof casserole over high heat. Add the meat and cook for 1–2 minutes until browned, turn and cook for 1–2 minutes on the other side. Immediately place the pan or casserole in the oven and roast for 8–10 minutes. Transfer the beef to a board, cover loosely and let stand for 10 minutes. With a knife, loosen the meat from the rib bone, and then carve into thick slices. Serve with the onion sauce.

CHÂTEAUBRIAND WITH BÉARNAISE *Châteaubriand Béarnaise*

Châteaubriand is a lean and tender cut from the thick center of the fillet that is pounded to give it its characteristic shape. It is usually served for two, but could easily stretch to three.

SERVES 2

⅔ cup butter, cut into pieces
1½ tbsp tarragon vinegar
1½ tbsp dry white wine
1 shallot, finely chopped
2 egg yolks
1 pound beef fillet, about 5–6 inches long, cut from the thickest part of the fillet
1 tbsp vegetable oil
salt and freshly ground black pepper
sautéed potatoes, to serve

1 Clarify the butter by melting it gently in a saucepan; do not boil. Skim off any foam and set aside.

2 Put the vinegar, wine and shallot in a small heavy saucepan over high heat and boil to reduce until the liquid has almost all evaporated. Remove from the heat and cool slightly. Add the egg yolks and whisk for 1 minute. Place the saucepan over very low heat and whisk constantly until the yolk mixture begins to thicken and the whisk begins to leave tracks on the base of the pan, then remove the pan from the heat.

3 ▼ Whisk in the melted butter, drop by drop until the sauce begins to thicken, then pour in the butter a little more quickly, leaving behind the milky solids at the bottom of the pan. Season with salt and pepper and keep warm, stirring occasionally.

4 ▲ Place the meat between two sheets of wax paper or plastic wrap and pound with the flat side of a meat pounder or roll with a rolling pin to flatten to about 1½ inches thick. Season with salt and pepper.

5 Heat the oil in a heavy frying pan over medium-high heat. Add the meat and cook for about 10–12 minutes, turning once, until done as preferred (medium-rare meat will be slightly soft when pressed, medium will be springy and well-done firm).

6 Transfer the steak to a board and carve in thin diagonal slices. Strain the sauce, if you prefer, and serve with the steak, accompanied by sautéed potatoes.

COOK'S TIP

Beef fillet is often cheaper when bought whole than when it has been divided into steaks. If you buy a whole fillet, you can cut a *Châteaubriand* from the thickest part, *filet mignon* steaks from less thick parts, *tournedos* from the thinner part and use the thinnest tail part for stir-frying or Stroganoff. If you wish, wrap tightly and freeze until needed.

FILET MIGNON WITH MUSHROOMS *Tournedos Rossini*

In the time of Escoffier, this haute cuisine *dish was made with truffle slices but large mushroom caps are more readily available and look attractive, especially when they are fluted.*

SERVES 4

4 thin slices white bread
4 ounces pâté de foie gras *or mousse de foie gras*
5 tbsp butter
4 large mushroom caps
2 tsp vegetable oil
4 fillet steaks (about 1 inch thick)
3–4 tbsp Madeira or port
½ cup beef broth
watercress, to garnish

COOK'S TIP

If *pâté de foie gras* is difficult to find, you could substitute pork liver pâté.

1 ▼ Cut the bread into rounds about the same diameter as the steaks, using a large round cutter or by cutting into squares, then cutting off the corners. Toast the bread and spread with the *foie gras*, dividing it evenly. Place the croûtons on warmed plates.

2 ▲ Flute the mushroom caps using the edge of a knife blade, if you wish, for a decorative effect. Melt about 2 tbsp of the butter over medium heat and sauté the mushrooms until golden. Transfer to a plate and keep warm.

3 ▲ In the same pan, melt another 2 tbsp of the butter with the oil over medium-high heat, swirling to combine. When the butter begins to brown, add the steaks and cook for 6–8 minutes, turning once, until done as preferred (medium-rare meat will still be slightly soft when pressed, medium will be springy and well-done firm). Place the steaks on the croûtons and top with the mushroom caps.

4 Add the Madeira or port to the pan and boil for 20–30 seconds. Add the broth and boil over high heat until reduced by three-quarters, then swirl in the remaining butter. Pour a little sauce over each steak, then garnish with watercress.

PROVENÇAL BEEF STEW — *Daube de Boeuf à la Provençal*

This Provençal stew is named after the daubière, *the old earthenware container it was cooked in. Like most slow-cooked stews, it improves by cooking a day ahead and gently reheating.*

SERVES 6–8

2–4 tbsp olive oil
8 ounces lean salt pork or thick cut
 bacon, diced
4 pounds chuck steak or other stewing
 beef cut into 3 inch pieces
3 cups fruity red wine
4 carrots, thickly sliced
2 large onions, coarsely chopped
3 ripe tomatoes, peeled, seeded and
 coarsely chopped
1 tbsp tomato paste
2–4 garlic cloves, very finely chopped
bouquet garni
1 tsp black peppercorns
1 small onion, studded with 4 cloves
grated zest and juice of 1 unwaxed
 orange
2–3 tbsp chopped fresh parsley
salt and freshly ground black pepper

3 Transfer the meat to the casserole and continue browning the rest of the meat in batches, adding a little more oil if needed.

4 ▼ Set the casserole over medium heat, pour in the wine and, if needed, add water to cover the beef and bacon. Bring to a boil, skimming off any foam that rises to the surface.

5 ▲ Stir in the carrots, onions, tomatoes, tomato paste, garlic, bouquet garni, peppercorns and clove-studded onion. Cover tightly and simmer over low heat for about 3 hours, or until the meat and vegetables are very tender. Uncover the casserole and skim off any fat. Season with salt and pepper. Discard the bouquet garni and clove-studded onion and stir in the orange zest and juice and the parsley.

1 ▲ In a large heavy frying pan, heat 2 tbsp of the olive oil over medium-high heat, add the salt pork or bacon and cook for 4–5 minutes, stirring frequently, until browned and the fat is rendered. Transfer with a slotted spoon to a large flameproof casserole.

2 Add enough meat to the pan to fit easily in one layer (do not overcrowd the pan or the meat will stew in its own juices and not brown). Cook for 6–8 minutes until browned, turning to color all sides.

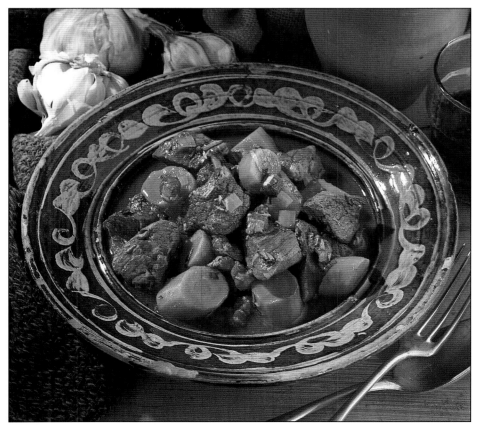

BURGUNDY BEEF STEW *Boeuf Bourguignon*

Tradition dictates that you should use the same wine in this stew that you plan to serve with it, but a less expensive full-bodied wine will do for cooking. The stew reheats very well.

SERVES 6

3½ pounds lean stewing beef (chuck or shin)
6 ounces lean salt pork or thick cut bacon
3 tbsp butter
¾ pound pearl onions
¾ pound small button mushrooms
1 onion, finely chopped
1 carrot, finely chopped
2 or 3 garlic cloves, finely chopped
3 tbsp flour
3 cups red wine, preferably Burgundy
1½ tbsp tomato paste
bouquet garni
2½–3 cups beef broth
1 tbsp chopped fresh parsley
salt and freshly ground black pepper

1 ▲ Cut the beef into 2 inch pieces and dice the salt pork or cut the bacon crosswise into thin strips.

2 In a large heavy flameproof casserole, cook the pork or bacon over medium heat until golden brown, then remove with a slotted spoon and drain. Pour off all but 2 tbsp of the fat.

3 ▲ Increase the heat to medium-high. Add enough meat to the pan to fit easily in one layer (do not crowd the pan or the meat will not brown) and cook, turning to color all sides, until well browned. Transfer the beef to a plate and continue browning the meat in batches.

4 ▲ In a heavy frying pan, melt one-third of the butter over medium heat, add the pearl onions and cook, stirring frequently, until evenly golden. Set aside on a plate.

5 ▲ In the same pan, melt half of the remaining butter over medium heat. Add the mushrooms and sauté, stirring frequently, until golden, then set aside with the pearl onions.

6 ▲ When all the beef has been browned, pour off any fat from the casserole and add the remaining butter. When the butter has melted, add the onion, carrot and garlic and cook over medium heat for 3–4 minutes until just softened, stirring frequently. Sprinkle over the flour and cook for 2 minutes, then add the wine, tomato paste and bouquet garni. Bring to a boil, scraping the base of the pan.

7 ▲ Return the beef and bacon to the casserole and pour on the broth, adding more if needed to cover the meat and vegetables when pressed down. Cover the casserole and simmer very gently over low heat, stirring occasionally, for about 3 hours or until the meat is very tender. Add the sautéed mushrooms and pearl onions and cook, covered, for 30 minutes more. Discard the bouquet garni and stir in the parsley before serving.

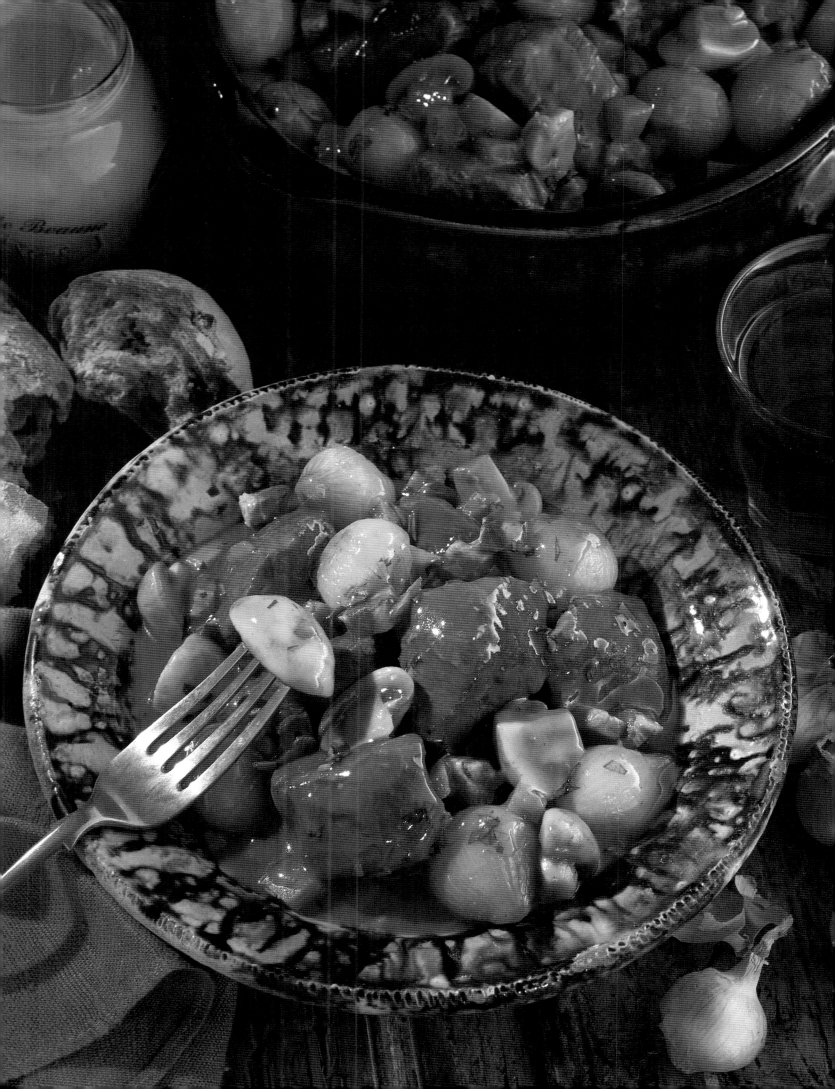

CALVES' LIVER WITH HONEY

Foie de Veau au Miel

Liver is prepared in many ways all over France – this is a quick and easy, slightly contemporary treatment. Cook the liver until it is browned on the outside but still rosy pink in the center.

SERVES 4

4 slices calves' liver (about 6 ounces each and ½ inch thick)
flour, for dusting
2 tbsp butter
2 tbsp vegetable oil
2 tbsp sherry vinegar or red wine vinegar
2–3 tbsp chicken broth
1 tbsp honey
salt and freshly ground black pepper
watercress sprigs, to garnish

1 ▼ Wipe the liver slices with damp paper towels, then season both sides with a little salt and pepper and dust the slices lightly with flour, shaking off any excess.

2 ▲ In a large heavy frying pan, melt half of the butter with the oil over high heat and swirl to blend.

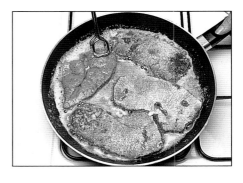

3 ▲ Add the liver slices to the pan and cook for 1–2 minutes until browned on one side, then turn and cook for 1 minute more. Transfer to warmed plates and keep warm.

4 ▲ Stir the vinegar, broth and honey into the pan and boil for about 1 minute, stirring constantly, then add the remaining butter, stirring until melted and smooth. Spoon over the liver slices and garnish with watercress sprigs.

VEAL KIDNEYS WITH MUSTARD *Rognons de Veau à la Moutarde*

*In France, veal kidneys are easily found, but this dish is equally delicious made with lambs'
kidneys. Be sure not to cook the sauce too long once the mustard is added or it will lose its piquancy.*

SERVES 4

2 veal kidneys or 8–10 lamb kidneys,
 trimmed and membranes removed
2 tbsp butter
1 tbsp vegetable oil
4 ounces button mushrooms, quartered
4 tbsp chicken broth
2 tbsp brandy (optional)
¾ cup crème fraîche or heavy cream
2 tbsp Dijon mustard
salt and freshly ground black pepper
snipped fresh chives, to garnish

1 ▲ Cut the veal kidneys into
pieces, discarding any fat. If using
lambs' kidneys, remove the central
core by cutting a V-shape from the
middle of each kidney. Cut each
kidney into three or four pieces.

2 ▲ In a large frying pan, melt the
butter with the oil over high heat
and swirl to blend. Add the kidneys
and sauté for about 3–4 minutes,
stirring frequently, until well
browned, then transfer them to a
plate using a slotted spoon.

3 ▲ Add the mushrooms to the
pan and sauté for 2–3 minutes until
golden, stirring frequently. Pour in
the chicken broth and brandy, if
using, then bring to a boil and boil
for 2 minutes.

4 ▼ Stir in the crème fraîche or
heavy cream and cook for about 2–3
minutes until the sauce is slightly
thickened. Stir in the mustard and
season with salt and pepper, then
add the kidneys and cook for 1
minute to reheat. Scatter over the
chives before serving.

WHITE VEAL STEW

Blanquette de Veau

A blanquette is a "white" stew traditionally enriched with cream and egg yolks. This bistro favorite is usually made with veal, but in the South of France, it is often made with lamb.

SERVES 6

3 pounds boneless veal shoulder, cut into 2 inch pieces
6¼ cups veal or chicken broth or water (or more if needed)
1 large onion, studded with 2 cloves
4 carrots, sliced
2 leeks, sliced
1 garlic clove, halved
bouquet garni
1 tbsp black peppercorns
5 tbsp butter
½lb button mushrooms, quartered if large
½lb pearl onions
1 tbsp superfine sugar
¼ cup flour
½ cup crème fraîche or heavy cream
pinch of ground nutmeg
2–4 tbsp chopped fresh dill or parsley
salt and white pepper

1 Put the veal in a large flameproof casserole and cover with the broth or water. Bring to a boil over medium heat, skimming off any foam that rises to the surface.

2 ▲ Add the studded onion, one of the sliced carrots, the leeks, garlic, bouquet garni and peppercorns, then cover and simmer over medium-low heat for about 1 hour until the veal is just tender.

3 ▲ Meanwhile, in a frying pan, melt 1 tbsp of the butter over medium-high heat, add the mushrooms and sauté until lightly golden. Transfer to a large bowl using a slotted spoon.

4 ▲ Add another 1 tbsp butter to the pan and add the pearl onions. Sprinkle with the sugar and add about 6 tbsp of the veal cooking liquid, then cover and simmer for 10–12 minutes until the onions are tender and the liquid has evaporated. Transfer the onions to the bowl with the mushrooms.

COOK'S TIP

If you would like to use the traditional egg and cream mixture, stir the cream into two beaten egg yolks before whisking into the white sauce and proceed as above. Simmer until the sauce thickens, but do not allow the sauce to boil or it may curdle.

5 ▲ When the veal is tender, transfer it to the same bowl using a slotted spoon. Strain the cooking liquid and discard the cooked vegetables and bouquet garni, then wash the casserole and return it to the heat.

6 ▲ Melt the remaining butter, add the flour and cook for 1–2 minutes over medium heat, but do not allow the mixture to brown. Slowly whisk in the reserved cooking liquid and bring to a boil, then simmer the sauce for 15–20 minutes until smooth and slightly thickened. Add the remaining carrots and cook for 10 minutes more until tender.

7 Whisk the cream into the sauce and simmer until the sauce is slightly thickened. Return the reserved meat, mushrooms and onions to the sauce and simmer for 10–15 minutes until the veal is very tender, skimming and stirring occasionally. Season with salt and white pepper and a little nutmeg, then stir in the chopped dill or parsley and serve.

PAN-GRILLED VEAL CHOPS
Côtes de Veau à la Poële

Veal chops from the loin are an expensive cut and are best cooked quickly and simply. The flavor of basil goes well with veal, but other herbs can be used instead if you prefer.

SERVES 2

2 tbsp butter, softened
1 tbsp Dijon mustard
1 tbsp chopped fresh basil
olive oil, for brushing
2 veal loin chops, 1 inch thick (about
* 8 ounces each)*
salt and freshly ground black pepper
basil sprigs, to garnish

COOK'S TIP

If you prefer, replace the basil in the herb butter with fresh thyme or marjoram, or use a mixture of both. Or, omit the herb butter and top the veal chops with Tapenade.

1 ▲ To make the basil butter, cream the butter with the mustard and chopped basil in a small bowl, then season with pepper.

2 Lightly oil a heavy cast iron skillet. Set over high heat until very hot but not smoking. Brush both sides of each chop with a little oil and season with a little salt.

3 ▼ Place the chops on the skillet and reduce the heat to medium. Cook for 4–5 minutes, then turn and cook for 3–4 minutes more until done as preferred (medium-rare meat will still be slightly soft when pressed, medium meat will be springy and well-done firm). Top each chop with half the basil butter and serve at once.

VEAL SCALLOPS WITH TARRAGON
Veau à l'Estragon

These thin slices of veal need little cooking, and the sauce is made very quickly as well.

SERVES 4

4 veal scallops (about 4–5 ounces each)
1 tbsp butter
2 tbsp brandy
1 cup chicken or beef broth
1 tbsp chopped fresh tarragon
salt and freshly ground black pepper
tarragon sprigs, to garnish

1 Place the veal scallops between two sheets of wax paper or plastic wrap and pound with the flat side of a meat mallet or roll them with a rolling pin to flatten to about ¼ inch thickness. Season with salt and pepper.

2 ▼ Melt the butter in a large frying pan over medium-high heat. Add enough meat to the pan to fit easily in one layer (do not overcrowd the pan; cook in batches if necessary) and cook for 1½–2 minutes, turning once. (It should be lightly browned, but must not be overcooked.) Transfer to a serving platter or plates and cover to keep warm.

3 ▲ Add the brandy to the pan, then pour in the stock and bring to a boil. Add the tarragon and continue boiling until the liquid is reduced by half.

4 Return the veal to the pan with any accumulated juices and heat through. Serve immediately, garnished with tarragon sprigs.

VEAL STEW WITH TOMATOES

Sauté de Veau Marengo

The combination of tomatoes and orange in this dish brings to mind Mediterranean sunshine.

SERVES 6

4 tbsp flour
3 pounds boneless veal shoulder, cut into
 1½ inch pieces
2–3 tbsp olive oil
4 or 5 shallots, finely chopped
2 garlic cloves, very finely chopped
1¼ cups dry white wine
1 pound tomatoes, peeled, seeded and
 chopped
grated zest and juice of 1 unwaxed
 orange
bouquet garni
1 tbsp tomato paste
1 tbsp butter
¾lb button mushrooms, quartered if
 large
salt and freshly ground black pepper
chopped fresh parsley, to garnish

1 ▼ Put the flour in a plastic bag and season with salt and pepper. Drop the pieces of meat into the bag a few at a time and shake to coat with flour, tapping off the excess. Discard the remaining flour.

2 ▲ Heat 2 tbsp of the oil in a flameproof casserole over medium-high heat. Add enough meat to the pan to fit easily in one layer (do not overcrowd the pan or the meat will not brown). Cook, turning to color all sides, until well browned, then transfer to a plate. Continue browning the meat in batches, adding more oil if needed.

3 ▲ In the same pan, cook the shallots and garlic over medium heat, stirring, until just softened, then stir in the wine and bring to a boil. Return the meat to the pan and add the tomatoes, orange zest and juice, bouquet garni and tomato paste. Bring back to a boil, then reduce the heat to low, cover and simmer gently for 1 hour.

4 Melt the butter in a frying pan over medium heat and sauté the mushrooms until golden. Add the mushrooms to the casserole and cook, covered, for 20–30 minutes, or until the meat is very tender. Adjust the seasoning and discard the bouquet garni before serving. Garnish the stew with parsley.

ROAST LEG OF LAMB WITH BEANS

Gigot d'Agneau

Leg of lamb is the classic Sunday roast. In France, the shank bone is not removed, but it is cut through for easier handling. The roast is often served with green or fava beans.

SERVES 8–10

6–7 pound leg of lamb
3 or 4 garlic cloves
olive oil
fresh or dried rosemary leaves
1 pound dried navy or fava beans, soaked
 overnight in cold water
1 bay leaf
2 tbsp red wine
⅔ cup lamb or beef broth
2 tbsp butter
salt and freshly ground black pepper
watercress, to garnish

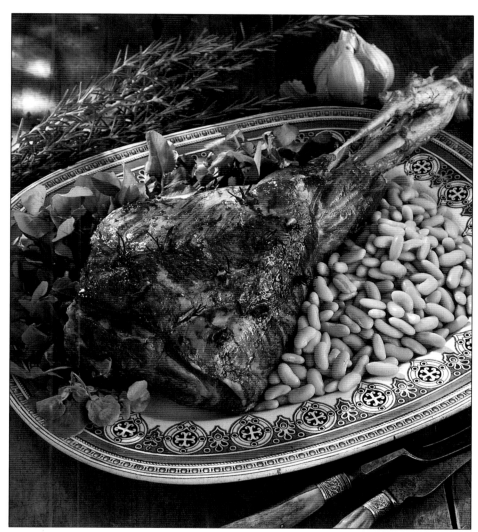

1 ▲ Preheat the oven to 425°F. Wipe the leg of lamb with damp paper towels and dry the fat covering well. Cut 2 or 3 of the garlic cloves into 10–12 slivers, then with the tip of a knife, cut 10–12 slits into the lamb and insert the garlic slivers into the slits. Rub with oil, season with salt and pepper and sprinkle with rosemary.

2 Set the lamb on a rack in a shallow roasting pan and put in the oven. After 15 minutes, reduce the heat to 350°F and continue to roast for 1½–1¾ hours (about 18 minutes per pound) or until a meat thermometer inserted into the thickest part of the meat registers 135–140°F for medium-rare to medium meat or 150°F for well-done.

3 Meanwhile, rinse the beans and put in a saucepan with enough fresh water to cover generously. Add the remaining garlic and the bay leaf, then bring to a boil. Reduce the heat and simmer for 45 minutes–1 hour, or until tender.

4 Transfer the roast to a board and stand, loosely covered, for 10–15 minutes. Skim off the fat from the cooking juices, then add the wine and broth to the roasting pan. Boil over medium heat, stirring and scraping the base of the pan, until slightly reduced. Strain into a warmed gravy boat.

5 ▼ Drain the beans, discard the bay leaf, then toss the beans with the butter until it melts and season with salt and pepper. Garnish the lamb with watercress and serve with the beans and the sauce.

Roast Stuffed Lamb

Gigot Farcie

The lambs that graze in the salty marshes along the north coast of Brittany and Normandy are considered the best in France. The stuffing is suitable for either leg or shoulder joints.

Serves 6–8

4–4½ pound boneless leg or shoulder of
 lamb (not tied)
2 tbsp butter, softened
1–2 tbsp flour
½ cup white wine
1 cup chicken or beef broth
salt and freshly ground black pepper
watercress, to garnish
sautéed potatoes, to serve
For the stuffing
5 tbsp butter
1 small onion, finely chopped
1 garlic clove, finely chopped
⅓ cup long grain rice
⅔ cup chicken broth
½ tsp dried thyme
4 lamb kidneys, halved and cored
10 ounces young spinach leaves,
 well washed
salt and freshly ground black pepper

1 ▲ To make the stuffing, melt 2 tbsp of the butter in a saucepan over medium heat. Add the onion and cook for 2–3 minutes until just softened, then add the garlic and rice and cook for about 1–2 minutes until the rice appears translucent, stirring constantly. Add the broth, salt and pepper and thyme and bring to a boil, stirring occasionally, then reduce the heat to low and cook for about 18 minutes, covered, until the rice is tender and the liquid is absorbed. Spoon the rice into a bowl and fluff with a fork.

2 In a small frying pan, melt about 2 tbsp of the remaining butter over medium-high heat. Add the kidneys and cook for about 2–3 minutes, turning once, until lightly browned, but still pink inside, then transfer to a board and let cool. Cut the kidneys into pieces and add to the rice, season with salt and pepper and toss to combine.

3 ▲ In a frying pan, heat the remaining butter over medium heat until foaming. Add the spinach leaves and cook for 1–2 minutes until wilted, drain off excess liquid, then transfer the spinach to a plate and let cool.

4 ▲ Preheat the oven to 375°F. Lay the meat skin-side down on a work surface and season with salt and pepper. Spread the spinach leaves in an even layer over the surface then spread the stuffing in an even layer over the spinach. Roll up the meat like a jelly roll and use a skewer to close the seam.

5 ▲ Tie the meat at 1 inch intervals to hold its shape, then place in a roasting pan, spread with the softened butter and season with salt and pepper. Roast for 1½–2 hours until the juices run slightly pink when pierced with a skewer, or until a meat thermometer inserted into the thickest part of the meat registers 135–140°F for medium-rare to medium. Transfer the meat to a carving board, cover loosely with foil and let rest for about 20 minutes.

6 Skim off as much fat from the roasting pan as possible, then place the pan over medium-high heat and bring to a boil. Sprinkle over the flour and cook for 2–3 minutes until browned, stirring and scraping the base of the pan. Whisk in the wine and broth and bring to a boil, then cook for 4–5 minutes until the sauce thickens. Season and strain into a gravy boat. Carve the meat into slices, garnish with watercress and serve with the gravy and potatoes.

Variation

If kidneys are difficult to obtain, substitute about ¼ pound mushrooms. Chop coarsely and cook in butter until tender. Don't use dark mushrooms – they will make the rice a murky color.

RACK OF LAMB WITH MUSTARD *Carré d'Agneau à la Moutarde*

This recipe is perfect for entertaining. You can coat the lamb with the crust before your guests arrive, and put it in the oven when you sit down for the first course.

SERVES 6–8

3 racks of lamb (7–8 ribs each), trimmed of fat, bones "French" trimmed
2 or 3 garlic cloves
4 ounces (about 4 slices) white or wholewheat bread, torn into pieces
1½ tbsp fresh thyme leaves or 1 tbsp rosemary leaves
1½ tbsp Dijon mustard
freshly ground black pepper
2 tbsp olive oil
fresh rosemary, to garnish
new potatoes, to serve

1 ▼ Preheat the oven to 425°F. Trim any remaining fat from the lamb, including the fat covering over the meat.

2 ▲ In a food processor fitted with the metal blade, with the machine running, drop the garlic through the feed tube and process until finely chopped. Add the bread, herbs, mustard and a little pepper and process until combined, then slowly pour in the oil.

3 ▲ Press the mixture onto the meaty side and ends of the racks, completely covering the surface.

4 Put the racks in a shallow roasting pan, and roast for about 25 minutes for medium-rare or 35 minutes more for medium (a meat thermometer inserted into the thickest part of the meat should register 135–140°F for medium-rare to medium). Transfer the meat to a carving board or warmed platter. Cut down between the bones to carve into chops. Serve garnished with rosemary and accompanied by new potatoes.

LAMB CHOPS WITH MINT *Côtes d'Agneau Vinaigrette à la Menthe*

Serving vinaigrette sauces with meat came in with nouvelle cuisine *and stayed. This one offers a classic combination – lamb and mint – in a new style.*

SERVES 4

8 loin lamb chops or 4 double loin chops
 (about ¾ inch thick)
coarsely ground black pepper
fresh mint, to garnish
sautéed potatoes, to serve
FOR THE MINT VINAIGRETTE
2 tbsp white wine vinegar
½ tsp honey
1 small garlic clove, very finely chopped
4 tbsp extra virgin olive oil
⅓ cup (packed) fresh mint leaves, finely
 chopped
1 ripe plum tomato, peeled, seeded and
 finely diced
salt and freshly ground black pepper

1 ▲ To make the vinaigrette, put the vinegar, honey, garlic, salt and pepper in a small bowl and whisk thoroughly to combine.

2 ▲ Slowly whisk in the oil, then stir in the mint and tomatoes and set aside for up to 1 hour.

3 ▼ Put the lamb chops on a board and trim off any excess fat. Sprinkle with the pepper and press onto both sides of the meat, coating it evenly.

COOK'S TIP

The chops may also be broiled under a preheated broiler or barbecued over charcoal until done as you like.

4 ▲ Lightly oil a heavy cast iron griddle and set over a high heat until very hot but not smoking. Place the chops on the griddle and reduce the heat to medium. Cook the chops for 6–7 minutes, turning once, or until done as preferred (medium-rare meat will still be slightly soft when pressed, medium will be springy and well-done firm). Serve the chops with the vinaigrette and the sautéed potatoes, garnished with mint.

LAMB STEW WITH VEGETABLES *Navarin d'Agneau Printanier*

A navarin *is a stew made with lamb and a selection of young tender spring vegetables such as carrots, new potatoes, pearl onions, peas, green beans and especially turnips!*

SERVES 6

4 tbsp vegetable oil
3 pounds lamb shoulder or other stewing meat, well trimmed, cut into 2 inch pieces
3–4 tbsp flour
4 cups beef or chicken broth
1 large bouquet garni
3 garlic cloves, lightly crushed
3 ripe tomatoes, peeled, seeded and chopped
1 tsp tomato paste
1½ pounds small potatoes, peeled if desired
12 baby carrots, trimmed and scrubbed
4 ounces green beans, cut into 2 inch pieces
2 tbsp butter
12–18 pearl onions, peeled
6 medium turnips, peeled and quartered
2 tbsp sugar
¼ tsp dried thyme
1¼ cups peas
2 ounces snow peas
salt and freshly ground black pepper
3 tbsp chopped fresh parsley or cilantro, to garnish

1 Heat 2 tbsp of the oil in a large heavy frying pan over a medium-high heat. Add enough of the lamb to fit easily in one layer (do not overcrowd the pan or the meat will not brown). Cook, turning to color all sides, until well browned.

2 Transfer the meat to a large flameproof casserole and continue browning the rest of the meat in batches, adding a little more oil if needed. Add 3–4 tbsp of water to the pan and boil for about 1 minute, stirring and scraping the base of the pan, then pour the liquid into the casserole.

3 ▲ Sprinkle the flour over the browned meat in the casserole and set over medium heat. Cook for 3–5 minutes until browned. Stir in the broth, the bouquet garni, garlic, tomatoes and tomato paste and season with salt and pepper.

4 ▲ Bring to a boil over high heat, skimming off any foam that rises to the surface. Reduce the heat to low and simmer, stirring occasionally, for about 1 hour until the meat is tender. Cool the stew to room temperature, then chill, covered, overnight.

5 About 1½ hours before serving, take the casserole from the refrigerator and remove the fat from the surface, wiping the surface with paper towels to remove all traces of fat. Set the casserole over medium heat and bring to a simmer.

6 Cook the potatoes in boiling salted water for 15–20 minutes until tender, then using a slotted spoon, transfer to a bowl and add the carrots to the same water. Cook for 4–5 minutes until just tender and transfer to the same bowl. Add the green beans and boil for 2–3 minutes until tender, yet crisp. Transfer to the bowl with the other vegetables.

7 ▲ Melt the butter in a heavy frying pan or saucepan over medium-high heat. Add the onions and turnips with 3–4 tbsp water and cook, covered, for 4–5 minutes. Uncover the pan, stir in the sugar and thyme and cook, stirring and shaking the pan occasionally, until the onions and turnips are shiny and caramelized. Transfer them to the bowl of vegetables. Add 2–3 tbsp of water to the pan to deglaze and boil for 1 minute, scraping the base of the pan, then add this liquid to the lamb.

8 When the lamb and gravy are hot, add the reserved vegetables to the stew and stir gently to distribute. Stir in the peas and snow peas and cook for 5 minutes until they turn bright green, then stir in 2 tbsp of the parsley or cilantro and pour into a large warmed serving dish. Scatter over the remaining parsley.

Moroccan Lamb Stew *Tagine d'Agneau aux Pois Chiches*

The colorful spicy cuisines of French colonial North Africa have left their mark on French cooking. Tagine, named after the conical-shaped pottery dish in which it is cooked, is a favorite.

Serves 6–8

1⅓ cups dried chick peas soaked in cold
 water overnight
4 tbsp olive oil
2 tsp sugar
2 tsp ground cumin
1 tsp ground cinnamon
1 tsp ground ginger
½ tsp ground turmeric
½ tsp powdered saffron or paprika
3 pounds lamb shoulder, trimmed of all
 fat and cut into 2 inch pieces
2 onions, coarsely chopped
3 garlic cloves, finely chopped
2 tomatoes, peeled, seeded and chopped
⅔ cup raisins, soaked in warm
 water
10–24 pitted black olives (such as
 Kalamata)
2 preserved lemons, thinly sliced, or
 grated zest of 1 unwaxed lemon
4–6 tbsp chopped fresh cilantro
salt and freshly ground black pepper
1 pound couscous, to serve

1 Drain the chick peas, rinse under cold running water and place in a large saucepan, then cover with water and boil vigorously for 10 minutes. Drain the chick peas and return to a clean saucepan. Cover with fresh cold water and bring to a boil over high heat, then reduce the heat and simmer, covered, for about 1–1½ hours until tender. Remove the pan from the heat, add a little salt and set aside.

2 In a large bowl, combine half the olive oil with the sugar, cumin, cinnamon, ginger, turmeric, saffron or paprika, pepper and 1 tsp salt. Add the lamb, toss to coat well and set aside for 20 minutes.

3 ▲ In a large heavy frying pan, heat the remaining oil over medium-high heat. Add enough lamb to fit easily in one layer (do not overcrowd the pan) and cook for 4–5 minutes, turning the pieces to color all sides, until well browned. Transfer to a large flameproof casserole and continue browning the meat in batches, adding a little more oil if necessary.

4 ▲ Add the onions to the pan and stir constantly until well browned. Stir in the garlic and tomatoes with 1 cup water, stirring and scraping the base of the pan. Pour into the casserole and add enough water to just cover, then bring to a boil over high heat, skimming any foam that rises to the surface. Reduce the heat to low and simmer for about 1 hour, or until the meat is tender when pierced with a knife.

5 ▲ Drain the chick peas, reserving the liquid, and add to the lamb in the casserole with about 1 cup of the liquid. Stir in the raisins and their soaking liquid and simmer for 30 minutes more. Stir in the olives and sliced preserved lemons or lemon zest and simmer 20–30 minutes more, then add half the chopped cilantro.

6 ▲ About ½ hour before serving, prepare the couscous according to the instructions on the packet. Spoon the couscous on to a warmed serving dish, spoon the lamb stew on top and sprinkle with the remaining fresh cilantro.

Cook's tip

Preserved lemons are frequently used in Moroccan-style cooking. They are available in specialty shops but, if you can't find them, a little grated lemon zest makes an adequate substitute.

PORK WITH CAMEMBERT

Médaillons de Porc au Camembert

Not surprisingly, most cheese-producing regions of France have a tradition of recipes using their own home-produced cheese. This recipe combines several of the fine products of Normandy.

SERVES 3–4

¾–1 pound pork tenderloin
1 tbsp butter
3 tbsp sparkling dry cider or dry white
 wine
½–¾ cup crème fraîche or heavy cream
1 tbsp chopped fresh mixed herbs, such as
 marjoram, thyme and sage
½ Camembert cheese (4 ounces), rind
 removed (2½ ounces without
 rind), sliced
1½ tsp Dijon mustard
freshly ground black pepper
fresh parsley, to garnish

1 ▼ Slice the pork tenderloin crosswise into small steaks about ¾ inch thick. Place between two sheets of wax paper or plastic wrap and pound with the flat side of a meat mallet or roll with a rolling pin to flatten to a thickness of ½ inch. Sprinkle with pepper.

2 ▲ Melt the butter in a heavy frying pan over medium–high heat until it begins to brown, then add the meat. Cook for 5 minutes, turning once, or until just cooked through and the meat is springy when pressed. Transfer to a warmed dish and cover to keep warm.

3 ▲ Add the cider or wine and bring to a boil, scraping the base of the pan. Stir in the cream and herbs and bring back to a boil.

4 ▲ Add the cheese and mustard and any accumulated juices from the meat. Add a little more cream if needed and adjust the seasoning. Serve the pork with the sauce and garnish with parsley.

PORK TENDERLOIN WITH SAGE

Filet de Porc à la Sauge

Sage is often partnered with pork – there seems to be a natural affinity. The addition of orange brings complexity and balances the sometimes overpowering flavor of sage.

SERVES 4

2 pork tenderloins (about ¾ pound each)
1 tbsp butter
½ cup dry sherry
¾ cup chicken broth
2 garlic cloves, very finely chopped
grated zest and juice of 1 large orange
3 or 4 sage leaves, finely chopped
2 tsp cornstarch
salt and freshly ground black pepper
orange wedges and sage leaves,
 to garnish

1 ▼ Season the pork tenderloins lightly with salt and pepper. Melt the butter in a heavy flameproof casserole over medium-high heat, then add the meat and cook for 5–6 minutes, turning to brown all sides evenly.

2 Add the sherry, boil for about 1 minute, then add the broth, garlic, orange zest and sage. Bring to a boil and reduce the heat to low, then cover and simmer for 20 minutes, turning once until the juices run clear when the meat is pierced with a knife or a meat thermometer inserted into the thickest part of the meat registers 150°F. Transfer the pork to a warmed platter and cover to keep warm.

3 ▲ Bring the sauce to a boil. Blend the cornstarch and orange juice and stir into the sauce, then boil gently over medium heat for a few minutes, stirring frequently, until the sauce is slightly thickened. Strain into a gravy boat.

4 ▼ Slice the pork diagonally and pour the meat juices into the sauce. Spoon a little sauce over the pork and garnish with orange wedges and sage leaves. Serve the remaining sauce separately.

ROAST LOIN OF PORK WITH PRUNES *Rôti de Porc aux Pruneaux*

The combination of pork and prunes is often found in casseroles and stews from the Loire Valley, perhaps with one of the local wines. For the best flavor, soak the prunes overnight.

SERVES 6–8

18–24 prunes, pitted
3 cups fruity white wine, preferably Vouvray
4 pounds center cut pork loin (about 8 ribs), backbone and skin removed
2 tbsp vegetable oil
1 large onion, coarsely chopped
1 large leek, sliced
2 carrots, chopped
1 celery stalk, sliced
2 tbsp brandy (optional)
1 cup chicken broth
bouquet garni
2–3 tbsp cornstarch, blended with 3 tbsp cold water
4 tbsp heavy cream
salt and freshly ground black pepper
watercress, to garnish
new potatoes, to serve

1 ▲ Put the prunes in a bowl, pour over the wine, then cover and let soak for several hours or overnight.

COOK'S TIP

It is important that the pork isn't overcooked – so for accurate timing, use a meat thermometer. Insert it into a fleshy part of the meat away from bones before roasting, or if using an instant-read thermometer, insert toward the end of cooking, following the manufacturer's instructions.

2 ▲ Preheat the oven to 400°F. Wipe the meat with damp paper towels, then dry the fat thoroughly. Score the surface of the fat with a sharp knife.

3 In a flameproof casserole or large heavy roasting pan, heat the oil over high heat until hot. Add the onion, leek, carrot and celery and cook for 3–5 minutes until browned, stirring frequently. Add the brandy, if using, broth and bouquet garni and stir well.

4 ▲ Put the pork on top of the vegetables and place in the oven. Roast for about 1½ hours until the juices run clear when the meat is pierced with a skewer, or a meat thermometer inserted into the thickest part of the meat registers 150°F. (If the liquid in the casserole or roasting pan evaporates, add a little of the prune soaking liquid or water to prevent the vegetables from burning.) Transfer the meat to a warmed serving platter, cover loosely with foil and let stand for 15 minutes.

5 ▲ Using a slotted spoon, transfer the prunes to a medium saucepan. Skim off as much fat as possible from the casserole or roasting pan and place over high heat. Add the prune liquid to the casserole or roasting pan and bring to a boil, stirring constantly and scraping the base. Boil for 3–4 minutes.

6 ▲ Stir the blended cornstarch into the casserole or pan and cook, stirring frequently for 2–3 minutes until the sauce thickens, then strain the contents of the pan into the saucepan with the prunes, pressing the vegetables to extract all the juice. Return the saucepan to medium heat, stir in the cream and simmer for 2 minutes, then season with salt and pepper. Reduce the heat to low and simmer gently, stirring frequently, until ready to serve.

7 Spoon the prunes onto the serving plate with a little of the sauce and pour the remaining sauce into a gravy boat. Garnish with watercress before serving with new potatoes.

PORK CHOPS WITH TOMATO SAUCE *Côtes de Porc Sauce Nénette*

Use the best pork chops for a tender result. This sauce is equally delicious with veal or chicken.

SERVES 4

1 tbsp butter
1 tbsp vegetable oil
4 large center loin pork chops, about
 1 inch thick, trimmed
salt and freshly ground black pepper
4 tbsp white wine or chicken
 broth
½ tsp dried thyme
1 cup heavy cream
1 tsp tomato paste
1 tbsp Dijon mustard
1 tomato, peeled, seeded and chopped
1 tbsp chopped fresh tarragon, chervil or
 parsley
fresh tarragon or other herbs, to garnish
Straw Potato Cakes, to serve

1 ▼ Melt the butter with the oil in a large heavy frying pan over high heat until sizzling. Season the pork chops with salt and pepper, then add to the pan and reduce the heat to medium-high. Cook for 2–3 minutes on each side until browned, then transfer the pork chops to a plate and pour off all the fat.

2 ▲ Add the wine or broth and thyme to the pan and bring to a boil. Cook for 2–3 minutes until the wine has almost evaporated.

3 ▲ Add the cream and tomato paste and simmer for 2 minutes, stirring frequently, then return the pork chops to the sauce and cook for 4–5 minutes over medium-low heat until just firm to the touch. Take care not to overcook.

4 ▲ Add the mustard, chopped tomato and herbs, stirring and shaking the pan to distribute them, and cook for 1 minute to heat through. Serve the chops with the sauce, accompanied by Straw Potato Cakes and garnished with sprigs of tarragon or other fresh herbs.

BRAISED HAM WITH MADIERA SAUCE *Jambon Braisé au Madère*

The Morvan district of Burgundy is known for producing fine quality, mild cured hams.
Accompanied by this rich Madeira sauce, a simple ham steak is transformed into an elegant dish.

SERVES 4

4 tbsp unsalted butter
4 shallots, finely chopped
2 tbsp flour
2 cups beef broth
1 tbsp tomato paste
6 tbsp Madeira
4 ham steaks (about 6–7 ounces
 each)
salt and freshly ground black pepper
watercress, to garnish
mashed potatoes, to serve

1 ▲ Melt half the butter in a heavy medium-size saucepan, over medium-high heat, then add the shallots and cook for 2–3 minutes until just softened, stirring frequently.

2 ▲ Sprinkle over the flour and cook for 3–4 minutes until well browned, stirring constantly, then whisk in the stock and tomato paste and season with pepper. Simmer over low heat until the sauce is reduced by about half, stirring occasionally.

3 ▼ Taste the sauce and adjust the seasoning, then stir in the Madeira and cook for 2–3 minutes. Strain into a small serving bowl or gravy boat and keep warm. (The sauce can be made up to three days in advance and chilled. Reheat to serve.)

COOK'S TIP

To make the sauce a deeper, richer color, add a few drops of gravy browning liquid to the stock.

4 ▲ Snip the edges of the ham steaks to prevent them from curling. Melt the remaining butter in a large heavy frying pan over medium-high heat, then add the ham steaks and cook for 4–5 minutes, turning once, until the meat feels firm to the touch. Arrange the ham steaks on warmed plates and pour a little sauce over each. Garnish with watercress and serve the steaks with a little more of the sauce accompanied by mashed potatoes.

SAUERKRAUT WITH PORK AND SAUSAGES *Choucroûte Garnie*

This Alsatian speciality shows the German influence on the region's cuisine. Strasbourg is renowned for its pork and beef sausages – use them if you can.

SERVES 8

2 tbsp vegetable oil
1 onion, halved and sliced
4 ounces smoked bacon slices, chopped
2 pounds bottled sauerkraut, well rinsed
 and drained
1 apple, peeled and sliced
1 or 2 bay leaves
½ tsp dried thyme
4–5 juniper berries
1 cup dry white wine
½ cup apple juice or water
6 Strasbourg sausages, knackwurst or
 frankfurters
6 spareribs
2 pounds small potatoes, peeled
4 pork chops or ham steaks
salt and freshly ground black pepper

1 ▼ Preheat the oven to 300°F. Heat half the oil in a large flameproof casserole over medium heat, then add the sliced onion and chopped bacon and cook, stirring occasionally for about 5 minutes until the onion is soft and the bacon just colored.

2 ▲ Tilt the pan, spoon off the fat, then stir in the sauerkraut, apple, bay leaves, thyme, juniper berries, wine and apple juice or water. Cover the casserole, place in the oven and cook for 30 minutes.

3 In a second large flameproof casserole, heat the remaining oil over medium-high heat and add the spareribs. Cook, turning frequently, until browned on all sides. Add the spareribs to the other casserole with the sausages and cook, covered, for 1½ hours, stirring occasionally.

4 ▲ Bring a large saucepan of lightly salted water to the boil over medium-high heat. Add the potatoes and cook for 10 minutes. Drain and add to the casserole with the pork chops. Push them into the sauerkraut and continue cooking, covered, for 30–45 minutes more. Season with salt, if needed, and pepper before serving.

TOULOUSE CASSOULET

Cassoulet

There are as many versions of this regional speciality in Southwest France as there are towns.

SERVES 6–8

*1 pound dried white beans (navy or
 cannellini), soaked overnight in cold
 water, then rinsed and drained*
1½ pounds French garlic sausages
*1¼ pounds each boneless lamb and pork
 shoulder, cut into 2 inch pieces*
1 large onion, finely chopped
3 or 4 garlic cloves, very finely chopped
4 tomatoes, peeled, seeded and chopped
1¼ cups chicken broth
bouquet garni
4 tbsp fresh bread crumbs
salt and freshly ground black pepper

1 Put the beans in a saucepan with water to cover. Boil vigorously for 10 minutes and drain, then return to a clean saucepan, cover with water and bring to a boil. Reduce the heat and simmer for 45 minutes, or until tender, then add a little salt and let soak in the cooking water.

2 ▲ Preheat the oven to 350°F. Prick the sausages, place them in a large heavy frying pan over medium heat and cook for 20–25 minutes until browned, turning occasionally. Drain on paper towels and pour off all but 1 tbsp of the fat from the pan.

3 Increase the heat to medium-high. Season the lamb and pork and add enough of the meat to the pan to fit easily in one layer. Cook until browned, then transfer to a large dish. Continue browning in batches.

4 Add the onion and garlic to the pan and cook for 3–4 minutes until just soft, stirring. Stir in the tomatoes and cook for 2–3 minutes, then transfer the vegetables to the meat dish. Add the broth and bring to a boil, then skim off the fat.

5 ▲ Spoon a quarter of the beans into a large casserole, and top with a third of the sausages, meat and vegetables.

6 Continue layering, ending with a layer of beans. Tuck in the bouquet garni, pour over the broth and top up with enough of the bean cooking liquid to just cover.

7 Cover the casserole and bake for 2 hours (check and add more bean cooking liquid if it seems dry). Uncover the casserole, sprinkle over the bread crumbs and press with the back of a spoon to moisten them. Continue cooking the cassoulet, uncovered, for about 20 minutes more until browned.

COUNTRY-STYLE PÂTÉ WITH LEEKS *Pâté de Porc aux Poireaux*

Traditionally this sort of pork pâté (or more correctly, terrine, since it has no crust) contains pork liver and egg to bind. This version uses leeks instead for a fresher flavor and a lighter result.

SERVES 8–10

1 pound trimmed leeks (white and light
 green parts)
1 tbsp butter
2 or 3 large garlic cloves, finely chopped
2¼ pounds lean pork leg or shoulder
5 ounces smoked bacon strips
1½ tsp chopped fresh thyme
3 sage leaves, finely chopped
¼ tsp quatre èpices (a mix of ground
 cloves, cinnamon, nutmeg and
 pepper)
¼ tsp ground cumin
pinch of freshly grated nutmeg
½ tsp salt
1 tsp freshly ground black pepper
1 bay leaf

1 ▲ Cut the leeks lengthwise, wash well and slice thinly. Melt the butter in a large heavy saucepan, add the leeks, then cover and cook over medium-low heat for 10 minutes, stirring occasionally. Add the garlic and continue cooking for about 10 minutes until the leeks are very soft, then set aside to cool.

COOK'S TIP

In France, *cornichons* (small dill pickles) and mustard are traditional accompaniments for pork terrines along with slices of crusty baguette.

2 ▲ Trim all the fat, tendons and connective tissue from the pork and cut the meat into 1¾ inch cubes. Working in two or three batches, put the meat into a food processor fitted with the metal blade; the bowl should be about half-full. Pulse to chop the meat to a coarse purée. Alternatively, pass the meat through the coarse blade of a meat grinder. Transfer the meat to a large mixing bowl and remove any white stringy pieces.

3 Reserve two of the bacon strips for garnishing, and chop or grind the remaining bacon strips. Add the chopped or ground bacon to the pork in the bowl.

4 Preheat the oven to 350°F. Line the base and sides of a 6¼ cup terrine or loaf pan with wax paper or non-stick baking paper.

5 ▲ Add the leeks, herbs, spices and salt and pepper to the bowl with the pork and bacon and, using a wooden spoon or your fingertips, mix until well combined.

6 ▲ Spoon the mixture into the terrine or loaf pan, pressing it into the corners and compacting it. Tap firmly to settle the mixture and smooth the top. Arrange the bay leaf and bacon strips on top, then cover tightly with foil.

7 ▲ Place the terrine or loaf pan in a roasting pan and pour boiling water to come halfway up the sides. Bake for 1¼ hours.

8 Lift the terrine out of the roasting pan and pour out the water. Put the terrine back in the pan and place a baking sheet or board on top. If the pâté has not risen above the sides of the terrine, place a foil-covered board inside the pan to lie directly on the pâté. Weight with two or three large cans or other heavy objects while it cools. (Liquid will seep out which is why the terrine should stand inside a roasting pan.) Chill until cold, preferably overnight, before slicing.

PASTRY
AND
CAKES

Pastry is a mainstay of French cuisine, although not particularly of home cooking. Delectable pastries and elegant tarts have always been available in local *pâtisseries* and French cooks are much more likely to buy these than labor over them at home. However, they do enjoy making simple fruit tarts and cakes. Most homemade cakes are based on a sponge, or *génoise*, which doesn't use baking powder, but relies on air beaten into the eggs for lightness. In addition, almost every French housewife has a "secret" recipe for a rich chocolate cake, one which they love to discuss, although rarely share!

APPLE TART

Tarte aux Pommes

This easy-to-make apple tart has rustic charm – it is just as you might find in a French farmhouse. Cooking the apples before putting them on the pastry prevents a soggy crust.

SERVES 6

2 pounds medium cooking apples,
 peeled, quartered and cored
1 tbsp lemon juice
¼ cup superfine sugar
4 tbsp butter
¾ pound shortcrust or sweet pastry (pâte
 sucrée)
crème fraîche or lightly whipped cream,
 to serve

VARIATION

For Spiced Pear Tart, substitute pears for the apples, cooking them for about 10 minutes until golden. Sprinkle with ½ tsp ground cinnamon and a pinch of ground cloves and stir to combine before arranging on the pastry.

1 Cut each cooking apple quarter lengthwise into two or three slices. Sprinkle with lemon juice and sugar and toss to combine.

2 ▲ Melt the butter in a large heavy frying pan over medium heat and add the apples. Cook, stirring frequently, for about 12 minutes until the apples are just golden brown. Remove the frying pan from the heat and set aside. Preheat the oven to 375°F.

3 ▲ On a lightly floured surface, roll out the pastry to a 12 inch round and trim the edge if uneven. Carefully transfer the pastry round to a baking sheet.

4 ▲ Spoon the apple slices onto the pastry round, heaping them up, and leaving a 2 inch border all around the edge of the pastry.

5 ▲ Turn up the pastry border and gather it around the apples to enclose the outside apples. Bake the tart for 35–40 minutes until the pastry is crisp and browned. Serve warm, with crème fraîche or cream.

UPSIDE-DOWN APPLE TART

Tarte Tatin

This tart was first made by two sisters who served it in their restaurant near Sologne in the Loire Valley. A special tarte tatin *pan is ideal, but an ovenproof frying pan will do very well.*

SERVES 8–10

½ pound puff or shortcrust pastry
10–12 large Golden Delicious apples
lemon juice
½ cup butter, cut into pieces
½ cup superfine sugar
½ tsp ground cinnamon
crème fraîche or whipped cream, to serve

1 On a lightly floured surface, roll out the pastry into an 11 inch round less than ¼ inch thick. Transfer to a lightly floured baking sheet and chill.

2 Peel the apples, cut them in half lengthwise and core. Sprinkle the apples generously with lemon juice.

3 ▲ In a 10 inch *tarte tatin* pan, cook the butter, sugar and cinnamon over medium heat until the butter has melted and sugar dissolved, stirring occasionally. Continue cooking for 6–8 minutes, until the mixture turns a medium caramel color, then remove the pan from the heat and arrange the apple halves, standing on their edges, in the tin, fitting them in tightly since they shrink during cooking.

4 Return the apple-filled pan to the heat and bring to a simmer over a medium heat for 20–25 minutes until the apples are tender and colored. Remove the pan from the heat and cool slightly.

5 ▼ Preheat the oven to 450°F. Place the pastry on top of the apple-filled pan and tuck the edges of the pastry inside the edge of the pan around the apples. Pierce the pastry in two or three places, then bake for 25–30 minutes until the pastry is golden and the filling is bubbling. Let the tart cool in the pan for 10–15 minutes.

6 To serve, run a sharp knife around edge of the pan to loosen the pastry. Cover with a serving plate and, holding them tightly, carefully invert the pan and plate together (do this carefully, preferably over the sink in case any caramel drips). Lift off the tin and loosen any apples that stick with a spatula. Serve the tart warm with cream.

COOK'S TIP

If you do not have a heavy ovenproof pan, use a deep, straight-sided frying pan. If the handle is not ovenproof, wrap well in several layers of strong foil to protect it from the heat.

LEMON TART

Tarte au Citron

This tart has a refreshing tangy flavor. You can find it in bistros and pâtisseries *all over France.*

SERVES 8–10

12 ounces shortcrust or sweet shortcrust
 pastry
grated rind of 2 or 3 lemons
⅔ cup freshly squeezed lemon juice
½ cup superfine sugar
4 tbsp crème fraîche or heavy cream
4 eggs, plus 3 egg yolks
confectioner's sugar, for dusting

1 ▼ Preheat the oven to 375°F. Roll out the pastry thinly and use to line a 9 inch pie pan. Prick the base of the pastry.

2 ▲ Line the pastry shell with foil and fill with baking beans. Bake for about 15 minutes until the edges are set and dry. Remove the foil and beans and continue baking for 5–7 minutes more until golden.

3 ▲ Place the lemon rind, juice and sugar in a bowl. Beat until combined and then gradually add the crème fraîche or heavy cream and beat until well blended.

4 ▲ Beat in the eggs, one at a time, then beat in the egg yolks and pour the filling into the pastry shell. Bake for 15–20 minutes, until the filling is set. If the pastry begins to brown too much, cover the edges with foil. Let cool. Dust with confectioner's sugar before serving.

PEAR AND ALMOND CREAM TART *Tarte aux Poires Frangipane*

This tart is equally successful made with other kinds of fruit, and some variation can be seen in almost every good French pâtisserie. Try making it with nectarines, peaches, apricots or apples.

SERVES 6

3 firm pears
lemon juice
¾ pound shortcrust or sweet shortcrust
 pastry
1 tbsp peach brandy or water
4 tbsp peach jam, strained
FOR THE ALMOND CREAM FILLING
¾ cup blanched whole almonds
¼ cup superfine sugar
5 tbsp butter
1 egg, plus 1 egg white
few drops almond extract

1 ▲ Roll out pastry thinly and use to line a 9 inch pie pan. Chill the pastry case while you make the filling. Put the almonds and sugar in a food processor fitted with the metal blade and pulse until finely ground; they should not be pasty. Add the butter and process until creamy, then add the egg, egg white and almond extract and mix well.

2 Place a baking sheet in the oven and preheat to 375°F. Peel the pears, halve them, remove the cores and rub with lemon juice. Put the pear halves cut side down on a board and slice thinly crosswise, keeping the slices together.

3 ▲ Pour the almond cream filling into the pastry shell. Slide a spatula under one pear half and press the top with your fingers to fan out the slices. Transfer to the tart, placing the fruit on the filling like spokes of a wheel. If you like, remove a few slices from each half before arranging and use to fill in any gaps in the center.

4 Place the tart on the hot baking sheet and bake for 50–55 minutes, or until the filling is set and well browned. Cool on a wire rack.

5 ▼ Meanwhile, heat the brandy or water and the jam in a small saucepan, then brush over the top of the hot tart to glaze. Serve the tart at room temperature.

STRAWBERRY TART

Tarte aux Fraises

This tart is best assembled just before serving, but you can bake the pastry shell early in the day, make the filling ahead and put it together in a few minutes.

SERVES 6

¾ pound puff pastry
½ pound cream cheese
grated rind of ½ orange
2 tbsp orange liqueur or orange juice
3–4 tbsp confectioner's sugar, plus more for dusting (optional)
1 pound ripe strawberries, hulled

1 Roll out the pastry to about a ⅛ inch thickness and use to line an 11×4 inch rectangular flan pan. Trim the edges, neatly, then chill for 20–30 minutes. Preheat the oven to 400°F.

2 ▼ Prick the base of the pastry all over. Line the pastry case with foil, fill with baking beans and bake for 15 minutes. Remove the foil and beans and bake for 10 minutes until the pastry is browned. Gently press down on the pastry base to deflate, then leave to cool on a wire rack.

3 ▲ Using a hand mixer or food processor, beat together the cheese, orange rind, liqueur or orange juice and confectioner's sugar to taste. Spread the cheese filling in the pastry shell. Halve the strawberries and arrange them on top of the filling. Dust with sugar, if you like.

FRESH FRUIT TARTLETS

Tartelettes aux Fruits

These tartlets are so pretty filled with colorful fruit. Use a selection of whatever soft fruit is in season – cut large fruits into pieces that will fit easily into the tartlet cases.

SERVES 6

¾ pound shortcrust or sweet shortcrust pastry
4 tbsp apple jelly or raspberry jam
1–2 tbsp Kirsch or fruit juice
1 pound ripe small fruits (such as strawberries, raspberries, red currants, grapes, figs, kiwi fruit or apricots), hulled, pitted and sliced, as necessary

1 Preheat the oven to 400°F. Lightly butter six 3½in tartlet pans.

2 ▲ Roll out the pastry to about a ⅛ inch thickness. Using a tartlet pan, cut out six rounds, re-rolling trimmings as necessary. Use the pastry rounds to line the pans, then roll the rolling pin over the top of the pans to cut off the excess pastry. Prick the bases with a fork.

3 Line the pastry cases with foil and add a layer of baking beans. Bake for 15 minutes until slightly dry and set, then remove the foil and beans and continue baking for 5 minutes more. Cool on a wire rack.

4 ▲ Shortly before serving, melt the jam in a small saucepan over low heat with the Kirsch or fruit juice until melted. Arrange the fruit in the tartlet shells and brush all over with the glaze.

VARIATION

If you like, spoon a little flavored whipped cream into the pastry cases before filling with fruit. Whip about ½ cup heavy cream, sweeten to taste with confectioner's sugar and flavor with a little brandy or a fruity liqueur.

ALSATIAN PLUM TART
Tarte aux Prunes Alsacienne

Fruit and custard tarts, similar to a fruit quiche, are typical in Alsace. Sometimes they have a yeast dough base instead of pastry. You can use other seasonal fruits in this tart, or a mixture of fruit.

SERVES 6–8

1 pound ripe plums, halved and pitted
2 tbsp Kirsch or plum brandy
¾ pound shortcrust or sweet shortcrust
 pastry
2 tbsp seedless raspberry jam
FOR THE CUSTARD FILLING
2 eggs
¼ cup superfine sugar
¾ cup heavy cream
grated rind of ½ lemon
¼ tsp vanilla extract

COOK'S TIP

If you have time, chill the
pastry shell for 10–15 minutes
before baking.

1 ▼ Preheat the oven to 400°F. Mix the prepared plums with the Kirsch or plum brandy and set aside for about ½ hour.

2 Roll out the pastry thinly and use to line a 9 inch pie pan. Prick the base of the pastry shell all over and line with foil. Add a layer of baking beans and bake for 15 minutes until slightly dry and set. Remove the foil and the baking beans.

3 ▲ Brush the base of the pastry shell with a thin layer of jam, then bake for 5 minutes more. Remove the pastry shell from the oven and transfer to a wire rack. Reduce the oven temperature to 350°F.

4 ▲ To make the custard filling, beat the eggs and sugar until well combined, then beat in the cream, lemon rind, vanilla extract and any juice from the plums.

5 ▲ Arrange the plums, cut side down, in the pastry shell and pour over the custard mixtur . Bake for about 30–35 minutes until a knife inserted in the center comes out clean. Serve the tart warm or at room temperature.

NECTARINE PUFF PASTRY TARTS *Tartes Feuilletées aux Nectarines*

These simple fresh fruit pastries are easy to put together, but the puff pastry makes them seem very elegant. You could use peaches, apples or pears instead of nectarines.

<u>SERVES 4</u>

½ pound puff pastry
1 pound nectarines
1 tbsp butter
2 tbsp superfine sugar
ground nutmeg
crème fraîche or lightly whipped cream,
* to serve (optional)*

1 Lightly butter a large baking sheet and sprinkle very lightly with water.

2 ▲ On a lightly floured surface, roll out the puff pastry to a large rectangle, about 15×10 inch and cut into six smaller rectangles.

3 ▲ Transfer to the baking sheet. Using the back of a small knife, scallop the edges of the pastry. Then using the tip of the knife, score a line ½ inch from the edge of each rectangle to form a border. Chill for 30 minutes. Preheat the oven to 400°F.

4 ▼ Cut the nectarines in half and remove the pits, then slice the fruit thinly. Arrange the nectarine slices down the center of the rectangles, leaving the border uncovered. Sprinkle the fruit with the sugar and a little ground nutmeg.

5 Bake for 12–15 minutes until the edges of the pastry are puffed and the fruit is tender.

6 Transfer the tarts to a wire rack to cool slightly. Serve warm with a little cream, if you like.

COOK'S TIP

These free-form puff pastry tarts can be made in other shapes, if you wish. Cut them in diamond shapes instead of rectangles, or cut into rounds, using a large cutter or a plate as a guide. Be sure to leave a border to allow the pastry to rise.

MINI NAPOLEONS

Petite Mille-Feuille

This pâtisserie *classic is a delectable combination of tender puff pastry sandwiched with luscious pastry cream. As it is difficult to cut, making individual servings is a perfect solution.*

SERVES 8

1 pound puff pastry
6 egg yolks
⅓ cup superfine sugar
3 tbsp flour
1½ cups milk
2 tbsp Kirsch or cherry liqueur
 (optional)
1 pound raspberries
confectioner's sugar, for dusting
strawberry or raspberry coulis,
 to serve

1 Lightly butter two large baking sheets and sprinkle them very lightly with cold water.

2 ▼ On a lightly floured surface, roll out the pastry to a ⅛ inch thickness. Using a 4 inch cutter, or a saucer as a guide, cut out 12 rounds. Place on the baking sheets and prick each a few times with a fork. Chill for 30 minutes. Preheat the oven to 400°F.

3 Bake the pastry rounds for about 15–20 minutes until golden, then transfer to wire racks to cool.

4 ▲ Whisk the egg yolks and sugar for 2 minutes until light and creamy, then whisk in the flour until just blended. Bring the milk to a boil over medium heat and pour it over the egg mixture, whisking to blend. Return to the saucepan, bring to the boil and boil for 2 minutes, while whisking constantly. Remove the pan from the heat and whisk in the Kirsch or liqueur, if using. Pour into a bowl and press plastic wrap onto the surface to prevent a skin forming. Set aside to cool.

5 ▲ To assemble, carefully split the pastry rounds in half. Spread one round at a time with a little pastry cream. Arrange a layer of raspberries over the cream and top with a second pastry round. Spread with a little more cream and a few more raspberries. Top with a third pastry round flat side up. Dust with confectioner's sugar and serve with the fruit *coulis*.

CHOCOLATE CREAM PUFFS

Profiteroles au Chocolat

This mouth-watering dessert is served in cafés throughout France. Sometimes the cream puffs are filled with whipped cream instead of ice cream, but they are always drizzled with chocolate sauce.

SERVES 4–6

10 ounces semisweet chocolate
8 tbsp warm water
3 cups vanilla ice cream
FOR THE CREAM PUFFS
¾ cup flour
¼ tsp salt
pinch of ground nutmeg
¾ cup water
6 tbsp unsalted butter, cut into
 6 pieces
3 eggs

1 Preheat the oven to 400°F and lightly butter a large baking sheet.

2 To make the profiteroles, sift together the flour, salt and nutmeg. In a medium saucepan, bring the water and butter to a boil. Remove from the heat and add the dry ingredients all at once. Beat with a wooden spoon for about 1 minute until well blended and the mixture starts to pull away from the sides of the pan, then set the pan over a low heat and cook the mixture for about 2 minutes, beating constantly. Remove from the heat.

3 ▲ Beat 1 egg in a small bowl and set aside. Add the remaining eggs, one at a time, to the flour mixture, beating well after each. Add the beaten egg by teaspoonfuls until the dough is smooth and shiny; it should pull away and fall slowly when dropped from a spoon.

4 ▼ Using a tablespoon, drop the dough onto the baking sheet in 12 mounds. Bake for 25–30 minutes until the pastry is well risen and browned. Turn off the oven and leave the puffs to cool with the oven door open.

5 To make the sauce, place the chocolate and water in a double-boiler or in a bowl placed over a pan of hot water and let melt, stirring occasionally. Keep warm until ready to serve, or reheat, over simmering water.

6 Split the cream puffs in half and put a small scoop of ice cream in each. Arrange on a serving platter or divide among individual plates. Pour the chocolate sauce over the top and serve at once.

SPONGE CAKE WITH FRUIT AND CREAM *Génoise aux Fruits*

Génoise is the French cake used as the base for both simple and elaborate creations. You could simply dust it with confectioner's sugar, or layer it with seasonal fruits to serve with tea.

SERVES 6

¾ cup flour
pinch of salt
4 eggs, at room temperature
⅔ cup superfine sugar
½ tsp vanilla extract
*4 tbsp butter, melted or clarified and
 cooled*
FOR THE FILLING
1 pound fresh strawberries or raspberries
2–4 tbsp superfine sugar
2 cups whipping cream
1 tsp vanilla extract

1 Preheat the oven to 350°F. Lightly butter a 9 inch springform pan or deep cake pan. Line the base with nonstick baking paper, and dust lightly with flour. Sift the flour and salt together twice.

2 ▲ Half-fill a medium saucepan with hot water and set over low heat (do not allow the water to boil). Put the eggs in a heatproof bowl that just fits into the pan without touching the water. Using an electric mixer, beat the eggs at medium-high speed, gradually adding the sugar, for 8–10 minutes until the mixture is very thick and pale and leaves a ribbon trail when the beaters are lifted. Remove the bowl from the pan, add the vanilla extract and continue beating until the mixture is cool.

3 ▲ Fold in the flour mixture in three batches, using a balloon whisk or metal spoon. Before the third addition of flour, stir a large spoonful of the mixture into the melted or clarified butter to lighten it, then fold the butter into the remaining mixture with the last addition of flour. Work quickly, but gently, so the mixture does not deflate. Pour into the prepared pan, smoothing the top so the sides are slightly higher than the center.

4 ▲ Bake in the oven for about 25–30 minutes until the top of the cake springs back when touched and the edge begins to shrink away from the side of the pan. Place the cake in its pan on a wire rack to cool for 5–10 minutes, then invert the cake onto the rack to cool completely. Peel off the paper carefully.

5 ▲ To make the filling, slice the strawberries, place in a bowl, sprinkle with 1–2 tbsp of the sugar and set aside. Using an electric mixer or balloon whisk beat the cream with 1–2 tbsp of sugar and the vanilla extract until it holds soft peaks.

6 ▲ To assemble the cake (up to 4 hours before serving), split the cake horizontally, using a serrated knife. Place the top, cut side up, on a serving plate. Spread with a third of the cream and cover with an even layer of sliced strawberries.

7 Place the bottom half of the cake, cut side down, on top of the filling and press lightly. Spread the remaining cream over the top and sides of the cake. Chill the cake until ready to serve. Serve the remaining strawberries with the cake.

QUEEN OF SHEBA CAKE

Gâteau Reine de Saba

This rich chocolate and almond cake is so moist it needs no filling. It is wonderful for entertaining as it can be made in advance and stored, well wrapped, in the refrigerator. for up to three days.

SERVES 8–10

⅔ cup whole blanched almonds, lightly toasted
⅔ cup superfine sugar
¼ cup flour
½ cup unsalted butter, softened
5 ounces semisweet chocolate, melted
3 eggs, separated
2 tbsp almond liqueur (optional)
FOR THE CHOCOLATE GLAZE
¾ cup heavy cream
8 ounces semisweet chocolate, chopped
2 tbsp unsalted butter
2 tbsp almond liqueur (optional)
chopped toasted almonds, to decorate

3 ▲ In a medium bowl, beat the butter with an electric mixer until creamy, then add half of the remaining sugar and beat for about 1–2 minutes until very light and creamy. Gradually beat in the melted chocolate until well blended, then add the egg yolks one at a time, beating well after each addition, and beat in the liqueur, if using.

4 ▲ In another bowl, beat the egg whites until soft peaks form. Add the remaining sugar and beat until the whites are stiff and glossy, but not dry. Fold a quarter of the whites into the chocolate mixture to lighten it, then alternately fold in the almond mixture and the remaining whites in three batches. Spoon the mixture into the prepared pan and spread evenly. Tap the pan gently to release any air bubbles.

5 Bake for 30–35 minutes until the edge is puffed but the center is still soft and wobbly (a skewer inserted about 2 inches from the edge should come out clean). Transfer the cake in its pan to a wire rack to cool for about 15 minutes, then remove the sides of the cake pan and let cool completely. Invert the cake onto an 8 inch cake board and remove the base of the pan and the paper.

6 To make the chocolate glaze, bring the cream to a boil in a saucepan. Remove from the heat and add the chocolate. Stir gently until the chocolate has melted and is smooth, then beat in the butter and liqueur, if using. Cool for about 20–30 minutes until slightly thickened, stirring occasionally.

7 ▲ Place the cake on a wire rack over a baking sheet and pour over the warm chocolate glaze to cover the top completely. Using a spatula, smooth the glaze around the sides of the cake. Spoon a little of the glaze into a pastry bag fitted with a writing nozzle and use to write a name, if you like. Let stand for 5 minutes to set slightly, then carefully press the nuts onto the sides of the cake. Using two long spatulas, transfer the cake to a serving plate and chill until ready to serve.

1 ▲ Preheat the oven to 350°F. Lightly butter an 8–9 inch springform pan or deep loose-based cake pan. Line the base with nonstick baking paper and dust the pan lightly with flour.

2 In the bowl of a food processor fitted with the metal blade, process the almonds and 2 tbsp of the sugar until very fine. Transfer to a bowl and sift over the flour. Stir to mix then set aside.

RICH CHOCOLATE CAKE
Torte au Chocolat

This dark, fudgy cake is easy to make, stores well and is a chocolate lover's dream come true.

SERVES 14–16

9 ounces semisweet chocolate, chopped
1 cup unsalted butter, cut into pieces
5 eggs
½ cup superfine sugar, plus 1 tbsp and
 some for sprinkling
1 tbsp cocoa powder
2 tsp vanilla extract
cocoa powder, for dusting
chocolate shavings, to decorate

1 Preheat the oven to 325°F. Lightly butter a 9 inch springform pan and line the base with nonstick baking paper. Butter the paper and sprinkle with a little sugar, then tap out the excess sugar from the pan.

2 ▲ The cake is baked in a *bain-marie*, so carefully wrap the base and sides of the pan with a double thickness of foil to prevent water from leaking into the cake.

3 Melt the chocolate and butter in a saucepan over low heat until smooth, stirring frequently, then remove from the heat. Beat the eggs and ½ cup of the sugar with an electric mixer for 1 minute.

4 ▲ Mix together the cocoa and the remaining 1 tbsp sugar and beat into the egg mixture until well blended. Beat in the vanilla extract, then slowly beat in the melted chocolate until well blended. Pour the mixture into the prepared pan and tap gently to release any air bubbles.

5 ▲ Place the cake pan in a roasting tin and pour in boiling water to come ¾ inch up the side of the wrapped pan. Bake for 45–50 minutes until the edge of the cake is set and the center still soft (a skewer inserted 2 inches from the edge should come out clean). Lift the pan out of the water and remove the foil. Place the cake on a wire rack, remove the side of the pan and let the cake cool completely (the cake will sink a little in the center).

6 Invert the cake onto the wire rack. Remove the base of the pan and the paper. Dust the cake liberally with cocoa and arrange the chocolate shavings around the edge. Slide the cake onto a serving plate.

FRENCH CHOCOLATE CAKE

Gâteau au Chocolat

This is typical of a French homemade cake – dense, dark and delicious. The texture is very different from a sponge cake and it is excellent served with cream or a fruit coulis.

SERVES 10–12

¾ cup superfine sugar, plus some for sprinkling
10 ounces semisweet chocolate, chopped
¾ cup unsalted butter, cut into pieces
2 tsp vanilla extract
5 eggs, separated
¼ cup flour, sifted
pinch of salt
confectioner's sugar, for dusting

1 ▲ Preheat the oven to 325°F. Generously butter a 9½ inch springform pan, then sprinkle the pan with a little sugar and tap out the excess.

2 Set aside 3 tbsp of the sugar. Place the chocolate, butter and remaining sugar in a heavy saucepan and cook over low heat until the chocolate and butter have melted and the sugar has dissolved. Remove the pan from the heat, stir in the vanilla extract and let the mixture cool slightly.

3 ▼ Beat the egg yolks into the chocolate mixture, beating each in well, then stir in the flour.

4 In a clean greasefree bowl, using an electric mixer, beat the egg whites slowly until they are frothy. Increase the speed, add the salt and continue beating until soft peaks form. Sprinkle over the reserved sugar and beat until the whites are stiff and glossy. Beat one-third of the whites into the chocolate mixture, then fold in the remaining whites.

5 ▲ Carefully pour the mixture into the pan and tap the pan gently to release any air bubbles.

6 Bake the cake for about 35–45 minutes until well risen and the top springs back when touched lightly with a fingertip. (If the cake appears to rise unevenly, rotate after 20–25 minutes.) Transfer the cake to a wire rack, remove the side of the pan and let cool completely. Remove the pan base. Dust the cake with confectioner's sugar and transfer to a serving plate.

203

POUND CAKE WITH RED FRUIT *Quatre Quarts aux Fruits*

Quatre quarts *literally translates as "four quarters," in this case, the equal weights of the four main ingredients. This orange-scented cake is good for tea or as a dessert with a fruit coulis.*

SERVES 6–8

1 pound fresh raspberries, strawberries or
 pitted cherries, or a combination of
 any of these
⅞ cup superfine sugar, plus
 1–2 tbsp and some for sprinkling
1 tbsp lemon juice
1⅓ cups flour
2 tsp baking powder
pinch of salt
¾ cup unsalted butter, softened
3 eggs, at room temperature
grated zest of 1 orange
1 tbsp orange juice

1 Reserve a few whole fruits for decorating. In a food processor fitted with the metal blade, process the fruit until smooth.

2 ▼ Add 1–2 tbsp of the sugar and the lemon juice to the fruit purée, then process again to blend. Strain the sauce and chill.

3 Butter the base and sides of an 8×4 inch loaf pan or an 8 inch springform pan and line the base with nonstick baking paper. Butter the paper and the sides of the pan again, then sprinkle lightly with sugar and tap out any excess from the pan. Preheat the oven to 350°F.

4 ▲ Sift the flour, baking powder and a pinch of salt. In a medium bowl, beat the butter with an electric mixer for 1 minute until creamy. Add the sugar and beat for 4–5 minutes until very light and fluffy, then add the eggs, one at a time, beating well after each addition. Beat in the orange zest and juice.

5 ▲ Gently fold the flour mixture into the butter mixture in three batches, then spoon the mixture into the prepared pan and tap gently to release any air bubbles.

6 Bake the cake for 35–40 minutes until the top is golden and springs back when touched. Transfer the cake in its pan to a wire rack and leave to cool for 10 minutes. Remove the cake from the pan, then cool for about ½ hour. Remove the paper and serve slices or wedges of the warm cake with a little of the fruit sauce and decorate with the reserved fruit.

INDIVIDUAL BRIOCHES

Petites Brioches

These buttery rolls with their distinctive little topknots are delicious with a spoonful or two of jam and a cup of café au lait – or try them split and filled with scrambled eggs.

MAKES 8

scant 1 tbsp active dry yeast
1 tbsp superfine sugar
2 tbsp warm milk
2 eggs
1½ cups flour
½ tsp salt
6 tbsp butter, cut into 6 pieces, at room temperature
1 egg yolk beaten with 2 tsp water, for glazing

1 ▲ Lightly butter eight individual brioche pans or muffin cups. Put the yeast and sugar in a small bowl, add the milk and stir until dissolved. Let stand for about 5 minutes until foamy, then beat in the egg.

2 ▲ Put the flour and salt into a food processor fitted with the metal blade, then with the machine running, slowly pour in the yeast mixture. Scrape down the sides and continue processing for about 2–3 minutes, or until the dough forms a ball. Add the butter and pulse about 10 times, or until the butter is incorporated.

3 Transfer the dough to a lightly buttered bowl and cover with a cloth. Set aside to rise in a warm place for about 1 hour until doubled in size, then punch down.

4 ▲ Set aside quarter of the dough. Shape the remaining dough into eight balls and put into the prepared pans. Shape the reserved dough into eight smaller balls, then make a depression in the top of each large ball and set a small ball into it.

5 Allow the brioches to rise in a warm place for about 30 minutes until doubled in size. Preheat the oven to 400°F.

6 Brush the brioches lightly with the egg glaze and bake them for 15–18 minutes until golden brown. Transfer to a wire rack and let cool before serving.

COOK'S TIP

The dough may also be baked in the characteristic large brioche pan with sloping fluted sides. Put about three-quarters of the dough into the pan and set the remainder in a depression in the top, cover and let rise for about 1 hour, then bake for 35–45 minutes.

SAVARIN WITH SUMMER FRUIT

Savarin aux Fruits

This traditional dessert from Alsace-Lorraine is made from a rich yeast dough moistened with syrup and cherry liqueur. For babas au rhum, *the same dough can be baked in individual pans and soaked with rum syrup – either way it is quite delicious.*

SERVES 10–12

scant 1 tbsp active dry yeast
¼ cup superfine sugar
4 tbsp warm water
2¼ cups flour
4 eggs, beaten
1 tsp vanilla extract
7 tbsp unsalted butter, softened
1 pound fresh raspberries or strawberries
mint leaves, to decorate
1¼ cups whipping cream, sweetened to
 taste and whipped, to serve
FOR THE SYRUP
1¼ cups superfine sugar
2½ cups water
6 tbsp red currant jelly
3 tbsp Kirsch (optional)

1 ▲ Generously butter a 9 inch savarin or ring mould. Put the yeast and 1 tbsp of the sugar in a medium bowl, add the water and stir until dissolved, then leave the yeast mixture to stand for about 5 minutes until frothy.

2 ▲ Put the flour and remaining sugar in a food processor fitted with the metal blade and pulse to combine. With the machine running, slowly pour in the yeast mixture, eggs and vanilla extract, then scrape down the sides and continue processing for 2–3 minutes, or until a soft dough forms. Add the butter and pulse about 10 times, until all the butter is incorporated.

3 ▲ Place the dough in spoonfuls into the mold, leaving a space between each mound of dough (this will fill in as the dough rises). Tap the mold gently to release any air bubbles, then cover with a dish towel and leave in a warm place to rise for about 1 hour. The dough should double in volume and come just to the top of the mold. Preheat the oven to 400°F.

4 Place the savarin or ring mold on a baking sheet in the oven and immediately reduce the temperature to 350°F. Bake for about 25 minutes until the top is a rich golden color and springs back when touched. Turn out the cake onto a wire rack and let stand to cool slightly.

5 ▲ To make the syrup, blend the sugar, water and 4 tbsp of the red currant jelly in a saucepan. Bring to a boil over medium-high heat, stirring until the sugar and jelly dissolve, and boil for 3 minutes. Remove from the heat and allow to cool slightly, then stir in the Kirsch, if using. In a small bowl, combine 2 tbsp of the hot syrup with the remaining red currant jelly and stir to dissolve. Set aside.

6 Place the rack with the cake, still warm, over a baking tray. Slowly spoon the syrup over the cake, catching any extra syrup in the tray and spooning it over the cake, until all the syrup has been absorbed. Carefully transfer the cake to a shallow serving dish (the cake will be very fragile) and pour over any remaining syrup. Brush the red currant glaze over the top, then fill the center with raspberries or strawberries and decorate with mint leaves. Chill, then serve with cream.

MACAROONS

Macarons

Freshly ground almonds, lightly toasted beforehand to intensify the flavor, give these biscuits their rich taste and texture so, for best results, avoid using ready-ground almonds as a shortcut.

MAKES 12

1⅓ cup blanched almonds, toasted
⅞ cup superfine sugar
2 egg whites
½ tsp almond or vanilla extract
confectioner's sugar, for dusting

1 Preheat the oven to 350°F. Line a large baking sheet with non-stick baking paper. Reserve 12 almonds for decorating. In a food processor fitted with the metal blade, process the rest of the almonds and the sugar until finely ground.

2 With the machine running, slowly pour in enough of the egg whites to form a soft dough. Add the almond or vanilla extract and pulse to mix.

3 ▲ With moistened hands, shape the mixture into walnut-size balls and arrange on the baking sheet.

4 Press one of the reserved almonds onto each ball, flattening them slightly, and dust lightly with confectioner's sugar. Bake the macaroons for about 10–12 minutes until the tops are golden and feel slightly firm. Transfer to a wire rack, cool slightly, then peel the cookies off the paper and leave to cool completely.

COOK'S TIP

To toast the almonds, spread them on a baking sheet and bake in the preheated oven for 10–15 minutes until golden. Cool before grinding.

MADELEINE CAKES

Madeleines

These little tea cakes, baked in a special pan with shell-shaped cups, were made famous by Marcel Proust, who referred to them in his memoirs. They are best eaten on the day they are made.

MAKES 12

1¼ cups flour
1 tsp baking powder
2 eggs
¾ cup confectioner's sugar, plus some for dusting
grated zest of 1 lemon or orange
1 tbsp lemon or orange juice
6 tbsp unsalted butter, melted and slightly cooled

COOK'S TIP

If you don't have a special pan for making *madeleines*, you can use a muffin pan, preferably with a nonstick coating. The cakes won't have the characteristic ridges and shell shape, but they are quite pretty dusted with a little confectioner's sugar.

1 Preheat the oven to 375°F. Generously butter a 12 cup madeleine pan. Sift together the flour and baking powder.

2 ▲ Using an electric mixer, beat the eggs and confectioner's sugar for 5–7 minutes until thick and creamy and the mixture forms a ribbon when the beaters are lifted. Gently fold in the lemon or orange zest and the lemon or orange juice.

3 ▲ Beginning with the flour mixture, alternately fold in the flour and melted butter in four batches. Let the mixture stand for 10 minutes, then carefully spoon into the pan. Tap gently to release any air bubbles. Bake the *madeleines* for 12–15 minutes, rotating the pan halfway through cooking, until a skewer inserted in the center comes out clean. Turn out onto a wire rack to cool completely and dust with confectioner's sugar before serving.

ALMOND TILE COOKIES

Tuiles d'Amandes

These cookies are named after the French roof tiles they so resemble. Making them is a little tricky, so bake only four at a time until you get the knack. With a little practice you will find them easy.

MAKES ABOUT 24

½ cup whole blanched almonds, lightly
 toasted
⅓ cup superfine sugar
3 tbsp unsalted butter, softened
2 egg whites
½ tsp almond extract
scant ¼ cup flour, sifted
⅔ cup sliced almonds

1 Preheat oven to 400°F.
Generously butter two heavy baking
sheets.

> ### COOK'S TIP
>
> If the cookies flatten or lose their
> crispness, reheat them on a baking
> sheet in a moderate oven, until
> completely flat, then reshape
> over a rolling pin.

2 Place the almonds and about
2 tbsp of the sugar in a food
processor fitted with the metal blade
and pulse until finely ground; they
should not be pasty.

3 ▼ With an electric mixer, beat
the butter until creamy, then add
the remaining sugar and beat for
1 minute until light and fluffy.
Gradually beat in the egg whites
until the mixture is well blended,
then beat in the almond extract. Sift
the flour over the butter mixture and
fold in, then fold in the ground
almond mixture.

4 ▲ Drop tablespoons of mixture
onto the baking sheets about
6 inches apart. With the back of a
wet spoon, spread each mound into
a paper-thin 3 inch round. (Don't
worry if holes appear, they will fill
in.) Sprinkle each round with a few
sliced almonds.

5 ▲ Bake the cookies, one sheet at a
time, for 5–6 minutes until the edges
are golden and the centers still pale.
Remove the baking sheet to a wire
rack and, working quickly, use a
thin spatula to loosen the edges of
one cookie. Lift the cookie on the
spatula and place over a rolling pin,
then press down the sides of the
cookie to curve it.

6 Continue shaping the cookies,
transferring them to a wire rack as
they cool and crisp. If the cookies
become too crisp to shape, return
the baking sheet to the hot oven for
15–30 seconds to soften them, then
continue as above. To avoid damage
store the cookies in a single layer in
airtight containers.

SPICED-NUT PALMIERS

Palmiers

These delicate pastries, said to resemble palm trees, are popular throughout France. They are often simply rolled in sugar, but in this recipe the filling includes cinnamon and nuts.

MAKES ABOUT 40

½ cup chopped almonds, walnuts or
 hazelnuts
2 tbsp superfine sugar, plus some for
 sprinkling
½ tsp ground cinnamon
½ pound puff pastry, defrosted
 if frozen
1 egg, lightly beaten

1 ▲ Lightly butter two large baking sheets, preferably non-stick. In a food processor fitted with the metal blade, process the nuts, sugar and cinnamon until finely ground. Transfer half to a small bowl.

2 ▲ Sprinkle the work surface and pastry with sugar and roll out the pastry to a 20×8 inch rectangle about ⅛ inch thick, sprinkling with more sugar as necessary. Brush the pastry lightly with beaten egg and sprinkle evenly with half of the nut mixture in the bowl.

3 ▼ Fold in the long edges of the pastry to meet in the center and flatten with the rolling pin. Brush with egg and sprinkle with most of the nut mixture. Fold in the edges again to meet in the center, brush with egg and sprinkle with the remaining nut mixture. Fold one side of the pastry over the other.

4 Using a sharp knife, cut the pastry crosswise into ⅜ inch thick slices and place the pieces cut-side down about 1 inch apart on the prepared baking sheets.

5 ▲ Spread the pastry edges apart to form a wedge shape. Chill the palmiers for at least 15 minutes. Preheat oven to 425°F.

6 Bake the palmiers for about 8–10 minutes until golden, carefully turning them over halfway through the cooking time. Watch carefully as the sugar can easily scorch. Transfer to a wire rack to cool.

BRITTANY BUTTER COOKIES

Petites Gâteaux Bretons

These little cookies are similar to shortbread, but richer. Like most of the cakes and pastries from this province, they are made with the lightly salted butter, beurre demi-sel, *from around Nantes.*

MAKES 18–20

6 egg yolks, lightly beaten
1 tbsp milk
2 cups flour
⅞ cup superfine sugar
⅞ cup lightly salted butter, at room
 temperature, cut into small pieces

COOK'S TIP

To make one large Brittany Butter Cake, pat the dough with well floured hands into a 9 inch loose-based cake pan or springform pan. Brush with egg glaze and score the lattice pattern on top. Bake for 45 minutes–1 hour until firm to the touch and golden brown.

1 Preheat the oven to 350°F. Lightly butter a large heavy baking sheet. Mix 1 tbsp of the egg yolks with the milk to make a glaze and set aside.

2 ▲ Sift the flour into a large bowl and make a well in the center. Add the egg yolks, sugar and butter and, using your fingertips, work them together until smooth and creamy.

3 ▲ Gradually add a little flour at a time from the edge of the well, working it to form a smooth and slightly sticky dough.

4 ▲ Using floured hands, pat out the dough to about ½ inch thick and cut out rounds using a 3 inch cookie cutter. Transfer the rounds to a baking sheet, brush each with a little egg glaze, then using the back of a knife, score with lines to create a lattice pattern.

5 Bake the cookies for about 12–15 minutes until golden. Cool in the pan on a wire rack for 15 minutes, then carefully remove the cookies and let cool completely on the rack. Store in an airtight container.

CHOCOLATE TRUFFLES

Truffes au Chocolat

These truffles, like the prized fungi they resemble, are a Christmas speciality in France. They can be rolled in cocoa or nuts, or dipped in chocolate – use plain, milk or even white chocolate.

MAKES 20–30

¾ cup heavy cream
10 ounces semisweet chocolate, chopped
2 tbsp unsalted butter, cut into pieces
2–3 tbsp brandy (optional)
FOR THE COATING
cocoa
finely chopped pistachio nuts or
* hazelnuts*
14 ounces semisweet, milk or white
* chocolate or a mixture*

1 ▲ In a saucepan over medium heat, bring the cream to a boil. Remove from the heat and add the chocolate, then stir until melted and smooth. Stir in the butter and the brandy, if using, then strain into a bowl and leave to cool. Cover and chill for 6–8 hours or overnight.

2 ▲ Line a large baking sheet with wax paper. Using a small ice cream scoop or two teaspoons, form the chocolate mixture into 20–30 balls and place on the paper. Chill if the mixture becomes soft.

3 ▲ To coat the truffles with cocoa, sift the cocoa into a small bowl, drop in the truffles, one at a time, and roll to coat well, keeping the round shape. To coat with nuts, roll truffles in finely chopped nuts. Chill well wrapped, for up to 10 days.

4 To coat with chocolate, freeze the truffles for at least 1 hour. In a small bowl, melt the dark, milk or white chocolate over a pan of barely simmering water, stirring until melted and smooth, then allow to cool slightly.

5 Using a fork, dip the frozen truffles into the cooled chocolate, one at a time, tapping the fork on the edge of the bowl to shake off the excess. Place on a baking sheet lined with nonstick baking paper and chill at once. If the melted chocolate thickens, reheat until smooth. Wrap and store as for nut-coated truffles.

DESSERTS

In France a family meal usually ends with dessert. Though, since there may well have been two or three other courses, it is likely to be something light and refreshing – perhaps just a piece of fresh fruit, eaten with a knife and fork, or a simple fruit salad. In summer, fresh strawberries and raspberries are always welcome, either moistened with wine, or puréed for sorbets and mousses. In cooler weather, a compôte of winter fruits might be served, or, if the rest of the meal is light, a crusty apple charlotte or baked custard. Fancy desserts such as soufflés, crêpes and meringues are reserved for the weekends or special celebrations.

BAKED CARAMEL CUSTARD

Crème Caramel

Also called crème renversée, *this is one of the most popular French desserts and is wonderful when freshly made. This is a slightly lighter version of the traditional recipe.*

SERVES 6–8

1¼ cups granulated sugar
4 tbsp water
1 vanilla bean or 2 tsp vanilla extract
1¾ cups milk
1 cup heavy cream
5 large eggs
2 egg yolks

1 Put ⅞ cup of the sugar in a small heavy saucepan with the water to moisten. Bring to a boil over high heat, swirling the pan to dissolve the sugar. Boil, without stirring, until the syrup turns a dark caramel color (this will take about 4–5 minutes).

2 ▼ Immediately pour the caramel into a 4 cup soufflé dish. If it is hot, hold the dish with oven mitts, before quickly swirling the dish to coat the base and sides with the caramel and set aside. (The caramel will harden quickly as it cools.) Place the dish in a small roasting pan.

3 ▲ Preheat the oven to 325°F. With a small sharp knife, carefully split the vanilla bean lengthwise and scrape the black seeds into a medium saucepan. Add the milk and cream and bring just to a boil over medium-high heat, stirring frequently. Remove the pan from the heat, cover and set aside for 15–20 minutes.

4 In a bowl, whisk the eggs and egg yolks with the remaining sugar for 2–3 minutes until smooth and creamy. Whisk in the hot milk and carefully strain the mixture into the caramel-lined dish. Cover with foil.

5 Place the dish in a roasting pan and pour in enough boiling water to come halfway up the side of the dish. Bake the custard for 40–45 minutes until a knife inserted about 2 inches from the edge comes out clean (the custard should be just set). Remove from the roasting pan and cool for at least ½ hour, then chill overnight.

6 To turn out, carefully run a sharp knife around the edge of the dish to loosen the custard. Cover the dish with a serving plate and, holding them tightly, invert the dish and plate together. Gently lift one edge of the dish, allowing the caramel to run over the sides, then slowly lift off the dish.

BAKED CUSTARD WITH BURNED SUGAR *Crème Brûlée*

This dessert actually originated in Cambridge, England, but has become associated with France and is widely eaten there. Add a little liqueur, if you like, but it is equally delicious without it.

SERVES 6

1 vanilla bean
4 cups heavy cream
6 egg yolks
½ cup superfine sugar
2 tbsp almond or orange liqueur
⅓ cup light brown sugar

1 Preheat the oven to 300°F. Place six ½ cup ramekins in a roasting pan or ovenproof dish and set aside.

2 ▲ With a small sharp knife, split the vanilla bean lengthwise and scrape the black seeds into a medium saucepan. Add the cream and bring just to a boil over medium-high heat, stirring frequently. Remove from the heat and cover. Set aside to stand for 15–20 minutes.

3 ▲ In a bowl, whisk the egg yolks, superfine sugar and liqueur until well blended. Whisk in the hot cream and strain into a large pitcher. Divide the custard equally among the ramekins.

4 ▲ Pour enough boiling water into the roasting pan to come halfway up the sides of the ramekins. Cover the pan with foil and bake for about 30 minutes until the custards are just set. Remove from the pan and let cool. Return to the dry roasting pan and chill.

5 Preheat the broiler. Sprinkle the sugar evenly over the surface of each custard and broil for 30–60 seconds until the sugar melts and caramelizes. (Do not let the sugar burn or the custard curdle.) Place in the refrigerator to set the crust and chill completely before serving.

COOK'S TIP

To test whether the custards are ready, push the point of a knife into the center of one – if it comes out clean the custards are cooked.

FLOATING ISLANDS

Oeufs à la Neige

*Oeufs à la Neige means "snow eggs," which is what these oval-shaped meringues look like.
Originally they were poached in milk and this was then used to make the rich custard sauce.*

SERVES 4–6

1 vanilla bean
2½ cups milk
8 egg yolks
¼ cup granulated sugar
FOR THE MERINGUES
4 large egg whites
¼ tsp cream of tartar
1¼ cups superfine sugar
FOR THE CARAMEL
¾ cup granulated sugar

1 Split the vanilla bean lengthwise and scrape the tiny black seeds into a medium saucepan. Add the milk and bring just to a boil over medium-high heat, stirring frequently. Remove the pan from the heat and cover. Set aside for 15–20 minutes.

2 In a medium bowl, whisk the egg yolks and sugar for 2–3 minutes until thick and creamy. Whisk in the hot milk and return the mixture to the saucepan. With a wooden spoon, stir over medium-low heat until the sauce begins to thicken and coat the back of the spoon (do not allow the custard to boil or it may curdle). Immediately strain into a chilled bowl, allow to cool, stirring occasionally and then chill.

3 Half-fill a large wide frying pan or saucepan with water and bring just to the simmering point. In a clean greasefree bowl, whisk the egg whites slowly until they are frothy. Add the cream of tartar, increase the speed and continue whisking until they form soft peaks. Gradually sprinkle over the superfine sugar, about 2 tbsp at a time, and whisk until the whites are stiff and glossy.

4 ▲ Using two tablespoons, form egg-shaped meringues and slide them into the water (you may need to work in batches). Poach them for 2–3 minutes, turning once until the meringue is just firm. Using a large slotted spoon, transfer the cooked meringues to a baking sheet lined with paper towels to drain.

5 Pour the cold custard into individual serving dishes and arrange the meringues on top.

6 ▲ To make the caramel, put the sugar into a small saucepan with 3 tbsp of water to moisten. Bring to a boil over high heat, swirling the pan to dissolve the sugar. Boil, without stirring, until the syrup turns a dark caramel color. Immediately drizzle the caramel over the meringues and custard in a zigzag pattern. Serve cold. (The caramel will soften if made too far ahead.)

MOCHA CREAM POTS

Petits Pots de Crème au Mocha

The name of this rich baked custard, a classic French dessert, comes from the baking cups, called pots de crème. *The addition of coffee gives the dessert an exotic touch.*

SERVES 8

1 tbsp instant coffee powder
2 cups milk
⅓ cup superfine sugar
8 ounces semisweet chocolate, chopped
2 tsp vanilla extract
2 tbsp coffee liqueur (optional)
7 egg yolks
whipped cream and candied cake
 decorations

1 Preheat the oven to 325°F. Place eight ½ cup *pots de crème* cups or ramekins in a roasting pan.

2 ▲ Put the instant coffee into a saucepan and stir in the milk, then add the sugar and set the pan over medium–high heat. Bring to a boil, stirring constantly, until the coffee and sugar have dissolved.

3 ▲ Remove the pan from the heat and add the chocolate. Stir until the chocolate has melted and the sauce is smooth. Stir in the vanilla extract and coffee liqueur, if using.

4 ▲ In a bowl, whisk the egg yolks to blend them lightly. Slowly whisk in the chocolate mixture until well blended, then strain the mixture into a large pitcher and divide equally among the cups or ramekins. Place them in a roasting pan and pour in enough boiling water to come halfway up the sides of the cups or ramekins.

5 ▼ Bake for 30–35 minutes until the custard is just set and a knife inserted into a custard comes out clean. Remove the cups or ramekins from the roasting pan and allow to cool. Place on a baking sheet, cover and chill completely. Decorate with whipped cream and candied cake decorations, if you like.

CREAM CHEESE WITH FRUIT SAUCE

Coeur à la Crème

This elegant yet simple to prepare dessert gets its French name, "hearts of cream," from the perforated heart-shaped molds they are traditionally made in.

SERVES 6–8

8 ounces cream cheese, softened
1 cup sour cream
1 tsp vanilla extract
about 3 tbsp superfine sugar, to taste
2 egg whites
pinch of cream of tartar
raspberries or other small fruit,
* to decorate*
FOR THE PASSION FRUIT SAUCE
6 ripe passion fruits
1 tsp cornstarch blended with
* 1 tsp water*
4 tbsp fresh orange juice
2–3 tbsp superfine sugar, to taste
1–2 tbsp orange liqueur (optional)

1 ▲ Line six to eight *coeur à la crème* molds with cheesecloth. In a large bowl, beat the cream cheese until smooth. Add the sour cream, vanilla extract and sugar, beating the mixture until smooth.

2 In a clean greasefree bowl, using an electric mixer, beat the egg whites slowly until they become frothy. Add the cream of tartar, increase the speed and continue beating until they form stiff peaks that just flop over a little at the top.

3 Beat a spoonful of whites into the cheese mixture to lighten it, then fold in the remaining whites.

4 ▲ Spoon the cheese mixture into the molds, smooth the tops and place on a baking sheet to catch any drips. Cover the sheet with plastic wrap and chill overnight.

5 ▲ To make the sauce, cut each passion fruit in half crosswise and scoop the flesh and seeds into a medium saucepan. Add the blended cornstarch and stir in the orange juice and sugar. Bring the sauce to a boil over medium heat and simmer for 2–3 minutes until the sauce thickens, stirring frequently. Remove from the heat and cool slightly, then strain into a serving pitcher and stir in the orange liqueur, if using.

6 To serve, unmold the cheeses onto individual plates and remove the cheesecloth. Pour the fruit sauce around and decorate with fruit.

CHOCOLATE LOAF WITH COFFEE SAUCE *Marquise au Chocolat*

This type of chocolate dessert is popular in many French restaurants. Sometimes the loaf is encased in sponge cake, but this version is easier and it can be served cold or frozen.

SERVES 6–8

6 ounces semisweet chocolate, chopped
4 tbsp butter, softened
4 large eggs, separated
2 tbsp rum or brandy (optional)
pinch of cream of tartar
chocolate curls and chocolate coffee beans,
 to decorate
FOR THE COFFEE SAUCE
2½ cups milk
9 egg yolks
¼ cup superfine sugar
1 tsp vanilla extract
1 tbsp instant coffee powder, dissolved in
 2 tbsp hot water

1 ▲ Line a 5 cup terrine or loaf pan with plastic wrap, smoothing it evenly over the base and sides.

2 ▲ Put the chocolate in a bowl and set over hot water and set aside for 3–5 minutes, then stir until melted and smooth. Remove the bowl from the pan and quickly beat in the softened butter, egg yolks, one at a time, and rum or brandy, if using.

3 ▲ In a clean greasefree bowl, using an electric mixer, beat the egg whites slowly until frothy. Add the cream of tartar, increase the speed and continue beating until they form soft peaks, then stiffer peaks that just flop over a little. Stir one-third of the egg whites into the chocolate mixture, then fold in the remaining whites. Pour into the terrine or pan and smooth the top. Cover and freeze until ready to serve.

4 To make the coffee sauce, bring the milk to a simmer over medium heat. Whisk the egg yolks and sugar for 2–3 minutes until thick and creamy, then whisk in the hot milk and return the mixture to the saucepan. With a wooden spoon, stir over low heat until the sauce begins to thicken and coat the back of the spoon. Strain the custard into a chilled bowl, stir in the vanilla extract and coffee and set aside to cool, stirring occasionally. Chill.

5 To serve, uncover the terrine or pan and dip the base into hot water for 10 seconds. Invert the dessert onto a board and peel off the plastic wrap. Cut the loaf into slices and serve with the coffee sauce. Decorate with the chocolate curls and chocolate coffee beans.

BITTER CHOCOLATE MOUSSE *Mousse au Chocolat Amer*

This is the quintessential French dessert – easy to prepare ahead, rich and extremely delicious. Use the darkest chocolate you can find for the best and most intense chocolate flavor.

SERVES 8

8 ounces semisweet chocolate, chopped
4 tbsp water
2 tbsp orange liqueur or brandy
2 tbsp unsalted butter, cut into small
 pieces
4 eggs, separated
6 tbsp heavy cream
1/4 tsp cream of tartar
3 tbsp superfine sugar
crème fraîche or sour cream and chocolate
 curls, to decorate

COOK'S TIP

As the flavor of this dessert depends on the quality of the chocolate used, it is worth searching in specialty shops for really good chocolate, such as Valrhona and Lindt Excellence.

1 Place the chocolate and water in a heavy saucepan. Melt over low heat, stirring until smooth. Remove the pan from the heat and whisk in the liqueur and butter.

2 ▲ With an electric mixer, beat the egg yolks for 2–3 minutes until thick and creamy, then slowly beat into the melted chocolate until well blended. Set aside.

3 ▲ Whip the cream until soft peaks form and stir a spoonful into the chocolate mixture to lighten it. Fold in the remaining cream.

4 In a clean greasefree bowl, using an electric mixer, beat the egg whites slowly until frothy. Add the cream of tartar, increase the speed and continue beating until they form soft peaks. Gradually sprinkle over the sugar and continue beating until the whites are stiff and glossy.

5 ▲ Using a rubber spatula or large metal spoon, stir a quarter of the egg whites into the chocolate mixture, then gently fold in the remaining whites, cutting down to the bottom, along the sides and up to the top in a semicircular motion until they are just combined. (Don't worry about a few white streaks.) Gently spoon into an 8 cup dish or into eight individual dishes. Chill for at least 2 hours until set and chilled.

6 Spoon a little crème fraîche or sour cream over the mousse and decorate with chocolate curls.

CHOCOLATE SOUFFLÉS

Petits Soufflés au Chocolat

These soufflés are easy to make and can be prepared in advance – the filled dishes can wait for up to one hour before baking. For best results, use good quality bittersweet chocolate.

<u>SERVES 6</u>

6 ounces bittersweet chocolate, chopped
⅔ cup unsalted butter, cut in small pieces
4 large eggs, separated
2 tbsp orange liqueur (optional)
¼ tsp cream of tartar
3 tbsp superfine sugar
confectioner's sugar, for dusting
FOR THE WHITE CHOCOLATE SAUCE
6 tbsp heavy cream
3 ounces white chocolate, chopped
1–2 tbsp orange liqueur
grated zest of ½ orange

1 Generously butter six ⅓ cup ramekins. Sprinkle each with a little superfine sugar and tap out any excess. Place the ramekins on a baking sheet.

2 ▲ In a heavy saucepan over very low heat, melt the chocolate and butter, stirring until smooth. Remove from the heat and cool slightly, then beat in the egg yolks and orange liqueur, if using. Set aside, stirring occasionally.

3 Preheat the oven to 425°F. In a clean greasefree bowl, whisk the egg whites slowly until frothy. Add the cream of tartar, increase the speed and whisk until they form soft peaks. Gradually sprinkle over the sugar, 1 tbsp at a time, whisking until the whites are stiff and glossy.

4 ▼ Stir a third of the whites into the cooled chocolate mixture to lighten it, then pour the chocolate mixture over the remaining whites. Using a rubber spatula or large metal spoon, gently fold the sauce into the whites, cutting down to the bottom, then along the sides and up to the top in a semicircular motion until they are just combined. (Don't worry about a few white streaks.) Spoon into the prepared dishes.

5 ▲ To make the white chocolate sauce, put the chopped white chocolate and the cream into a small saucepan. Set over a low heat and cook, stirring constantly, until melted and smooth. Remove from the heat and stir in the liqueur and orange zest, keep warm.

6 Bake the soufflés for 10–12 minutes until risen and set, but still slightly wobbly in the center. Dust with confectioner's sugar and serve immediately with the sauce.

223

GINGER BAKED PEARS *Poires au Gingembre*

This simple dessert is the kind that would be served after Sunday lunch or a family supper. Try to find Comice or Anjou pears – the recipe is especially useful for slightly underripe fruit.

<u>SERVES 4</u>

4 large pears
1¼ cups heavy cream
¼ cup superfine sugar
½ tsp vanilla extract
¼ tsp ground cinnamon
pinch of ground nutmeg
1 tsp grated gingerroot

VARIATION

If desired, you could substitute about 1 tbsp finely chopped ginger preserved in syrup for the fresh gingerroot and add a little of the ginger syrup to the cream.

1 Preheat the oven to 375°F. Lightly butter a large shallow baking dish.

2 ▼ Peel the pears, cut them in half lengthwise using a large sharp knife and remove the cores. Arrange, cut-sides down, in a single layer in the baking dish.

3 ▲ Mix together the cream, sugar, vanilla extract, cinnamon, nutmeg and ginger and pour over the pears.

4 Bake for 30–35 minutes, basting from time to time, until the pears are tender and browned on top and the cream is thick and bubbly. Cool slightly before serving.

PRUNES POACHED IN RED WINE *Compôte de Pruneaux Agennaise*

Serve this simple dessert on its own, or with crème fraîche or vanilla ice cream. The most delicious plump prunes come from the orchards around Agen in Southwest France.

<u>SERVES 8–10</u>

1 orange
1 lemon
3 cups fruity red wine
2 cups water
¼ cup superfine sugar, or to taste
1 cinnamon stick
pinch of freshly grated nutmeg
2 or 3 cloves
1 tsp black peppercorns
1 bay leaf
2 pounds large pitted prunes, soaked in cold water
strips of orange rind, to decorate

1 Using a vegetable peeler, peel two or three strips of rind from both the orange and lemon. Squeeze the juice from both and put in a large saucepan.

2 Add the wine, water, sugar, spices, peppercorns, bay leaf and strips of rind to the pan.

3 ▲ Bring to a boil over a medium heat, stirring occasionally to dissolve the sugar. Drain the prunes and add to the saucepan, reduce the heat to low and simmer, covered, for 10–15 minutes until the prunes are tender. Remove from the heat and set aside until cool.

4 ▼ Using a slotted spoon, transfer the prunes to a serving dish. Return the cooking liquid to medium-high heat and bring to a boil. Boil for 5–10 minutes until slightly reduced and syrupy, then pour or strain over the prunes. Cool, then chill before serving, decorated with strips of orange rind, if you like.

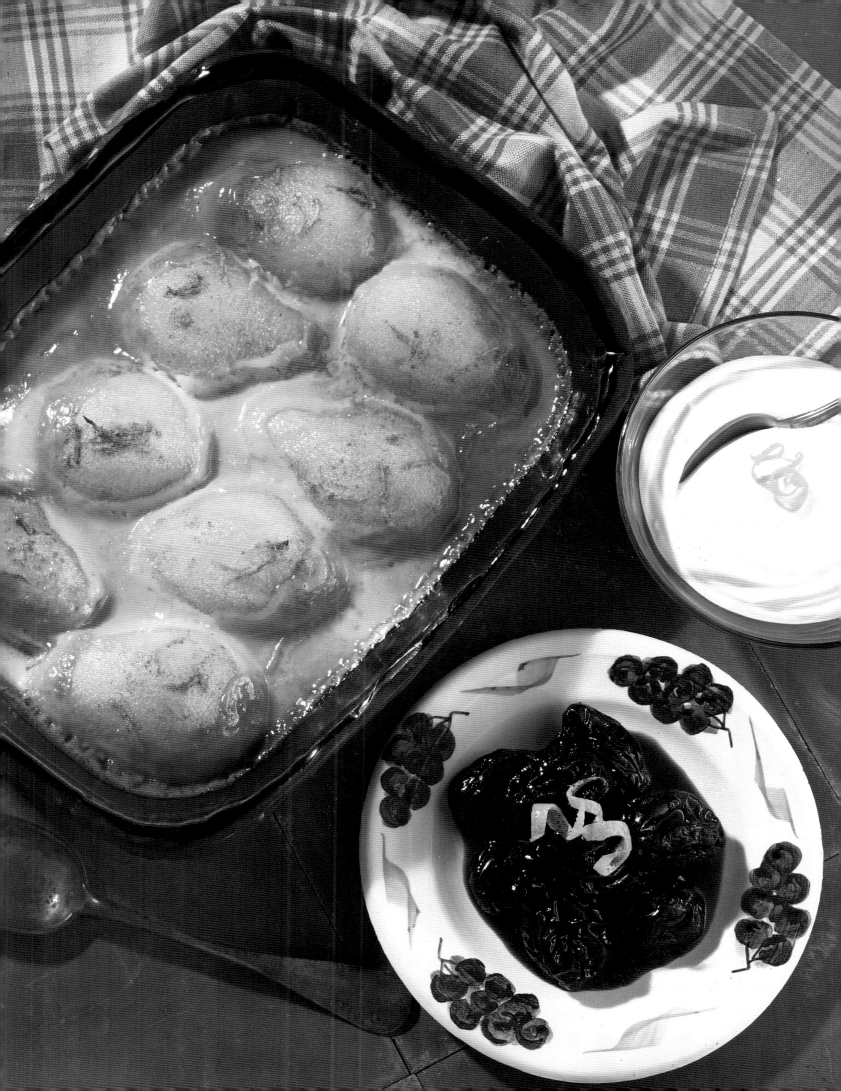

CHERRY BATTER PUDDING

Clafoutis aux Cerises

This dessert originated in the Limousin area of central France, where batters play an important role in the hearty cuisine. Similar fruit and custard desserts are found in Alsace.

SERVES 4

1 pound ripe cherries
2 tbsp Kirsch or fruit brandy or 1 tbsp
 lemon juice
1 tbsp confectioner's sugar
3 tbsp flour
3 tbsp granulated sugar
¾ cup milk or light cream
2 eggs
grated zest of ½ lemon
pinch of ground nutmeg
¼ tsp vanilla extract

1 ▼ Pit the cherries if you like, mix them with the Kirsch, brandy or lemon juice and confectioner's sugar and set aside for 1–2 hours.

2 ▲ Preheat the oven to 375°F. Generously butter an 11 inch oval gratin dish or other shallow ovenproof dish.

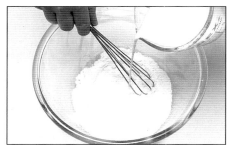

3 ▲ Sift the flour into a bowl, add the sugar and slowly whisk in the milk until smoothly blended. Add the eggs, lemon zest, nutmeg and vanilla extract and whisk until well combined and smooth.

4 ▲ Scatter the cherries evenly in the baking dish. Pour over the batter and bake for 45 minutes, or until set and puffed around the edges. A knife inserted in the center should come out clean. Serve warm or at room temperature.

APPLE CHARLOTTE

Charlotte aux Pommes

This classic dessert takes its name from the straight-sided pan with heart-shaped handles in which it is baked. The buttery bread crust encases a thick sweet, yet sharp apple purée.

SERVES 6

2½ pounds apples
2 tbsp water
⅔ cup light brown sugar
½ tsp ground cinnamon
¼ tsp ground nutmeg
7 slices firm textured sliced white bread
5–6 tbsp butter, melted
custard, to serve (optional)

1 ▲ Peel, quarter and core the apples. Cut into thick slices and put in a large heavy saucepan with the water. Cook, covered, over medium-low heat for 5 minutes, and then uncover the pan and cook for 10 minutes until the apples are very soft. Add the sugar, cinnamon and nutmeg and continue cooking for 5–10 minutes, stirring frequently, until the apples are soft and thick. (There should be about 3 cups of apple purée.)

COOK'S TIP

If preferred, microwave the apples without water in a large glass dish on High (100% power), tightly covered, for 15 minutes. Add the sugar and spices and microwave, uncovered, for about 15 minutes more until very thick, stirring once or twice.

2 ▼ Preheat the oven to 400°F. Trim the crusts from the bread and brush with melted butter on one side. Cut two slices into triangles and use as many as necessary to cover the base of a 6 cup charlotte pan or soufflé dish, placing the bread triangles buttered-sides down and fitting them tightly. Cut the fingers of bread the same height as the pan or dish and use them to completely line the sides, overlapping them slightly.

3 ▲ Pour the apple purée into the pan or dish. Cover the top with bread slices, buttered-side up, cutting them as necessary to fit.

4 Bake the charlotte for 20 minutes, then reduce the oven temperature to 350°F and and bake for 25 minutes until well browned and firm. Let stand for 15 minutes. To turn out, place a serving plate over the pan or dish, hold tightly, and invert, then lift off the pan or dish. Serve with custard, if desired.

CRÊPES WITH ORANGE SAUCE

Crêpes Suzette

This is one of the best known French desserts and is easy to do at home. You can make the crêpes in advance; then you will be able to put the dish together quickly at the last minute.

SERVES 6

⅔ cup flour
¼ tsp salt
2 tbsp superfine sugar
2 eggs, lightly beaten
1 cup milk
4 tbsp water
2 tbsp orange flower water or orange
 liqueur (optional)
2 tbsp unsalted butter, melted, plus more
 for frying
FOR THE ORANGE SAUCE
6 tbsp unsalted butter
¼ cup superfine sugar
grated zest and juice of 1 large orange
grated zest and juice of 1 lemon
⅔ cup fresh orange juice
4 tbsp orange liqueur, plus more for
 flaming (optional)
brandy, for flaming (optional)
orange segments, to decorate

2 ▲ Heat a 7–8 inch crêpe pan (preferably nonstick) over medium heat. Stir the melted butter into the crêpe batter. Brush the hot pan with a little extra melted butter and pour in about 2 tbsp of the batter. Quickly tilt and rotate the pan to cover the base with a thin layer of batter. Cook for about 1 minute until the top is set and the base is golden. With a spatula, lift the edge to check the color, then carefully turn over the crêpe and cook for 20–30 seconds, just to set. Slide the crêpe out onto a plate.

1 ▲ In a medium bowl, sift together the flour, salt and sugar. Make a well in the center and pour in the beaten eggs. Using an electric whisk, beat the eggs, adding a little flour until it is all incorporated. Slowly whisk in the milk and water to make a smooth batter. Whisk in the orange flower water or liqueur, if using, then strain the batter into a large pitcher and set aside for 20–30 minutes. If the batter thickens, add a little milk or water to thin.

3 ▲ Continue cooking the crêpes, stirring the batter occasionally and brushing the pan with a little melted butter as and when necessary. Place a sheet of wax paper between each crêpe as they are stacked to prevent sticking. (Crêpes can be prepared ahead to this point – wrap and chill until ready to use.)

4 To make the sauce, melt the butter in a large frying pan over medium-low heat, then stir in the sugar, orange and lemon zest and juice, the additional orange juice and the orange liqueur.

5 ▲ Place a crêpe in the pan browned-side down, swirling gently to coat with the sauce. Fold it in half, then in half again to form a triangle and push to the side of the pan. Continue heating and folding the crêpes until all are warm and covered with the sauce.

6 ▲ To flame the crêpes, heat 2–3 tbsp each of orange liqueur and brandy in a small saucepan over medium heat. Remove the pan from the heat, carefully ignite the liquid with a match then gently pour over the crêpes. Scatter over the orange segments and serve at once.

SIMPLE FRUIT DESSERTS

Les Fruits Fraîches

Weekday meals in a French home are likely to finish with fresh seasonal fruit – either a selection from the perpetually changing fruit bowl or an attractive yet simple-to-prepare fruit dessert.

Seasonal fruits can be made into tasty desserts quickly and easily. Each season produces its own special gems, strawberries in spring, peaches at the height of summer and apples, figs and citrus fruits in the fall and winter.

Some fruits seem to go particularly well with each other, while others are perfect partners to certain herbs and spices. For a classic fruit dessert, try a plate of fresh peach slices sprinkled with fresh raspberries; or sauté apple slices in butter, then sprinkle them with a little sugar and cinnamon and serve with yogurt. Do the same with pear slices, but sprinkle with a little sugar and ginger, then top with a spoonful of diced ginger and a dash of its syrup.

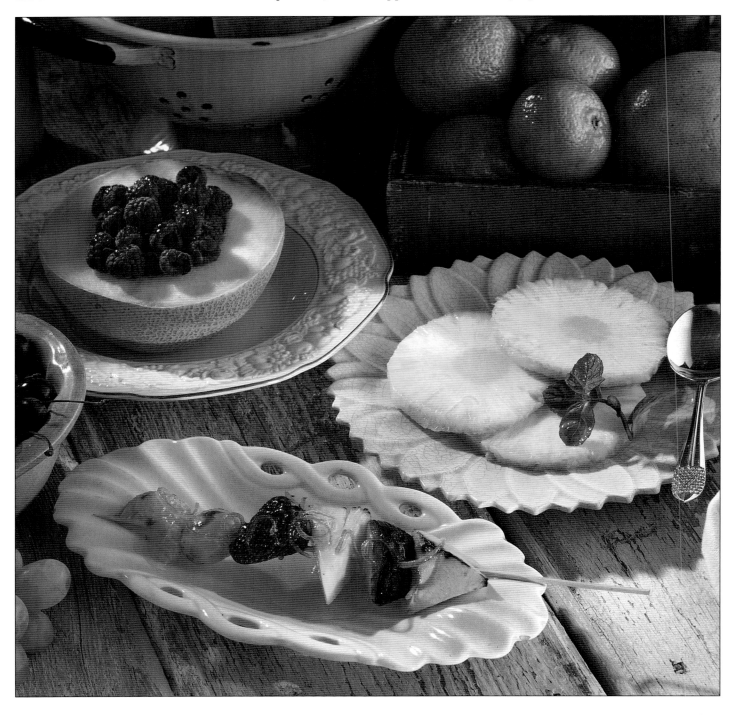

Oranges go well with just about everything. Segment a few oranges, saving the juice, combine the segments with sliced kumquats and sprinkle with pomegranate seeds for a simple yet stunning dessert.

Strawberries, raspberries and blueberries are best just as they are. If you like, sprinkle them with a little sugar, more for the crunch than anything else, or with a splash of orange liqueur or just some good fresh cream. Try flavoring the cream with a few crushed bay leaves, cardamom seeds or fresh mint leaves, then just pour over the fruit, or whip and serve separately. For a quick elegant dessert, spoon sliced or quartered strawberries into pretty dessert *coupes* or Champagne glasses, sprinkle with a little sugar and a dash of raspberry liqueur. Just before serving, pour over a little pink Champagne.

Melon and kiwi fruit slices look pretty together and are always refreshing. Serve ripe, aromatic mango slices on their own with a squeeze of lime juice or scatter over a few green or red grape halves to set off the color.

Fresh figs go well with juicy raspberries. For a more substantial dessert, cut a deep cross in the top of the figs and fill with a spoonful or two of cream cheese sweetened with honey and beaten with a little cream until fluffy. Sprinkle liberally with raspberries and douse with a little raspberry liqueur, if you like.

For fruit desserts, let the seasons, quality and a sense of color be your guide. You will find that fruits which are ripe at the same time are usually good together.

Fresh Pineapple with Kirsch
Ananas au Kirsch

Serves 6–8
1 large pineapple
2 tbsp superfine sugar
2–4 tsp Kirsch or cherry brandy
mint sprigs, to decorate

Using a large sharp knife cut off the top and bottom of the pineapple. Stand the pineapple on a board. Cut off the peel from top to bottom using a small sharp knife, then lay the pineapple on its side and, following the direction of the eyes, use a sharp knife to remove them, cutting out a V-shaped wedge. You will end up with a spiral shape. Cut the pineapple into slices and use an apple corer or small round cutter to remove the tough central core, if you like. Arrange the slices on a large serving plate. Sprinkle evenly with sugar and Kirsch or cherry brandy. Chill until ready to serve, then decorate with mint sprigs.

Melon with Raspberries
Melons aux framboises

Serves 2
2 tiny or 1 small ripe melon
1 cup fresh raspberries
1–2 tbsp raspberry liqueur (optional)

Cut off a thin slice from the bottom of each melon to create a stable base.

If the melons are tiny, cut off the top third and scoop out as much flesh as possible from each top. Cut the flesh into tiny dice. If a larger melon is used, cut off a thin slice from both the top and bottom to create two stable bases; then split melon in half. In either case, scoop out and discard seeds. Fill the center of the melon halves with the raspberries and, if you like, sprinkle with a little liqueur. Chill the melons before serving or serve on a bed of crushed ice.

Broiled Fruit Kebabs
Brochettes de fruits grillées

Makes 4–6
4 or 5 kinds of firm ripe fruit, such as pineapple and mango cubes, nectarine and pear slices, grapes and tangerine segments
2 tbsp unsalted butter, melted
grated rind and juice of 1 orange
sugar, to taste
pinch of ground cinnamon or nutmeg
yogurt, sour cream, crème fraîche or fruit coulis, for serving

Preheat the broiler. Line a baking sheet with foil. Thread the fruit on to 4–6 skewers (soaked in water), alternating fruits to create an attractive pattern. Arrange the skewers on foil, spoon over the melted butter, orange rind and juice and sprinkle with the sugar to taste, together with a pinch of cinnamon or nutmeg. Broil for 2–3 minutes until the sugar just begins to caramelize and serve the kebabs at once with yogurt, sour cream or crème fraîche.

231

POACHED PEACHES WITH RASPBERRY SAUCE *Pêche Melba*

The story goes that one of the great French chefs, Auguste Escoffier, created this dessert in honor of the opera singer Nellie Melba, now forever enshrined in culinary, if not musical, history.

SERVES 6

4 cups water
¼ cup superfine sugar
1 vanilla bean, split lengthwise
3 large peaches
FOR THE RASPBERRY SAUCE
1 pound fresh or frozen raspberries
1 tbsp lemon juice
2–3 tbsp superfine sugar
2–3 tbsp raspberry liqueur (optional)
vanilla ice cream, to serve
mint leaves, to decorate

1 In a saucepan large enough to hold the peach halves in a single layer, combine the water, sugar and vanilla bean. Bring to a boil over medium heat, stirring occasionally to dissolve the sugar.

2 ▼ Cut the peaches in half and twist the halves to separate them. Using a small teaspoon, remove the peach pits. Add the peach halves to the poaching syrup, cut-sides down, adding more water, if needed to cover the fruit. Press a piece of wax paper against the surface of the poaching syrup, reduce the heat to medium-low, then cover and simmer for 12–15 minutes until tender – the time will depend on the ripeness of the fruit. Remove the pan from the heat and let the peaches cool in the syrup.

3 ▲ Remove the peaches from the syrup and peel off the skins. Place on several thicknesses of paper towels to drain (reserve the syrup for another use), then cover and chill.

4 ▲ Put the raspberries, lemon juice and sugar in a food processor fitted with the metal blade. Process for 1 minute, scraping down the sides once. Press through a fine strainer into a small bowl, then stir in the raspberry liqueur, if using, and chill.

5 To serve, place a peach half, cut-side up on a dessert plate, fill with a scoop of vanilla ice cream and spoon the raspberry sauce over the ice cream. Decorate with mint leaves.

COOK'S TIP

Prepare the peaches and sauce up to one day in advance. Leave the peaches in the syrup and cover them and the sauce before chilling.

FRESH FRUIT WITH MANGO SAUCE *Fruits au Coulis de Mangue*

Fruit sauce, coulis, *became fashionable in the 1970s with* nouvelle cuisine. *This bright, flavorful sauce is easy to prepare and ideal to make a simple fruit salad seem special.*

SERVES 6

1 large ripe mango, peeled, pitted
 and chopped
rind of 1 orange
juice of 3 oranges
superfine sugar, to taste
2 peaches
2 nectarines
1 small mango, peeled
2 plums
1 pear or ½ small melon
2 heaping tbsp wild strawberries
 (optional)
2 heaping tbsp raspberries
2 heaping tbsp blueberries
juice of 1 lemon
small mint sprigs, to decorate

1 ▲ In a food processor fitted with the metal blade, process the large mango until smooth. Add the orange rind, juice and sugar to taste and process again until very smooth. Press through a strainer into a bowl and chill the sauce.

2 Peel the peaches, if desired, then slice and pit the peaches, nectarines, small mango and plums. Quarter the pear and remove the core and seeds, or if using, slice the melon thinly and remove the peel.

3 ▼ Place the sliced fruits on a large plate, sprinkle the fruits with the lemon juice and chill, covered with plastic wrap, for up to 3 hours before serving. (Some fruits may discolor if cut ahead of time.)

4 ▲ To serve, arrange the sliced fruits on serving plates, spoon the berries on top, drizzle with a little mango sauce and decorate with mint sprigs. Serve the remaining sauce separately.

ORANGES IN CARAMEL SAUCE

Oranges Caramelisés

The appeal of this refreshing dessert is the contrast between the sweetness of the caramel and the tangy tartness of the oranges. Made in advance, it is easy and convenient for entertaining.

SERVES 6

6 large unwaxed seedless oranges
½ cup granulated sugar

1 ▲ With a vegetable peeler, remove wide strips of rind from two of the oranges. Stack two or three strips at a time and cut into very thin julienne strips.

2 ▼ On a board, using a sharp knife, cut a slice from the top and the base of each orange. Cut off the peel in strips from the top to the base, following the contours of the fruit, then slice the peeled fruit crosswise into rounds about ½ inch thick. Put the orange slices in a serving bowl and pour over any juice.

3 ▲ Half-fill a large bowl with cold water and set aside. Place the sugar and 3 tbsp water in a small heavy saucepan without a nonstick coating and bring to a boil over high heat, swirling the pan to dissolve the sugar. Boil, without stirring, until the mixture turns a dark caramel color. Remove the pan from the heat and, standing well back, dip the base of the pan into the cold water to prevent the caramel cooking further.

4 ▲ Add 2 tbsp water to the caramel, pouring it down the sides of the pan, and swirl to combine. Add the strips of orange rind and return the pan to the heat. Simmer over medium-low heat for 8–10 minutes until they are slightly translucent, stirring occasionally.

5 Pour the caramel and rind over the oranges, turn gently to mix and chill for at least 1 hour.

STRAWBERRIES WITH COINTREAU *Coupe de Fraises au Cointreau*

Strawberries at the height of the season are one of summer's greatest pleasures. Try this simple but unusual way to serve them. If you wish, use a mixture of fresh seasonal berries.

SERVES 4

1 orange
3 tbsp granulated sugar
5 tbsp water
3 tbsp Cointreau or orange liqueur
3 cups strawberries, hulled
1 cup whipping cream

1 ▲ With a vegetable peeler, remove wide strips of rind without the pith from the orange. Stack two or three strips at a time and cut into very thin julienne strips.

2 ▲ Combine the sugar and water in a small saucepan. Bring to a boil over high heat, swirling the pan occasionally to dissolve the sugar. Add the julienne strips and simmer for 10 minutes. Remove the pan from the heat and let the syrup cool completely, then stir in the Cointreau or liqueur.

3 ▼ Reserve four strawberries for decoration and cut the rest lengthwise in halves or quarters. Put them in a bowl and pour the syrup and orange rind over the top. Set aside for at least 30 minutes or for up to 2 hours.

4 ▲ Using an electric mixer or a whisk, whip the cream until it forms soft peaks. Sweeten to taste with a little of the syrup from the strawberries.

5 To serve, spoon the chopped strawberries into glass serving dishes and top with dollops of cream and the reserved strawberries.

CHOCOLATE MOUSSE CAKE

Gâteau Mousse au Chocolat

This special occasion dessert is a double batch of chocolate mousse, glazed with chocolate ganache and decorated with long, slim chocolate curls – heaven for chocolate lovers!

SERVES 8–10

10 ounces semisweet chocolate, chopped
½ cup unsalted butter, cut into pieces
8 eggs, separated
¼ tsp cream of tartar
3 tbsp brandy or rum (optional)
chocolate curls, to decorate
FOR THE CHOCOLATE GANACHE
1 cup heavy cream
8 ounces semisweet chocolate, chopped
2 tbsp brandy or rum (optional)
2 tbsp unsalted butter, softened

1 Preheat the oven to 350°F. Lightly butter two 8–9 inch springform pans or loose-based cake pans and line the bases with buttered wax paper or nonstick baking paper.

2 ▲ In a saucepan, melt the chocolate and butter over low heat until smooth, stirring frequently. Remove the pan from the heat and whisk in the egg yolks until completely blended. Beat in the brandy or rum, if using, and pour into a large bowl. Set aside, stirring occasionally.

3 In a clean greasefree bowl, using an electric mixer, beat the egg whites slowly until frothy. Add the cream of tartar, increase the speed and continue beating until they form soft peaks, then stiffer peaks that just flop over a little at the top.

4 Stir a large spoonful of white into the chocolate mixture to lighten it, then fold in the remaining white until they are just combined (a few white streaks do not matter).

5 ▲ Divide about two-thirds of the mousse between the two prepared pans, smoothing the tops evenly, and tap gently to release any air bubbles. Chill remaining mousse.

6 Bake for 30–35 minutes until puffed; the cakes will fall slightly. Cool on a wire rack for 15 minutes, then remove the sides of the pans and let cool completely. Invert the cakes on to the rack, remove the cake pan bases and peel off the papers. Wash the cake pans.

7 ▲ To assemble the cake, place one layer, flat side down in one of the clean pans. Spread the remaining mousse over the surface, smoothing the top. Top with the second cake layer, flat side up. Press down gently so the mousse is evenly distributed. Chill for 2–4 hours or overnight.

8 ▲ To make the *ganache*, bring the cream to a boil in a heavy saucepan over medium-high heat. Remove the pan from the heat and add the chocolate all at once, stirring until melted and smooth. Stir in the brandy or rum, if using, and beat in the softened butter. Set aside for about 5 minutes to thicken slightly (*ganache* should coat the back of a spoon in a thick smooth layer).

9 ▲ Run a knife around the edge of the assembled cake to loosen it, then remove the sides of the pan. Invert the cake onto a wire rack, remove the base and place the rack over a baking sheet. Pour the warm *ganache* over the cake all at once, tilting gently to help spread it evenly on all surfaces. Use a spatula to smooth sides, decorate the top with chocolate curls, then allow to set.

MERINGUES WITH CHESTNUT CREAM

Petits Mont Blancs

This dessert takes its name from the famous peak in the French Alps, Mont Blanc, as the meringues piled high with chestnut purée and whipped cream resemble it.

SERVES 6

*2 egg whites
pinch of cream of tartar
½ cup superfine sugar
½ tsp vanilla extract
chocolate shavings, to decorate*

FOR THE CHESTNUT CREAM
*⅓ cup superfine sugar
½ cup water
1 pound can unsweetened chestnut purée
1 tsp vanilla extract
1½ cups heavy cream*

FOR THE CHOCOLATE SAUCE
*8 ounces semisweet chocolate, chopped
¾ cup heavy cream
2 tbsp rum or brandy (optional)*

3 ▲ Spoon the whisked egg whites into a large pastry bag fitted with a medium-size plain or star nozzle and pipe six spirals following the outlines on the marked paper. Bake for about 1 hour until the meringues feel firm and crisp, lowering the oven temperature if they begin to brown. Using a thin spatula, transfer the meringues to a wire rack to cool completely.

5 ▲ In another bowl, with an electric mixer, whisk the cream until soft peaks form, then add a spoonful to the chestnut cream and pulse to combine. Chill the remaining whipped cream.

1 ▲ Preheat the oven to 275°F. Line a baking sheet with non-stick baking paper. Use a small plate to outline six 3½ inch circles and turn the paper over (so the meringue does not touch the pencil marks).

2 In a clean greasefree bowl, using an electric mixer, beat the egg whites slowly until frothy. Add the cream of tartar, then increase the speed and continue beating until they form soft peaks. Gradually sprinkle over the sugar, 2 tbsp at a time, and continue beating until the whites are stiff and glossy. Beat in the vanilla extract.

4 ▲ To make the chestnut cream, place the sugar and water in a small saucepan over medium-high heat and bring to a boil, stirring until the sugar dissolves. Boil for about 5 minutes, then remove the pan from the heat and set aside to cool. Put the chestnut purée in a food processor fitted with the metal blade and process until smooth. With the machine running, slowly add the sugar syrup in a thin stream until the chestnut purée is soft, but still holds its shape (you may not need all the syrup). Add the vanilla extract and process again then spoon into a medium bowl.

6 ▲ Spoon the chestnut cream into a pastry bag fitted with a large star nozzle. Pipe a mound of chestnut cream in a swirl onto each meringue then pipe or spoon the remaining cream on top of the chestnut cream to resemble a mountain peak. Chill until ready to serve.

7 To make the chocolate sauce, heat the chocolate and cream in a small saucepan over medium-low heat, stirring frequently. Remove the pan from the heat and stir in the rum or brandy, if using. Set aside to cool, stirring occasionally. (Do not chill or the sauce will set.)

8 To serve, place each meringue on a plate and sprinkle with chocolate shavings. Serve the chocolate sauce separately.

FROZEN RASPBERRY MOUSSE

Crème Glacée aux Framboises

This dessert is like a frozen soufflé. Freeze it in a ring mold, then you can fill the center with fresh raspberries moistened with framboise or raspberry liqueur or just a little orange juice.

SERVES 6

3 cups raspberries, plus more for serving
3 tbsp confectioner's sugar
2 egg whites
¼ tsp cream of tartar
½ cup granulated sugar
1½ tbsp lemon juice
1 cup whipping cream
15ml/1 tbsp framboise or Kirsch
mint leaves, to decorate

1 Put the raspberries in a food processor fitted with the metal blade and process until smooth, then press through a sieve. Or, simply work the raspberries through the fine blade of a food mill.

2 Pour a third of the purée into a small bowl, stir in the confectioner's sugar, then cover and chill. Reserve the remaining purée for the mousse.

3 ▼ Half-fill a medium saucepan with hot water and set over low heat (do not allow the water to boil). Combine the egg whites, cream of tartar, sugar and lemon juice in a heatproof bowl that just fits into the pan without touching the water. Using an electric mixer, beat at medium–high speed until the beaters leave tracks on the base of the bowl, then beat at high speed for about 7 minutes until the mixture is very thick and forms stiff peaks.

4 ▲ Remove the bowl from the pan and continue beating the egg white mixture for 2–3 minutes more until it is cool. Fold in the reserved raspberry purée.

5 Whip the cream until it forms soft peaks and fold gently into the raspberry mixture with the liqueur. Spoon into a 6 cup ring mold, then cover and freeze for at least 4 hours or overnight.

6 ▲ To unmold, dip the mold in warm water for about 5 seconds and wipe the base. Invert a serving plate over the mold and, holding it tightly against the mold, turn over together, then lift off the mold.

7 If you wish, fill the center of the mousse with raspberries, decorate with mint leaves and serve with the sweetened raspberry purée.

ICED COFFEE AND NUT MERINGUE

Dacquoise Givrée

This impressive frozen dessert may seem difficult, but it is actually very easy to prepare.

SERVES 8–10

1 cup hazelnuts, toasted
1⅓ cups superfine sugar
5 egg whites
pinch of cream of tartar
4 cups coffee ice cream
FOR THE CHOCOLATE CREAM
2 cups whipping cream
10 ounces semisweet chocolate, melted
 and cooled
2 tbsp coffee liqueur
white chocolate curls and fresh
 raspberries, to decorate

1 ▲ Preheat the oven to 350°F. Line three baking sheets with non-stick baking paper, then, using a plate as a guide, mark an 8 inch circle on each sheet and turn the paper over. In a food processor fitted with the metal blade, process the hazelnuts until chopped. Add a third of the sugar and process until finely ground.

2 ▲ In a clean grease-free bowl, whisk the egg whites until frothy, then add the cream of tartar and whisk until they form soft peaks. Gradually sprinkle the sugar over the whites, 2 tbsp at a time, whisking until the whites are stiff and glossy, then fold in the nut mixture. Divide the meringue among the baking sheets and spread out within the marked circles. Bake for 1 hour until firm and dry. Let cool in the turned-off oven, then peel off the paper.

3 ▼ Let the ice cream stand for 15–20 minutes in a large bowl and then beat with an electric mixer until smooth. Spread half of the ice cream over one meringue layer, top with a second meringue layer and spread with the remaining ice cream. Place the last meringue layer on top, press down gently, then wrap and freeze for at least 4 hours until firm.

4 ▲ To make the chocolate cream, beat the whipping cream until soft peaks form. Quickly fold in the cooled melted chocolate and the liqueur. Take the meringue cake out of the freezer, unwrap and place on a serving plate. Spread the chocolate cream over the top and sides of the meringue and return to the freezer. Wrap when firm. To serve, let the meringue stand for 15 minutes at room temperature to soften slightly before cutting.

BLACK CURRANT SORBET

Sorbet au Cassis

Black currants, which are prolific in Burgundy, make a vibrant and intensely flavored sorbet.

SERVES 4–6

½ cup superfine sugar
½ cup water
1 pound black currants
juice of ½ lemon
1 tbsp egg white

1 In a small saucepan over medium-high heat, bring the sugar and water to the boil, stirring until the sugar dissolves. Boil the syrup for 2 minutes, then remove the pan from the heat and set aside to cool.

2 ▼ Remove the black currants from the stalks, by pulling them through the tines of a fork.

3 In a food processor fitted with the metal blade, process the black currants and lemon juice until smooth. Alternatively chop the black currants coarsely, then add the lemon juice. Mix in the sugar syrup.

4 ▲ Press the purée through a sieve to remove the seeds.

5 ▲ Pour the black currant purée into a nonmetallic, freezerproof dish. Cover the dish with plastic wrap or a lid and freeze until the sorbet is nearly firm, but still slushy.

6 ▲ Cut the sorbet into pieces and put into the food processor. Process until smooth, then with the machine running, add the egg white and process until well mixed. Tip the sorbet back into the dish and freeze until almost firm. Chop the sorbet again and process until smooth. Serve immediately or freeze, tightly covered, for up to 1 week. Allow to soften for 5–10 minutes at room temperature before serving.

CHOCOLATE SORBET

Sorbet au Chocolat

This velvety smooth sorbet has long been popular in France. Unsweetened chocolate gives by far the richest flavor, but if you can't track this down, then use the very best quality dark Continental plain chocolate that you can find or the sorbet will be too sweet.

<u>SERVES 6</u>

5 ounces unsweetened chocolate, chopped
4 ounces plain chocolate, chopped
1 cup superfine sugar
2 cups water
chocolate curls, to decorate

1 ▲ Put all the chocolate in a food processor, fitted with the metal blade and process for 20–30 seconds until finely chopped.

2 ▲ In a pan over medium-high heat, bring the sugar and water to a boil, stirring until the sugar dissolves. Boil for about 2 minutes, then remove from the heat.

3 ▼ With the machine running, pour the hot syrup over the chocolate. Allow the machine to continue running for 1–2 minutes until the chocolate is completely melted and the mixture is smooth, scraping down the bowl once.

4 ▲ Strain the chocolate mixture into a large measuring cup or bowl, and leave to cool, then chill, stirring occasionally. Freeze the mixture in an ice cream machine, following the manufacturer's instructions or see Cook's Tip (left). Allow the sorbet to soften for 5–10 minutes at room temperature and serve in scoops, decorated with chocolate curls.

COOK'S TIP

If you don't have an ice cream machine, freeze the sorbet until firm around the edges. Process until smooth, then freeze again.

PRALINE ICE CREAM IN BASKETS *Tulipes á la Glace Pralinée*

Praline, a delicious crunchy caramel and nut mixture, is a very popular flavoring in France – it can be made with almonds or hazelnuts or a mixture of the two, if you prefer.

SERVES 6–8

½ cup blanched almonds or
 hazelnuts
⅞ cup superfine sugar
4 tbsp water
1 cup heavy cream
2 cups milk
6 egg yolks
FOR THE BISCUIT BASKETS
½ cup whole blanched almonds, lightly
 toasted
½ cup superfine sugar
3 tbsp unsalted butter, softened
2 egg whites
½ tsp almond extract
scant ¼ cup flour, sifted

1 ▲ Lightly brush a baking sheet with oil. Put the nuts in a saucepan with ⅓ cup of the sugar and the water. Bring to a boil over high heat, swirling the pan to dissolve the sugar, then boil, without stirring, for 4–5 minutes until the syrup is a medium caramel color and the nuts begin to pop. Immediately pour on to the baking sheet (do not touch the hot caramel). Set aside to cool completely.

2 Break the praline into small pieces. Put in a food processor fitted with the metal blade and process until finely ground. Or, put in a strong plastic bag and, crush with a rolling pin.

3 ▼ Pour the cream into a cold bowl and set aside. Bring the milk just to a simmer over medium heat. In a medium bowl, whisk the egg yolks and remaining sugar for 2–3 minutes until thick and creamy, then whisk in the hot milk and return the mixture to the saucepan.

4 With a wooden spoon, stir over low heat for 3–4 minutes until the sauce begins to thicken and coat the back of the spoon (do not boil or the custard may curdle). Immediately strain the custard into the bowl of cream to stop it cooking further. Cool, then chill until cold. Stir in the praline and freeze in an ice cream maker, following the manufacturer's instructions.

5 Preheat the oven to Gas 6. Generously butter two baking sheets. To make the biscuit baskets, put the almonds and about 2 tbsp of the sugar in a food processor fitted with the metal blade and process until finely ground. In a separate bowl, using an electric mixer, beat the butter until creamy.

6 ▲ Add the remaining sugar and beat for 1 minute until light and fluffy, then gradually beat in the egg whites until well blended; beat in the almond extract. Sift the flour over the butter mixture and fold in, then fold in the ground almond mixture.

7 ▲ Drop tablespoons of mixture about 8 inches apart on to the prepared baking sheets. With the back of a wet spoon, spread each mound into a paper-thin 4 inch round. (Do not worry if holes appear; they will fill in.)

8 ▲ Bake the cookies, one sheet at a time, for 4–5 minutes until the edges are golden and the centers are still pale. Transfer to a wire rack and, working quickly, loosen the edge of a hot cookie and carefully transfer to an upturned drinking glass or ramekin, pressing gently over the base to form a fluted basket shape. Repeat with the remaining cookies. If the cookies become too crisp to shape, return them to the oven to soften for 15–30 seconds, then continue shaping. Set aside to cool completely before transferring to a wire rack.

9 To serve, leave the ice cream to soften at room temperature for 5–10 minutes. Place the baskets on dessert plates and fill with scoops of the ice cream.

BASIC RECIPES

This section includes essential basic recipes for French cooking – flavorful stocks for soups and stews, classic savory and sweet sauces and perfect pastries – all you need to get started.

HOMEMADE STOCKS

Homemade stocks are best for sauces and stews, and if you need to reduce them, the sodium will be lower than with storebought broth which tends to be high in sodium. Homemade stock is very easy to make, and cooks itself.

Meat Stock
Fond de viande

MAKES 12 CUPS

8–10 pounds raw or cooked beef or veal bones and meat and/or poultry carcasses, clean trimmings and giblets
2 large unpeeled onions, halved and root end trimmed
2 medium carrots, peeled and cut in large pieces
1 large celery stalk, cut in large pieces
2 leeks, cut in large pieces
1 or 2 parsnips, cut in large pieces
2–4 garlic cloves
large bouquet garni
1 tbsp black peppercorns

Place all the ingredients in a large stock pot and cover with cold water by at least 1 inch. Bring to a boil over medium heat. As the liquid heats, foam will begin to appear on the surface. Begin skimming off the foam with a large spoon or ladle as soon as it appears, continuing until it stops surfacing; this will take at least

5 minutes and by then the stock will be boiling. Reduce the heat until the stock is just simmering and simmer very slowly, uncovered, for 4–5 hours, skimming occasionally. Do not allow the stock to boil again or cover it as this can cause the stock to sour or cloud. Top up with a little boiling water during cooking if the liquid level falls below the bones and vegetables.

Ladle the stock into a large bowl; discard the bones and vegetables. Leave the stock to cool, then chill to allow any fat to solidify, then scrape off the fat. To remove any further traces of fat, "wipe" a piece of paper towel across the surface. The stock can be used as it is or, if you wish, reduced to concentrate the flavor and chilled or frozen.

Brown Stock
Fond brun

Brown stock has a rich flavor and deep color, obtained by browning the meats and vegetables before cooking. Place the meat and vegetables in a large roasting tin and brown in the oven at 450°F for 30–40 minutes, turning occasionally. Put ingredients in the stockpot with the bouquet garni and proceed as for Meat Stock.

Chicken Stock
Fond de volaille

MAKES 8 CUPS

4½ pounds raw chicken carcasses, necks or feet or cooked carcasses
2 large onions, unpeeled, halved and root end trimmed
3 carrots, peeled and cut in large pieces
1 celery stalk, cut in large pieces
1 leek, cut in large pieces
2 garlic cloves, unpeeled and lightly smashed
1 large bouquet garni

Proceed as for Meat Stock, but simmer for 2 hours.

Brown Chicken Stock
Fond de volaille brun

Brown the chicken pieces in a frying pan, as roasting is too intense and the chicken could easily burn. Put the ingredients in the stockpot with the bouquet garni and proceed as for Chicken Stock.

Game Stock
Fond de gibier

Proceed as for Chicken Stock using game carcasses, with or without browning as described.

Fish Stock
Fumet de poisson

MAKES 8 CUPS
*2 pounds heads and bones and trimmings
 from white flesh
1 onion, thinly sliced
1 carrot, thinly sliced
1 leek, thinly sliced
8 parsley stems
½ bay leaf
1 cup dry white wine
1 tsp black peppercorns*

Put all the ingredients in a large non-reactive saucepan or flameproof casserole and add enough cold water to cover. Bring to a boil over medium-high heat, skimming any foam which rises to the top. Simmer gently for 25 minutes; strain through a cheesecloth-lined strainer. Cool, then chill. Reduce, if you wish, for storage or freezing.

COOK'S TIP

Make stock whenever you roast a piece of meat on the bone or a bird, or save bones and carcasses in the freezer until you have enough for a large pot of stock. After making stock, reduce it by at least half and freeze in an ice cube tray. Store the cubes in a strong freezer bag and add to soups and sauces without defrosting. Never add salt to the stock as it will be concentrated during reduction and always season sauces after adding the stock.

BASIC SAVORY SAUCES

There is a huge repertoire of sauces in classic French cuisine, but many are variations of a few types which you can master with a little practice. Sauces are usually categorized by the way they are made.

REDUCTION SAUCES
These are simply the cooking juices, sometimes with additional liquid such as wine, stock and/or cream, boiled to concentrate the flavor and thicken by evaporation.

FLOUR-BASED SAUCES
This type of sauce is usually thickened with cooked butter and flour (*roux*) and they are among the most useful for the home cook. They can be made with milk for *béchamel* or stock for *velouté* sauce, are sometimes enriched with cream and may also be flavored with other ingredients such as cheese, mushrooms, spices, mustard or tomato.

Sometimes the cooking liquid of soups and stews is thickened with flour, either by flouring the ingredients before browning them or by sprinkling over the flour during cooking. Alternatively, a flour and butter paste, known as *beurre manié*, may be stirred in at the end of cooking to thicken the liquid. Other flours, such as cornstarch, potato flour or arrowroot, may also be used for thickening sauces.

EMULSIFIED SAUCES
Hollandaise, *Béarnaise* and butter sauces, are included in this group. These sauces are very quick to make, but can be tricky to prepare and keep warm. The most common cause of the sauce separating or curdling is overheating. Mayonnaise is also an emulsified sauce and all the ingredients should be at room temperature for best results.

FLAVORED BUTTERS
These "hard" sauces, butter flavored with herbs or garlic, are useful to have on hand to give a lift to plain vegetables or sautéed or broiled meat, poultry or fish. An even simpler flavored butter, *beurre noisette*, is made by heating butter until it turns nutty brown before pouring over food.

VEGETABLE SAUCES
Sauces may also be thickened with vegetable purées, using, for instance, the aromatic vegetables cooked with a stew. Or a vegetable purée may be the sauce itself, for instance, fresh tomato sauce.

White Sauce
Béchamel

MAKES ABOUT 1 CUP
*2 tbsp butter
3 tbsp flour
1 cup milk
1 bay leaf
freshly grated nutmeg
salt and freshly ground black pepper*

Melt the butter in a heavy saucepan over a medium heat, add the flour and cook until just golden, stirring occasionally. Pour in half the milk, stirring vigorously until smooth, then stir in the remaining milk and add the bay leaf. Season with salt, pepper and nutmeg, then reduce the heat to medium-low, cover and simmer gently for about 5 minutes, stirring occasionally.

Velouté Sauce

Proceed as for White Sauce above, using stock or cooking liquid instead of milk.

Hollandaise Sauce

Serves 6
¾ cup unsalted butter, cut
 into pieces
3 egg yolks
1 tbsp cold water
1–2 tbsp fresh lemon juice
½ tsp salt
cayenne pepper

Clarify the butter by melting it in a small saucepan over a low heat; do not boil. Skim off any foam.

In a small heavy saucepan or in the top of a double boiler, combine the egg yolks, water, 1 tbsp of the lemon juice, and salt and pepper and whisk for 1 minute. Place the saucepan over a very low heat or place the double boiler top over barely simmering water and whisk constantly until the egg yolk mixture begins to thicken and the whisk begins to leave tracks on the base of the pan; remove from heat.

Whisk in the clarified butter, drop by drop until the sauce begins to thicken, then pour in the butter a little more quickly, making sure the butter is absorbed before adding more. When you reach the milky solids at the bottom of the clarified butter, stop pouring. Season to taste with salt and cayenne and a little more lemon juice if wished.

Béarnaise Sauce

Combine 2 tbsp each tarragon vinegar and dry white wine with 1 finely chopped shallot in a small heavy saucepan, set over a high heat and boil to reduce until the liquid has almost evaporated. Remove from the heat and leave to cool slightly. Proceed as for Hollandaise Sauce, but omit the lemon juice and add the egg yolks to the shallot mixture. Strain before serving if you prefer.

Butter Sauce
Beurre blanc

Serves 4–6
2 shallots, finely chopped
6 tbsp white wine vinegar
1 tbsp light cream
¾ cup unsalted butter, cut into
 12 pieces
salt and white pepper

Put the shallots and vinegar in a small heavy saucepan. Boil over a high heat until the liquid has almost evaporated, leaving only about 1 tbsp. Stir in the cream. Reduce the heat to medium and add the butter, one piece at a time, whisking constantly until it melts before adding the next (lift the pan from the heat if the butter melts faster than it can be incorporated). Strain the sauce and adjust the seasoning before serving.

Cook's tip

Delicate sauces, such as Béarnaise, Hollandaise and Butter Sauce, are easy to keep warm in a wide-mouthed thermos flask.

Mayonnaise

Makes about ½ cup
2 egg yolks
1 tbsp Dijon mustard
1 cup extra virgin olive oil
lemon juice or white wine vinegar
salt and white pepper

Combine the egg yolks and mustard in a small bowl. Beat for 30 seconds until creamy. Beat in the olive oil drop by drop until the mixture begins to thicken, then add the remaining oil in a thin stream until the mixture is thick. Thin the mayonnaise with a little lemon juice or vinegar, and season to taste. Store in the fridge for up to 2 days.

BASIC SWEET SAUCES

Custard Sauce
Crème Anglaise

Serves 4–6
1 vanilla bean
2½ cups milk
8 egg yolks
¼ cup granulated sugar

Split the vanilla bean lengthwise and scrape the tiny black seeds into a saucepan. Add the milk and bring just to a boil, stirring frequently. Remove from the heat, cover and let stand for 15–20 minutes.

Whisk the egg yolks and sugar for 2–3 minutes until thick. Whisk in the hot milk and return the mixture to the saucepan.

With a wooden spoon, stir over a medium-low heat until the sauce begins to thicken and coat the back of the spoon (do not allow to boil or the custard may curdle).
Immediately strain the sauce into a chilled bowl and let cool, stirring occasionally, then chill.

Fruit Sauce
Coulis de Fruit

MAKES 1¼ CUPS
1 pound fresh fruit, such as raspberries, strawberries, mangoes, peaches and kiwi fruit
1 tbsp lemon juice
2–3 tbsp superfine sugar
2–3 tbsp fruit brandy or liqueur (optional)

Put the fruit, lemon juice and sugar in a food processor fitted with the metal blade. Process for 1 minute, scraping down the sides once. Press the fruit purée through a fine sieve into a small bowl, stir in the brandy or liqueur, if using, and chill for 1–2 hours until cold.

Chocolate Sauce
Sauce Chocolat

MAKES ⅔ CUP
3 ounces semisweet or Continental chocolate, chopped
6 tbsp heavy cream
1–2 tbsp brandy or liqueur

In a small saucepan, bring the cream to a boil, then remove from the heat. Add the chocolate all at once and stir gently until melted and smooth. Stir in the brandy or liqueur, pour into a sauceboat and keep warm until ready to serve.

FRENCH PASTRY

French pastry has a firm, compact texture, much like shortbread, yet it is extremely light and crisp.

To make pastry the French use a special low-gluten flour. All-purpose flour produces good results, but better still, use a special cake and pastry flour, or use imported French flour which can be found in speciality shops, or look for low-gluten flour in health food shops.

Unsalted butter produces a crisp texture but, for a more tender result, substitute one part vegetable shortening to three parts butter.

Pastry, especially *pâte sucrée*, can be flavoured with vanilla extract, ground cinnamon, brandy or a liqueur, and ground almonds or hazelnuts can be substituted for part of the flour.

When using a food processor, be careful not to overwork the pastry.

Shortcrust Pastry
Pâte Brisée

Pâte brisée, which means "broken dough", is a versatile basic shortcrust pastry. The ingredients are "broken together" or rubbed in. After the liquid is added, it is kneaded by a process called *fresage*, where the heel of one hand is used to blend the ingredients into a soft pliable dough.

Pâte brisée is suitable for pies, quiches, tarts and tartlets. For sweet recipes a little sugar may be added which gives the pastry extra color and crispness.

FOR A 9–10 INCH PIE OR TART OR TEN 3 INCH TARTLETS
1¼ cups flour, plus more if needed
½ tsp salt
1 tsp superfine sugar (optional)
½ cup unsalted butter, cut into small pieces
3–8 tbsp iced water

In a large bowl, sift together the flour, salt and sugar, if using. Add the butter and rub in using your fingertips, until fine crumbs form. Alternatively, whizz the ingredients in a food processor.

Slowly add the water, mixing until a crumbly dough begins to form; do not overwork the dough or it will be tough. Pinch a piece of dough: it should hold together. If the dough is crumbly add a little more water. If it is wet and sticky, sprinkle over a little more flour.

Turn the dough on to a piece of plastic wrap. Hold the plastic wrap

with one hand and use your other hand to push the dough away from you until the dough is smooth and pliable. Flatten the dough to a round and wrap in the plastic wrap. Chill for 2 hours or overnight. Leave to soften for 10 minutes at room temperature before rolling out.

To line a pie pan: lightly butter a 9–10in loose-based pie pan. On a lightly floured surface, roll out the dough to a thickness of about ⅛in. Gently roll the pastry loosely around the rolling pan, then unroll over the pie pan and gently ease the pastry into the pan, leaving a 1in overhang.

With floured fingers, press the overhang down slightly toward the base of the pan to reinforce the side; roll the rolling pin over the rim to cut off the excess. Press the pastry against the side of the pan to form a rim slightly higher than the side of the pan. If you like, crimp the edge. Prick the base with a fork and chill for at least 1 hour.

Quick Puff Pastry
Pâte demi-feuilletée

Puff pastry, *pâte feuilletée*, is tricky and time-consuming to make – this quick and easy pastry gives a similar feather-light result.

MAKES 1¼ POUNDS
⅞ cup cold unsalted butter
1½ cups cake or pastry flour
¼ tsp salt
½ cup cold water

Cut the butter into 14 pieces and place in the freezer for 30 minutes, or until very firm.

Put the flour and salt into a food processor and pulse to combine. Add the butter and pulse three or four times; there should still be large lumps of butter. Run the machine for 5 seconds while pouring the water through the feed tube, then stop the machine. The dough should look curdy. Tip the mixture on to a lightly floured, cool work surface and gather into a flat ball – you should still be able to see pieces of butter. If the butter is soft, chill the dough for 30 minutes or longer.

Roll out the dough on a floured surface to a 16 × 6 inch rectangle. Fold in thirds, bringing one end down to cover the middle, then fold the other end over it, like folding a letter. Roll out again to a long rectangle and fold again the same way. Chill the dough for at least 30 minutes.

Roll and fold twice more, then chill and fold the dough, well wrapped, for at least 30 minutes, or for up to 3 days, before using.

COOK'S TIP

The richer the pastry dough, the harder it is to handle. However, if rolling the dough becomes too difficult, simply press it into the pan with your hands, patching any cracks or holes with extra dough.

Rich Shortcrust Pastry
Pâte Sucrée

Pâte sucré, sweet pastry, is a type of *pâte brisée* with sugar and egg yolks added. Sugar makes the dough more crumbly, or "sandy" and in fact it is often called *pâte sablée*, or "sandy pastry". It is somewhat difficult to handle, but is especially delicious for fruit tarts.

FOR A 9–10 INCH TART OR TEN 3 INCH TARTLETS
1 cup flour, plus more if needed
½ tsp salt
3–4 tbsp confectioner's sugar
½ cup unsalted butter, cut into small pieces
2 egg yolks beaten with 2 tbsp iced water and ½ tsp vanilla extract (optional)

In a food processor fitted with the metal blade, process the flour, salt, sugar and butter for 15–20 seconds, until fine crumbs form. Remove the cover and pour in the beaten egg yolk and water mixture. Pulse the machine just until the dough begins to stick together. Do not allow the dough to form a ball or the pastry will be tough. If the dough appears dry, add a little water and pulse until the dough just holds together. Turn the dough onto a piece of plastic wrap and, holding the plastic with one hand, use your other hand to push the dough away from you until it is smooth and pliable. Flatten the dough into a round and wrap in the plastic. Chill for at least 2 hours.

GLOSSARY

The following terms are frequently used in French cooking. In the recipes we have tried to reduce the use of technical terms by describing the procedures, but understanding these words is helpful.

BAIN-MARIE: a baking pan or dish set in a roasting pan or saucepan of water. It allows the food to cook indirectly and protects delicate foods; a double boiler is also a kind of water bath, or *bain-marie*.

BAKE BLIND: to bake or part-bake a pastry shell before adding a filling, usually done to prevent the filling making the pastry soggy.

BASTE: to moisten food with fat or cooking juices while it is cooking.

BEURRE MANIÉ: equal parts of butter and flour blended to a paste and whisked into simmering cooking liquid for thickening after cooking is completed.

BLANCH: to immerse vegetables and sometimes fruit in boiling water in order to loosen skin, remove bitterness or saltiness or preserve color.

BOIL: to keep liquid at a temperature producing bubbles that break the surface.

BOUQUET GARNI: a bunch of herbs, usually including a bay leaf, thyme sprigs and parsley stalks, used to impart flavor during cooking, often tied for easy removal.

CLARIFY: to make an opaque liquid clear and remove impurities; stocks are clarified using egg white, butter by skimming.

COULIS: a purée, usually fruit or vegetable, sometimes sweetened or flavored with herbs, but not thickened, used as a sauce.

CROÛTONS: small crisp pieces of fried or baked crustless bread.

DEGLAZE: to dissolve the sediment from the bottom of a cooking pan by adding liquid and bringing to a boil, stirring. This is then used as the basis for a sauce or gravy.

DEGREASE: to remove fat from cooking liquid, either by spooning off after it has risen to the top or by chilling until the fat is congealed and lifting it off.

DICE: to cut food into square uniform pieces about ¼in.

EMULSIFY: to combine two usually incompatible ingredients until smooth by mixing rapidly while slowly adding one to the other so they are held in suspension.

FOLD: to combine ingredients, using a large rubber spatula or metal spoon, by cutting down through the center of the bowl, then along the side and up to the top in a semicircular motion; it is important not to deflate or over-work ingredients while folding.

FOOD MILL *(mouli-légumes)*: tool for puréeing found in most French kitchens which strains as it purées.

GLAZE: to coat food with a sweet or savory mixture producing a shiny surface when set.

GRATINÉ: to give a browned, crisp surface to a baked dish.

HERBES DE PROVENCE: a mixture of aromatic dried herbs, which grow wild in Provence, usually thyme, marjoram, oregano and summer savory.

INFUSE: to extract flavor by steeping in hot liquid.

JULIENNE: thin matchstick pieces of vegetables, fruit or other food.

MACERATE: to bathe fruit in liquid to soften and flavor it.

PAPILLOTE: a greased non-stick baking paper or foil parcel, traditionally heart-shaped, enclosing food for cooking.

PARBOIL: to partially cook food by boiling.

POACH: to cook food, submerged in liquid, by gentle simmering.

REDUCE: to boil a liquid for the purpose of concentrating the flavor by evaporation.

ROUX: a cooked mixture of fat and flour used to thicken liquids such as soups, stews and sauces.

SAUTÉ: to fry quickly in a small amount of fat over a high heat.

SCALD: to heat liquid, usually milk, until bubbles begin to form around the edge.

SCORE: to make shallow incisions to aid penetration of heat or liquid or for decoration.

SIMMER: to keep a liquid at just below boiling point so the liquid just trembles.

SKIM: to remove froth or scum from the surface of stocks etc.

STEAM: moist heat cooking method by which vaporized liquid cooks food in a closed container.

SWEAT: to cook gently in fat, covered, so liquid in ingredients is rendered to steam them.

INDEX